Renaissance Master Bronzes
from the collection of the
Kunsthistorisches Museum, Vienna

MANFRED LEITHE-JASPER

RENAISSANCE
FROM THE COLLECTION OF

MASTER BRONZES

THE KUNSTHISTORISCHES MUSEUM
VIENNA

Scala Books

in association with

Smithsonian Institution Traveling Exhibition Service

Washington DC

1986

© 1986 Smithsonian Institution
Renaissance Bronzes and the Vienna Collection and
the Catalog © 1986 Kunsthistoriches Museum, Vienna,
and Manfred Leithe-Jasper.

First published in 1986 by Scala Publications Ltd
26 Litchfield Street, London WC2H 9NJ
and distributed in the USA by Scala Books
c/o Harper & Row, 10 East 53rd Street, New York, NY 10022

ISBN 0–86528–034–7 (paperback)
ISBN 0–935748–69–5 (US hardback)
ISBN 0–85667–227–0 (UK hardback)

Library of Congress Cataloging-in-Publication Data

Renaissance master bronzes from the
Kunsthistorisches Museum, Vienna.

 Bibliography: p. 287
 Includes index.
 1. Bronzes, Italian—Exhibitions. 2. Bronzes, Renaissance—
Italy—Exhibitions. 3. Bronzes, Renaissance—Exhibitions. 4.
Bronzes—Vienna (Austria)—Exhibitions. 5. Kunsthistorisches
Museum Wien—Exhibitions. I. Leithe-Jasper, Manfred. II.
Kunsthistorisches Museum Wien. III. Smithsonian Institution.
Traveling Exhibition Service.
NB615.R46 1986 735′.21 86–15563
ISBN 0–86528–034–7

Edited and produced by Scala Publications Ltd
Consultants: Clark Robinson Limited, London
Filmset by August Filmsetting and BAS Printers, England
Printed and bound in Italy by Graphicom, Vicenza

Published on the occasion of an exhibition organized by the
Smithsonian Institution Traveling Exhibition Service and the
Kunsthistorisches Museum, Vienna, as shown at:

National Gallery of Art
Washington DC

Los Angeles County Museum of Art
Los Angeles, California

The Art Institute of Chicago
Chicago, Illinois

This publication was compiled under the supervision of
Donald R. McClelland, International Exhibition Coordinator,
Smithsonian Institution Traveling Exhibition Service.

The translation of all German text (including *Renaissance
Bronzes and the Vienna Collection*, catalog entries and
biographies) was by P.S. Falla, with advice from Anthony
Radcliffe.

Photography by Marianne Haller, Vienna, Austria
Cover photograph by Fotostudio Otto, Vienna, Austria

Illustration on p. 17 by permission of The National
Galleries of Scotland, Edinburgh. All other illustrations
by permission of the Kunsthistorisches Museum, Vienna

FRONT COVER: Bertoldo di Giovanni (*c.*1420–91),
Bellerophon taming Pegasus

Contents

As Austrian Ambassador to the United States I am delighted to extend a special word of welcome to the visitors of the exhibition *Renaissance Master Bronzes from the Collection of the Kunsthistorisches Museum, Vienna*. I also wish to thank all those who contributed towards arranging and organizing this wonderful display, in particular Peggy A. Loar, Director, and Donald R. McClelland, Exhibition Coordinator, at the Smithsonian Institution Traveling Exhibition Service. This exceptional exhibition is being presented to the American people by three of the foremost museums in the world, the National Gallery of Art in Washington DC, the Chicago Art Institute and the Los Angeles County Museum, and I want to thank them for all their efforts.

This marvelous show comprises the finest and most precious objects from the sculpture collection of the oldest Austrian museum, the world-renowned Kunsthistorisches Museum in Vienna with its many priceless treasures. It reflects the predominant position of Italian art in the Renaissance period as well as Austria's historic and on-going contribution to Europe's cultural development and the centuries-old tradition of art collecting in our country.

It is my firm hope that this unique exhibition will become another successful example of Austrian-American cultural cooperation and thus contribute to strengthen further the bonds of friendship between the people of the United States and those of Austria.

THOMAS KLESTIL
Ambassador of Austria

Acknowledgements

The Smithsonian Institution Traveling Exhibition Service is particularly pleased to bring to the United States the exhibition *Renaissance Master Bronzes from the Collection of the Kunsthistorisches Museum, Vienna*. While the exhibition does not attempt to present the historic development of the Renaissance bronze, it does represent the richness and importance of the Kunsthistorisches Museum's collection and indicates as well the unique position it holds among the museums of the world.

The exhibits for *Renaissance Master Bronzes* have been selected with scholarly discrimination by Manfred Leithe-Jasper, Director for Sculpture and Decorative Arts, Kunsthistorisches Museum, Vienna; Douglas Lewis, Curator of Sculpture, National Gallery of Art, Washington DC; and Donald McClelland, Exhibition Coordinator, Smithsonian Institution Traveling Exhibition Service. The important catalog entries for the bronzes, about which much new evidence is here presented for the first time, were expertly prepared by Manfred Leithe-Jasper. Dr Leithe-Jasper's complete understanding of the period's traditions makes this catalog a critical contribution to the study of Renaissance bronze sculptures.

We at SITES are deeply grateful to the Ministry for Science and Research and the Ministry of Foreign Affairs, Vienna, for their generous assistance in making this exhibition available for its American tour. The Austrian Embassy kindly sponsored the exhibition in the United States, and we thank particularly His Excellency Thomas Klestil, the Ambassador, and Wolfgang Waldner, Cultural Attaché, for their conscientious assistance. Others who have significantly facilitated the exchange of exhibitions between Austria and the USA are Dr Karl Kogler, Dr Carl Blaha, and Dr Georg Freund.

The organization and coordination of this international exhibition required expertise in many areas and a sense of dedication and enthusiasm both here and abroad. Therefore, to our colleagues at the Kunsthistorisches Museum, Vienna, particularly Dr Rotraud Bauer, we express our sincere gratitude for their support and assistance. Our special thanks goes to the Director of the Kunsthistorisches Museum, Professor Dr Hermann Fillitz, for his consuming interest in the exhibition. At SITES a special note of recognition goes to Lindsey A. Haines, Research Assistant; Andrea Stevens, Publications Officer; Nancy Eickel, Editor; Elizabeth L. Hill, Public Relations Coordinator; and Mary Jane Clark, Registrar, and her able staff. We also appreciate the contribution of Dr Anthony Radcliffe of the Victoria and Albert Museum, London.

At the National Gallery of Art we acknowledge the assistance of Gaillard F. Ravenel, Chief of Design, and Alison Luchs of the Department of Sculpture. Similarly, at the Los Angeles County Museum of Art, Scott Schaeffer, Curator of European Painting and Sculpture, Myrna Smoot, Assistant Director for Museum Programs, and John Passi, Exhibition Coordinator, offered their professional expertise, while at the Chicago Institute of Art, Katherine C. Lee, Assistant Director, and Ian Wardropper, Associate Curator, European Decorative Arts and Sculpture, provided their valuable services to presenting *Renaissance Master Bronzes*.

I would especially like to thank the following directors of our host museums for their counsel and cooperation: J. Carter Brown, National Gallery of Art; James N. Wood, The Art Institute of Chicago; and Earl A. Powell III, Los Angeles County Museum of Art.

Finally, we should like to express our thanks to Michael Rose, Hal Robinson, Hugh Merrell and Paul Holberton of Scala Publications for their work on the production of this catalog.

Peggy A. Loar
Director, SITES

Author's acknowledgements

The idea of organizing an exhibition in the USA of bronze statuettes from the Sammlung für Plastik und Kunstgewerbe of the Kunsthistorisches Museum in Vienna originated with Professor Dr Hermann Fillitz, First Director of this Museum. The Smithsonian Institution took up the idea with enthusiasm and has carried it out with praiseworthy generosity.

It is natural to raise the question of the usefulness of such an exhibition, since it must not be forgotten that works of art sent halfway across the world are exposed to all kinds of risks. The motive was certainly not one of display for its own sake, since the splendors of the Kunsthistorisches Museum can only be properly appreciated in Vienna itself. Rather, it was the intention to comply with a frequently heard request that the American public might for a brief period be given the opportunity to enlarge its knowledge by comparing the holdings of its own museums with a selection of works from abroad of a kind that simply cannot be acquired at the present day.

In recent decades the interest taken in bronze statuettes in the USA has increased by leaps and bounds. A well directed purchasing policy, using all the opportunities that the art trade still offers, has enriched public and private collections to an extent without parallel outside America. As the object of American collectors' interest bronze statuettes have taken on an importance like that which they once enjoyed in Europe in the sixteenth century, and again late in the nineteenth century and at the beginning of the twentieth.

This interest is expressed not only in ever-growing collections but also in important exhibitions and publications. One need only mention the exhibition of bronzes at Cleveland in 1975, and the increase in scientific studies of the subject, to which a major stimulus has been given in recent years by the publications of American scholars.

The "old" European collections – and above all those which, like the Kunsthistorisches Museum in Vienna, owe their origin to the *Kunstkammer* ("art chamber") of a reigning sovereign – have, despite all their gaps, an advantage that "modern" collections cannot rival, despite all the energy devoted to them and despite many successes. Even though the old collections are nowadays often prevented from expanding by shortage of finance, they are usually the only places in which it is possible to view whole groups of works by individual masters – for example, in Vienna, the incomparable collection of pieces by Antico or Giambologna. Moreover the provenance of such works is usually well documented, and they are generally in a good state of preservation, which only a long and continuous history as part of a collection can guarantee.

The choice of works for this exhibition has been governed by the desire to provide a historical cross-section representing a centuries-long collector's tradition, and also to exhibit bronze statuettes of which there are replicas, variants or counterparts in American collections.

To preserve a certain uniformity in a selection limited to 75 items, preference has been given to bronzes by artists of the Italian Renaissance and such non-Italians as were influenced by Italian style. At the same time it must be admitted that the Kunsthistorisches Museum possesses scarcely any French bronzes.

The catalog entries are intended to take account of the interests of a wide public as well as of specialists. Hence, while technical data and those of provenance are given in full, and references to literature and critics' opinions on particular works are as complete as possible, the descriptions of items and of their iconography are perhaps more extensive than usual.

I have to thank the Smithsonian Institution and Scala Publications Ltd for their accommodating attitude toward all the author's proposals and for making possible the production of such a splendidly illustrated catalog. Here I am specially obliged to Mr Donald McClelland, Exhibition Coordinator of the Smithsonian Institution, to Kathy Elgin and Michael Rose of Scala Publications, and also to Mr P.S. Falla for translating my text into English. Owing to an accident I have been unable to meet all deadlines punctually; I have been greatly touched by the patience shown me in this respect.

I have also many colleagues to thank. Anthony Radcliffe, Keeper of the Department of Sculpture in the Victoria and Albert Museum, gave advice and practical help and was also kind enough to assist the translator over technical terms. Douglas Lewis, Keeper of the Department of Sculpture of the National Gallery in Washington DC, was tireless in answering questions about works in American possession, and helpful in procuring photographs for comparison, as were Dr Ursula Schlegel, Director of the Italian section of the Department of Sculpture of the Staatliche Museen, West Berlin, and Dr Sabine Jacob, Assistant Keeper of the Herzog Anton Ulrich Museum in Brunswick. Mr Volker Krahn, working as a temporary assistant in Vienna, kindly helped to complete the bibliography. Dr Herbert Beck, Director of the Liebieghaus in Frankfurt, was kind enough to show me, before publication, the manuscript of the exhibition catalog *Natur und Antike in der Renaissance*; for this help I am also obliged to his scholarly collaborators.

In the Kunsthistorisches Museum, I am especially grateful to all my colleagues in the Sammlung für Plastik und Kunstgewerbe for their consideration and understanding. Christa Angermann, the conservation expert, was always ready with advice on technical questions. Dr Alfred Bernhard-Walcher, Assistant Keeper of the Department of Antiquities of the Kunsthistorisches Museum, made it possible to establish in many cases the continuous provenance of bronzes that were transferred to this collection in the early nineteenth century but were removed from it at the end of the century. Dr Alfred Auer, Assistant Keeper of the Collections of the Kunsthistorisches Museum at Schloss Ambras, was kind enough to carry out time-consuming checks on inventories in the Innsbruck archives. Last but not least, I have to thank Fräulein Sieglinde Ochnitzberger of the Museum staff for typing my manuscript with her usual accuracy in addition to her normal duties.

My wife and children have seen little of me in the past year, and I thank them warmly for their understanding. I conclude with the hope that this exhibition by the Kunsthistorisches Museum in Vienna will give pleasure to the art-loving public in Washington, Los Angeles and Chicago.

Manfred Leithe-Jasper
Director, Department of Sculpture and Decorative Art,
Kunsthistorisches Museum, Vienna.

Introduction

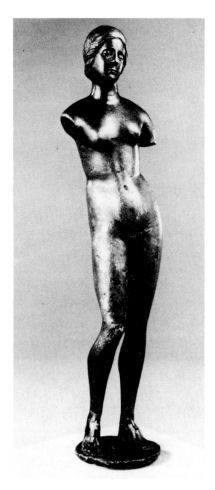

Fig. 1. North Italian *Venus*, bronze, end of 15th century (see p. 146).

The exhibition *Renaissance Master Bronzes from the Collection of the Kunsthistorisches Museum, Vienna* presents America with a unique opportunity to see, for the first time, a selection of bronze statuettes and plaquettes that are among the chief glories of one of the greatest museums in the world. A number of them were made especially for the Habsburg *Kunstkammer* or similar princely art rooms, others for the educated and discriminating private collector.

To observe closely these small masterpieces, by some of the greatest artists of the Renaissance, is to be a part of a moment when artists and men of letters expressed in their work a belief in the genius of man and a sense of his harmony with nature. These bronzes, with their lingering spirit of antiquity, are tangible reminders of the artist and his age, an age that determined much of the character of Western civilization. Although the fifteenth and sixteenth centuries were rent with violence and political tensions, the arts reflected a renewed and relaxed view of man, a vision of an ideal world in which the nude figure was accepted as a part of man's natural setting.

Thoughtful consideration of the small bronzes in this exhibition can bring us to a better understanding of the Italian Renaissance and its astonishing range of artistic and scholarly achievements.

It is, I believe, correct to say that the Renaissance bronze was intended as a conscious emulation of the antique, though the evolution of Renaissance bronze sculpture was quite different from that of its Greek and Roman antecedents. Indeed, many statuettes were obvious copies of recently found antique models, with partial breaks and missing parts in imitation of the originals, as in the *Venus* (fig. 1), an early sixteenth-century figure from Northern Italy once attributed to the Venetian Tullio Lombardo. Kenneth Clark, commenting on the influence of the antique on Renaissance artists, said:

Michelangelo had, throughout his life, two ideals of antiquity which were in a sense complementary to each other. One was the ideal of perfection, the belief that what gave antique art its durability was the unflinching firmness with which every detail was realized. But parallel to this admiration for its completeness, Michelangelo was fascinated by the fragmentary character of ancient sculpture; and the appeal of weather-worn survivors of a mightier age was all the stronger because they gave a free play to the imagination.[1]

Other artists, too, must have shared this view of antiquity – how else do we explain the production of a bronze such as the *Venus*?

It was not long before collectors prized these new bronzes as much as those from Greece or Rome, and placed them with equal authority next to the antique figures in their cabinets. This visual comparison of antique and contemporary artistic models occurred for example in Florence, with the Medici collection, and later in Austria with the treasury of Archduke Ferdinand II (1529–95) in the Castle of Ambras near Innsbruck, where a number of the bronzes in this exhibition were first seen.

It is not surprising that the early Italian Renaissance should have had as its

center the city of Florence, although the cities of northern Italy, and of course Rome, also played an important role in its development. It has often been said that, if Florence was the cradle of the Renaissance, Rome was certainly its mother. In Rome it was difficult, if not impossible, to be unaware of the city's glorious past, still reflected in the majesty of its ancient monuments. The Renaissance, however, could not rely only on the memory of old triumphs, but needed the practical stimulus of a vibrant and healthy economic patronage.

Florence in the fifteenth century had a particular advantage in the strength of its *Arti*, or guilds, which united the merchants and skilled craftsmen responsible for making the city one of the economic and commercial centers of Italy. Commerce became a crucial factor in determining the city's role, and through its influence the cultural aspects of the Renaissance – art, architecture, literature, and humanizing ideas – were spread across Europe in many ways. Against this background, the exchange of diplomatic gifts was a recurring need, and the small bronze was seen as ideal for this purpose.

Perhaps we should look briefly at certain factors that led to a fondness for the small bronze. There was at this time a passion for the rediscovery of the ancient world and its relevance to contemporary culture and literature. There was, too, a renewed interest in essentially decorative objects. For the Renaissance patron, the scale of the bronzes and the informal and private character of each individual piece were appealing. They were meant to be handled, caressed, and passed from one observer to another – indeed, so intricate and sensual in spirit are these little works of art that not to touch them is to miss a great deal of their attraction. Yet often they also had a functional nature, serving, for instance, as an inkwell or door knocker, and thus providing an altogether different dimension to the possessor's convenience and delight. I should add that bronze, almost a precious metal with its glorious luster, also has the capability of reflecting directly the imprint of the artist's mind and hand on the model from which it is cast, so in this way too it served the desired new ideals of the Renaissance. According to Italian tradition, bronze above all materials gave a particular sense of importance and permanence to a work of art. That antiquity also placed a special premium upon bronze for statuettes only compounded its importance.

Let us look for a moment at three bronzes from the Kunsthistorisches Museum that for me best express the breadth and richness of this exhibition. Perhaps the most beautiful of all, relief-like in its composition, is Bertoldo's *Bellerophon taming Pegasus* (fig. 2), which depicts the youth at the height of his physical and mental powers, when he tamed the winged horse Pegasus and aspired to ride to the throne of the gods atop Mount Olympus. Bertoldo di Giovanni (*c*.1440–92), as we know from the Renaissance art historian Giorgio Vasari, was trained in the workshop of Donatello, where he studied the technical aspects of bronze casting and continued his deep involvement with the antique. Around 1459, he presumably assisted his aging master in casting and finishing several sections of the reliefs in the Medicean church of San Lorenzo, Florence. For a brief period, Bertoldo may have served as

Fig. 2. Bertoldo di Giovanni *c*.1440–92), *Bellerophon taming Pegasus*, bronze, signed, *c*.1480/84 (see p. 51).

Fig. 3. Moderno (active *c*.1490–1540), *The Flagellation of Christ*, silver, partial-gilt, 16th century, see p. 125).

master of the young Michelangelo. Another distinguished artist, Adriano Fiorentino (*c*.1450/60–99), worked with Bertoldo in the early 1480s: in fact, *Bellerophon* is signed "Expressit me Bertholdus conflavit Hadrianus" ("Bertoldo modeled me; Adriano cast me").

Bertoldo's reputation and success were at first largely associated with Donatello and later with the Medici. As a close friend of Lorenzo the Magnificent (1449–92), he played a prominent role in the artistic life of Florence: perhaps because of Bertoldo's significant knowledge of antique sculpture, Lorenzo appointed him "keeper" of the collection of antiquities in his garden and casino at San Marco.

Bertoldo also worked for a time in Padua, where the university has always been a leader in the study of the classics. The idea for *Bellerophon* may have sprung either from this or from some other humanist environment, but it is recorded that a statuette of *Bellerophon* was seen in the early sixteenth century in a private Paduan collection. As John Pope-Hennessy has pointed out, a classic originality certainly underlies the *Bellerophon*, "and in the ecstatic figure of the youth the pulse of Greek bronzes seems to have been reborn."[2]

One cannot help but be astonished by Moderno's relief of the *Flagellation of Christ* (fig. 3). The silver-plated plaquette with firegilt figures inscribed "OP MODERNI" has been discussed in detail by John Pope-Hennessy in his study of the artist in *The Italian Plaquette*[3], where he reasserted that Moderno's real name, as first proposed by Bode, was Galeazzo Mondella. Several figures in the plaquette closely resemble antique models, and the central figure of Christ is based on the renowned sculpture of the *Laocoön*. Known to early classical scholars only from Pliny's *Historia Naturalis*, the *Laocoön* was dramatically rediscovered in 1506 in the ruins of Nero's Golden House, and engravings by Giovanni Antonio da Brescia and others soon spread news of the archeological find throughout Italy. Pope-Hennessy believes, however, that a somewhat later engraving by Marco Dente is the more likely source of Moderno's anguished Christ.

It is probably safe to say that Moderno, or Mondella, was a Veronese goldsmith and engraver of gems. Most likely he later worked in Rome where this plaquette may have been produced. The delicate and masterly handling of the figures and their architectural setting aptly demonstrates Moderno's firmness of control as well as his complete understanding of sculptural techniques.

Federico Zuccaro's (*c*.1540–1609) sensitive drawing in red and black chalk of the Renaissance artist Giambologna, or Giovanni Bologna (fig. 4), in a fluent yet somewhat dry "counter-maniera" style, served as a preliminary sketch for his portrait among the frescoes of the cupola of Florence Cathedral completed around 1575–76. It tells us much about Giambologna and his obviously inquisitive nature. Born in Flanders in 1529, Giambologna was a leading master of the late Renaissance and died in Florence in 1608. The sitter, shown holding what has been identified as the model for *Samson and the Philistine*, is dressed in a fashionable cloak and doublet, his arresting eyes seeming to grasp and absorb the lessons of his Florentine environment.

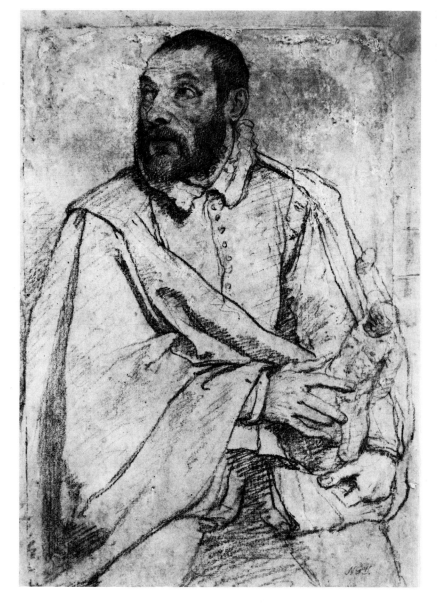

Fig. 4. Federico Zuccaro (1540–1609), *The artist Giambologna*, black and red chalk on paper, National Gallery of Scotland.

When we look at Giambologna's *Flying Mercury* (fig. 5), with its transparent golden bronze glow, we see an ideal figure as a divine messenger. Signed ·I· ·B·, the bronze, with its splendidly balanced pose and extraordinarily refined finish, was first listed in the inventory of Emperor Rudolf II's *Kunstkammer* of 1607–11. This celebrated piece may have been one of the bronzes that Francesco de' Medici sent as a diplomatic gift to the Emperor Maximilian II in 1565, though, as Manfred Leithe-Jasper indicates, the Vienna *Mercury* is probably of a somewhat later date than the work mentioned by both Vasari and Borghini.[4] But whenever the statuette came into the imperial collection, the bronze is obviously a very remarkable work of art.

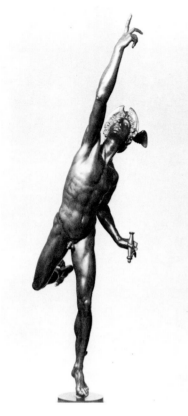

Fig. 5. Giovanni Bologna, or Giambol-
ogna (1529–1608), *Flying Mercury*,
(see p. 198).

Through his workshop, Giambologna established a tradition in bronze sculpture that came to be emulated throughout Europe. The master's gifted pupils and associates, who inherited many of his wax and terracotta models (as well as bronzes like the *Flying Mercury*), cast them and similar variants superbly until the middle of the seventeenth century. In this way, Giambologna's gracefully idealized figures of ageless beauty and power have continued to entrance their possessors to this day.

While this exhibition of *Renaissance Master Bronzes from the Collection of the Kunsthistorisches Museum, Vienna* does not attempt to trace the history of the European Renaissance bronze, it does reflect many different stylistic outlooks in sculpture, particularly in Italy. The bronzes in this exhibition by Bertoldo, Moderno or Giambologna give us an exceptionally stimulating opportunity to observe the amazing breadth of ideas and ideals to be found in the Renaissance. Studying and enjoying these sculptures, we can become a part of that world for a moment and observe the customs and manners of the period.

The collection of the Renaissance master bronzes at the Kunsthistorisches Museum first began as the Imperial Collection of the House of Austria, and eventually formed an artistic and historic unity that is unique. A brief glance at the history of individual bronzes shows us that the character of each piece often reflects a particular collector's personality – though here we must limit our attention to the artists represented in the exhibition. The thoughts of these creators were not constrained by medieval traditions or limited to the miracles of the saints, but were boldly focused on man's abilities and the importance of the individual. Bernard Berenson once said, "No artefact is a work of art if it does not help to humanize us."[5] How could it be otherwise as we observe the intimate and yet majestic Renaissance master bronzes of Vienna?

Donald R. McClelland
Exhibition Coordinator,
Smithsonian Institution Traveling Exhibition Service

Notes

1. Kenneth Clark, "The Young Michel-angelo," in *The Horizon Book of the Renaissance*, ed. Richard M. Ketchem (American Heritage Publishing, New York 1961), p. 108.
2. John Pope-Hennessy, *Italian Renaissance Sculpture*, second edition (Phaidon, London and New York 1971), p. 84.
3. John Pope-Hennessy, "The Italian Pla-quette," in *Proceedings of the British Academy*, L, 1964, pp. 69–70; republished in Pope-Hennessy, *The Study and Criticism of Italian Sculpture* (The Metropolitan Museum of Art in association with Princeton University Press, New York and Princeton, 1980), pp. 202–203.
4. Manfred Leithe-Jasper, "Bronze Statuettes by Giambologna in the Imperial and other Early Collections," *Giambologna 1529–1608, Sculptor to the Medici*, ed. Charles Avery and Anthony Radcliffe (The Arts Council of Great Britain, London, 1978), pp. 85–86.
5. Bernard Berenson, *The Italian Painters of the Renaissance* (Phaidon, London, 1954), p. xiii.

On the nature of Renaissance bronzes

What in fact are Renaissance bronze statuettes? Why were they made, by what sort of artist, and for what clientele? How frequent were they, how much did they cost, and – above all – what were they understood to mean, in the contexts for which they were created? The answers to some of these questions are still elusive, but the uninterrupted aesthetic and intellectual appeal of small bronzes, as one of the most characteristic art forms of the European Renaissance, ensures that these and other aspects of their study exert a continuing fascination.

In the first place, these small bronze statuettes are masterworks of consummate craftsmanship. Their intricate shapes and carefully chiseled surfaces remind us that their artists were often goldsmiths and silversmiths, sometimes signing their works as "AURIFEX". Even if most makers of bronzes did not practice these more rarefied crafts, in a surprising number of the cases for which we have evidence they had in fact been trained by goldsmiths and silversmiths, masters of the most exacting and refined arts of metalwork. The bronzes themselves bear witness to this exceptional level of training and craftsmanship: their subtly reflective surfaces are delicately hammered and punched, painstakingly worked to achieve the most exquisite detail of facial features, expressive gestures, and surface textures. Moreover, many small bronzes are partially or even totally gilded, so that their glittering surfaces suggest a common origin with the masterworks of the goldsmith's skill.

Renaissance bronzes served most frequently as ornaments to "cabinets of curiosities": a notable part of the collection in Vienna itself derives from such a cabinet at Schloss Ambras, near Innsbruck. Rather than being limited to royal or imperial houses, however, such collections, combining natural curiosities with masterworks of human craftsmanship, are encountered through a wide social scale: not only did they embellish the castles and palaces of princes, but they were attractions as well in the households of knights and churchmen, merchants and mercenaries, statesmen and scholars. Such assemblages varied in extent from an imperial *Wunderkammer* (such as that at Ambras), with hundreds of objects including scores of bronzes, to an isolated statuette or figured utensil on the desk of a humanist writer (as we glimpse, for example, in Carpaccio's painting of *St Augustine in his study* in the Scuola di San Giorgio in Venice). A unifying characteristic would have been the function of such a chamber as a place of private retirement, for study and contemplation: both this context and this associative character are reflected in the most frequent types of Renaissance bronzes.

The contents of a typically developed *Kunstkammer* would have included natural curiosities of all sorts: ostrich eggs and plumages of birds, crystals, fossils and amber from exotic lands, as well as shells, corals, and narwhal tusks from the sea – the latter standing in for the "unicorn horns" of still more distant and more magical realms. Within such an encyclopedic panorama it becomes easier to understand the appeal of an intensely lifelike bronze warbler (cat. 68) or the "hyperexaggerated" reality of a grimacing bronze crane (cat. 57), as representatives of the realm of air; of artistically coiled or knotted bronze serpents, or of actively croaking frogs (cat. 17), as

denizens of the darker worlds beneath our feet; and of bronze shells and crabs (cat. 16), as well as images of many other creatures, as inhabitants of ocean deeps.

All these latter "curiosities" are bronze casts made directly from nature, called "life casts": but here already, in this ostensibly simplest and most obvious repertory of bronze subjects, we come immediately upon the ambiguities and double meanings that make these "artefacts" – these images of nature transformed directly into art – capable of inspiring that meditative ratiocination which documents their higher humanist function. Even so uncomplicated a translation as that of a living warbler into its bronze surrogate may well have involved its contemplative Renaissance observer in prototypes to Keats's questions about his *Nightingale*: thoughts of permanence and change, or transitoriness and truth. The sensuous curvilinear beauty of elegantly knotted bronze snakes, again, might evoke for a bemused observer the aesthetic possibilities asleep in unseen spaces beneath the earth; while the fantastical creatures with which Renaissance *bronzisti* figuratively populated the realm of Neptune (as in cat. 43, 59, 69, and 70) perhaps best demonstrate the Protean inventiveness so essential even to this "reproductive" genre of bronzes as "specimens" in cabinets of curiosities. Bronze birds, for example, are apparently the simplest and most direct of such transformations, straightforward preservations of ephemeral natural prototypes – but even they represent a perpetually suggestive threshold between permanence and decay. The more elaborated derivations, as in manneristically coiled serpents or artfully yawning toads, remind us of man's constant and global enterprise of transforming Nature into Art; while the Renaissance bronzemaker's endlessly burgeoning world of fantastical sea-creatures – tritons, nereids, mermen, hippocamps, and ichthyocentaurs – takes us through a further type of transformation yet, one exactly analogous to Circe's of Odysseus's men (see cat. 27): the transmogrifications of magic and inventive fantasy. These developments take us far from the world of experience, and thus from cabinets of natural curiosities: they constitute palpable images of worlds unconstrained by ordinary reality.

Transitional vehicles for the human imaginings of such worlds, among small bronzes, are afforded by images of the nobler animals. Individuals such as the lion (cat. 55), panther (cat. 13) and horse (cat. 14 and 64), as exemplars of grandeur, power, and grace, were evident and popular candidates for celebration in these terms; more elaborated as forms and more engaging to human speculation are representations of animal passion (cat. 58) and competitiveness (cat. 71), fidelity (cat. 61) and fortitude (cat. 62). The individual members of a bronze menagerie thus function both as genre figures and symbolic allegories: they are both image and emblem, exemplars at once of nature and of supra-natural emotive or expressive forces, which bind them closely to inner aspects of human experience.

It is in this sense that we should understand the most pervasive and the most challenging of the supra-natural creatures presented to us in Renaissance bronzes: the race of Pan. Majestic in isolation as a generative force of wild

nature (cat. 20), Pan and his innumerable satyr train are also, through their
very character of unachieved humanity, poignantly moving representatives
of another of those worlds (like that of the fantastical sea-creatures) that
hovers on the verge of human consciousness, yet is barred to direct access
through experience. Far more than in monumental sculpture, with its public
requirements of unambiguous rational reference, Renaissance bronzes –
especially in these favored themes, of images from haunted woodlands and
magical depths – present a world where inspiration from observable nature is
left behind, and a new universe is perceived. The imperfect civil society of
the race of satyrs, grandly independent in their animal nature (cat. 37), or
ineffably poignant in their yearning for humanity (cat. 3, 22), reminds con-
templative men of the imperfect distinction of human from bestial nature,
that is, of the central ambiguity in humanity itself. This concept is supremely
epitomized among the Vienna bronzes by Giambologna's spectacular group
of *Nessus abducting Deianira* (cat. 52); this frenzy of animal passion is un-
leashed by a mythical creature half man and half beast, though in other per-
sonifications (such as that of Chiron as the wise teacher of heroic youth) the
centaur exemplifies instead the ideal union of animal potency and human
genius.

The Renaissance bronzes that are most evocative of man's many-faceted
humanity are thus in large measure the ones that derive their suggestive
power from the broadly descriptive imagery of ancient myth, that body of
thought at the core of the grandly developed ethos of the classical world. It is
probably as much for this reason, as for the generally adduced motive of dir-
ectly emulating the actual statuettes of antiquity, that the most interesting
Renaissance bronzes focus upon the ideal world of Greco-Roman classicism.
This most revered of human cultures, this nostalgically venerated Golden
Age, stood at the heart of the Renaissance understanding of human ex-
perience. The painstaking recovery of ancient texts, as the life-giving im-
petus that inspired the modern world's "re-naissance" of classical wisdom
and wholeness, is recalled in the earliest of the Vienna bronzes: Filarete's
stele-like relief depicting the *Return of Odysseus* (cat. 1). Just as the recovery
of classical artefacts aggrandized and legitimized the modern regimes which
invoked such works as visible links with the ideal Empire of antiquity (as
witnessed by the papal usage of carrying classical statuary in triumphal pro-
cession), so too the assimilation of classial virtues ennobled and "civilized"
the Renaissance individuals who adopted them. Because the prestige of the
classical world was so nearly universal among the humanist patrons of small
bronzes, we find exemplified throughout their repertory the persuasive
imagery of antique *virtù*. Busts of "Illustrious Men" are an obvious type that
proved perfectly adaptable to small bronzes (see for example cat. 31).
Another was mounted horsemen, who became reincarnations of ancient
knights or princes: modern rulers (cat. 65 and 66) chose the form as reflecting
the great *Marcus Aurelius* of the Roman Capitol, though the larger bronze-
making shops produced equally beautiful but more anonymous variants, pre-
senting a generic image of knightly virtue (cat. 18) that could be adopted as a

personal ideal by a client of the most modest rank or means. The "perfect knight's" antagonists were not neglected: sometimes the equestrian hero destroys a symbolic serpent, occasionally he might be arrayed at least conceptually against a "barbarian" combatant (cat. 41), or in other cases (as in Leonardo's drawings for monumental sculptural groups) against "infidel" or other armed opponents (cat. 39): the Vienna collection exemplifies the longevity of these themes, by including a late Renaissance variant of the latter fifteenth-century type (cat. 40). A summation of this millennial ideal of *virtù* is afforded by Vienna's magnificent relief by Giambologna of Olympian protection extended to a dutifully attentive modern prince (cat. 53): it depicts the young Francesco de' Medici sponsored in personal and political virtue by the classical gods. The fact that many of the Vienna bronzes (including this one) were conceived as dynastic memorials, and circulated to northern courts as diplomatic presents from Italian allies and patrons such as the Medici, underscores the universality of the classical idiom. It also reminds us why so many European small bronzes, from their beginnings in the fifteenth century until their gradual eclipse in the nineteenth and early twentieth, are either reproductions of antique types, or even self-conscious forgeries in an antique style (as for example the "*Venus* of Cardinal Granvella", cat. 12).

The figural language of classical myth in fact afforded Renaissance bronze-makers the richest conceivable vocabulary for imaginative embodiments of the human condition. Qualities, feelings and moods could be expressed with elegant concision through recourse to their classical exemplars: eloquence as personified by *Mercury* (cat. 49), joy by music-making *putti* (cat. 47–48), cold by the embodiment of *Winter* (cat. 44), love by a *putto* riding a dolphin (cat. no. 59), age through the figure of *Saturn* (cat. 60). Classical experience provided legible emblems of such celebrated humanist ideals as the constructive balance of opposites (for example *Venus* and *Mars* as love and strife, cat. 72), the control of individual passions (as in *Bellerophon taming Pegasus*, cat. 2, with its exalted imagery of unruly nature channeled into poetic power), or even the soul's ascent to God, through the person of *Europa* (cat. 19) extending a propitiatory wreath toward the brow of her now-missing bull, who himself personified one of the *amori di Giove* – or, as Renaissance platonism interpreted the type, one of the passions of God for the redemption of the human individual.

These philosophical underpinnings of Renaissance allegory speak deeply to the fundamental nature of man – most especially to the underlying harmony, achieved through the medium of art, of human life in its most sensitive balance with a classical perception of nature. In this sense the final triumph of Renaissance figural bronzes is to offer us provocative glimpses of one more empirically imperceptible realm (after those of the distant empyrean, the haunted wood, the nether world, and the teeming sea): that is of the thrones of heaven, presided over by the Olympians as civilizing forces who are perpetually at work on behalf of men, inspiring deeds of valor and *virtù* in the "humanizing" of inimical nature. Thus human destiny, *Fortuna* (cat. 45), enters the figural canon as a feminine paradigm of grace and beauty, as ad-

mirable as she is desirable; and Hercules sturdily performs his miraculous
Labors of purging the world of its monsters (cat. 9, 10), creating through
dutiful devotion a human landscape cleansed of fear. But Hercules as a
civilizing paragon of noble virtue (cat. 11, 36), or Fortune as a personific-
ation of destiny, are still peripheral to the core *personae* of classically inspired
Renaissance bronzes, which culminate with the supremely humane images of
the gods themselves. We have noticed among their epiphanies in Vienna the
figures of Venus and Mars, Mercury and Neptune. Their overlordship in
bronzes, as in the classical texts, is vested in Jupiter – who early in this great
collection appears almost as a human celebrant, draped and accoutered for
the sacrifice, might have conceived him (cat. 7); three-quarters of a century
later (cat. 42) he emerges as the paradigm of man's sublime perception of the
gods in human form, resplendent in the majestic, heroic nudity of terrestrial
and Olympian perfection. These images bespeak the transcendent summit of
humanist belief: but the broad catholicity and tolerance that is epitomized by
the classicizing universe of Renaissance bronzes frequently embraces pious
images of Christianity as well, movingly and delicately exemplified, for
example, in the poignant humanity of the suffering *Christ* (cat. 54), or the
pathetic penitence of an ascetic *St Jerome* (cat. 74).

The world of images and meanings which we have sketched for
Renaissance bronze statuettes, no matter how grand their eventual compen-
dium collections were to become, began on the individual writing-desks of
Renaissance humanists. The conceptions of the universality of seen and un-
seen realms, across whose thresholds bronzes migrate more suggestively than
almost any alternative medium, and above all of the civilizing truth of an-
cient experience as exemplified in these images, were disseminated through
the persuasive media of humanist writings far more widely and effectively
than through the rare and precious bronzes themselves. In this respect the
historicizing scholars of the Renaissance well knew that they were fulfilling
one more mandate of their classical training; for the most respected ancient
texts which actually referred to bronze statuettes were couched in terms
which can only be called ecstatic, and which securely established a *topos* for
the appropriate emulation of succeeding centuries. Both Martial and Statius
had described a statuette supposedly by Lysippus, a *Hercules resting after his
Labors*, whose noble owners were said to have included Alexander the Great,
Hannibal and Sulla, as well as the connoisseur-collector contemporary with
the Roman writers, Novius Vindex. Upon seeing it, as Statius wrote in his
Silvae (IV, vi, 32–58),

I fell deeply in love; nor, though long I gazed, were my eyes sated with it; such dig-
nity had the work, such majesty, despite its narrow limits. A god was he small to
the eye, yet a giant to the mind! . . . What preciseness of touch, what daring imagin-
ation the cunning master had, at once to model an ornament for the table and to con-
ceive in his mind mighty colossal forms!

This exhibition of *Renaissance Master Bronzes* thus encapsulates a legacy of
beauty as pure object, inseparable from an ancient ideal of genius and virtue,

which is the content of the image. The content is, to the modern audience, the most ephemeral; for the objects have endured, and have even been endowed by the passage of time with the seductive allure of old patinas. But their meanings have proved more fragile; for their humanist patrons they not only emulated directly the choicest sculptural treasures of antiquity, they brought the wisely tolerant and pious attitudes of the classical world directly to bear upon modern experience: they became in this sense *lares* and *penates*, as important as household gods. If to us their appeal is more immediately aesthetic, their richly resonant nature still evokes the splendor of their origins: they are, in their several ways, paradigms of wonder; emblems of ennoblement; icons of virtue; and exemplars of grace.

Douglas Lewis
Curator of Sculpture,
National Gallery of Art

Renaissance bronzes and
the Vienna Collection

The early fifteenth century saw the awakening in Italy of an interest in ancient art which grew steadily from that time onward. Excavations were zealously pursued, and antiques of the most varied kind were brought to light in ever greater numbers. Besides the coveted marble sculptures, inscribed tablets and pottery of all kinds, the works discovered included numerous bronze figures and utensils, so that artists and collectors began to take an interest in these also. The possibility of reproducing bronze casts in large numbers was recognized at an early date; an increasingly large public with an interest in the humanities could thus be supplied with reduced copies of antique statues and statuettes that were not available to them in the original.

Marble sculptures, the discovery of which never failed to create a sensation, were immediately taken into the possession of a few individuals, chiefly the popes and cardinals resident in Rome; much more occasionally they found their way into the collections of Italian princes who had particularly close Roman connections. Bronzes were discovered in much greater quantity than monumental sculpture, but even so there were not nearly enough of them to satisfy the antiquarian and archeological interest and the passion for collecting that arose on every hand.

The shortage was supplied by bronze casting. By a unique historical chance, the bronze statuette as an independent, usually secular work of sculpture came to be one of the most successful and fruitful of Renaissance innovations: the technique of bronze casting made it possible to reproduce originals, which were the property of the few, in a smaller size and in almost unlimited numbers. The bronze copies were relatively cheap and therefore available to a larger public. The use of bronze also made it easier to apply the increasing knowledge of archeology so as to restore "scientifically" marble sculptures that were often excavated in a fragmentary state. In this way princes, scholars and humanistically educated layfolk could be supplied on their doorstep, as it were, with products of the increasingly familiar world of ancient mythology and history, either in the form of conscious forgeries or avowed copies, or in new artistic inventions or free variations on an antique model. Probably few then realized, however, that Renaissance bronze statuettes were destined to perform a basically different function from those of the ancient world. Classical bronze statuettes were almost exclusively religious or devotional objects, whereas the Renaissance statuette was valued for its artistic merit and as a depiction of the ancient world itself. It was collected for this reason and for purposes of private decoration, and accordingly most Renaissance statuettes do not depict Christian religious themes.

The fifteenth-century public's idea of the ancient world was chiefly formed on the basis of Roman art and imitations of it.[1] Greek art was known from literary sources and numerous Roman copies, but only in exceptional cases were originals available. Ancient Rome, by contrast, survived thanks to a continuous tradition: Rome, as the seat of the papacy, was the spiritual center of the world, and ideally at least it was the political center also, the Holy Roman Empire being the successor of ancient Rome. Con-

1. The problem of Renaissance attitudes to ancient art has been covered extensively in two recent exhibitions: *Römische Geschichte im Spiegel der Kunst* (Bregenz, 1985), and *Naturund Antike in der Renaissance* (Frankfurt am Main, 1985/86).

sequently the antique sculptures and bronzes that had remained on view through centuries of troubled history – such as the equestrian statue of *Marcus Aurelius* (believed in the Middle Ages to represent Constantine the Great), the *She-wolf*, and the *spinario* (*Boy plucking a thorn from his foot*) – were at all times treated with the respect due to symbols of Rome herself. For the same reason, statues excavated in Rome continued to be much revered; and the art of Roman antiquity received special and unique honor from the Renaissance to the Neoclassical period of the early nineteenth century. It is quite in keeping with this that the earliest surviving signed and dated small Renaissance bronze – Filarete's 1465 copy of the statue of *Marcus Aurelius* – should have one of the famous Roman antiquities as its prototype. As an inscription states, Filarete made a present of his statuette to Piero de' Medici, thus illustrating the function of early Renaissance bronzes as substitute antiques. The original statuette, now in Dresden, was the first of an unending series of versions of its subject, but the *She-wolf* and the *spinario* were also frequently and lovingly copied.

A decisive stage in the recognition of classical art was reached when at the beginning of the sixteenth century Pope Julius II displayed in the courtyard of the Villa Belvedere in the Vatican the principal antique sculptures newly discovered in Rome, such as the *Laocoön* group (excavated in 1506), the *Apollo* Belvedere, the group of *Hercules and Antaeus* and the *Venus Felix*. However, it was not only antique sculptures excavated in Rome that were copied, but others that were on public view in northern Italy, such as the horses on the façade of St Mark's in Venice and the equestrian statue in Pavia known as the *Regisole*.

The original center from which the Renaissance art of bronze statuette production developed was Florence, as it was in the case of monumental sculpture. But although Donatello and Ghiberti, the pioneers of the new style in sculpture, were also very considerable workers in bronze, they cannot be described as creators of statuettes of independent artistic value. They produced only a few such works, and those are mostly part of what was originally a larger context. Nonetheless, their reliefs for bronze doors and door-frames, their altars, fonts and pulpits, are peopled by numerous small secular figures as well as sacred ones, and these provided a starting-point for the next generation of artists, especially Donatello's pupils in Florence and Padua. Bertoldo di Giovanni, Antonio del Pollaiuolo and Francesco di Giorgio Martini in Tuscany, and Bartolomeo Bellano, Severo da Ravenna, Andrea Riccio and Jacopo Alari-Bonacolsi, called Antico, in northern Italy, are the artists associated with the finest bronze statuettes of the early Italian Renaissance.

Next to Florence, and gradually surpassing it in this genre, the university city of Padua, which was politically subject to Venice, became in the latter part of the fifteenth century the main center for the production of bronze statuettes. Donatello was summoned from Florence to Padua in 1443 to create a new high altar for the church of the Santo (Sant' Antonio), decorated with numerous bronze statuettes and reliefs. For this monumental

work, and also for the bronze equestrian statue of the *condottiere* Gattamelata, which was erected during this same time, he employed many assistants, some brought with him from Florence and others recruited in Padua. Some remained in that city; others, like Bellano, went back to Florence with Donatello but afterwards returned to Padua. These provided an artistic stimulus which was enhanced by the city's intellectual atmosphere. The university was a center of interest in classical literature, natural philosophy and hermeticism. The seed sown by Donatello in the fertile soil of this city of humanists soon blossomed abundantly, and the genre of bronze statuettes reached its first peak in the works of Andrea Riccio. This artist was a prolific inventor of new types, whose very personal style seemed to combine elements of classicism, inspired by antique prototypes, with underlying North Italian realism and, often, an intensely poetic quality. Besides the ancient Olympian deities he depicted rural figures of myth and fable, satyrs and other hybrid creatures, shepherds, peasants and animals. During his lifetime and for long after his death, aftercasts and imitations of his works were coveted by collectors in Italy and abroad. Nearby Venice, where the Renaissance set in later than in Padua, did not at once become a center of bronze statuette production; among those who practiced the art in due course were Tullio and Antonio Lombardo, Alessandro Leopardi and Vettore Gambello, called Camelio.

The cultivated court of the Gonzagas in Mantua also became a center of bronze production. Individual members of the dynasty, especially Gianfrancesco Gonzaga, Bishop Ludovico and Isabella d'Este, were passionate collectors and the real promoters of the genre, which was dominated in Mantua by a single sculptor, Jacopo Alari-Bonacolsi, called Antico. As is now known, he had been active in Rome as a restorer of monumental antique marble sculpture,[2] which fact seems to have recommended him to his patrons as a purchaser and copyist of ancient works. But the term "copyist" does not do him justice: he often treated antique models with considerable freedom, and in some cases his work was one of reconstruction. The subtlety of his finishing, and his elaborate treatment of surfaces, appealed to the refined taste of the Mantua court. His reductions of antique statues and imitations of classical reliefs are among the most exquisite works of bronze statuary that have ever been created.[3]

It is remarkable that the development of bronze statuettes in Florence seems to die out during the High Renaissance, or the period when Rome became the chief artistic center in Italy, that is from about 1500 until 1527, when Rome was sacked by Charles V's troops. At this time sculptors were preoccupied by monumental tasks; art seems to have become, first and foremost, a public affair. Only in the next generation did collecting resume on a grand scale; private homes were once more decorated to meet the demands of refined taste, and bronze statuettes took on an increasingly ornamental character.

The principal Florentine sculptors who reverted to bronze were Baccio Bandinelli, Benvenuto Cellini, Niccolò Tribolo, Vincenzo Danti, Bartolo-

2. A. Nesselrath (1982), pp. 353–57.
3. The most recent thorough appraisal of Antico is by A. Radcliffe in *Splendours of the Gonzaga*, exhibition catalogue, London, 1982, pp. 46–49, and cat. 49–62.

4. Giambologna and the problem of the European diffusion of his style were last treated in the exhibition *Giambologna – ein Wendepunkt der Europäischen Plastik*, Vienna, 1978/79.

5. On Jacques Jonghelinck see B. Meijer, 'The Re-emergence of a Sculptor: eight lifesize bronzes by Jacques Jonghelinck', *Oud Holland* 93, 1979, pp. 116–35. On Hendrick de Keyser, C. Avery, 'Hendrick de Keyser as a Sculptor of Small Bronzes', *Bulletijn van het Rijksmuseum*, 1973, 1, pp. 3–24. On Willem van Tetrode, A. Radcliffe, 'Schardt, Tetrode and some possible sculptural sources for Goltzius', in *Netherlands Mannerism. Papers given at a symposium in the National museum, Stockholm, September 21–22, 1984*.

6. K. Lanckheit, *Florentinische Barockplastik*, Munich, 1962; J. Montagu, 'The Bronze Groups made for the Electress Palatine', in *Kunst des Barock in der Toskana – Studien zur Kunst unter den letzten Medici*, Munich, 1976, pp. 126–36; C. Avery, 'Soldani's Small Bronze Statuettes after "Old Masters" Sculptures in Florence', in *Kunst des Barock in der Toskana*, pp. 165–72.

meo Ammanati, Giovanni Bandini and Giovanni Bologna (Giambologna). The court of the Medici, who had recovered control of Florence definitively in 1530, exercised a stimulating and eventually a dominant influence. However, Rome and Milan for the first time entered the field in a tangible way, with important works by Guglielmo della Porta, Leone Leoni and Annibale Fontana. Venice, which in this second phase clearly displaced Padua, was the second home of the Florentine Jacopo Tatti, called Sansovino, who fled from the sack of Rome in 1527. The city's position as one of the main centers for the production of bronze statuettes was due to Sansovino as the "renewer" of sculpture in Venice and especially to his pupils and their followers: Danese Cattaneo, Tiziano Minio, Alessandro Vittoria, Girolamo Campagna, Tiziano Aspetti and Nicolò Roccatagliata . These Venetian artists, and also to an especial degree the Fleming Giambologna, active in Florence from 1559, were the protagonists of Mannerism in sculpture, which spread rapidly as their works were collected throughout Europe, and which affected artistic style as late as the eighteenth century. Giambologna, who became the all-dominating court sculptor of the Medici, ran a large workshop consisting not only of Italian but also of French, German, Dutch and Flemish assistants, who carried its unmistakable style back to their homelands, where it was further developed and internationalized.[4] Bronze statuettes were especially popular in South Germany, which was the scene of a not inconsiderable production from the sixteenth century onward, in imitation of early Renaissance Italian statuettes. This popularity continued to the end of the Renaissance, when Giambologna's pupils were foremost in the creation of monumental fountains and tombs in Augsburg, Munich, Innsbruck and Prague. The most eminent artists were Johann Gregor van der Schardt, Hubert Gerhard, Adriaen de Vries, Hans Reichle and Caspar Gras. In the Netherlands, too, bronzes attained great popularity, created by Jacques Jonghelinck, Willem van Tetrode and Hendrick de Keyser.[5] The fashion was carried to France by Giambologna's pupil Pierre Francqueville (Pietro Francavilla); there, after somewhat timid beginnings in the sixteenth century, it asserted itself in the seventeenth and remained in fashion without a break until late in the nineteenth century.

In seventeenth-century Italy, Rome's recovery of its artistic hegemony accompanied a clear change of direction: marble once again became almost the sole medium for the execution of primarily monumental tasks. Again it was Florence – though French influence on the city should not be underrated – which broke the spell and for a short time once more became the center of bronze statuary.[6] The works of Giovanni Battista Foggini, Massimiliano Soldani and Giuseppe Piamontini, to name only the most important, were admired not only in Florence but also much more widely.

In and after the late eighteenth century, however, the genre of bronze statuettes declined visibly. Having achieved great independence in the course of centuries, it now relapsed into the mere reproduction of antique works. Classicism demanded white marble, and bronze was downgraded to the realm of travel souvenirs or gilt decoration. When bronze sculpture again

came into favor in the late nineteenth century the impulse came not from Italy but from France, where the tradition had remained unbroken. At the same time there was renewed interest in Renaissance bronzes, as shown by the creation of a new collections and the extension of old ones, and the development of critical and historical interest in bronze statuettes.

Naturally not all bronze statuettes can be associated with particular artists; indeed most of them remain anonymous, or rather they can be assigned to a place of origin but not to an individual. Bronzes are very seldom signed and as a rule are poorly documented. They are generally mentioned only incidentally in the *Vite*, the contemporary or posthumous *Lives* of the artists, though here again Giambologna is an exception. In the inventories, too, bronzes are as a rule only summarily described. They can seldom be directly related to the known monumental work of a given artist, though many sculptors of such works also made statuettes. Hence in this field of art history style criticism is of particular importance for identification; yet, since a technique of reproduction is involved, this method can only be applied with the utmost caution. Bronzes that appear to be in the style of a particular artist were not necessarily executed by him. Especially in Padua, Venice and elsewhere in northern Italy, the method of mass distribution has to be taken into account. The model was generally kept in a commercial casting foundry, which was seldom identical with the sculptor's workshop. It was recast by the foundry with or without slight variations, reproduced over succeeding decades and combined with the work of other artists in a way that might conceal its origin. For this reason it is very hard to speak of "originals" where bronze sculpture is concerned, especially the small-scale variety. Few artists personally superintended the casting of their models, or themselves reworked the cast statuettes. This is even more true of replicas. Only a small number of masterpieces show signs of having been finished under their creator's eye – when the surface has been chased with a skill equal to that of the composition as a whole, or has preserved the immediate freshness of the wax model, and is distinguished by an exquisite patina. But one cannot on the other hand say, "Then the wax model is the true original", for the artistic objective was the bronze statuette.

The creation of a bronze statuette
It seems useful here to say a few words about the technique of bronze casting. Renaissance casters were able to draw on an unbroken tradition dating back thousands of years and known to many of the world's civilizations. The process is in principle a very simple one. A freely created wax model is surrounded by a mantle ("investment") of clay or a mixture of fine sand and plaster, leaving channels open for liquid bronze to be poured in and for air to escape. After the coating has solidified it is made firm by burning, the heated wax being allowed to flow out, leaving a hollow space. The liquid metal is then poured into the negative mold so created. After cooling, the mold is destroyed and the raw cast appears. However, only a single cast can be made in this way; the model and mold are lost in this process.

The casting and cooling of the metal leads to severe tensions which can produce cracks or even break the mold. Hence this process is only suitable for smaller and simpler works. In order to economize on expensive metal, to reduce the weight of a statue or avoid the risk of cracks during cooling – which is relatively great in the case of a massive cast of a complex model composed of parts that differ greatly in strength – the practice of hollow casting was introduced for larger statuettes or statuary.

In this method the wax model is formed over a previously prepared clay core, the wax layer being of the same thickness as the eventual bronze. To prevent the core slipping during the casting process, producing an uneven distribution of the bronze which would not be without danger, the core is supported by iron or bronze pins which are inserted through the layer of wax into the core and anchor the clay mold when the investment is applied. Thus supported, the core remains firmly in position after the wax has melted.

In Florence this method of casting came slowly into use during the late fifteenth century. From this point of view North Italian foundries were more advanced; and they were already able at this time to make several casts from one model obtaining the additional advantage that the model remained intact.

However, this entailed a very expensive process of making special casting models. It is necessary to make a negative mold from the original model, which can only be done with the aid of many removable plaster piece-molds when a complex shape consisting of several simple shapes is involved, *eg* a human body with torso, arms, legs and head. These piece-molds are at first assembled individually, and individual limbs, head and trunk for the time being remain separate. Then liquid wax is poured into the moistened molds of the different parts; the wax in immediate contact with the inner surface of the cold mold solidifies at once. After a few seconds the piece-mold is inverted so that the superfluous wax, which has not yet solidified, flows out; a wax layer only a few millimeters thick remains in the mold. The hollow is now filled with a fluid mass of plaster and sand, which slowly solidifies and forms the core of the future casting model. Only when this mass has completely dried out is it possible to remove the sections of the piece-molds and thus obtain the separate pieces of the casting model, formed of wax and filled with a core. These parts are now fastened together with pins, the seams smoothed with a hot iron and the wax surface retouched. If necessary, details can be added or removed. Also, at the stage of combining the individual parts it is possible to some extent to alter the composition. Then the parts are combined and the support pins inserted, and canals for ventilation and the exit of the wax ("risers" and "runners") are provided, themselves formed of wax. Next the coating of liquid clay, or a liquid mixture of plaster and sand, is applied and built up to the requisite thickness. In this process the first layers are of a finer and more fluid mixture, so as to reproduce all the delicate features of the wax model. The coating is first gradually dried and hardened by exposure to the air and tempered and fired. As the mold slowly heats, the

wax is allowed to flow out, and then the hot liquid bronze can be poured into the hollow thus formed.

The mold, which has cooled after casting, is now destroyed, but this does not reveal to view a perfect statuette such as those we admire in collections. The product still requires extensive afterworking. First of all the runners and risers, which are now also of bronze and surround the figure on all sides, and the core support pins that protrude like spikes, have to be lopped off. "Fins" that have formed where the hot metal, under heavy pressure, has penetrated into cracks and pores of the casting mold must be filed off, casting flaws mended with fillings, and the casting core removed if possible, since it is hygroscopic and conducive to all kinds of corrosion. Only after all this has been done can the precision work begin. The rough surface as it has come from the casting mold must be carefully scraped and filed; sometimes it was even polished with pumice or, by contrast, it was hammered to give a more lively, painterly, vibrating appearance. Details such as the eyes, hair, toenails or fingernails were rendered by chasing, and the drapery given texture again by hammering. Finally the surface was patinated, since the intensive mechanical afterworking had produced a metallic sheen that did not give the desired impression of antiquity.

The various techniques of bronze casting are well known to us both from the sources and from modern technical analysis.[7] On the other hand, we know relatively little about methods of patination. This was generally a strictly kept secret of individual workshops, and even an artist like Benvenuto Cellini, who expatiates on it in his treatises, does not always make clear the formulae he actually used. There are all sorts of ways of treating a bronze surface: by warming, by etching in acid baths or the fumes of organic compounds, and by firegilding. In addition, bronzes were usually lacquered to prevent corrosion and to give them the desired coloring. Transparent or opaque lacquers existed in the most varied shades. Giambologna and his workshop, for instance, preferred a gold-tinged, reddish-brown lacquer, which was used through the years in darker and darker tones. A black coating of lacquer is typical of Venetian bronzes of the later sixteenth century.

The appearance of the surface also depends to a large extent on the alloy used. Bronze is a mixture of copper and tin, to which other metals were generally added, either intentionally, for instance when lead was used as a fluxing ingredient, or accidentally, owing to the impurity of ores mined in Renaissance times. The usual proportion of copper is 80–85%. North of the Alps, zinc was often added to the alloy; in Nuremberg it took the place of tin, so that the alloy is properly called brass.[8]

Jacopo Alari-Bonacolsi called Antico appears to have been the first artist who consistently used the complicated method of casting from a model made from piece-molds. A letter of his of 1519 to Isabella d'Este, Marchioness of Mantua, indicates that he had kept the models and casting molds of earlier bronze statuettes and was able to use them for aftercasts, which was only possible by the process in question. R.E. Stone has confirmed this deduction by X-ray examination of Antico's bronzes.[9] A similar technique was

7. R.E. Stone, 'Antico and the Development of Bronze Casting in Italy at the End of the Quattrocento', *Metropolitan Museum Journal* XVI, 1982, pp. 87–116.

8. J. Riederer, 'Metallanalysen von Statuetten der Wurzelbauer-Werkstatt in Nürnberg', in *Berliner Beiträge zur Archäometrie* 5, 1980, pp. 43–58; *id.*, 'Die Zusammensetzung deutscher Renaissancestatuetten aus Kupferlegierungen', in *Zeitschrift des deutschen Vereins für Kunstwissenschaft* 26, 1, 1982, pp. 42–48; *id.*, 'Metallanalysen an Erzeugnissen der Vischer-Werkstatt', *Berliner Beiträge* . . . , VIII, 1983, pp. 89–99.

9. See note 7.

10. *Cf* N. Gramaccini, 'Das genaue Abbild der Natur – Riccios Tiere und die Theorie des Naturabgusses seit Cennino Cennini', in *Natur und Antike in der Renaissance* (*cit.* note 1), pp. 198–225.

also used, as early as about 1500, by Severo da Ravenna in Padua, but this artist paid less attention than Antico to the afterworking of his bronzes, so that they are not always of equal quality. Andrea Riccio, also active in Padua at this time, used a different technique, modeling a clay core so as to reproduce the main features of the composition. Over such a core, which is easy to reproduce in quantity, he modeled the figure in wax, each time afresh and in full detail, so that the versions of his bronzes all vary slightly. Only bronzes made in this way can be regarded as Riccio originals. However, the great success of his statuettes led, even during his lifetime, to large-scale reproduction without the casting model being reworked in each separate case: this explains the extraordinary variation in the quality of later Paduan bronzes.

The piece-mold procedure was used and perfected on a large scale in the late sixteenth century and throughout the seventeenth, especially by Giambologna's workshop. It was the only means to satisfy the demand for his works. It is astonishing that the workshop, directed by different artists for several generations, should have maintained such a high standard at all times. Antico had made his statuettes in small numbers only; as a rule only three or four versions of a particular model are known, and even then the remolding process seems to have been carried out only several years later, and always with equal care. This perfection is lacking in very few replicas: these are probably casts made after his death, in order to preserve in durable form, for later generations, a wax model that was perhaps no longer in good condition.

Finally, a particular speciality of the Paduan workshops may be noted – that of casting from nature. The Vienna collection contains many examples of this technique, used for modeling natural objects such as plants or animals – frequently snakes, lizards, crabs, snails or toads. The creature was placed in the required posture, its mouth held open with small rods, and was then covered with a very fine-grained fluid clayey mass that would "take" the finest details of the epidermis, the object being to imitate nature as convincingly as possible. When the coating of clay was thick enough and had dried it was heated to a high temperature, so that the animal within was burnt to a cinder; what remained of its ashes could be blown out of the mold or washed out of the liquid bronze. This process was already described by Cennino Cennini at the end of the fourteenth century.[10]

Bronze collecting and the Habsburgs

What were the main themes of bronze statuettes? Some preferences can be discerned, and some topics of statuary were neglected. Christian religious themes are rare; figures of ancient mythology are common, not only gods and goddesses but especially satyrs and other such hybrids. Bronze statuettes of satyrs were in the first place objects of practical use, such as inkwells or oil lamps. But they also symbolized the forces of nature, fire and water, and were thus suitable for decorating inkwells, lamps and perfume burners. Eventually they became statuettes in their own right. Satyrs representing

natural forces even played a part in the hermetic symbolism of Riccio's Paschal candelabrum in the Santo in Padua.[11]

Also very popular were children or *putti*, a motif reintroduced into art by Donatello and Luca della Robbia. As angels or cupids, depending whether the subject was religious or secular, children figured increasingly in bronze statuettes. Then, besides the human form – antique gods, heroes, children – due attention was paid to animals: first to "heroic" or majestic beasts such as horses and lions, and also bulls. Especially popular in Padua were casts from nature – animals and plants, especially crabs, shellfish and snakes – which were sometimes converted into objects of use. Sculptured figures in antique style were often essential components of inkwells, candlesticks, oil lamps, perfume burners, mortars, cooling bowls and andirons.

Cultivated Italian homes began to be full of domestic objects of this kind, in addition to statuettes that were purely works of art. The humanistic upper class – scholars, church dignitaries, patricians and princes – began increasingly to collect bronze statuettes and to foster their production. At the outset, however, they confined themselves to collecting individual examples, which often adorned their desks and bookshelves amid a mixed collection of natural objects and scientific instruments. The statuettes were valued not only as works of art and for everyday use, but also as witness to their owners' literary culture. It became increasingly fashionable to treat the rooms of a palace as individual works of art, with architecture, sculpture and painting all contributing to the general effect, and bronzes much favored as part of the ensemble. Among the earliest examples are the *grotta* and the *studiolo* of Isabella d'Este in the palace at Mantua. In 1502 the highly cultivated Marchioness wrote to ask her uncle Bishop Ludovico for more bronzes by Antico as counterparts to those she already owned.[12] Probably the most famous example, still almost completely preserved, of an interior of this kind furnished in accordance with an iconographic and decorative scheme is the *studiolo* of Francesco de' Medici in the Palazzo Vecchio in Florence. This contains eight bronze statuettes, in niches, by the eight most eminent sculptors living in Florence at the beginning of the 1570s, including Giambologna, Bartolomeo Ammanati and Vincenzo Danti. Clearly the movement toward architectural coherence was calculated to encourage the production of statuettes in complete series, which had not been the case in the early Renaissance. Andrea Vendramin, the Venetian patrician, possessed a writing desk of ebony and olive wood decorated with seven bronze statuettes by Alessandro Vittoria.[13]

During the sixteenth century the interest in bronze statuettes spread north of the Alps. Works of this kind gradually began to fill the princely *Kunstkammern* that were coming into existence, first and foremost those of the imperial house. As we know from surviving inventories, bronze statuettes in large number were owned by – to mention only the most enthusiastic collectors – the Emperors resident in Vienna or Prague, the collateral line of Habsburgs in Graz and Innsbruck, the Electors of Saxony in Dresden, the Dukes of Bavaria in Munich, and the Counts of Württemberg in Stuttgart. Their

11. *Cf* D. Blume, 'Antike und Christentum', *ibid.* pp. 84–129.
12. H.J. Hermann, 'Pier Jacopo Alari-Bonacolsi, fennant Antico', *Jahtbuch der Kunsthistorischen Sammlungen der Allerhöchsten Kaiserhauses*, XXVIII, 1909–10, p. 209.
13. V. Scamozzi, *L'Idea dellà Architettura universale*, Venice, 1615, p. 305.

Fig. 6
Archduke Ferdinand II (1529–95).
Portrait in wax by Francesco Segala
(active between 1564 and 1593).
Kunsthistorisches Museum, Vienna,
Inv. No. Pl. 3085

Fig. 7
Emperor Rudolf II (1552–1612). Bust in
bronze by Adriaen de Vries (c.1545–
1626), made in 1603.
Kunsthistorisches Museum, Vienna,
Inv. No. Pl. 5506

enthusiasm was matched, as we know from documents, by wealthy patricians in the free imperial cities, such as Paulus von Praun in Nuremberg and Markus Zeh in Augsburg. Under Louis XIV the collections of the French crown came to take on importance, and seventeenth-century England under the Stuarts saw the beginning of a collector's tradition on the grand scale, to which many country houses still bear eloquent witness.[14]

The collection of bronzes in the Kunsthistorisches Museum is one of the most important of its kind along with those of the Museo Nazionale del Bargello in Florence, the Victoria and Albert Museum in London and the Louvre in Paris. It is the product of a tradition that goes back to the sixteenth century and is associated with some of the greatest collectors and patrons of art that Europe has ever known.[15]

The Emperor Maximilian I, his grandson Ferdinand I and great-grandson Maximilian II were patrons and collectors on a large scale, but no inventories have survived from their time that would enable us to identify particular works. Maximilian II (1527–76) is known to have taken an interest in classical art, to have summoned Johann Gregor van der Schardt to Vienna, and to have possessed at least three works by Giambologna.

The first member of the house of Habsburg whose collection can be satisfactorily traced through an almost continuous series of inventories is the Archduke Ferdinand II (1529–95)[16] (fig. 6). A brother of Maximilian II and second son of the Emperor Ferdinand I, he was appointed Regent of Bohemia by his father in 1547. On his father's death in 1564 he inherited Tyrol and the outlying Austrian possessions in Swabia. In 1557 he married Philippine Welser, a patrician's daughter from Augsburg, and in 1582 Anna Caterina Gonzaga of Mantua. He had begun to collect works of art in Bohemia, and continued to do so on a large scale in Tyrol. After moving to its capital, Innsbruck, he caused the nearby tenth-century castle of Ambras to be transformed into a Renaissance *château* with extensive grounds and accessory buildings, some of which were used to house the greatly enlarged collections. These were divided into three main sections: arms and armor, pictures including portraits, and a *Kunstkammer*. In the middle of the *Kunstkammer* were eighteen cabinets reaching from floor to ceiling, arranged back to back in a double row of 9, and two smaller cabinets, one at each end of the row. Each cabinet contained works of the same kind and in the same material, and was painted inside in a color contrasting with its contents.

Cabinet no. XIII contained Ferdinand's collection of bronzes. Although large – about 120 items, not including plaquettes and medals – it was not necessarily of exceptional value. Many of the statuettes listed as "damaged" were thought to be antique, and some of them probably were so. According to a persistent eighteenth-century tradition which cannot be confirmed, several bronzes in the Ambras collection came from the sack of Rome in 1527.[17] As far as we can reconstruct the collection, it does not testify to any special fondness of the Archduke for bronze statuettes, or show him to have been a connoisseur in this field: here as in other areas, he was apparently not in a position to develop his collection on a methodical basis. No doubt his

14. *Cf* M. Leithe-Jasper, 'Giambologna und die zeitgenössischen Sammler ausserhalb Italiens', in *Giambologna* (*cit.* note 4), pp. 73–82, with bibliography.
15. The standard work on the history of the Habsburg collections is still A. Lhotsky, *Festschrift des Kunsthistorischen Museums zur Feier des fünfzigjährigen Bestandes*, Part II, *Die Geschichte der Sammlungen*, Vienna, 1941–45. See also M. Leithe-Jasper and R. Distelberger, *Kunsthistorisches Museum, Wien, I. Schatzkammer und Sammlung für Plastik und Kunstgewerbe*, London/Munich/Florence, 1982.
16. *Kunsthistorisches Museum, Sammlung Schloss Ambras – Die Kunstkammer*, Innsbruck, 1977; E. Scheicher, *Die Kunst- und Wunderkammern der Habsburger*, Vienna/Munich/Zurich, 1979.
17. A. Primisser, *Die Kaiserliche-Königliche Ambraser-Sammlung*, Vienna, 1819, p. 176.

18. R. Bauer and H. Haupt, 'Das Kunst-kammerinventar Kaiser Rudolfs II., 1607–1611', *Jahrbuch der Kunsthistor-ischen Sammlungen in Wien*, LXXII, 1976.

confidence was often abused by wily agents. However, in the late sixteenth century bronze statuettes were an essential part of a *Kunstkammer*, and Ambras could not be an exception. The most important example in Ferdinand's collection at Ambras is certainly the bronze of *Cain* or *Hercules* with a club (cat. 36).

In 1605 the Emperor Rudolf II, Ferdinand's nephew, acquired the Ambras collection from Ferdinand's heirs and thus kept it in Habsburg possession. In the seventeenth century two members of the "new Tyrolese line" of Habsburgs, Leopold V (1586–1632) and Ferdinand Carl (1628–62) successively married daughters of the Medici, and there was a notable enrichment of the collection of bronzes. Hubert Gerhard, and Caspar Gras after him, were court sculptors at Innsbruck. The Ambras collections were seriously endangered for the first time during the war of the Spanish Succession, immedately after 1700. In 1806 there was again a threat from Napoleon's forces and those of Bavaria; large parts of the collection were therefore removed to Vienna, where they were housed in the Lower Belvedere palace as the "Imperial and Royal Ambras collection".

The Emperor Rudolf II (1552–1612) (*fig.* 7), son of Maximilian II and nephew of the Archduke Ferdinand II of Tyrol, must be regarded as the most eminent patron and collector of the late Renaissance in Europe.[18] His taste was no doubt fostered by a period of nearly eight years spent as a youth at the court of his uncle, Philip II of Spain. There he was able to admire the outstanding collection of Venetian painting, goldsmith's work, and the exotic art, natural objects and curiosities brought back by explorers from afar.

Maximilian II had been an enlightened Renaissance prince of universal culture, fluent in seven languages; the Archduke Ferdinand II was essentially a systematic collector, working to a program. In the next generation, Rudolf II's brother the Archduke Maximilian III was strongly interested in history, and the Archduke Ernest and Albert VII were connoisseurs of exceptional taste. Rudolf II himself was intent on the creation of a single, all-embracing treasury and *Kunstkammer*, to be the possession of the whole House of Austria (hence also his preservation of the Ambras collection). He transferred his capital from Vienna – always unruly, and moreover threatened by the Turks – to Prague, where he greatly extended and rebuilt the Hradčany castle as a home for his vast collections. His many interests included science as well as art. He was able to attract and keep at his court scientists and mathematicians such as Johannes Kepler, Tycho Brahe, Christoph Margraf and Joost Bürgi (Justus Byrgius), as well as the artists Hans Mont, Adriaen de Vries, Bartolomäus Spranger, Josef Heinz, Hans von Aachen, Ottavio Miseroni, Jan Vermeyen and Paulus van Vianen. Other major artists such as Christoph Jamnitzer and Giambologna, though they did not follow his call to Prague, sent him some of their finest works from abroad. Rudolf II was probably the last sovereign to watch personally over his collection, maintaining close contact with the artists who worked for him; he showed almost obsessive perseverance in pursuing coveted works of art, and at times did not shrink from using political pressure to obtain them.

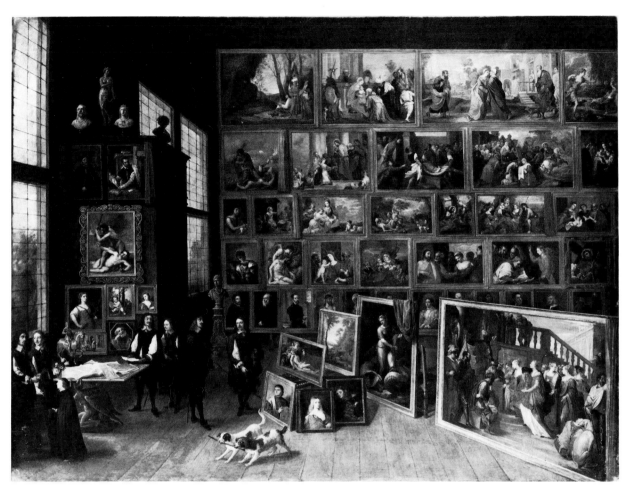

Fig. 8
Archduke Leopold Wilhelm visits his gallery
in Brussels, by David Teniers the Younger

His *Kunstkammer* was planned on a majestic scale. As Holy Roman Emperor he could command work of the highest quality, and his collection was intended to express the universality of the Empire. But, in contrast to the situation at Ambras, only a few people in Prague were privileged to view these legendary treasures. The Emperor was of shy disposition and un-married; in later years he fell increasingly into melancholy and fits of severe depression. He also abandoned himself to all kinds of astrological practices and the pursuit of alchemy, or shut himself up in seclusion among his pos-sessions. Thus Rudolf II and his collections came to be enshrouded in legend even during his lifetime.

Naturally small sculpture played an important part in Rudolf's *Kunst-kammer*. Apart from some antique or pseudo-antique works, such as the famous "*Venus* of Cardinal Granvella" (cat. 12), the bronzes in his collection were mainly by contemporary artists, especially Adriaen de Vries, his court sculptor, and Giambologna, on whom he conferred a hereditary title of nobility in 1588, and whose signed *Flying Mercury* (cat. 51) stood on an ebony desk in the center of the *Kunstkammer*. After Rudolf's death, in the reigns of his brother and successor Matthias (1557–1619) and his nephew Ferdinand II (1578–1637), large parts of his collection were removed to Vienna. A considerable amount, however, was looted by Swedish troops under General Königsmark in 1648, at the end of the Thirty Years' War. Large bronzes by Adriaen de Vries, and probably also by Giambologna, found their way to Sweden. However, unlike the pictures that were also looted from the imperial collection, they do not seem to have appealed to Queen Christina, since on her abdication she did not take them to Rome but left them behind.

The troubled period of the Thirty Years' War was not conducive to art collecting in central Europe, and considerably restricted the financial means of Ferdinand II and his successor Ferdinand III (1608–57). Later, in the Baroque period, the reigning Habsburgs' artistic interests were in other fields, chiefly architecture and above all music. Ferdinand III, Leopold I (1640–1705) and Joseph I (1678–1711) were themselves gifted composers.

An important exception was the art-loving Archduke Leopold Wilhelm (1614–62). As Ferdinand III's younger brother he was intended for a Church career, but proved a successful commander. He was Bishop of Passau, Stras-burg, Olmütz (Olomouc), Breslau (Wroclaw) and Halberstadt, and from 1641 Grand Master of the Teutonic Knights; also, from 1646 to 1656, Governor General of the Habsburg Netherlands. A prince of the Empire and the Church, a war hero and a wealthy friend of the arts, he was able to ac-cumulate one of the most important collections of his time; he bequeathed it to his nephew Leopold I, thus appreciably enlarging the imperial collections. He himself had purchased in Antwerp important parts of the collections of Charles I of England and the Duke of Buckingham, which were sold off by the Commonwealth; these included items that Charles had acquired from the Gonzaga in Mantua as recently as 1627.

Leopold Wilhelm (*fig.* 8) is known chiefly as one of the "founders" of the

collection of paintings in Vienna, but he also collected much small sculpture in stone, wood, ivory and bronze, including many bronze statuettes of the Italian Renaissance. Most of the famous works by Antico now in the Kunsthistorisches Museum came into the imperial collections from Leopold Wilhelm.

This large accretion of works of art in the seventeenth century made it necessary to reorganize the imperial collections in Vienna. Under the Emperor Charles VI (1685–1740) the picture gallery was transferred to the Stallburg building adjacent to the Hofburg, where *Kunstkammer* objects of old Viennese provenance were also housed, together with most of the contents of Leopold Wilhelm's *Kunstkammer*.[19] Some of these, as well as some of the contents of Rudolf II's *Kunstkammer*, were by this time in the Imperial Treasury, which was rearranged and reorganized in 1746–50 by Josef Angelo de France, Treasurer under the Empress Maria Theresa (1717–80). These works included numerous bronze statuettes, some of which were displayed for purely decorative purposes on the various shelves and cabinets. As had been the case at Ambras nearly 200 years before, de France filled each cabinet with works of a particular kind, but no system can be discerned in the arrangement of the bronze statuettes, other than a concern for decorative effect. It emerges from the inventories that the Treasury contained several bronzes from Rudolf's *Kunstkammer*, notably by Giambologna and van der Schardt, as well as Adriano Fiorentino's large *Satyr* (cat. 3) and probably also Riccio's drinking *Satyr* (cat. 20). In 1755, 22 more bronze statuettes were brought to the Treasury from Prague. On the other hand, other bronzes from Vienna went to Ambras in the eighteenth century, probably in exchange for coins, medals and manuscripts in which Vienna was more interested.

Josef Angelo de France (1691–1761) (*fig.* 9) was an art-lover and collector on a large scale.[20] Born of a wealthy family in Besançon, he came at an early age to Vienna, where he was a successful banker and dealer in bills of exchange. In 1734 he abandoned this profession and entered the service of the court, where he dealt with complicated matters of inheritance. After his reorganization of the Treasury, Maria Theresa made him Director General of all the imperial collections. Apart from pictures, tapestries and precious furnishings of all kinds, his personal collection comprised 6,266 items, including 1,680 coins, 3,507 carved stones, 735 statues and statuettes in bronze, marble and ivory, 261 busts, 269 reliefs and many other objects. The collection was sold by his heirs: the coins went to the Hunterian Museum in London, the cameos to Catherine II of Russia. The small sculptures were bought in 1808 by the court of Vienna for the Imperial and Royal Cabinet of Coins and Antiquities. In this way the Kunsthistorisches Museum was to acquire such important bronzes from de France's collection as Filarete's relief of *Odysseus* (cat. 1), Bertoldo's *Bellerophon* group (cat. 2), Riccio's *Boy with a goose* (cat. 21), and Vittoria's *Winter* (cat. 44). De France collected classical, medieval and Renaissance art, including a remarkable number of Quattrocento bronzes. In his day many of these were still thought to be antiques, which

19. W. Prohaska, *Kunsthistorisches Museum Wien, II. Gemäldegalerie,* London/Munich/Florence, 1984.
20. J. Bergmann, *Pflege der Numismatik in Österreich im XVIII. Jahrhundert. Mit besonderem Hinblick auf das k.k. Münz- und Antiken-Cabinet in Wien,* Vienna, 1856, pp. 19–22.

21. G.H. Martini, *Musei Franciani Descriptio, pars posterior*, Leipzig, 1781.

22. L. Planiscig, *Die Estensische Kunstsammlung*, vol. I, *Skulpturen und Plastiken des Mittelalters und der Renaissance*, Vienna, 1919.

23. L. Planiscig, *Führer durch die Sammlung Gustav Benda*, Vienna, 1932.

was no doubt why they were at first placed in the Cabinet of Coins and Antiquities. An exhaustive catalogue of de France's collection was compiled in 1781.[21] It was far more comprehensive than any of the Habsburg inventories at that time.

By order of the Emperor Josef II (1741–90) the imperial picture gallery was transferred to the Upper Belvedere, while in 1806 the main items from the Ambras collection were moved to the Lower Belvedere in Vienna. This marked the beginning of a systematic assembly and reorganization of the imperial collections in Vienna – a process completed by the establishment of the Kunsthistorisches Museum, opened on October 17, 1891 by the Emperor Franz Josef (1830–1916). Around 1800 large numbers of bronze statuettes had been transferred from the Treasury and the picture gallery to the Cabinet of Coins and Antiquities; later it was decided that these would be properly housed with the Ambras collection in Vienna (*fig.* 10). Transfers from the Cabinet of Coins and Antiquities began in 1824, from the Treasury in 1871. By 1880 all the statuettes in the Cabinet of Antiquities that were then recognized as Cinquecento bronzes had been moved to the Ambras collection, which was finally incorporated in the Kunsthistorisches Museum in 1891.

After the First World War the collection of Sculpture and Decorative Art of the Kunsthistorisches Museum was enlarged by two more important holdings of bronze statuettes. The first, in 1923, consisted of parts of the Este art collection, that is, principally the collection of the Marchese Tommaso degli Obizzi in the Cataio castle near Padua.[22] Obizzi, like his friend Teodoro Correr in Venice, had rescued art treasures from churches that were threatened with desecration and had also collected a great deal of historic art, musical instruments and small sculpture, especially of Venetian origin, which he bequeathed in 1805 to the ducal house of Este. His will provided that if that house should die out, all his property should go to the youngest son of the marriage between Riccarda Maria Beatrix, the last member of the house of Este, and Archduke Ferdinand of Austria, the youngest son of Maria Theresa. This youngest son was Archduke Maximilian. The last person to own the collection was the Archduke Franz Ferdinand of Austria-Este, heir to the Austro-Hungarian monarchy, whose murder at Sarajevo in 1914 occasioned the First World War.

Secondly, in 1932 the Kunsthistorisches Museum received as a bequest the private collection of the connoisseur Gustav von Benda. This consisted mainly of Florentine works of the early Renaissance, including the marble bust of a *Laughing Boy* by Desiderio da Settignano, but also such fine bronzes as Antonio Lombardo's bust of a *Girl* (cat. 28) or the relief of the *Virgin, Child and Angels* attributed to Francesco di Giorgio Martini (cat. 5).[23]

In subsequent years the bronze collection has been increased by individual purchases from time to time. Today it comprises about 650 statuettes, busts and implements and about 500 plaquettes. About a third of the statuettes are of no special artistic importance, but are an interesting indication of the interests of past collectors and their degree of connoisseurship. They include replicas of statuettes that exist elsewhere in versions of better quality, and

Fig. 9
Josef Angelo de France (Salomon Kleiner
after an engraving by J.G. Haid of the
portrait by Martin von Meytens)

also models that are not otherwise known and are valuable on this account. It is not individual masterpieces that make a collection, but its totality.

The internal history of the Habsburg Collections

Thanks to the preservation of numerous inventories, including some complete sequences of inventories of imperial collections, it is frequently possible to trace the provenance of particular works through the centuries.[24] The Ambras collection is particularly well documented, since the series begins with the posthumous inventory, dated May 30, 1596, of the Archduke Ferdinand's collections at Ruhelust, Innsbruck and Ambras. Thirteen further inventories are extant, down to 1875. There seem, however, to have been gaps in the eighteenth century, so that it is still impossible to ascertain at what date certain objects were transferred from Vienna (where they are previously documented with certainty) to Ambras, where they suddenly appear in the record. The identification of particular objects in the Ambras inventories is made difficult, moreover, by the very summary, incomplete descriptions and by the fact that no measurements are given until the inventory of 1788. It is also a complication that the cabinets are often differently numbered from one inventory to the next. Thus the bronzes originally were in a cabinet numbered XIII, but in 1730 this changes to IV and in 1788 to VIII. In the same way, compartments are sometimes numbered from top to bottom, sometimes the reverse. However, as a rule the inventory compilers copied one another's entries, and in some cases added more details.

The 1607–11 inventory of Rudolf II's *Kunstkammer* likewise gives only a summary account of bronzes, especially single figures; in the case of groups or reliefs, where the subject is more complex, more details had to be given, so that the situation is somewhat better. Measurements are still lacking, however. Artists are seldom named; Giambologna is mentioned by name four times, though we know that Rudolf II owned a far greater number of his works. Adriaen de Vries, living in Prague as court sculptor, was naturally better known to the compiler, and is mentioned 14 times. The posthumous inventory of the Emperor Matthias (1619) is even more laconic; however, the order of entries agrees in some cases with Rufolf II's inventory.

Fortunately, more detail is provided by the 1659 inventory of the Archduke Leopold Wilhelm's *Kunstkammer* in Vienna. Here at last measurements are given, in precise terms of span and finger-breadth. The authors of bronzes are seldom mentioned by name, but help is accorded by the numbering of works in a single series; sometimes the numbers also appear on the objects themselves, so that they can be identified with certainty.

In 1720–33 Ferdinand Storffer compiled a highly ornamental, exquisitely painted pictorial inventory, in three volumes, of the imperial gallery in the Stallburg. The objects from Leopold Wilhelm's *Kunstkammer*, which were mostly incorporated in this collection, are included in the second volume of this work, and in some cases can be clearly recognized. Some of them are also reproduced in four plates of the *Prodromus zum Theatrum Artis Pictoriae*, a

book of engravings of items of the collection by the artists Franz von Stampart and Anton von Prenner, published in Vienna in 1735.

As we have seen, in 1746 the Empress Maria Theresa entrusted Josef Angelo de France with the task of reorganizing the Imperial Treasury, and in fulfilment of his charge he drew up a new inventory in 1750. This is the first surviving complete inventory of the collection. It was preceded by the *Inventar der kleinen geheimen Schatzkammer* drawn up for Charles VI in 1731, but this chiefly listed jewels and similar valuables. All previous Vienna *Kunstkammer* or Treasury inventories have disappeared – indeed de France himself is said to have destroyed them. This is the more regrettable since we know from other sources that there were Habsburg treasuries and art collections in Vienna from the fourteenth century onward. As it is, we have no means of ascertaining which objects were in the *Kunstkammer* of Ferdinand I or Maximilian II, which of these found their way to Rudolf II's *Kunstkammer* in Prague, and which finally became part of Maria Theresa's Treasury in Vienna. All this must largely be a matter of conjecture. Moreover de France's inventory of the Treasury, at least as regards the uncased statuettes, is so cursory that it is seldom possible to identify particular bronzes with certainty. Here again measurements are lacking. In subsequent years the bronzes were constantly moved about, so that it is only possible to reach fairly firm

Fig. 10
View of the sculpture collection of the K.u.K. Ambraser Sammlung on display at the Lower Belvedere in Vienna in 1870. Watercolor by C. Goebel. Kunsthistorisches Museum, Vienna

conclusions by comparing all inventory entries between 1750 and 1874. The Treasurer at any given time was evidently not so much a connoisseur of the priceless works in his charge as an administrator. Significantly, the inventory entries of the Ambras collection in Vienna, to which all the bronzes from the Treasury were transferred during the nineteenth century, are much more precise and informative. Thanks to this it is possible to make inferences about former contents of the Treasury, especially as the bronzes are often listed in the same sequence in the Ambras inventory as they were in the Treasury one.

It is somewhat strange that a man like Josef Angelo de France, himself a connoisseur and collector, should not have been concerned to make an exact description of the Treasury sculpture. The catalogues of his own collection – compiled, it is true, by experts after his death, but certainly on the basis of information supplied by him – are admirably precise and detailed (*cf* cat. 2, 21 or 44). Another important inventory, though no more satisfactory than the eighteenth-century ones of the imperial collections in Vienna, is the inventory of the collection of the Marchese Tommaso degli Obizzi compiled in 1806 by F.A. Visconti – who was certainly an expert, but more interested in antique art. This was followed by some incompetent partial inventories of the same collection.

Early in the nineteenth century, many bronze statuettes that are now in the Sculpture Department of the Kunsthistorisches Museum were transferred from the Treasury or the de France collection to the Imperial and Royal Cabinet of Coins and Antiquities. So the inventories of the latter are also relevant to questions of provenance.

In 1891 all the imperial collections that had till then been housed in various parts of the Hofburg and other Viennese palaces were moved to the newly founded Kunsthistorisches Museum. A new inventory was drawn up for each section of the Museum's holdings. The inventory of decorative art (*Inventar der Sammlung Kunstindustrieller Gegenstände des Allerhöchsten Kaiserhauses*), compiled at that time and presented in 1896, is still valid, and is the source of the inventory numbers in the present catalogue.

It is natural that the keepers of a collection of which bronzes form one of the principal components should have devoted especial attention to these and made them an object of extensive study.[25] Albert Ilg and Julius von Schlosser were pioneers in this respect. Hermann Julius Hermann wrote the first comprehensive work on Antico, which is to a large extent still valid. Leo Planiscig was first to catalogue, more or less completely, the holdings of the Este collection, which was not yet incorporated in the Kunsthistorisches Museum, and those of the Museum's Sculpture Department. His intensive study of the Vienna bronzes resulted in monumental publications: *Die venezianischen Bildhauer der Renaissance*, the first comprehensive monograph on Andrea Riccio, and many others. While these are now partly out of date, they have provided generations of art historians with suggestions and a foundation for their own research.

M.L.-J.

Short list of books in English
related to the exhibition

Art the Ape of Nature: Studies in Honor of H.W. Janson, edd. Barash, M. and
Sandler, L.F. New York 1981

Avery, Charles *Florentine Renaissance Sculpture*, New York 1970

Avery, Charles *Studies in European Sculpture*, London 1981

Bennett, B.A. and Wilkins, D.G. *Donatello*, Oxford 1985

Bode, Wilhelm *The Italian Bronze Statuettes of the Renaissance*, ed. Draper,
James D. New York 1980

Ettlinger, L.D. *Antonio and Piero Pollaiuolo*, Oxford 1978

Giambologna, 1529–1608: Sculptor to the Medici, edd. Avery, C. and Radcliffe,
A. London, 1978

Hill, Sir George *Medals of the Renaissance* (revised and enlarged by Graham
Pollard) London 1978

Italian Renaissance Sculpture in the Times of Donatello, exhibition catalog,
Detroit Institute of Arts, 23 October 1985 – 5 January 1986, Kimbell Art
Museum, Fort Worth, 22 February – 27 April 1986

Jones, Mark *The Art of the Medal*, London 1979

Leithe-Jasper, Manfred and Distelberger, Rudolf *The Kunsthistorisches
Museum, Vienna. The Treasury and Collection of Sculpture*, London 1982

Mariarcher, Giovanni *Venetian Bronzes from the Collections of the Correr
Museum, Venice*, circulated by the Smithsonian Institution, Washington DC
1968

Montagu, Jennifer *Bronzes*, London, 1963

Pope-Hennessy, John *Essays on Italian Sculpture*, London and New York 1968

Pope-Hennessy, John *Study and Criticism of Italian Sculpture*, Princeton 1980

Radcliffe, Anthony *European Bronze Statuettes*, London 1966

Sheard, Wendy Stedman *Antiquity in the Renaissance*, exhibition catalog,
Smith College Museum of Art, 6 April – 6 June 1978, Northampton 1979

Splendours of the Gonzaga, exhibition catalogue, edd. Chambers, D. and
Martineau, J. Victoria and Albert Museum, London 1981

Wilson, Carolyn C. and Lewis, Douglas *Renaissance Small Bronze Sculpture and
Associated Decorative Arts and the National Gallery of Art*, Washington DC
1983

Wixom, William *Renaissance Bronzes from Ohio Collections*, The Cleveland
Museum of Art, Cleveland 1975

The Catalog

The bronzes are arranged in broadly chronological order throughout the catalog. Dimensions are in centimeters with height preceding width.

All works of art have been lent by the Kunsthistorisches Museum, Vienna.

1. Odysseus and Irus

Antonio di Pietro Averlino,
called **Filarete**

*c.*1400–1469
(See Biography, p. 279)

Bronze relief; thick casting, casting
bubbles visible on the outside of the
border molding. The right volute of
the acroterion has broken off. Black
lacquer, green spots (remains of arti-
ficial patination?). The figure 28 in
white on the back is the inventory
number, made prior to 1823, of the
Imperial and Royal Cabinet of Coins
and Antiquities.
Height 27.5 cm; width 16.4 cm.
Inv. no. Pl. 6127.

PROVENANCE
Collection of the Imperial Treasurer Josef
Angelo de France (Martini 1781, p. 130, Des-
criptio Anaglyphorum seu operum caela-
torum, no. 96: "(Scrin. 7. Ser. 5. Cat. A. n.
870) Porticus fornicata, in qua septem per-
sonae duas Syntheses (Gruppi) efficiunt. In
earum altera est Antinous, rex, paludatus et
pileatus, qui manu d. Ulyssem ostendit, et
pomum s. gestat: pone eum stat senex alius
barbatus et tunicatus, laeva sublata nonnihil
tenens; ad latus autem duo alii tunicati, alter
imberbis, alter barbatus, qui laeve sublata
caput hircinum fert. In altera cernitur Irus,
nudus, verberans Ulyssem, itidem nudum et
barbatum, qui, pugno dext. lateri quasi ob-
nitens, sinistra Antinoum, secum loquentem,
ostendit: pone eum accedit femina tunica et
velo vestita. Nomina trium personarum
principium adscripta sunt hoc modo:
ʼΑΝΤΊΝΟΟϹ.ʼΙΡΟϹ.ΟΔ ΥϹ∼ΕΥϹʼ. Super fornice,
in utroque latere est genius. Infra inscriptio:
VICISSATIM. Aes, 8 3/4 alt. 6 1/6 lat. 1/2 crass.
et supra, quam suspiceris, grave.") Acquired
in 1808 for the Imperial and Royal Cabinet of
Coins and Antiquities, passing in 1880 to the
Imperial and Royal Ambras collection and
transferred with the entire collection to the
Kunsthistorisches Museum in 1891.

The relief represents a scene in *Odyssey* XVIII, 1–115. Odysseus has returned
to his native Ithaca after the ten-year siege of Troy followed by ten years of
wandering. His wife Penelope, who has waited faithfully for him, is beset by
numerous suitors. Unable to resist them further, she promises to wed
whoever of them can bend Odysseus's bow on the coming festival of
Apollo. Odysseus, although presumed dead, has meanwhile returned to his
palace under Athene's protection in the guise of a poor beggar. He warns the
suitors that Odysseus himself will return shortly, but they laugh him to
scorn. Irus, a young beggar who sees the disguised Odysseus as a rival, abuses
him and challenges him to a boxing match, but to the surprise of all
Odysseus is victorious.

The relief shows an entrance hall with a coffered barrel-vaulted ceiling
supported by four Corinthian columns. On the right is seen the boxing
match between the old, bearded but still vigorous Odysseus and the young
good-for-nothing Irus. Four suitors who have entered from a room on the
left watch the fight with interest and seem to be urging the rivals on. One of
them is Antinous, dressed in a tunic and chlamys, with a cap on his head and
an apple in his left hand; another suitor lifts up the head of a he-goat, pre-
sumably intended as the winner's prize. In the entrance to the right is a
veiled female figure, presumably Penelope or the faithful nurse Euryclea. On
the background wall, in raised letters, is the Greek inscription ʼΑΝΤΊΝΟΟϹ.
ʼΙΡΟϹ.ʼΟΔΥČΕΥČ., identifying the three main actors. On the threshold below,
also in raised letters is the inscription VICISSATIM (in turn). Odysseus's old
weapons are suspended from rings in the vault: the bow, which the suitors
will seek in vain to bend (only Odysseus is able to, and by this he is finally
recognized); a quiver with arrows, two double-edged battleaxes, a shield de-
picting the infant Hercules strangling the serpents, and a helmet adorned
with a relief of a centaur.

In the spandrels above the arch are two winged *genii*; the one on the right
holds a bunch of grapes in his right hand. The profiled rim framing the relief
is integrally cast, as is the acroterion in the form of an acanthus tendril clus-
tered in the middle.

The unusually flat relief with its stage-like setting derives a spatial quality
from a slight but effective shift of the perspective vanishing point toward the
right, approximately at the point of Irus's raised fist. Similarly there is a dif-
ferentiation in the scenic arrangement of the almost sketchlike figures.
Odysseus and Irus, facing each other in near symmetry, are closer to the
foreground and appear larger. Ranged on the left is a somewhat smaller
group of three suitors, to whom a fourth advances rapidly through the left
entrance. In the background on the extreme right, partly concealed by the
architecture – which is more foreshortened on this side – is the veiled
Penelope or Euryclea, flat as a shadow and standing as if in the wings of a
theater.

The relief shows only slight traces of afterworking: the most noticeable is
the extremely delicate matt-punching. These punched areas reflect the light
less strongly, giving an effect of chiaroscuro and spatial depth.

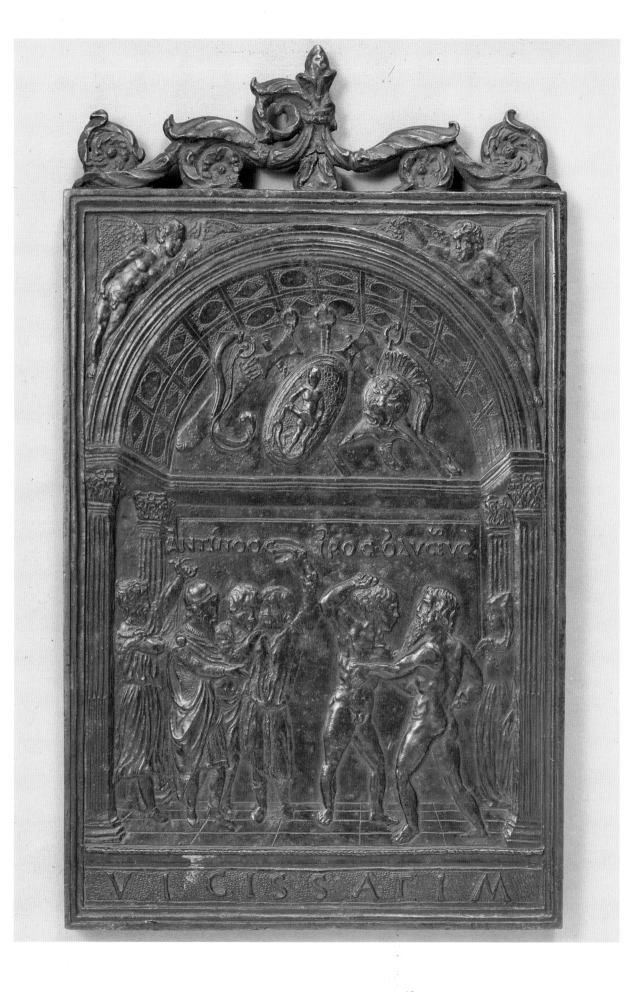

BIBLIOGRAPHY

Ilg, A. and Boeheim, W. 1882, p. 108, No. 345.

Frimmel, T. 1883, p. 62, No. 991.

Molinier, E. 1886, I. p. 53, No. 82.

Courajod, L. 1887, pp. 286–288.

Ilg, A. 1891, p. 236, No. 96.

von Schlosser, J. 1901, p. 11, Plate xiv/1.

Bode, W. 1892–1905, p. 178, Addendum, Plate DL/1.

Venturi, A. 1908, vi, p. 541.

Lazzaroni, M. and Muñoz, A. 1908, pp. 142–144.

von Schlosser, J. 1910, p. 1, Plate II/1.

Übersicht 1916/1917, p. 193, No. 5.

Planiscig, L. 1924, p. 3, No. 1.

Planiscig, L. and Kris, E. 1935, p. 50, Room x, Case 3, No. 2.

Pope-Hennessy, J. 1958, p. 332.

Mahl, E. 1966, pp. 4, 5, No. 185.

Middeldorf, U. 1973, p. 82 (1980. II., p. 375).

Spencer, J.R. 1979, p. 554.

Cannata, P. 1985 (1987).

The relief was first attributed to Filarete by Courajod (1887), to whom Molinier (1886) owed his knowledge of the work. In older inventories and publications of the Kunsthistorisches Museum (1821) it was classified as Byzantine, but afterward correctly as fifteenth-century Italian (Ilg 1882, Frimmel 1883).

The relief resembles in many ways those of the *Martyrdoms* of St Peter and St Paul on the doors completed by Filarete in 1445 for St Peter's in Rome. A very similar helmet, also with a relief of a centaur, appears in Filarete's statuette of Marcus Aurelius in Dresden: according to the inscription he presented this to Piero de' Medici in 1465, but it was probably made earlier in Rome. Lazzaroni and Muñoz (1908) propose a date for the relief *c*.1445. Cannata (1985) considers this too late, as the reliefs on the doors of St Peter's appear to him more advanced. But the subtlety of the present relief, above all its architectural arrangement, seems rather to indicate a considerable experience, which would include, for instance, knowledge of Donatello's reliefs for the high altar of the Santo in Padua, or the same artist's *Dance of Salome* (Musée Wicar, Lille), and not merely the stark frontality of Masaccio's *Trinity* fresco in Santa Maria Novella in Florence.

In the present relief Filarete has abandoned the "detailed classicism" of his Roman works for an overall classicism of composition in the style of the Florentine early Renaissance. It seems more likely, therefore, that the work was executed in about 1450, after the doors of St Peter's and after Filarete's precipitate departure from Rome in 1447 and after a fresh encounter with Donatello's work in Florence. It seems less likely that Filarete could have achieved such a high degree of classical balance in the artistic environment of Rome.

2. Bellerophon taming Pegasus

Pegasus, the miraculous winged horse of Greek mythology, was the off-spring of Poseidon and the Gorgon Medusa. When Perseus struck off Medusa's head, Pegasus sprang from his mother's body and flew up to Olympus. By stamping his hoof on Mount Helicon, sacred to the Muses, he produced the fountain of Hippocrene and became a symbol of poetic and artistic inspiration.

Bellerophon was a grandson of Sisyphus and son of Glaucus, king of Corinth. The myth of Bellerophon and Pegasus goes back to Pindar's *Olympian* XIII. After attempting in vain to tame Pegasus, Bellerophon sought the advice of the seer Polyeidus and spent a night in Athene's sanctuary. There the goddess appeared to him in a dream and gave him a golden bridle, with the aid of which he was able to tame the winged horse by the fountain of Pirene, and it henceforth became the emblem of Corinth.

Mounted on Pegasus Bellerophon performed many heroic deeds, especially the slaying of the monstrous Chimaera. However, when Bellerophon became over-proud and attempted to ride on Pegasus to Heaven, the horse threw him. Bellerophon finally went mad, and Pegasus returned to Jupiter.

The theme is rather rare in Renaissance sculpture. Bertoldo di Giovanni does not follow Pindar's version in which Bellerophon attaches the bridle to Pegasus's mouth with "gentle magic"; instead, the hero uses main force and also wields a cudgel. It should not, however, be concluded from this that the subject of the bronze is not *Bellerophon and Pegasus* but *Hercules and Arion*, as was suggested by Gericke (1956) with reference to an Etruscan bronze in the Museo Archeologico in Florence, which also depicts a winged horse being tamed with a cudgel. Like Hercules and Perseus, Bellerophon is one of the Greek heroes whose undying fame was mainly due to their overcoming monsters that were a danger to mankind. However, while Hercules found a place among the immortals on Olympus, Bellerophon, who tried to storm the gods' abode, was cast down to earth and punished with madness. A representation of Bellerophon might therefore suggest that pride would lead to a fall. Bredekamp (1985) sees the group as a symbol of the taming of unruly forces, which may break forth again if the tamer himself loses his sense of measure.

For the formal composition of the *Bellerophon and Pegasus* group Bertoldo could have found inspiration in antique works, notably the *Horse-tamers* of Monte Cavallo in Rome, or also the horse-tamers in the frieze of Donatello's *Resurrection* pulpit in San Lorenzo, Florence, on which he is supposed to have assisted when young. Frimmel (1887) mentions a Greek relief in the British Museum as a possible source. The motif can also be found on the corners of Roman sarcophagi, and antique cameos may also have served as models. Hiller (1970) gives a survey of representations of Bellerophon in classical art.

The horse-tamers in Donatello's frieze are markedly three-dimensional, with the horses and men confronting each other from opposite directions in a trial of strength. In Bertoldo's group, by contrast, the two figures move in the same direction, parallel to each other: the group is in effect a high relief, free-standing and separated from its background. The only viewpoint it ad-

Bertoldo di Giovanni
*c.*1420–1491
(See Biography, p. 279)

Bronze group; the base integrally cast. The horse's body is a thick-walled casting (almost 1 cm), the remainder of the work solid. Small flaws on the horse's belly and back and on the base. Pegasus's left foreleg has been broken off above the carpus and restored, the right foreleg has been broken off below the carpus and resoldered, not precisely in its original position. A crack on Bellerophon's left calf. In the horse's belly a large rectangular opening, about 2.4 by 2 cm, chiseled out to remove the casting core. Old dark-grayish-brown artificial patina and remains of later black lacquer. On the underside of the base an inscription, integrally cast, engraved in the model: 'EXPRESSIT ME BERThOLDVS. CONFLAVIT HADRIANVS'. The figure 987 in white on the upper surface of the base is the inventory number of the Imperial and Royal Cabinet of Coins and Antiquities, prior to 1823. Height 32.5 cm; base 24.9 x 10.8 cm. Inv. no. Pl. 5596.

PROVENANCE
In the early 16th century in the possession of
Alessandro Capella at Padua (von Frimmel,
Der Anonimo Morelliano, Vienna 1888, p. 18,
"In Padoa in casa di Misser Alexandro Capella
in borgho zucho . . . Lo Bellorophonte di
bronzo che ritiene el Pegaso, de grandezza
dun piede, tutto ritondo, fu di mano di
Bertoldo, ma gettado da Hadriano suo disci-
pulo et è opera nettissima et buona", ("The
bronze *Bellerophon* holding back Pegasus,
height one foot, free-standing, was made by
Bertholdo, but cast by his pupil Hadriano; it
is a very well finished and good piece.")
Collection of the Imperial Treasurer Josef
Angelo de France in Vienna (Martini 1781, p.
82, Descriptio Signorum "(Int. Scr. VI, et VII.
no. 131. Cat. A. 849) BELLEROPHON, PEGASUM
domans. Aes 13. alt. 15 1/2 long. In lamina
oblonga, simul fusa.") Acquired in 1808 for
the Imperial and Royal Cabinet of Coins and
Antiquities, passing to the Ambras collection
and transferred with the entire collection to
the Kunsthistorisches Museum in 1891.

mits is from the right of side-on, because nearly half of Bellerophon's trunk
is conjoined with the horse's body – an unusual feature which is aesthetically
unsatisfactory if the group is viewed from the front. The composition attains
its full effect only if viewed in this way, indeed it almost needs to be framed.
There was no concept of a sculpture that opened up different views as one
walked round it.

The whole force of the movement – the way the horse rears in response to
Bellerophon's mighty tug and turns his head to the right as the hero grips his
muzzle; the way Bellerophon has run a short way with the horse but checks
its impetus by throwing back the upper part of his body and digging his
heels into the ground, aiming a blow with the cudgel in his right hand – all
this can be seen properly only from the right-hand side of the group. This
view gives full effect to the orthogonal opposition of the two main axes, the
forward thrust of the horse and the backward pull of its master. It was prob-
ably for this reason that the opening subsequently chiseled out for the re-
moval of the casting core was made not in the center of the horse's belly,
where it could be seen from the right-hand side, but somewhat to the left of
center where it was almost invisible to a spectator from that side. Pegasus's
left wing and left legs are placed so as to be seen clearly from that direction.
The only suggestion of spatial projection is in the opposition between
Bellerophon's upper right arm and the horse's head turned to the left, and in
the thrust of the hero's knees.

The question arises whether this single viewpoint, reminiscent of a relief,
was due to the artist alone, or was at least partly a response to technical prob-
lems. It seems likely that the founder had some say in the matter. The in-
scription underneath the base, mentioning both Bertoldo as the molder and
Adriano as the caster, suggests that the two cooperated at the stage of prepar-
ing the casting pattern. The representation of a prancing horse in a free-
standing piece of sculpture involves static problems which are solved here by
having Bellerophon support the upper part of the horse's body. Although
for this alone the two need not have been conjoined – it would have sufficed
for them to lean against each other – separate figures would have been more
complicated from the casting point of view. As an example of casting tech-
nique, the group is not a masterpiece. Only Pegasus's body is hollow, and
that is cast with extremely thick walls. The animal's head, legs and tail, and
of course its wings, are cast solid, as is the figure of Bellerophon. But while
other early Florentine casts generally needed considerable afterworking (and
therefore quite often remained unfinished), the afterwork in this case could
essentially be confined to smoothing the surface. Subsequent chiseling or en-
graving is hardly noticeable and was not necessary – only the cudgel was
given a livelier appearance by hammering the surface. Features of a markedly
graphic kind – the wrinkles of the horse's coat, the hairs and above all its
wing-feathers – appear essentially as they were formed in the casting, thus
justifying the founder's part in the inscription.

If we compare the *Bellerophon* group with other works by Bertoldo, the
Hercules (or *Wildman on a horse*) in the museum in Modena makes a heavier

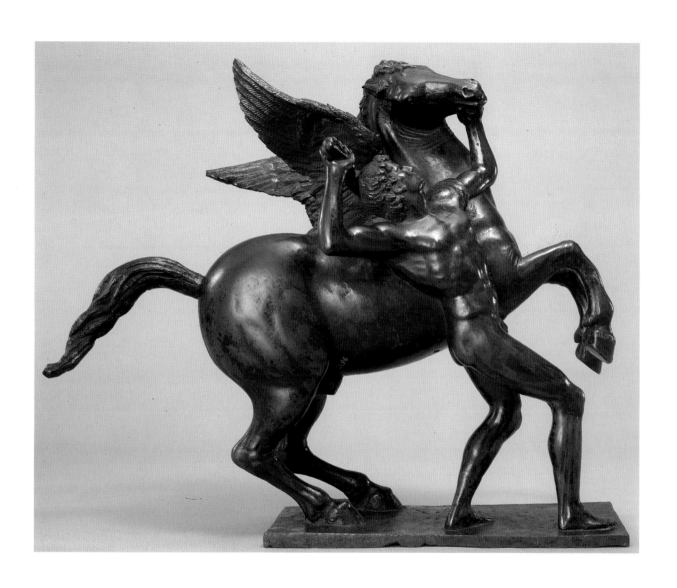

Bellerophon taming Pegasus, front view

Bellerophon taming Pegasus, front view
(detail)

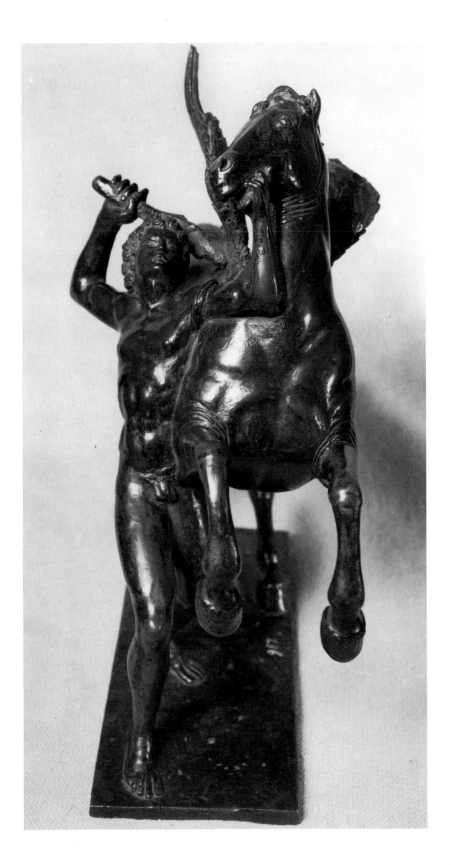

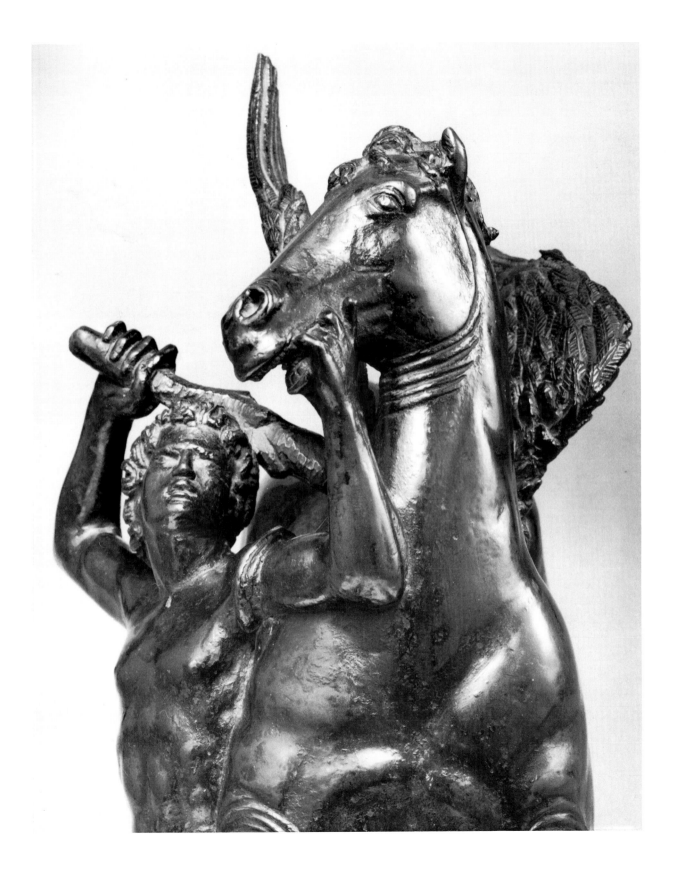

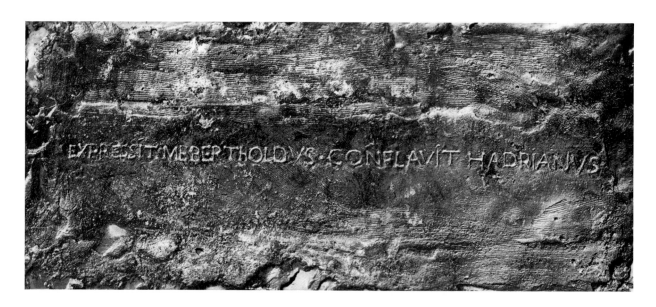

Bellerophon taming Pegasus, signature

impression, while the figures in the equestrian *Battle* in the Bargello in Florence are slimmer, wirier and more mobile. Above all, there is more graphic detail in the figures in that relief than in the *Bellerophon*, probably as a result of more extensive afterwork. In both cases, however, we find the almost semicircular drawing of the horse's cheek that is so characteristic of Bertoldo.

Antonio Pollaiuolo, in his *Hercules and Antaeus* group in the Bargello in Florence, was the first sculptor since classical times to portray the effects of the impact of two opposed figures. Bertoldo in the present work was the next to create a group of figures displaying violent movement and its forcible restraint. Although one can still perceive in it a struggle for artistic form obstructed by technical problems, the Bellerophon group shows a captivating spontaneity and freshness of invention. This lack of restraint and relative freedom from precedent in Bertoldo's work led Middeldorf (1978) to take the view that he was not a trained artist but a dilettante member of the household of Lorenzo de' Medici, one of the latter's circle of scholars or perhaps – since the sources report him on familiar terms with Lorenzo – an illegitimate offspring of the Medici, a son of Giovanni di Cosimo and thus actually Lorenzo's cousin.

There is no record of the date of the bronze, but some evidence is provided by the inscription, with its mention of both Bertoldo and Adriano, and by the first documentary record of the work, by Marcantonio Michiel at the beginning of the sixteenth century: at that time it was already in the possession of Alessandro Capella in his house in Padua.

Adriano Fiorentino is described by Marcantonio Michiel as Bertoldo's pupil, which seems likely enough when the works known to be by him are compared with Bertoldo's. From 1486 at the latest he was no longer in Florence but had become a gun founder in the service of the *condottiere* Virginio Orsini and afterwards of King Ferdinand I of Naples. Since

Bertoldo died at the end of December 1491, the two could presumably have worked together only until 1486 at the latest. Bertoldo, however, is recorded as being in Padua in 1483–84, where he was commissioned to make two bronze reliefs for the choir of the Santo. The first of these proved a failure, and the commission for the second was transferred to Bartolomeo Bellano. It can hardly be supposed that after his failure in Padua Bertoldo was able to find any further customers in that city, and nothing is known of Adriano Fiorentino ever going to Padua: consequently Planiscig's supposition (1927) that the bronze was made in Padua appears groundless. A better suggestion is that Bertoldo took it with him when he went to Padua in 1483 or earlier. Alessandro Capella, the owner of the bronze in Padua, was the son of Febo Capella, the Venetian envoy in Florence from 1461 to 1482. His father might have acquired the *Bellerophon* and also conveyed to Bertoldo the commission for the reliefs in the Santo.

Bode's belief (1925) that Bertoldo executed the commission in Florence and never went to Padua is refuted by documents (Sartori 1976). Pope-Hennessy (1963) also seems to connect the *Bellerophon* with the Padua commission. However, he regards both the *Horseman* in Modena and the *Battle* in Florence as earlier than the *Bellerophon*, despite the fact that the compositional technique of the relief in the Bargello is more varied than in the *Bellerophon* group, while the Modena *Horseman* is a more ponderous work. This stylistic consideration would suggest that the Bellerophon group was the second of the three works to be executed. A definitive answer may be provided by James Draper in a thesis unfortunately not available to scholars.

Marcantonio Michiel's exact knowledge of the authors of the bronze, who were both dead at the time he saw it, seems to indicate that the inscription underneath the base was then still visible. When T. Frimmel rediscovered it in 1884 it was covered by a thick layer of greenish-brown wax: Frimmel supposed that it had been intentionally concealed so as to pass the work off as classical and so obtain a better price for it. The authorship of the bronze was unknown in the mid eighteenth century, when the group adorned the collection of the imperial treasurer Josef Angelo de France in Vienna, whence it later found its way to the Imperial and Royal Cabinet of Coins and Antiquities. As late as 1883, Frimmel had still classified it as "in the manner of Andrea Riccio". Only the erudite Courajod, though he had not seen the inscription, identified the group in 1883 as the work attributed by Michiel to Bertoldo and Adriano. This identification was duly confirmed by Frimmel's rediscovery of the inscription. Since then the bronze group of *Bellerophon taming Pegasus* has been one of the most admired bronzes of the Quattrocento.

ADDITIONAL BIBLIOGRAPHY

Gericke, T. 1956, pp. 193–201.
Hiller, S. 1970.
Sartori, A. 1976, pp. 19–22.

BIBLIOGRAPHY

von Sacken, E. and Kenner, F. 1866, p. 481, No. 19.
Ilg, A. and Boeheim, W. 1882, p. 85, No. 30.
Frimmel, T. 1883, p. 53, No. 903.
Courajod, L. 1883, pp. 148, 149 and pp. 268, 269.
von Fabriczy, C. 1885, p. 412.
Frimmel, T. 1887, pp. 90–96.
Frimmel, T. 1888, pp. 18, 19.
Ilg, A. 1891, p. 219, Room XXIV, Case I, No. 86.
Bode, W. 1892–1905, pp. 133, 134, Plate CCCCXXIXb.
Bode, W. 1895, pp. 146–148.
Reymond, M. 1899, pp. 44, 45.
von Schlosser, J. 1901, pp. 11, 12, Plate XV/1.
von Fabriczy, C. 1903, pp. 71, 72.
Schottmüller, F. 1907, p. 505.
Bode, W. 1907, I., p. 13, Plate IX.
Venturi, A. 1908, p. 514.
von Schlosser, J. 1910, p. 1, Plate I.
Bode, W. 1910, pp. 245, 246.
Schubring, P. 1915, pp. 146, 147, Fig. 193.
Übersicht 1916/1917, p. 189, Room XXIV, No. 42.
Schottmüller, F. 1918, pp. 79–80, Fig. 51.
Planiscig, L. 1921, p. 110.
von Schlosser, J. 1922, pp. 4, 5.
Bode, W. 1922, pp. 12–14, Plate VI.
Knapp, F. 1923, pp. 73, 74, Plate LXXXII.
Planiscig, L. 1924, pp. 5, 6, No. 3.
Planiscig, L. 1925, pp. 7–8.
Bode, W. 1925, pp. 88–91.
Planiscig, L. 1927, p. 44.
Planiscig, L. 1930, p. 6, Plate VI/9.
Planiscig, L. and Kris, E. 1935, p. 58, Room X, No. 48.
Maclagan, E. 1935, p. 164.
Galassi, G. 1949, p. 142.
Delogu, G. 1956, pp. 152, 153.
Pope-Hennessy, J. 1958, pp. 101–104 and pp. 318–320.
Pope-Hennessy, J. 1963, p. 17.
Montagu, J. 1963, pp. 23–26, Fig. 11.
Vermeule, C. 1965, p. 58.
Radcliffe, A.F. 1966, pp. 28, 29, Fig. 9.
Negri-Arnoldi, F. 1966, p. 6, Fig. 13.
Seymour Jr., C. 1966, p. 245, Note 3.
Mahl, E. 1966, pp. 2, 3, No. 182.
Weihrauch, H.R. 1967, pp. 87, 88, and p. 459, Ill. 92.
Seymour, C. 1967, pp. 489–491.
Savage, G. 1968, p. 160, Fig. 134.
Castelfranco, G. 1968, p. 16, Plate LVI.
Pope-Hennessy, J. 1970, pp. 37–40.
Herzner, V. 1972, pp. 135, 136.
Leithe-Jasper, M. 1978, p. 100.
Middeldorf, U. 1978, pp. 314–316.
Leithe-Jasper, M. 1981, pp. 3188–3190.
Distelberger, R. 1982, pp. 65 and 68.

3. Standing satyr

Adriano di Giovanni de' Maestri,
called
Adriano Fiorentino
c. 1450/60–1499
(See Biography, p. 279)

Bronze statuette; the base integrally cast. Thick-walled, largely solid cast. The left hand broken off and re-attached (or recast?). Several core-support pins visible at the back. A fairly large hole at the back of the satyr's head, probably made for the removal of the casting core and then filled with red resin. A round hole in the restored, outstretched left hand indicates that the satyr originally held some object in it. Two screw-holes underneath the base, where the statuette was fixed to a socle. Reddish-brown varnish, not original, and underneath it a grayish-brown, artificial(?) patina. Underneath the base an inscription originally engraved in the model, somewhat disturbed by the screw-holes: . . . ADRIANVS FLOR.FACIEB . . .
Height 41.4 cm.
Inv. no. Pl. 5851.

PROVENANCE
In Imperial possession at least since the early 17th century, first mentioned in an inventory of the Treasury in Vienna after the death of Emperor Matthias in 1619. (Köhler 1906–07, p. xv, No. 28. "1 Saturus, in der rechten Hand ein baumb haltend"). Passed in 1871 from the Treasury to the Ambras collection and transferred with the entire collection to the Kunsthistorisches Museum in 1891.

In ancient times "Satyr" or "Pan" denoted a universal divinity, a symbol of nature, free sexuality and unbridled lust, corresponding to the he-goat in the animal world. Hence from classical times onward Pan and the satyrs were depicted as hybrid beings, half man and half goat: see the account by Blume (1985).

The satyr – a tall figure on extremely slender goat's legs – rests his left foot on the fork of a bare tree-stump, the broken-off upper end of which he holds in his right hand. The gesture of his raised left hand, and his grinning gaze in the same direction, indicate a conversation with some imaginary figure or perhaps a companion piece, no longer extant. The hole in the left hand clearly indicates that something was once held in it, possibly panpipes.

In Cesare Ripa's *Iconologia* the god Pan – symbolizing "Mondo", the world – can be seen holding an instrument of the same kind in a similar attitude.

The structure and modeling of the statuette, and the similarity of gesture, are reminiscent of Bertoldo's work, so that we may believe Marcantonio Michiel's statement that Adriano was Bertoldo's pupil. However, the figure has a more three-dimensional quality than Bertoldo's, revealed through the sense of movement and deriving from the pronounced torsion which emerges fully only as the spectator changes viewpoint. There is a strong contrast between the smooth body and the very crisply modeled strands of shaggy, woolly hair that cover the satyr's head and thighs.

The afterworking technique also resembles that of Bertoldo's *Bellerophon* group. It is somewhat less careful, as shown by several traces of heavy filing. The surface texture of the tree-trunk was produced by hammering.

The reddish-brown lacquer is quite untypical of Quattrocento bronzes but characteristic of Florence in the late Cinquecento, especially of bronzes from Giambologna's workshop. It was probably applied to the statuette later still, when it was displayed in a *Kunstkammer* as a pendant to a later bronze.

Planiscig (1921 and 1924) attributed the work to an imitator of Riccio in Padua, *c.*1540, such as Tiziano Minio or Desiderio da Firenze. He compared it with Riccio's *Drinking Satyr* in Vienna (cat. 20), which he had also at first attributed to Desiderio, and with a *Standing Satyr* now in the Victoria and Albert Museum in London which is modeled on the satyr in an erotic group by Riccio in the Musée de la Renaissance at Écouen (Jestaz 1983).

Rejecting these quite erroneous comparisons, Leithe Jasper (1973) preferred on stylistic grounds to place the statuette in central Italy and date it to the later fifteenth century. When the statuette returned from an exhibition in Tokyo in 1983 the fastening to the socle had become loose and part of a layer of plaster between the socle and the base had been detached. This revealed the inscription . . . ADRIANVS FLOR.FACIEB . . . underneath the base, confirming the new supposition and enriching the small known *œuvre* of Adriano Fiorentino with a further signed statuette. More important, however, seems to be the fact that this statuette may be one of the earliest, if not the first autonomous satyr statuette of the Renaissance period. Adriano would seem to be the first to have taken up in bronze sculpture a theme that

BIBLIOGRAPHY

Planiscig, L. 1921, pp. 401–403, Fig. 425.
Planiscig, L. 1924, pp. 90, 91, No. 158.
Leithe-Jasper, M. 1973, No. 16.
Leithe-Jasper, M. 1976, pp. 77, 78, No. 52.
Leithe-Jasper, M. 1981, p. 319.
Blume, D. 1985.

ADDITIONAL BIBLIOGRAPHY

von Fabriczy, C. 1903, pp. 71–98.
Hill, G. 1930, pp. 82–87.
Lisner, M. 1967 (1964), Vol. II, p. 84.
Koepplin, D. 1974, p. 84, No. 27.
Avery, C. and Radcliffe, A.F. 1983,
 pp. 107–122.
Jestaz, B. 1983, pp. 25–54.

was to enjoy immense popularity. His treatment of the motif was indeed arbitrary, probably modeled on book illuminations and having little to do with classical models (Blume 1985). In this respect he had no real imitators until Severo da Ravenna and Riccio (Avery and Radcliffe 1983).

It seems impossible as yet to date the statuette, in the lack of sufficiently firm dates for Adriano's work as a whole. The stylistic resemblance to Bertoldo's works would suggest that it was executed in Florence before 1486, when Adriano entered the service of Virginio Orsini (Fabriczy 1903), mainly as a gun founder. Adriano's later known work consists chiefly of medals (Hill 1930). In his last years he spent some time in Germany, probably in the service of Maximilian I. During that time he executed the portrait bust now in Dresden, signed and dated 1498, of the Elector Frederick the Wise of Saxony, who was then in Maximilian's entourage (Koepplin 1974), and also a medal of Nicolaus von Firmian, governor of the Adige region, a confidant of Maximilian's and chamberlain to Bianca Maria Sforza, the Emperor's second wife. As the statuette is known to have been in the imperial collection in 1619, it is at least possible that Maximilian himself owned it. Another reason for supposing it to have crossed the Alps at such an early date is that in Albrecht Dürer's *Ecce Homo* woodcut in his *Great Passion* of 1498 a satyr, seen in a niche, shows the possible influence of Adriano Fiorentino's (private communication from Helmut Trnek).

A small faun's head in bronze in the Bargello in Florence was suggested by Lisner (1967) to be an echo of an early work by Michelangelo, recorded by his biographers but now lost. However, the bust in Florence also bears some resemblance to the present statuette, and there may be a connection. If Michelangelo was the originator, which is hardly probable as he was then no more than a youth, the statuette could not be dated before 1490. It seems more likely that both works derived from the same classical model.

4. Entombment

Three men are laying Christ's body to rest in a sarcophagus, the front of which is decorated with a relief in classical style representing Amazons led by a winged Fury driving a war chariot. Mary Magdalene holds and kisses Christ's left hand, while his right hand hangs down in front of the sarcophagus. The Virgin Mary, overwhelmed with grief, stands on the extreme left. She is supported by a figure who may be St John. She is the only figure with a halo. On the right, partly cut off by the frame, is a seated Roman soldier, thoughtfully resting his chin on his right hand. A weeping, frightened child runs toward him. The mourner behind them, grasping his left upper arm with his right hand and extending his left hand in a violent gesture toward the dead Christ, has also been identified as St John. Behind him, on the extreme right, two young men stand observing the scene. In the background are six more figures, some manifesting their pain and sorrow violently.

The scene takes place on a shallow stage. The slight concealment of the figures at both ends by the frame, the staggered arrangement of the groups on either side, and the somewhat smaller background figures standing around the central group by the sarcophagus give the relief only a small degree of spatial depth, and this is largely neutralized by the smoothing and gilding of the background. But this in turn enhances the silhouette of the group of figures, so that they give the impression of being cut out and applied to the background.

The composition of the relief is also very flat. Individual bodily parts, mostly heads and extremities, are strongly undercut and detach themselves as if they were cut out of the background. All the heads are in profile except those of the child, a veiled woman in the background and the figure supporting the Virgin Mary. The relief as a whole and the individual figures are graphically rather than sculpturally modeled. The very detailed drawing not only determines the composition but also endows the relief with its high degree of expression.

The subtle chiseling, reflective of every nuance, is of a refinement unmatched by any other bronze of the early Italian Renaissance, and can only be the work of a trained goldsmith and graphic artist. The question arises, however, whether this dominance of the graphic element does not obscure the form rather than define it, and whether the relief can achieve its ideal effect without the differentiation of hues that bronze is unable to provide. The gilding of the sarcophagus does something in this direction, whereas the gilded background rather enhances the frieze-like character of the work.

Despite its markedly individual features of style and technique, the authorship of the relief and its place and date of origin are still unknown. In view of the partial gilding it has been thought, perhaps rightly, that it must have been commissioned by a court patron – most likely at Mantua, where such parcel-gilt bronzes were prized for their costly appearance, as many works by Antico testify. But it does not seem justified to conclude from this fact alone that the relief must have been executed in Mantua itself.

The attribution of the relief to Donatello, which goes back to Sacken (1865) and was accepted by Perkins (1868), Müntz (1885), Molinier (1886)

North Italian (Padua or Mantua), c.1470–80

Bronze relief. The depressions on the back correspond to the convex parts of the front. In the frame, on both sides and at the bottom there are fairly large cracks, originating in the casting; those on the sides have been sealed with fillings in the shape of a double wedge. The sarcophagus, background, frame and acroterion are firegilt, the human figures artificially patinated dark-brown. Height 24.4 cm without the acroterion, which is 3 cm high; width 44.9 cm.
Inv. no. Pl. 6059.

PROVENANCE
Collection of Archduke Leopold Wilhelm in Vienna. Inventory of 1659, fol 447, 447', no. 119. "Ein Grablegung von Metal, warin der Grundt vnd das Grab verguldt. Antico. 1 Span 2 Finger hoch vnndt 2 Spann 1 Finger braidt". (Berger 1883, p. CLXIX). Transferred at an unknown date, but before the publication of the *Prodromus* in 1735 and the reference to it in the Ambras Inventory of 1788, case VIII, no. 183, to Schloss Ambras near Innsbruck. Transferred to the Ambras collection in Vienna in 1821 and transferred with the entire collection to the Kunsthistorisches Museum in 1891.

BIBLIOGRAPHY
Primisser, A. 1819, p. 177, No. 216.
von Sacken, E. 1855, p. 96.
von Sacken, E. 1865, pp. 53, 54, Plate XXXVI.
Perkins, C. 1868, p. 312.
Ilg, A. and Boeheim, W. 1882, p. 108, No. 351.
Frimmel, T. 1883, pp. 62, 63, No. 992.
Müntz, E. 1885, p. 80.
Molinier, E. 1886, pp. 38–40, No. 71 and pp. 162–164, No. 220.
Semper, H. 1887, p. 98.
Ilg, A. 1891, p. 234, No. 28.
Semrau, M. 1891, pp. 99, 100, Note 1.
Bode, W. 1892–1905, p. 38.
Schottmüller, F. 1904, p. 76 and p. 90.
Eisler, R. 1905, p. 153.
von Fabriczy, C. 1907, p. 53.
Schubring, P. 1907, p. 202, Plate CLXXVI.
Venturi, A. VI, 1908, pp. 504–507, Fig. 335.
Hermann, H.J. 1909/1910, p. 278.
von Schlosser, J. 1910, p. 3, Plate VII.
Übersicht 1916, p. 193, Room XXIV, Case VI, No. 4.
Planiscig, L. 1924, pp. 8, 9, No. 9.
Bode, W. 1925, pp. 114–117.
Planiscig, L. 1927, p. 46 and pp. 290–292, Fig. 334.
Planiscig, L. and Kris, E. 1935, p. 50, Room X, Case 3, No. 4.
Pope-Hennessy, J. 1964², reprinted 1980, pp. 210–211.
Pope-Hennessy, J. 1965, p. 62, No. 206.
Mahl, E. 1966, p. 27, No. 229.
Leithe-Jasper, M. 1973, No. 7.
Leithe-Jasper, M. 1978, p. 94.
Distelberger, R. 1982, p. 69.

and Semper (1887), is no longer entertained. Semrau (1891) suggested an imitator of Donatello, Schottmüller (1904) a Paduan follower of Donatello. Ilg (1882) was the first to notice Mantegna's influence, and Eisler (1905) actually supposed Mantegna to have designed the relief. Bode (1892–1905 and 1925) ascribed it to Bertoldo, Venturi (1908) to a follower of Bertoldo's, while Schubring (1907) and Schlosser (1910) proposed Minelli. Planiscig (1924) emphasized the Mantegnesque character of the relief and the costly execution typical of Mantua, but also for the first time drew attention to a plaquette which he attributed to Riccio (Molinier 1886, no. 220; examples in the Kunsthistorisches Museum, Vienna; the Kress Collection, Washington; and elsewhere), and in which use was made of the central motif of the relief in Vienna as well as elements from several engravings by Mantegna – the Longinus in the engraving of the *Ecce Homo between Sts Andrew and Longinus* (Bartsch 4) and the grief-stricken Virgin comforted by women in the engraving of the *Entombment* (Bartsch 3). On these grounds Planiscig suggested with some reason that the *Entombment* relief might after all have originated in Padua.

The composition of the relief is undoubtedly based on Donatello's *Entombment* relief in St Peter's in Rome, and still more on that in the Santo in Padua. It has rightly been pointed out that in those reliefs Donatello used ideas from Roman sarcophagus sculpture, especially scenes of the death of Meleager (Janson 1975). The style of the present relief is also based on Donatello. By its resemblance to the Virgin on the left, it would appear that the relief of the *Madonna del Perdono* in Siena, executed in 1457–58 by Donatello and his workshop, marks the phase of Donatello's work that inspired the Vienna relief. Donatello, in Padua, had already made a chromatic differentiation of the sarcophagus in which Christ's body was laid; the fact that the Vienna relief depicts it as a classical sarcophagus with Amazons seems explicable at the period in question only on the basis of Mantegna's antiquarian interests, and possible only in the artistic milieu which took its character from him.

The friezelike composition and the classical treatment of the figures and the heads in particular – despite the expressiveness of mime and gesture – are distinctly reminiscent of Mantegna, as Eisler had already pointed out; but this does not entitle us to suppose that Mantegna made a design which was then executed in sculptural form. Neither Mantegna nor Donatello would have schematically represented nearly all the heads in profile. For this reason Bode compared the *Entombment* relief with two plaquettes of the *Education of Cupid* and *Venus and Mars in Vulcan's Smithy*, which he attributed to Bertoldo and which Pope-Hennessy now assigns respectively to Camelio and Alessandro Leopardi. There is indeed a resemblance in the structure of the relief, the form of the heads and the predilection for profile. However, comparison is difficult as these plaquettes are virtually unchased.

The influence of the Vienna relief extends not only to representations of the *Entombment* by Riccio, as Planiscig (1927) showed, but can also be seen in Venetian painting, especially Titian. Titian's habit of including sarcophagus

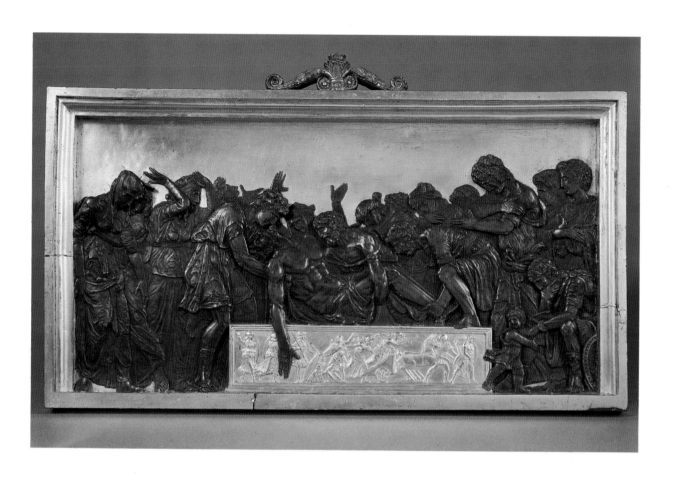

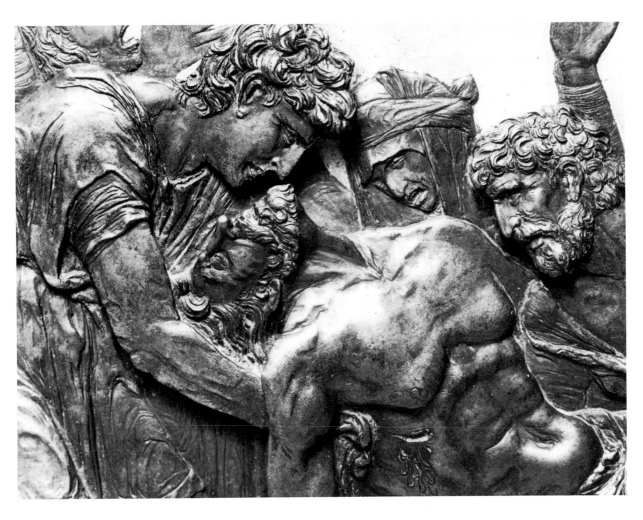

Entombment, detail

reliefs in his paintings may have been inspired by the Vienna relief, which, so far as is now known, was the first to show Christ's body being laid in an antique sarcophagus. Titian's *Entombment* in the Prado in Madrid shows a relief sarcophagus in antique style, with scenes depicted on it from the Old Testament.

The Vienna relief was owned by Archduke Leopold Wilhelm, who, around 1650, acquired a large part of the collection of King Charles I of England. As part of that collection had been bought in Mantua in 1627–28, it is not improbable that the relief originated there. The posthumous inventory of Duke Ferdinando of Mantua in 1627 listed "Un quadretto di bronzo di bassorilievo con Cristo cavato dal sepolcro", which may refer to the Vienna relief, although its distinctive gilding is not mentioned. However, as the Archduke acquired works of art from other sources, and as we are not well informed about the sale of Charles I's collections under the Commonwealth, particularly his sculpture, the identification of the Vienna relief with the one in the Mantua inventory of 1627 must remain a hypothesis.

5. Virgin and Child with three angels

The Virgin is seated on the ground, on a platform resembling a pedestal. She is turned three-quarters to her left and is offering her breast to the Christ child, whom she holds on her lap with both hands. She combines the "Madonna humilitatis" and the "Madonna lactans". A corner of her garment with its many folds hangs down over the pedestal, thus clarifying the spatial situation. On the right in front of her are two cherubs. The one behind is only recognizable in outline; the one in front holds up a garland in his left hand and seems to be picking it up from the ground with his right. Another angel, standing on the left behind the Madonna, is picking up the other end of the garland, which is evidently lying on the ground behind her. In the center of the pedestal on which the Virgin sits is a wide bordered round opening.

The modeling is highly differentiated, so that the figures rise from the relief ground in *stiacciato* to full plasticity. The somewhat rough cast could only do justice to these refinements to a limited extent. Bringing out the details would have required extremely subtle and intensive afterwork. The only afterworking has been on the left-hand cherub and the left side of the Madonna's drapery, and even there has not been done with the necessary sensitivity, so that the fall of the drapery on that side has lost something of the soft line of the model and makes a rather stiff impression. The rest of the relief is practically unworked, no doubt because too much work had already been spent on it without achieving the desired result, and the surface has a sketchy appearance that was certainly not originally intended.

The relief was probably designed as the door of a tabernacle. The large round opening on the pedestal might then have been intended to take an enameled copper plate with the monogram XP, like those on the stucco version in Berlin and the majolica copy in the Beit collection. But the relief is unfinished and was never used for its original purpose.

Despite its incomplete state, the work is highly attractive thanks to the originality of its composition and the masterful modeling, though this cannot be perceived in all details. As was pointed out by Bertaux (1906) and Bode (1925), the composition is ultimately based on works by Donatello such as the Shaw *Madonna* in the Museum of Fine Arts in Boston and, above all, the bronze *tondo* from the Este collection in the Kunsthistorisches Museum, Vienna, but it develops these examples in an independent manner. The spatial structure and the way the figures stand out from the plane point to an artist with great experience and special affinity with the relief medium – not a direct follower of Donatello but, it would seem, closer to Luca della Robbia in the corporeality of his figures.

Molinier (1886) classified the relief as "school of Donatello", Bertaux (1906) as a work by Donatello himself. Bode (1892–1905) first described the composition as by an "unknown Florentine master, *c.*1460", then until 1913 (according to Schottmüller 1933) he ascribed it to Donatello's workshop, and finally to Bertoldo di Giovanni (Bode 1921 and 1925). Like many of Bode's attributions to Bertoldo, this is not convincing and has not been accepted. Ragghianti (1938) first pointed a new direction by comparing the relief with

Tuscan, last quarter of the fifteenth century: Francesco di Giorgio Martini? 1439–1501
(See Biography, p. 281)

Bronze relief; thick cast, split at the top left; a flaw above the Virgin's head, two old round holes beside the head of the Christ child. At the back, four holes for the new mount; there is also a casting flaw, which shows as a crack through the panel, and reinforcement for the mounting of two hinges, which in fact were never fitted. Black-brown lacquer and dark brown natural patina.
Height 34.2 cm, width 21.9 cm.
Inv. no. Pl. 9118

PROVENANCE

Collection of Edouard Aynard, Lyon. Acquired by him *ca*.1875 from Stefano Bardini in Florence. Bought in 1913 by Gustav von Benda at the Aynard/Lyon auction (Lot no. 226) in Paris. Gustav von Benda collection, Vienna. Bequeathed to the Kunsthistorisches Museum by Gustav von Benda in 1932.

BIBLIOGRAPHY

Molinier, E. 1886, II, p. 199, No. 744.
Bertaux, E. 1906, pp. 88–92.
Bode, W. 1892–1905, p. 179, Plate 556.
Bertaux, E. 1910, pp. 158, 159.
Schottmüller, F. 1913, p. 29, No. 61.
Bode, W. 1921, pp. 256, 257.
Bode, W. 1925, pp. 64, 65.
Führer, Sammlung Benda. 1932, p. 14, No.65.
Schottmüller, F. 1933, p. 67, No. 2384.
Rackham, B. 1935, pp. 104–109.
Ragghianti, C.L. 1938, p. 182.
Weller, A.S. 1943, pp. 168–171.
Mahl, E. 1966, p. 13, No. 199.

works by Francesco di Giorgio, whom he believed to be its author; this opinion was later followed by Weller (1943).

The Vienna relief indeed shows much similarity to works by Francesco di Giorgio in structure and surface quality. Comparisons can be made in particular with the *Lamentation* in Venice, the *Flagellation* relief in Perugia, and the four *tondi* of Sts Jerome, Anthony Abbot, John the Baptist and Sebastian in Berlin, Vaduz and Washington. But it should not be overlooked that none of these works by Francesco presents as many "Florentine" features as the Madonna relief in Vienna. The present exhibition offers the opportunity of a direct comparison with Francesco's works in the National Gallery in Washington, which may make a definitive judgement possible. The existence of a copy in Urbinate glazed majolica, executed by Nicolò Pellipario at the beginning of the sixteenth century, in the Beit collection in London is an argument for Urbino as the place of origin of the relief (Schottmüller 1933, Rackham 1935, and Weller 1943).

Two stucco versions are known: one is in the Bode Museum in East Berlin, the other is in the Liechtenstein Collection at Vaduz.

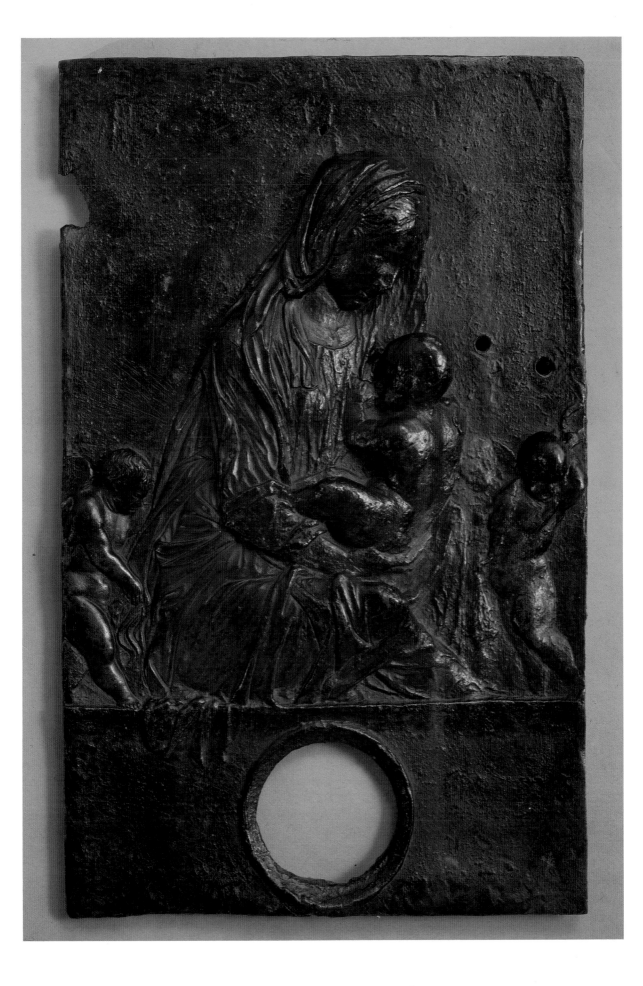

6. Putto mictans

Florentine, last quarter of the fifteenth century

Bronze statuette; an extremely thick-walled cast, in places about 1 cm thick, elsewhere cast solid. The genitals restored. On the buttocks an early fixing dowel, later cut off, and three late screw-holes for fastening to the base. At the lower end of the back two openings: one, extending into a hollow, presumably provided access for a water-pipe; the other, ending in the bronze mantle, connects with a pipe inside the cast. The lower end of the shirt at the back has been cut off at a later date. On the surface traces of old verdigris, reddish-brown artificial patina, remains of dark-brown lacquer and brown natural patina.
Height 44.2 cm.
Inv. no. Pl. 9988.

PROVENANCE
J.R. Heseltine collection, London. Robert Mayer, collection, Vienna. Acquired in 1954 from the Robert Mayer collection.

BIBLIOGRAPHY
Bode, W. 1907, II, Plate CLXVII.
Planiscig, L. and Kris, E. 1936, p. 6, No. 11.
Mahl, E. 1966, p. 6, No. 188.

ADDITIONAL BIBLIOGRAPHY
Bode, W. 1907, I, Plate III.
Marquand, A. 1922, II, pp. 184, 185, No. 335.
Schottmüller, F. 1933, pp. 73, 74, No. 151.
Weihrauch, H.R. 1967, pp. 77, 78, Ill. 144.
Ciardi-Dupré Dal Poggetto, M.G. 1978/1980, pp. 245–265.

In order to relieve himself the small boy has risen from a seated posture; his legs are spread apart and he holds up the front of his shirt in both hands, bending his head slightly forward to watch what he is doing. His hair is sparse and in small curls like a baby's.

This extremely massive cast was evidently intended to serve as a fountain, probably in the niche of a wall, with a bowl in front to receive the water. There is now no aperture in the penis, but a seam indicates that the whole of the private parts are a replacement. This is confirmed by a photograph dating from the beginning of this century and showing the *putto* "amputated", as it was in the J.R. Heseltine collection in London (Bode 1907, vol. II, pl. CLXVII). The missing part must therefore have been added quite recently. It may be that the original was so corroded by outflowing fountain water as to break off of its own accord. However, visible traces of old verdigris, and a tube inside the figure, suggest that after it had originally served as a fountain the surface of the bronze was thoroughly cleaned and underwent repatination. It is hard to judge today which of the numerous file marks on the surface – entirely to be expected in a Florentine bronze of the Quattrocento – are original, and which are due to a later working.

Bode (1907) unaccountably classified the work as Venetian, c. 1570. Planiscig and Kris (1936) regarded it as Florentine, of the second half of the fifteenth century, and supposed it to be by Vittore Ghiberti. Mahl (1966), following this attribution, pointed to a number of bronze heads and busts of children that Bode (1907) had attributed to Vittore Ghiberti. The comparison is not convincing, however. The heads in question have since, with more plausibility, been attributed by Weihrauch (1967) to Venice and the circle of Antonio Lombardo. It is also hard to find resemblances to Vittore Ghiberti's œuvre as assembled by Ciardi-Dupré (1978/80). All the more interest therefore attaches to a hitherto unnoticed work, the statuette of a *putto mictans* in glazed terracotta in the sculpture collection of the Staatliche Museen in West Berlin, which is ascribed to Andrea Della Robbia or his workshop (formerly in the Kaiser Friedrich Museum in Berlin: Marquand 1922, vol. II, pp. 184, 185, no. 335; Schottmüller 1933, pp. 73, 74, no. 151). The Berlin *putto* is considerably larger and more differentiated in modeling, and the hair is more abundant, indicating that it is later than the Vienna bronze and perhaps a copy of it.

It seems most likely that the Vienna *Putto mictans* originated in the Della Robbia workshop in the last quarter of the fifteenth century; it certainly has a closer stylistic resemblance to Della Robbia products than to products of the Ghiberti workshop.

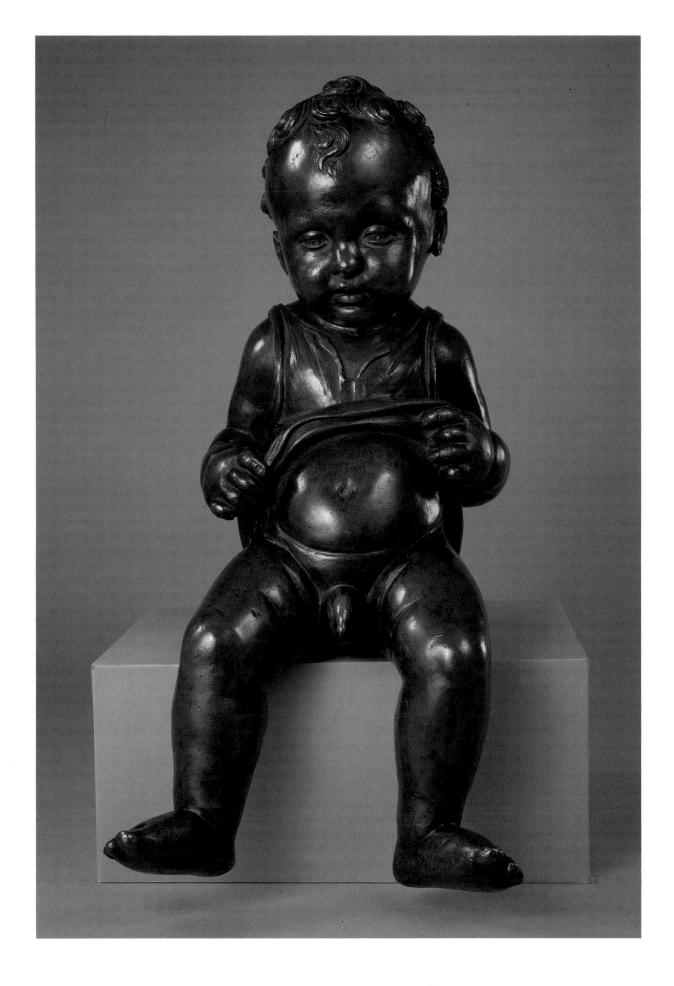

7. Jupiter

North Italian *c.* 1500

Statuette; bronze, thick-walled cast, the eyes inlaid in silver. The third and fourth fingers of the right hand are broken off, also the lower end of the thunderbolt; cracks in the lower left leg. The richly profiled octagonal socle, probably dating from the eighteenth century, is bound with strips of brass on the oblique edges. Under Jupiter's feet, remains of an imitation marble base in gray-toned stucco. Brown natural patina with remains of dark brown lacquer.

Height 35 cm.

Inv. no. Pl. 5769.

PROVENANCE
Before 1781 Josef Angelo de France collection. (Martini 1781, p. 8, Descriptio Signorum, Scrinium I, no. 62: "Ser. 5, Cat. A. 343. IVPITER, crispis et capillis et barba, e oculis argenteis insignis. Fracti in eo sunt d. digiti, medius sc. et annularis, dimidati, et fulminis pars inferior. Opere eleganti. Aes, 13 1/2 alt. In b. marmor affabre facta. Acquired in 1808 for the Imperial collection of Antiquities. Transferred to the Ambras collection in 1880. Transferred with the entire collection to the Kunsthistorisches Museum in 1891.

BIBLIOGRAPHY
Martini, G.H. 1781, p. 8, Descriptio Signorum No. 62.
Planiscig, L. 1924, p. 7, No. 7.
Leithe-Jasper, M. 1973, No. 1.
Leithe-Jasper, M. 1976, No. 1.

ADDITIONAL BIBLIOGRAPHY
Hermann, H.J. 1909/10, p. 217.
von Sacken, E. 1871, Plate II/1.

Jupiter stands in *contrapposto*. He wears a close-fitting mantle, held with a brooch on the right shoulder and leaving bare his right arm and the right upper part of his body. His lowered left hand holds the thunderbolt, while his upraised right hand probably held a spear.

The monumentality of the deity contrasts with the careful detail with which the surface is worked. The eyes are inlaid in silver; the curly hair and beard are depicted in parallel lines in a markedly graphic manner, and are further differentiated by punching in the recesses. Delicate strokes with the burin give the mantle the effect of raw, heavy cloth.

Despite the figure's eminently classical bearing, no specific model has yet been identified. There is, however, a somewhat similar Etruscan small bronze of *Jupiter* in the Kunsthistorisches Museum (Inventory of Antiquities no. VI/145, Sacken 1871, plate II/1). Nor has it yet been possible to locate the work with any certainty, still less identify its author. But it is difficult to follow Planiscig's suggestion of a stylistic resemblance with Florentine works of around 1500 such as statuettes from the shop of Bertoldo di Giovanni. The treatment of the head is reminiscent of Mantegna; the physique of the figure recalls statues of Hercules by Antico, and there is a certain resemblance to the nude rear view of Neptune in Mantegna's engraving of a *Battle of the Seagods*. The modeling of the statuette and the afterworking, especially of the drapery, has remarkable similarities to the *"Goddess of the Via Trajana"* statuette in the Staatliche Museen in West Berlin (Inv. no. 2550). That statuette, the attribution of which to Antico (Bode 1902, pp. 225, 226) can hardly be defended, is mentioned in the 1542 inventory of Duke Federigo II Gonzaga of Mantua as "una figura piccola di metale che sede cum una rota in mano" (Hermann 1909/10, pp. 253, 254). All this suggests the authorship of a hitherto unknown artist active in Mantua, who was possibly also a goldsmith.

The 1542 inventory of Duke Federigo II of Mantua also speaks of "Una figura de metale d'uno Jove cum uno fulgure rotto in mano", but there is no further indication that this is the Vienna statuette. The present figure can first be traced with certainty in the 1781 catalogue of the collection of Josef Angelo de France, former treasurer of the Empress Maria Theresa, where it appears as: "IVPITER, crispis et capillis et barba, et oculis argenteis insignis. Fracti in eo sunt d. digiti, medius sc. et annularis, dimidiati, et fulminis pars inferior. Opere eleganti. Aes, 13 1/2 alt. In b. marmor. affabre facta." No replicas are known.

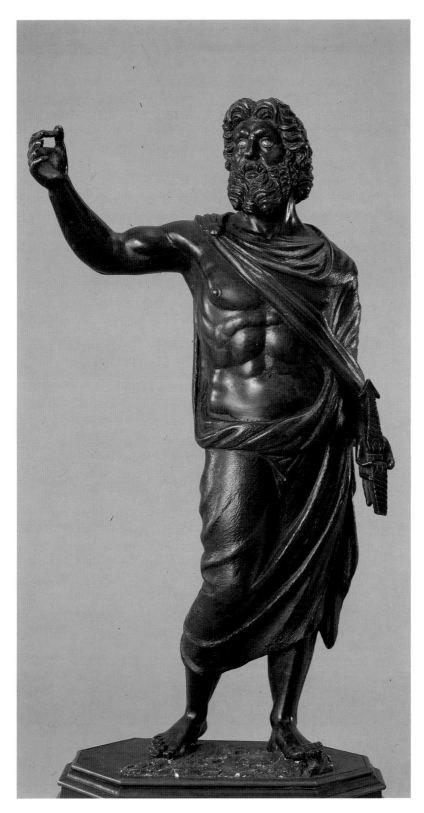

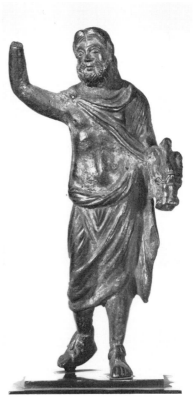

Etruscan bronze, for comparison

8. Venus felix

Pier Jacopo Alari-Bonacolsi,
called **Antico**
1460–1528
(See Biography, p. 279)

Bronze statuette; fairly thick-walled cast. Four fingers of the left hand broken off; only the thumb remains. Two holes drilled through from the palm to the back of this hand served for the fastening of an attribute, now lost. Core-support pins can be seen scattered all over the statue. The eyes inlaid with silver, the hair and drapery firegilt. The base of limewood stained dark brown and inlaid with ten gilt Roman silver and copper coins. Dark brown artificial patination, covered by thin dark brown lacquer. The figure 875 in white at the back of the base is the pre-1823 inventory number of the Imperial and Royal Cabinet of Coins and Antiquities.
Height without base 29.8 cm; height of base 2.4 cm.
Inv. no. Pl. 5726.

PROVENANCE
First documented in the inventory of the Imperial Treasury in Vienna in 1750; p. 35, no. 184 "Ein unbekante statua von ärzt mit vergolden kleidern, unten auf dem postament verschiedene kupferne und vergolde medaillen" (Zimmermann 1889, Reg. 6253, p. CCLVII). Transferred in 1800 to the Imperial and Royal Cabinet of Coins and Antiquities, transferred again in 1880 to the Ambras collection, then with the entire collection to the Kunsthistorisches Museum in 1891.

Venus stands in a balanced pose on a base shaped like a flattish cone, with a plinth-like section on top. Inlaid in the base are ten gilt Roman silver and copper coins with the portraits of the following emperors: Gordian III (twice), Philip, Valerian (four times), Probus, and Constans (twice). In her lowered right hand the goddess holds a piece of drapery with many folds, which is wrapped round her hip; the other end is looped over her right arm at the elbow, so that the right leg, which bears her weight, is uncovered. The folds of the drapery fan out diagonally toward its lower end, where they are lifted as if by a puff of wind. This gives additional lightness and grace to the figure, and at the same time adds firmness by broadening its outline.

The upper part of Venus's body is turned slightly to the left; her left hand, raised and bent, held some attribute which was no doubt lost long ago and of which we learn nothing from sources or replicas. Her head is turned still further to the left, her gaze fixed on some distant object. Her curled hair has a center parting and is combed to either side in fine strands, looped above her brow in a so-called crobylus, then carried along the temples in soft waves and knotted in the nape of the neck. Two long corkscrew curls fall to her shoulders, and two shorter ones over her temples. Finally the goddess's head is adorned by a wreath of oakleaves.

Venus's flawless, well-rounded body is carefully polished; the dark patination is in deliberate contrast to the gilding of drapery and hair. From small rubbed-down spots it can be seen that the gilding of the hair once extended over the face and was covered with dark brown lacquer. The subtlety of modeling is remarkable, and the amazing refinement of every detail – especially the head with the lively, graphic treatment of the hair, of which delicate locks stand out with precision, yet without harshness, against the smooth, softly sloping shoulders. All this bears witness to a perfection of casting technique unmatched in its time and a meticulousness of execution which marks the culmination of Antico's skill and is only rivaled by his *Meleager* in the Victoria and Albert Museum, London.

Hermann (1910) identified as the antique model for this statuette the so-called *Venus felix* in the Vatican collections. This work is traceable as early as 1509 in the possession of Pope Julius II and was long considered one of the finest objects in the Cortile del Belvedere: only the eighteenth century lost interest in it. It is said to have come from the imperial palace near the church of Santa Croce. The exact date of its discovery is unknown, but it is possible that Antico saw it during his stay in Rome in 1497, or earlier when he was restoring one of the Monte Cavallo horses (Nesselrath 1982). The main feature of the Vatican figure, distinguishing it from other statues of Venus, is that the drapery leaves one leg wholly uncovered. Antico retains this motif, while varying the model freely in other respects. In his version the drapery is wound round the body in the reverse direction and hangs over the goddess's lowered right arm instead of her upraised left arm. He dispensed with the Cupid who stands beside Venus in the antique version, and altered the hairstyle of the goddess – whose features are those of the younger Faustina (Helbig 1963) – by combining it with that of the *Apollo* Belvedere or other

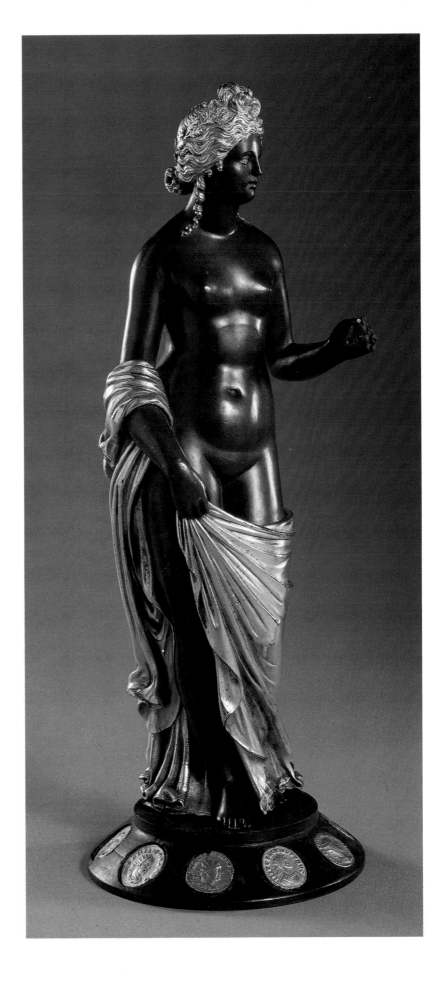

BIBLIOGRAPHY

von Sacken, E. and Kenner, F. 1866, p. 482,
　No. 80.
Ilg, A. 1891, p. 221, Case II, No. 61.
Bode, W. 1907, I, p. 35, Plate LXVIII.
Bode, W. 1907[2], pp. 297–303.
Hermann, H.J. 1909/1910, pp. 247–251.
von Schlosser, J. 1910, pp. 3, 4, Plate IX,
　No. 1.
Bode, W. 1922, pp. 35, 36, Plate XXX.
Planiscig, L. 1924, p. 56, No. 100.
Planiscig, L. 1930, p. 23, Plate XCIX, No. 169.
Venturi, A. 1935, X/1, pp. 296–298.
Planiscig, L. and Kris, E. 1935, p. 57, No. 35.
Pope-Hennessy, J. 1958, pp. 103 and 347, 348.
Landais, H. 1958, p. 48, Plate XIII.
Pope-Hennessy, J. 1963, p. 21.
Radcliffe, A.F. 1966, p. 47.
Heikamp, D. 1966, p. 5, Plate I and II.
Mahl, E. 1966, p. 15, No. 200.
Hibbard, H. 1977, p. 222, Plate LXX.
Leithe-Jasper, M. 1978, p. 130.
Distelberger, R. 1982, p. 71.
Stone, R.E. 1982, pp 90, and 103.
Nesselrath, A. 1982, pp. 353–357.

ADDITIONAL BIBLIOGRAPHY

Helbig, W. 1963, I, p. 186, No. 241.
Haskell, F. and Penny, N. 1981, pp. 323–325.

Venuses, and by the loop of hair over the brow. The oak wreath in the hair is also Antico's invention, and the same can probably be said of the attribute now lost, since the raised left hand of the antique *Venus felix* was missing in his time as it is now (Haskell and Penny 1981).

The lack of the attribute makes it impossible to identify the statuette with any of the bronzes mentioned in the Gonzaga inventories. Hermann (1909/10) suggested with due caution that it might be identical with the "nuda del speghio, de bronzo" listed in the 1496 inventory of Gianfrancesco Gonzaga; but this seems unlikely, if only because Venus's glance would be directed lower down if she were holding a mirror in her hand.

The extraordinary richness and delicacy of execution, and a kind of neoclassical refinement in the figure's attitude, suggest comparison with the *Apollo* of the Ca' d'Oro in Venice (from whose chlamys hangs a weight of lead similar to that at the lowest tip of the drapery by Venus's right foot), the *Meleager* in the Victoria and Albert Museum in London, the *Paris* in the Metropolitan Museum in New York, and the *Hercules* in the Frick Collection in New York. The same features distinguish this group from the more sparsely gilt but more dynamic *Apollo* in the Liebieghaus in Frankfurt, and the *Hercules*, similar as regards gilding, in the Museo Arqueológico Nacional in Madrid. According to Radcliffe's (1981) chronology of replicas – a valuable work and certainly correct in its approach, though at times somewhat inconsistent in detail (*eg* he excludes the *Meleager* from the present group, although the stylistic evidence is against him, and the absence of a source in this case can be no more than an argument *ex nihilo*) – the *Venus felix* in Vienna must be regarded as one of the bronzes made by Antico around 1500 for Bishop Ludovico Gonzaga, younger brother of Gianfrancesco and uncle-in-law of Isabella d'Este. But, since to all appearances Ludovico's inventories are lost, and no other known source mentions such a statuette of Venus, this classification must remain a hypothesis, though a likely one. For in this case, too, we seem to have no more than an argument *ex silentio*, supported by the fact that the statuette differs, above all in execution, both from the bronzes that can be shown to have been made by Antico for Isabella d'Este and from those that are regarded with good reason as early works by him, like the Madrid *Hercules* and the Frankfurt *Apollo*. From the point of view of provenance, moreover, no relevant indications as to origin can at present be adduced. The *Venus felix* does not come from the collection of Archduke Leopold Wilhelm, as Schlosser (1910) stated, confusing it with the so-called *Atropos* (Inv. no. Pl. 5545). It is first recorded in 1750 in the Imperial Treasury in Vienna – not among the bronzes, however, but in the cameo closet, as it was then apparently believed to be of classical origin. No doubt for this reason it was transferred in 1800 to the Imperial Cabinet of Coins and Antiquities. The elaborate base is also evidence for this: it was probably added in Vienna to give the statuette a costly appearance, in accordance with collectors' taste in the late sixteenth and seventeenth centuries. It was only thanks to the mention of the base that A. Bernhard-Walcher (oral communication) was able to identify the statuette with certainty in the Treasury inventory.

The lost original base might have facilitated placing of the statuette in Antico's work.

Bode (1907[2]) inferred from the oak wreath on Venus's head that the statuette was made for King Matthias Corvinus of Hungary, who liked to be represented with a similar wreath. From the point of view of provenance this would not be impossible – a good deal of Corviniana did come into Habsburg hands – but it is unlikely, as Corvinus died in 1490, which is probably too early as a *terminus ante quem* for the execution of the statuette.

The authorship of the statuette was established by Bode (1907[2]). E. von Sacken and F. Kenner (1866) had described it as Florentine, following the inventory of Cinquecento bronzes in the Imperial Collection of Coins and Antiquities. A. Ilg (1891) believed it to be French, and it appears as "French, seventeenth century" in the 1891 inventory of the Kunsthistorisches Museum.

The Victoria and Albert Museum in London possesses what appears to be a badly cast replica, with late black patination. Stone (1982) believes it to be a "relict cast" intended to preserve Antico's model, much used and in danger of deterioration. There is a weak variant in the Museo di Capodimonte in Naples, in which Venus's left hand is extended flat.

9. Hercules and Antaeus

Pier Jacopo Alari-Bonacolsi, called **Antico**

1460–1528

(See Biography, p. 279)

Bronze group; heavy, thick-walled cast. Corroded core-support pins (?) on the right lower legs of both figures. Many small round holes for core-support pins. Old, artificial dark-brown patina, covered by thin dark-brown lacquer. Beneath the separately cast base the integrally cast inscription: D/ISABEL/LA/ME MAR. The figure 130 in white on the channel at the front of the base is the 1659 inventory number of the collection of Archduke Leopold Wilhelm in Vienna; the adjacent figure 12 is the Treasury inventory number of 1750. Height without base 39.4 cm; height of base 3.8 cm.

Inv. no. Pl. 5767.

Hercules stands with legs apart, one foot slightly off the ground. He lifts Antaeus with both arms and holds him so tightly as to choke him. Powerless to resist the hero's grip, Antaeus leans his head sideways in pain and resignation.

The subject is an ancillary episode of the tenth Labor of Hercules, the capture of the oxen of the giant Geryon. Hercules, landing in Mauretania on the way to Geryon's abode, fought with the Libyan giant Antaeus, son of Poseidon and the earth mother Gaea. When thrown to the ground Antaeus repeatedly gained fresh strength from contact with his mother; therefore Hercules enveloped him in his arms, raised him aloft and crushed him.

The bronze is based on an antique marble sculpture now in the court of the Palazzo Pitti in Florence: it came to Florence probably as a gift from Pope Pius IV to Cosimo I de' Medici when Cosimo visited Rome in 1560. The statue, believed to be by Polyclitus, had been brought to the Vatican by order of Pope Julius II in 1509 and exhibited shortly afterwards in the court-yard of the Belvedere, along with the other most famous antique sculptures in Rome. The place and date of its discovery are still unknown, but it must have been discovered before 1474, if Mantegna used a variation of the motif in the vault of the Camera degli Sposi in Mantua (doubted by Möbius, 1970). Mantegna reversed the direction of the sculpture, so Antico cannot have derived his inspiration from there alone but must have seen the original – presumably at the latest in 1497, when he is known to have visited Rome. The work was then still a torso, the appearance of which is best conveyed by two drawings by Maarten van Heemskerck in Berlin: the restorations were carried out in Florence after 1560. Thus the figure of Hercules lacked the left lower leg, the right leg from the middle of the thigh downward, both fore-arms and the left shoulder; Antaeus lacked the head, the left shoulder, the left forearm, the right arm, the lower part of the body, the left leg, and the right leg from the middle of the thigh downward.

Antico's bronze group cannot therefore be regarded as a copy after the antique, but as an attempted reconstruction. The pose of his Hercules is more vertical and less dynamic than that of the antique model, as he made the legs straight instead of bent at the knee. For Hercules's head, however, he kept fairly close to the antique model. Antaeus's head, though, is freely invented in both type and attitude. As regards the style and the more expressive graphic presentation, Antico drew inspiration from Mantegna. The figure of Antaeus is altogether somewhat stiff, probably because the antique model was in an even more fragmentary state than the Hercules. The folded hands in particular seem illogical, implausible in the context of a fight, and flat when viewed from the side. Despite these evident shortcomings, which probably also reflect a lack of dramatic sense on Antico's part, the group is interesting as an attempt to reconstruct antique sculpture, by which he is known to have been fascinated, and as an example of his independent approach to antique themes. Antico was also in demand as a restorer; for instance he restored one of the Monte Cavallo horses in Rome, perhaps earlier than 1495 (Nesselrath 1982).

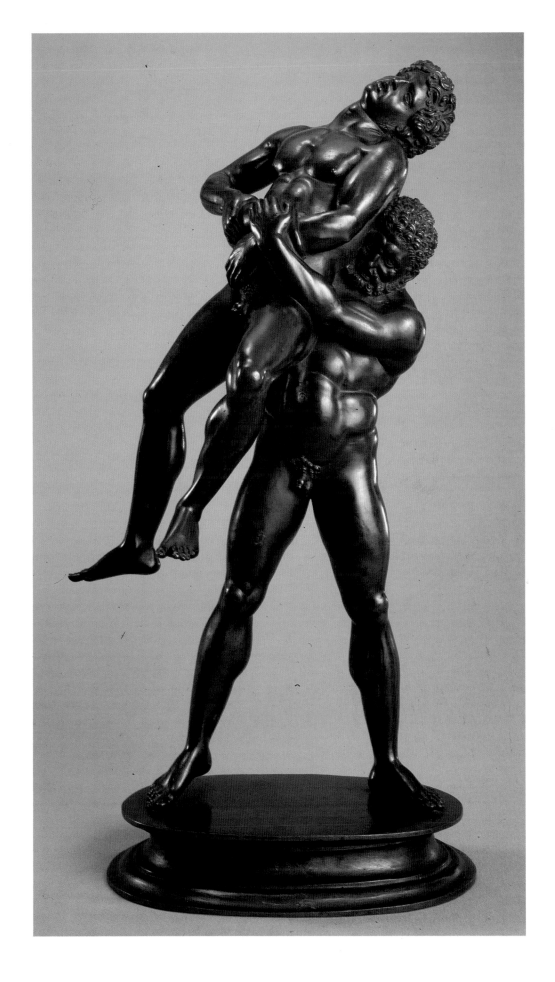

PROVENANCE
Collection of Isabella d'Este, Marchioness of Mantua *ca.*1519–20. Recorded in the inventory of 1542 set above a dado in Isabella's "Grotta". Not identifiable with certainty in the inventory of Duke Ferdinando's effects of 1627. Probably part of the Gonzaga Collections which were acquired by King Charles I of England in 1627–28, but still not identifiable in the English inventories. Presumably sold with the collection of King Charles I under the rule of the Commonwealth around 1650 and acquired by Archduke Leopold Wilhelm. Recorded in the 1659 inventory of Archduke Leopold Wilhelm's collection in Vienna, fol. 448 verso no. 130 (Berger 1883, p. CLXIX). At first installed at the Stallburg; depicted in the *Prodromus* of 1735 by F. von Stampart and A. von Prenner, plate 30 (Zimmermann 1888, plate 30). In 1748 transferred from the gallery at the Stallburg to the Imperial Treasury. (Zimmermann 1889, Reg. 6245, p. CCXLVII). Inventory of the Treasury of 1750, fol. 571, no. 12 (Zimmermann 1889, p. CCCX). In 1871 transferred from the Treasury to the Ambras collection and transferred with the entire collection to the Kunsthistorisches Museum in 1891.

Closer to the antique work, though far from matching Antico's artistic quality, is the reconstruction, perhaps of the same date, by another artist as yet unknown. This is preserved in several bronze replicas, for instance in the Kunsthistorisches Museum in Vienna (Planiscig 1924, no. 110), the Bargello in Florence (Bode 1907, pl. CIII), and the Walters Art Gallery in Baltimore (Bowron 1978, p. 29).

We first hear of a model of this theme by Antico in his celebrated letter of April 1519 to Isabella d'Este. Referring to an earlier request of hers, Antico offers to have Maestro Johan, who has worked in the past for Bishop Ludovico Gonzaga, produce second casts of certain bronze statuettes that he had made for Ludovico about twenty years before. He says in the letter that he has looked among his stocks and found the wax models or piece-molds of eight statuettes, including "la forma de l'Ercule che amaza Anteo, che la più bella antiquità che li fusse" (Rossi 1888, pp. 190–91). Isabella replied to Antico deferring a decision because she was busy with other matters (Rossi 1888, p. 191), but eventually accepted Antico's offer, as the surviving bronze shows. Thus the first version of the bronze group seems to have been made for Bishop Ludovico Gonzaga at Bozzolo just after his stay in Rome, while the Vienna example – as shown by the integrally cast inscription, engraved on the wax model: D(OMINA) / ISABEL / LA / M(ANTUA)E / MAR(CHIONISSA) – is the one made for Isabella d'Este after the first version, the model or piece-molds of which had been preserved as stated in Antico's letter.

In view of its well documented state and the inscription beneath the socle, the bronze has become a key work of Antico's for the purpose of establishing an undisputed *œuvre* (Hermann 1909/10) and a chronology of replicas (Radcliffe 1981).

Frimmel (1883) assigned the work to the school of Giambologna, having mistakenly connected the inscription below the base with Isabella de' Medici, a sister of Francesco de' Medici and wife of Paolo Giordano Orsini. Ilg (1891) actually attributed it to Caspar Gras.

Radcliffe was able to show that the version in the Victoria and Albert Museum in London – which is formally identical with that in Vienna but has the eyes inlaid in silver, a characteristic of Antico's early bronzes – is in all probability the first version of the *Hercules and Antaeus* group which Antico made for Ludovico Gonzaga around 1500, and of which piece-molds still existed in 1519. These could have been used for the second cast made for Isabella d'Este.

Antico, as he wrote, made Isabella a present of the molds, hoping in return for a commission to execute some bronze busts. The casts were to be made by Maestro Johan, who had already worked for Bishop Ludovico and who, Antico wrote, would be content with the very low price of 50 ducats for the *Hercules and Antaeus*; indeed he would do the work at an even cheaper rate – a salary of six ducats per month and free board for himself and three assistants. Hermann (1909/10) took "Maestro Johan" to be the goldsmith and mintmaster Gian Marco Cavalli, who is known to have worked for Ludov-

Hercules and Antaeus, inscription

BIBLIOGRAPHY

von Frimmel, T. 1883, p. 62, No. 976.

Rossi, U. 1888, pp. 190, 191.

Ilg, A. 1891, p. 222, Case II, No. 102.

Hermann, H.J. 1909/1910, pp. 239–241 and pp. 264–266.

von Schlosser, J. 1910, p. 3, Plate VIII.

Bode, W. 1907–1912, III, p. 17 and Plate CCXXXV.

von Schlosser, J. 1922, pp. 5–7.

Bode, W. 1922, pp. 34, 36, Plate XXXI.

Planiscig, L. 1924, pp. 54, 55, No. 98.

von Schlosser, J. 1925, pp. 24, 25.

Planiscig, L. 1930, p. 22, Plate XCVII, No. 166.

Planiscig, L. and Kris, E. 1935, p. 57, Room X, No. 36.

Lauts, J. 1952, p. 207.

Pope-Hennessy, J. 1958, p. 103.

Mezzetti, A. 1958, pp. 232, 244.

Montagu, J. 1963, p. 40.

Radcliffe, A.F. 1966, p. 47.

Heikamp, D. 1966, Plate IX.

Mahl, E. 1966, p. 17, No. 205.

Weihrauch, H.R. 1967, p. 118.

Möbius, H. 1970, pp. 39–47.

Hackenbroch, Y. 1971, p. 124.

Ettlinger, L.D. 1972, p. 134.

Brown, C.M. and Lorenzoni, A.M. 1977/I, p. 163.

Radcliffe, A.F. 1981, pp. 46–49 and p. 136, No. 55.

Fletcher, J.M. 1981, p. 55.

Distelberger, R. 1982, p. 71.

Nesselrath, A. 1982, pp. 353–357.

Stone, R.E. 1982, pp. 87–116.

ico Gonzaga. Radcliffe (1981), however, doubted the identification, as there is no firm information about Cavalli subsequent to 1508.

Antico's letter to Isabella d'Este is the only document to throw light on the origin of the Vienna bronze group, and is also our most important source of information on Antico's working methods (Stone 1983). The letter shows that Antico kept the piece-molds and therefore to all appearances intended from the first to make many copies of his bronzes. The method of casting from an intermediate model made from piece-molds after the original model was probably his own invention: it was new and still little known at the time. In Florence it was first introduced by Giambologna's workshop when the latter began to produce replicas on a large scale. The mention "dagandoli de cere netizate" indicates that the wax model made by Antico from existing piece-molds had to be perfect in every detail before he handed it over to the caster.

The care devoted to the casting model can be seen in the perfect reproduction of all details in the bronze – for instance the veins of the hands. The afterworking is also careful, no doubt carried out by Antico himself or at least supervised: this treatment of the surface, the polishing with very fine steel wool and brush, and the dark patination, are found in his late works just as they are in his early ones. His replicas for Isabella d'Este do not for the most part display the gilding and silver inlaid work that is typical of his bronzes for Ludovico Gonzaga: this was probably a question of taste rather than money, as Isabella was certainly better off than the collateral line of Bozzolo. Toward 1520 Renaissance art tended toward monumentality, after the manner of Raphael and Michelangelo. The detailed preciosity of late fifteenth-century work was no longer in demand: it only became popular again with the refined courtly taste of collectors in the late sixteenth century.

The form of the base with the prominent rim-molding and concave middle band is typical of the bronzes made by Antico for Isabella d'Este and differs from the bases of his earlier statuettes, which are less emphatic in profile or are simply oval plinths. A third version in the Houston Museum of Fine Arts seems to be a later aftercast.

10. Hercules and the Ceryneian Hind

Hercules was commanded by the Delphic oracle to serve Eurystheus, King of Mycenae, for twelve years and perform twelve labors at his behest. The third of these was to capture the Ceryneian Hind, an animal with golden antlers and feet of brass, which lived in Arcadia and was sacred to Artemis. The hero pursued the fleet-footed creature for a year before he was able to capture it alive by the Ladon river.

Although the sources describe the animal as a hind – as an animal sacred to Diana it would have to be female – if nevertheless had golden antlers. But since deer do not in reality bear antlers, the Ceryneian Hind almost always appears in art as a stag.

The relief illustrates the moment of capture. Hercules has succeeded in grasping the hind by the antlers and forcing it to the ground, where he holds it with one knee pressed into its back. Over his right shoulder he wears the pelt of the Nemean Lion, a monster which he slew as his first Labor for Eurystheus, and whose skin makes him invulnerable. Hercules's club rests against the tree on the right, and his bow and quiver are suspended from its branches.

A narrow exergue represents the ground, but apart from this the composition exploits the circular field, fanning out from the lower right corner. Full of tension and dynamic movement, it powerfully represents the hero's strength and the collapse of the subdued animal. The empty space on the left is open for the pursuit that has ended, and is itself bounded only by the edge of the field. The modeling of the figures is vigorous and differentiated, the relief in some parts being extremely high and undercut – part of the antlers, for instance, actually stands out in full relief. The casting is of the utmost perfection: scarcely any trace of afterworking can be seen. Only the smooth parts are carefully polished. The patination is not so dark as in Antico's gilded works but is of a rich, strong brown color, through which the reddish bronze, with its high proportion of copper, can be seen.

The third Labor of Hercules was not one frequently portrayed in Renaissance art, although it was often depicted in antiquity, in bronzes and terracotta reliefs, and sarcophagus reliefs. Antico's *tondo* was no doubt inspired by such antique works, even though no specific model has yet been traced. Late antique or medieval reliefs of Hercules's exploits can be seen on the façade of St Mark's in Venice. Much more similar to Antico's *tondo*, however, is the probably late antique marble relief representing *Hercules and the Ceryneian Hind* in the Museo Nazionale in Ravenna (see A. Venturi 1902, vol. II, p. 523, fig. 366).

Stylistically, for instance in the way the tree is reduced to a stage prop, Antico seems also to have followed the pattern of antique or medieval cameos, like the author of the *tondi* in the *cortile* of the Medici-Riccardi palace in Florence.

Five *tondi* by Antico representing Hercules's exploits have survived. All are 32.7 cm in diameter. Three of them – this relief; a *tondo* in the Victoria and Albert Museum, London, showing the infant hero strangling the snakes sent against him by Juno; and a third, also in the Victoria and Albert Museum, in

Pier Jacopo Alari-Bonacolsi, called **Antico**
1460–1528
(See Biography, p. 279)

Bronze *tondo*; a thick cast, the rough parts on the back chiseled off. Three casting flaws on the underside of the border. Brown, artificial(?) patina, covered by thin dark brown lacquer. The almost illegible figure 120 in white in the exergue relates to the 1659 inventory of the collection of the Archduke Leopold Wilhelm in Vienna.
Diameter 32.7 cm.
Inv. no. Pl. 5993.

Probably Gonzaga collection in Mantua. Mentioned in the inventory of effects of Duke Ferdinando in 1627 are "Tre tondi di bronzo con le forze di Ercole" (d'Arco 1857, p. 170). Probably reached King Charles I of England in 1627–28 and sold *ca.*1650 under the Commonwealth and acquired by Archduke Leopold Wilhelm of Austria; mentioned in the inventory of his collection in Vienna in 1659, fol. 447 verso, no. 120 "Ein rondes Stuckh von Metal, warin der Hercules einen Hierschen zu Boden wirfft. Hoch und braith 1 Span 6 Finger." (Berger 1883, p. CLXIX). As it does not appear in the *Prodromus* of 1735 it presumably reached Schloss Ambras as early as the beginning of the 18th century, where it is documented in the inventory of 1788, p. 130, case VIII, no. 182 as "Eine runde Tafel worauf in flacherhobener Arbeit Herkules mit beiden Händen einen Hirschen an den Geweihen hält und mit dem linken Bein auf dessen Leib kniet. Seitwärts an einem Baum Keule, Köcher und Bogen, Von Erz 12 1/4 Zoll im Durchmesser". In 1806 transferred from Schloss Ambras to Vienna. In 1891 it passed to the Kunsthistorisches Museum as part of the Ambras collection in the Lower Belvedere.

which he is carrying the Erymanthian Boar on his shoulders – are very similar in casting and execution, and it has been supposed that they belong to a series (Hermann 1909/10, Pope-Hennessy 1964, and Radcliffe 1981).

Two further *tondi* – now in the Bargello in Florence but which formerly belonged to the Este family in Modena and from 1868 to 1921 were part of the Este collection in Vienna (Hermann 1906, Planiscig 1919) – show Hercules doing battle with the Nemean Lion and with the Hydra. They differ from the other three in their still more subtle treatment of the surface and particularly in their parcel gilding and dark patination. They share this costly execution with a group of statuettes including, for example, the *Venus felix* (cat. 8). The Victoria and Albert Museum also possesses second casts of the two last-mentioned reliefs; these, however, are not gilt and are only 32.1 cm in diameter. They are less carefully executed than either the Este reliefs in Florence or the other two reliefs in London and the Vienna relief. They therefore cannot, as Pope-Hennessy (1964) thought, have formed a group with these latter. The two copies in question first made their appearance, with no indication of earlier provenance, at the sale of the Piot collection in 1890; and the suspicion must be voiced here that they may be the work of Salomon Weiniger, who is known to have made many forgeries after bronzes from the Este collection in Vienna.

While the two Florence *tondi* are distinguished from the other three reliefs by their elaborate facture, there are also substantial stylistic variations within the group as a whole. The London relief of the infant *Hercules strangling the serpents* is stylistically close to Antico's earliest works. With its detailed and additive composition, this relief is the least successful in adapting the design to the circular field of the *tondo*. The most mature solution, as regards the use of space and also the monumentality of individual figures, is offered by the present relief. Its dynamic composition is most nearly rivaled by the relief of *Hercules and the Hydra* in Florence. One must therefore postulate a development beginning with the two London reliefs, continuing with the two reliefs in Florence and concluded by the composition of the Vienna relief.

The two reliefs in Florence so clearly belong together as to justify the supposition that they are part of a series, though it is not known whether the set consisted of two or of more, or by whom they were commissioned or for what purpose. Hermann (1909/10) supposed that they were ordered by Isabella d'Este for a doorframe designed by Gian Cristoforo Romano in the palace at Mantua, decorated with Hercules's exploits. It is true that Isabella in 1500 requested Antico to help decorate a door for her *studiolo*; but Hermann's supposition is unlikely, as the *tondi* have rings attached to them for hanging and cannot therefore have been meant for insertion in a marble frame. Pope-Hennessy (1964) was probably right in supposing that they were presented by Isabella to her father, Duke Ercole I, in Ferrara and came later to Modena, together with a large part of the Este collections. As Ercole I died in 1505, if this supposition is correct the two reliefs must be of earlier date; this accords with their style, which resembles that of Antico's figures executed for Ludovico Gonzaga.

BIBLIOGRAPHY

Primisser, A. 1819, p. 177.

von Sacken, E. 1855, p. 96.

Molinier, E. 1886, Vol. II. pp. 82, 83, Nos. 486–489.

Hermann, H.J. 1906, pp. 99, 100.

Hermann, H.J. 1909/1910, pp. 271–276.

Planiscig, L. 1919, pp. 120–122, Nos. 183, 184.

Venturi, A. 1922, p. 145.

Planiscig, L. 1924, pp. 60, 61, No. 106.

Venturi, A. 1935, Vol. X/I, p. 301. (The relief in Vienna erroneously described as being in Florence.)

Planiscig, L. 1935, pp. 127, 128.

Planiscig, L. and Kris, E. 1935, p. 53, Case 8, No. 11.

Decorative Art of the Italian Renaissance 1958/1959, p. 104, Nos. 237 A/B and 238 A/B

Andrea Mantegna 1961, Nos. 114–117.

Pope-Hennessy, J. 1964, p. 321, Nos. 354–357.

Radcliffe, A.F. 1981, pp. 139, 140, Nos. 58–61.

Sheard, W.S. 1978, No. 93.

Whether, on the other hand, the Vienna relief and the two London *tondi* belong to a single series can probably only be determined, if at all, by an on-the-spot comparison of the technique of casting and afterwork, patination and lacquering. In any case there is one difference: the Vienna relief is the only one that has neither a ring nor a slit in its rim by which it can be hung up. Hence it alone might have been made to be inserted in a marble door-frame, although it bears no trace that would confirm this.

Although the identical dimensions strongly suggest that all five *tondi* were part of a set of "original models" by Antico, their stylistic differences are equally strong evidence for the opposite conclusion. It seems on balance likely that in the course of his career Antico repeatedly added to the series and that he intended to carry out all Twelve Labors eventually. However, there is no evidence that he actually made more than these five.

The surviving Gonzaga inventories do not throw much light on the questions of dating and provenance. The 1496 posthumous inventory of Gianfrancesco Gonzaga mentions only "Due tondi cum certe figure suso", "Una figura in su uno tondo", and "Uno tondo cum figura de veghio suso". Isabella d'Este's inventory says merely: "E più duoi tondi di bronzo di basso relievo". As we are told nothing of the subjects, we cannot relate these descriptions to any extant reliefs. In Duke Ferdinand's inventory of 1627 we find for the first time "Tre tondi di bronzo con le forze d'Ercole", which might refer to the present relief and the two in London. The former is from the collection of Archduke Leopold Wilhelm, who around 1650 purchased many works from the art collection of Charles I of England, then being sold off by the Commonwealth. Some of these the king had acquired as recently as 1627/28 from the Gonzaga collection in Mantua. The two *tondi* now in London came to England at a later date but have an older Venetian provenance (Pope-Hennessy 1964 and Radcliffe 1981), which makes it not unlikely that they came – like Antico's *Apollo* in the Ca' d'Oro in Venice – from the posthumous sale in Venice of the art collection of Ferdinando Carlo, the last Duke of Mantua.

The Vienna relief was originally categorized as "worthy Italian work" of the sixteenth century and was the last of the group to be studied by art historians. The London reliefs, when acquired, were attributed to Sperandio. Molinier (1886) classified them as North Italian along with the Este reliefs which were then in Vienna; he remarked that there was some resemblance to Riccio's style, and that their author was probably to be sought in Padua, Mantua or Venice. Hermann (1906 and, in more detail, 1909/10) was the first to recognize Antico's authorship of the five *tondi*. Venturi (1922), without giving any reasons, surprisingly attributed both the Florence reliefs to Caradosso; later (1935) he came round to Hermann's view, while expressing a low opinion of the quality of these and of Antico's works in general.

A relief in upright rectangular form in the Houston Museum of Fine Arts, showing Hercules standing beside the Nemean Lion, belongs to an earlier phase of Antico's art.

11. Standing Hercules

The youthful Hercules stands naked with crossed legs, leaning on the club propped under his right armpit. The top end of the club is padded with a drape, the rest of which passes behind the hero's back and encircles his left hand, which rests on his hip; the knotted end of the drapery then falls freely to a point midway down his left thigh. Hercules's head is turned to his right, and he looks slightly downward. The hair is short and tightly curled. The figure is carefully modeled and the surface afterworked with especial care. The skin appears smoothly polished; some details – such as the hair, the wrinkles on the toes, the fingernails and toenails – are elaborated by chasing; the eyes and the snags on the club are inlaid in silver. The work must originally have made an impression of even more costliness, as the drapery, the club and the hair were all gilt. The statuette is therefore thought to have been made for a princely *studiolo*, like Antico's figures executed for the Gonzaga. However, the resemblance to Antico's work is confined to these outward marks of surface treatment. The modeling is more robust and massive than Antico's and the whole effect more monumental. These qualities cannot be due only to a hypothetical prototype, they indicate a different artistic personality.

Six further versions of the statuette are known: (a) Museo Estense, Modena, inv. no. 6924 (formerly in the Este collection in Vienna, transferred to Italy in 1921, and now once more in Modena), height 33.8 cm; (b) Museo Estense, Modena, inv. no. 2245, height 32.6 cm; (c) Victoria and Albert Museum, London (Salting Bequest), inv. no. A.137–1910, with semicircular, integrally cast base plate, height 33.8 cm; (d) Metropolitan Museum of Art, New York, inv. no. 68,141.21 (from the Untermyer collection), formerly gilt, height 33.7 cm; (e) Peter Guggenheim collection, New York, with hammered surface; (f) David Daniels collection, Minneapolis, with triangular, integrally cast base plate, height 32.9 cm.

The earliest documented variants are the two now in Modena, described in the 1584 inventory of the Guardaroba of Duke Alfonso II d'Este in Ferrara as: "Uno Hercole grande in piedi si posa sulla clava con un poco di panno alla man manca", and "Un altro pur simile a quello quasi in tutto" (in *Documenti inediti per servire alla storia dei Musei d'Italia*, III, 1880, p. 19). They are again mentioned in 1684, this time in the "Casino di S.A. Ser.ma fuori di Porta Castello" in Modena: "Un Hercolo giovine in piedi appoggiato alla clava con piedestalo d'ebano", and "Un altro Hercole in tutto simile al suddetto" (*ibid*, p. 27). However, as Radcliffe (1979) rightly observed, at least one of these two statuettes must have been in Este possession by the beginning of the sixteenth century, as it is depicted on the recto of an early sixteenth-century drawing, regarded as Ferrarese, in the Ashmolean Museum in Oxford. The verso depicts a statuette of Marsyas playing the double flute, known since the late fifteenth century as the "*gnudo della paura*" (Parker 1956, p. 333, no. 624). The description of the *gnudo della paura* coincides largely with that of a bronze statuette in the Museo Estense in Modena which also figures in the 1584 inventory of the Guardaroba of Alfonso II. As it is only in the Este collections that a *gnudo della paura* and a standing

North Italian (circle of Antico), *c.*1500

Bronze statuette; heavy, probably largely solid cast. A crack in the club at the tip of the outstretched middle finger of Hercules's right hand. The eyes inlaid in silver, also the snags on the club. The former gilding of the drapery, club and hair preserved in patches or traces. Old, dark brown, probably artificial patina; over it, remains of a later black lacquer.
Height 33.4 cm.
Inv. no. Pl. 10130.

Supposedly excavated in Aquileia in 1805. In 1872 in the collection of Admiral Wilhelm von Breisach in Graz. The statuette was then considered a classical work. Acquired in 1980 by Dr Wilhelm von Buchta, a descendant of Breisach.

Hercules of this type are known to have been together as early as the sixteenth century, it is very probable that the Oxford drawing in fact represents one of the two Este statuettes of Hercules.

The present statuette is supposed, according to a tradition in the family of the previous owners, to have been excavated at Aquileia in 1805; but the almost flawless condition of the surface makes this improbable. No earlier provenance is known, however, for this or any of the other four versions.

However, the early existence of such a statuette in the Veneto region is attested, first, by a silverpoint drawing now attributed to Giovanni Bellini. Bound in with Jacopo Bellini's sketchbook in the Louvre in Paris, this depicts the statuette in front view, minus the feet and right arm (V. Goloubew 1908, pl. LXXXI, fol. 76a; H. Tietze and E. Tietze-Conrat 1944, p. 113). Bober (1963) was the first to connect this drawing with these statuettes.

A similar statuette was used by the so-called Master PP as the model for his copperplate engraving of *David*, the only example of which is in the Albertina in Vienna (A. Hind, vol. 5, 1948, p. 275, no. 3; K. Oberhuber, 1966, p. 73, no. 73, ill. 4). The statuette is depicted faithfully from the rear, with the addition of a huge head of Goliath at the figure's feet, and a sling tied to the club. There are small differences: the engraving does not show the snags on the club, and the hair seems to be bound with a narrow ribbon, which the statuettes do not show. Master PP is thought to have had close artistic connections with Padua and Ferrara, and he could have seen one of the statuettes in Este possession in Ferrara. The David in the engraving must have been modeled at the least on a very close replica of one of the statuettes now extant, perhaps with a different hairstyle. This is shown not only by the similarity of motif but by the monumental, idealized figure and the powerful treatment of the neck and throat that is so characteristic of the statuettes.

The statuettes were also depicted in graphic art in other parts of Italy in the early sixteenth century. Joannides (1981) noted their connection with a pen drawing by Parmigianino in the Galleria Nazionale in Parma (A.E. Popham 1971, vol. I, no. 548, p. 171; vol. III, pl. 408). Bober (1963), followed by Joannides (1977) and Radcliffe (1979), pointed out a drawing by Baldassare Peruzzi in the Dresden Printroom (C.L. Frommel, 1967–68, p. 70, no. 22, ill. XVIIIb), which exactly copies a statuette of Hercules from the rear and from the right-hand side, and also a drawing by Primaticcio of *Hercules and Omphale* in the Albertina in Vienna, at the extreme right of which is a figure clearly derived from the bronze statuettes (L. Dimier 1928, pl. VIII). This drawing is regarded as a study for Primaticcio's frescoes in the vestibule of the Porte Dorée at Fontainebleau. However, Radcliffe (1979) is probably right in thinking that it is an echo of the painter's Mantua period, where he could have seen one of the statuettes and where, moreover, he restored an antique marble torso after the pattern of these statuettes, transforming it into the statue of *Mercury* which Giulio Romano placed in a niche of the façade over the entrance to his house in Mantua.

Finally Joannides (1977) also pointed out a pen drawing belonging to the Albertina in Vienna representing a similar *Hercules* from the left-hand side,

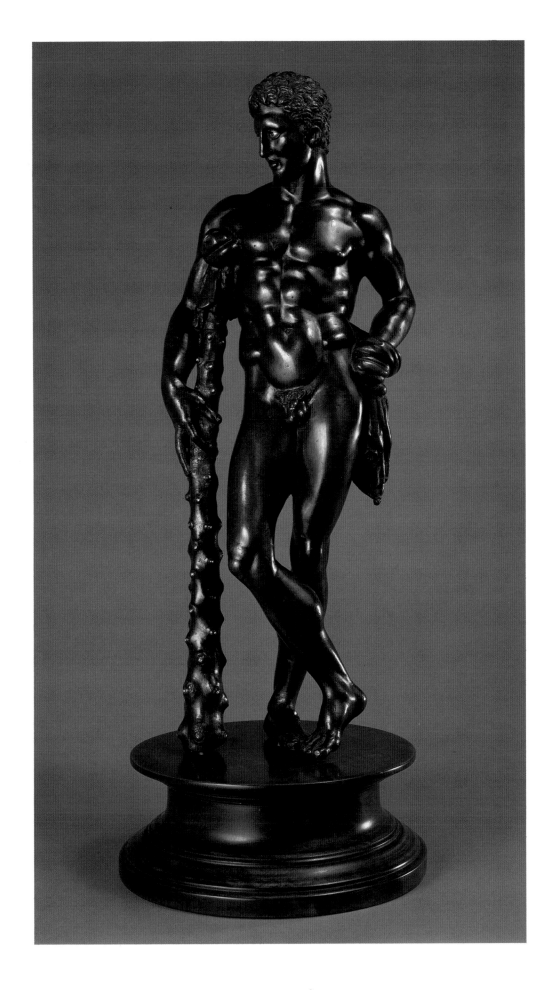

BIBLIOGRAPHY
The statuette is unpublished but mentioned
by Radcliffe, A.F. 1979, pp. 12–15, as
version e.

BIBLIOGRAPHY FOR OTHER VERSIONS
Hermann, H.J. 1906, p. 99.
Bode, W. 1907, Vol. II, p. 9, Plate C.
Planiscig, L. 1919, pp. 146, 147, No. 231.
Planiscig, L. 1930, p. 24, Plate CVIII, Fig. 186.
Bode, W. 1922, p. 76 and Plate LXXXVI.
Bober, P. 1963, pp. 86, 87.
Joannides, P. 1977, pp. 550–554.
Radcliffe, A.F. 1979, pp. 12–15, Cat. No. 1.
Joannides, P. 1981, pp. 20–23.

and bearing a sixteenth-century inscription "Di Mano di Michelangelo" (F. Wickhoff 1892, p. CXCII, no. 153). The drawing is listed as by Bartolomeo Passarotti; however, M. Delacre ascribed it to Michelangelo (1938, p. 103, fig. 56). Joannides believes that in view of its low viewpoint the drawing must have been based on a large sculpture. He draws attention to similarities with the figure of Hercules, also seen from behind, in Israel Silvestre's 1649 etching of the Jardin de l'Etang in Fontainebleau, and believes the Albertina drawing to represent Michelangelo's now lost sculpture of the early 1490s. However, Silvestre's etching is not detailed enough to give more than a conjectural idea of the appearance of Michelangelo's *Hercules*, which was formerly in Fontainebleau, but whose present location is unknown.

Equally interesting is Joannides's reference (1981) to two fifteenth-century instances of borrowed motifs in Florence, which must predate the creation of the seven extant bronze statuettes, and so presuppose knowledge in Florence at that time of an antique model which may have inspired the statuettes also. These are (a) a drawing by Antonio del Pollaiuolo in the Gabinetto dei Disegni of the Uffizi in Florence, showing *Adam* standing with crossed legs and a hoe propped under his left armpit, and (b) the figure of a shepherd in Benozzo Gozzoli's frescoes, dating from 1459, for the Cappella of the Palazzo Medici (Joannides 1981, ills. 44 and 45). The shepherd, who is clothed, also stands cross-legged, and, like Pollaiuolo's *Adam*, is posed in the opposite sense to the Hercules statuettes, with his left shoulder, not his right supported by his staff. However, still more important in this connection seems to be Joannides's reference to a passage in Vasari's life of Mariotto Albertinelli (Vasari-Milanesi, vol. IV, p. 218), which states that the painter copied antique reliefs in the Medici collection, including one depicting "duoi ignudi, un che siede ed ha a'piedi un cane, l'altro è ritto con le gambe sopraposte che s'appoggia ad un bastone". Joannides infers that the antique relief in the Medici collection may have depicted a scene similar to that in the Telephus frieze of the great altar of Pergamum in the Staatliche Museen in East Berlin, where Hercules is shown watching over Telephus in a pose that differs only in the position of his right arm (Joannides 1981, ill. 46). This or a similar relief – but not the one mentioned by Milanesi (Vasari-Milanesi IV, p. 218, n. 3), fixed in the wall above the entrance to the Galleria of Luca Giordano in the Palazzo Medici-Riccardi – might have been the model for Pollaiuolo and Benozzo Gozzoli, and perhaps for the bronzes also.

Their model was probably a relief of the type of Attic funeral stelae. Vasari's mention of a relief is all the more important since any comparison with the so-called Farnese *Hercules* (with his club under his arm) or with the *Mercury* in the Uffizi (formerly in the Belvedere Court in the Vatican; with crossed legs) is to some extent valid as regards motif but is ruled out for our purposes on chronological grounds.

Extremely early reflections of such antique reliefs are the *genii* by Wiligelmo on the façade of Modena Cathedral, dating from about 1170 (cf. Ladendorf 1953, table 2, ills. 6 and 7). Here the winged *genii* stand cross-legged, holding their dipped torches under either their right or left arms.

Radcliffe (1979) also thought that a relief might have been the original model for the statuettes: he drew attention to the flatness of the backs of the statuettes, and also to Antico's relief of *Hercules* in repose (Museum of Fine Arts, Houston) which also shows the hero with crossed legs and the club under his arm. As in the statuettes and all the graphic works related to them, this *Hercules* holds the club under his right arm, which may point to the existence of another antique relief with the direction reversed.

In this connection reference may be made to Antonio Lombardo's marble relief of *Mars, Venus and Cupid* in the Residenz at Munich, and to the bronze aftercast of it in the Staatliche Museen in Berlin-Dahlem, where Mars's pose is a variation of the standing Hercules in our statuettes (Schlegel 1984, figs. 1 and 5). Mars's body is turned to the left and his legs are crossed the other way round, but he holds the club in his right hand in the same way as the statuettes. Antonio Lombardo may have been acquainted with these: he went to Ferrara in 1506, at which time they may already have been in Este possession. His brother Tullio varies the same motif in his reliefs of *Adam and Eve* on the tomb of Pietro Bernardo in the Frari in Venice (Schlegel 1984, fig. 7). Finally we may refer to the scene of sacrifice on the reverse of the medal made for himself by Camelio, where there is a similar figure on the extreme left.

The seven versions of the statuette that are known today were evidently made in different workshops, as is shown by the diversity of execution and small variations in many details. Nevertheless they are so similar that it is permissible to suppose that they are all based on the same original model.

The examples in London and Minneapolis are the only ones with integrally cast bases, and are therefore slightly smaller than the rest as regards actual mass. The example in the Daniels collection, though it is more summary in modeling and the surface is less carefully worked than that of the others, is, as Radcliffe (1979) rightly observed, the most individual as regards facial features: the countenance can be called expressive. The treatment of the hair is also different: this is the only example with a forelock, and the slight depression in the hair at the back of the head calls to mind the David–Hercules in Master PP's engraving. All the other statuettes, like the drawings, are more classicizing, following the presumed Lysippan style of the antique prototype. The example which was in the Este Collection in Vienna and is now once more in Modena has a hammered surface, like that in the Peter Guggenheim collection in New York. The other Modena example and the one in London, which are both somewhat coarse in execution, have no ring on the upper end of the club. The bronze in the Metropolitan Museum seems to have been entirely gilt.

The example presented here for the first time, and acquired only a few years ago for the Kunsthistorisches Museum, displays a most refined treatment of the surface and exhibits features that were typical of courtly taste in Mantua as Antico himself helped to form it. The dark brown patination must have contrasted even more strongly than today with the formerly gilt parts of the drapery, hair and club, with the eyes inlaid in silver and the sil-

90

ver snags on the club, and this must have given the statuette exceptional brilliance. None of the other six examples can vie with it in this. It therefore seems safe to conclude that the Vienna statuette was made in Mantua at the beginning of the sixteenth century. The respect paid to this model in sculpture, painting and graphic art around 1500 is unusual and can only be compared with that accorded to the so-called *gnudo della paura*.

12. Venus of Cardinal Granvella

The naked *Venus* stands on her right leg, with the left drawn slightly back. She holds a scallop-shell in her outstretched right hand. Her left shoulder is somewhat raised, and the left arm bent. With the thumb and forefinger of her left hand, bent downward at the wrist, she holds an apple. Her luxuriant hair is center-parted, looped over the brow and knotted in the nape of the neck, whence two curly strands fall to her shoulders. The eyes are inlaid in silver; the right foot has been replaced in silver from above the ankle, the left from the instep only.

The statuette stands on a separately worked silver base with a profiled edge and engraved panels. It bears the Besançon hallmark of the second half of the sixteenth century, with the maker's mark CA (not to be confused with the Austrian reassay marks of 1805/07).

The statuette was probably made *c.*1500 in North Italy, most probably Padua or Venice. The classicizing physique, the smoothness of the surface and the fluency of movement distinguish it clearly from Riccio's work. In many ways it resembles the nymphs of the *Ichthyocentaur* group in the Frick Collection in New York and variants thereof, which likewise differ from Riccio's work by reason of their classicizing style. Pope-Hennessy and Radcliffe (1970, pp. 94–96) have it as Riccio, following Planiscig (1927); Stone, (1982, pp. 113–115) rightly questions Riccio's authorship.

The statuette is one of the best-known forgeries of antique art made in the Renaissance. Although it was already listed as not antique in 1863 (as no. 200 in the inventory of Cinquecento bronzes in the Imperial Cabinet of Coins and Antiquities), and in 1880 was accordingly transferred to the Imperial and Royal Ambras Collection, in 1892 it was taken back into the antique collection of the Kunsthistorisches Museum (inv. no. 2797). In the same year it was published as an antique work by Schneider, along with other recent additions to the antique collection, with a reference to the "original green patina, removed in places to the figure's detriment". Only in 1919 was it finally separated from the holdings of the antique collection.

Significantly, a variant in the Herzog Anton Ulrich Museum, Brunswick, traceable in Brunswick from the eighteenth century onward (Manuscript H 18 of 1753, p. 137, no. 58; H 29 of 1787, p. 8, no. 58), was also regarded as an antique until well into the present century. Its inventory number ABz 7, "ABz" indicating "antique bronze origin doubtful", is to be altered to Bro. 372. However, the *Führer durch die Sammlungen des Herzoglichen Museums in Braunschweig*, 1897 (p. 13, 'Antikensammlung', no. 279) states that the bronze base and the tree-trunk against which Venus leans are not antique (written communication from Sabine Jacob). The Brunswick example differs from the Vienna one in these details and in the lower position of the right hand.

The feet of the Vienna statuette, made up in silver, are especially noteworthy. They join on to the legs so smoothly and harmoniously that it can be assumed that they were cast from the same model as the statuette, with the intention of breaking off the bronze feet and replacing them with silver ones. In other words, when the figure left the artist's shop and was delivered to its first owner it was not in a fragmentary state but already had silver feet.

North Italian, *c.*1500

Bronze statuette; the feet replaced in silver, the eyes inlaid in silver, the base of silver with the Besançon hallmark (Master CA). Green artificial patina, with brown natural patina beneath. The figure 945 in white at the back of the base is an inventory number, prior to 1823, of the Imperial and Royal Cabinet of Coins and Antiquities.
Height 18.5 cm.
Inv. no. Pl. 7343.

PROVENANCE
Collection of Cardinal Antoine Perrenot de Granvella, Minister of State to Emperor Charles V and King Philip II of Spain; bequeathed to his nephew, Count Cantecroy, who sold it in 1600 to Emperor Rudolph II. In the correspondence relating to the purchase the *Venus* is once described as "La Venere con li piedi d'Argento", and another time as "Una femina antica col piedistallo d'Argento". Presumably the description on another list "femina in piedi di bronzo, che fu del cardinal de Carpi" refers to the same bronze statuette (Zimmermann 1888, pp. XLIX–LIII, Reg. no. 4648, 4656, 4658, 4661). Inventory of the Emperor's *Kunstkammer* in Prague of 1607–1611, no. 1943: "Eine Venere von metal, helt ein apfel in der lingken hand, und in der rechten ein muschel, steht uff einem silbernen piedistallo und seind ihr silbere füeß angelött, ligt in einem vergulten futral." (Bauer and Haupt 1976, p. 102, no. 1943). Later in the Imperial and Royal Cabinet of Coins and Antiquities in Vienna; thence in 1880 to the Ambras collection but returned to the Antiquities collection by 1892 and not finally transferred to the collection of Industrial Art at the Kunsthistorisches Museum until 1919.

BIBLIOGRAPHY
von Schneider, R. 1892, Beiblatt, p. 53,
 No. 89.
von Schlosser, J. 1922, pp. 7, 8 and 18.
Planiscig, L. 1924, p. 66, No. 114.
Weihrauch, H.R. 1967, pp. 487, 488, Ill. 569.

It can hardly be ascertained today if this was meant to allude to a passage in Pindar's *Pythian* IX, where the "silver-footed Aphrodite" is mentioned. A "silver-footed" Thetis cannot be intended, in view of the apple in the figure's left hand.

Cardinal Granvella, a later owner of the statuette, had the silver base added, as is shown by the Besançon hallmark. In an exchange of correspondence of 1600 between the Count of Cantecroy, Granvella's nephew and heir, and the Emperor Rudolf II, in connection with the sale to the Emperor of part of Granvella's collection, the figure, referred to as "La Venere con li piedi d'Argento" or "Una femina antica col piedistallo d'argento", is described as one of the most precious objects in the collection (Zimmermann 1888, p. LI and p. LII). Rudolf II actually kept it in a gilt case (Bauer and Haupt 1976, no. 1943).

Besides the example in the Herzog Anton Ulrich Museum in Brunswick mentioned above, several versions of the statuette are known: they differ from the Vienna example chiefly in that the right hand is stretched well down and does not hold a shell. They are also nearly all of poorer quality. They are: a gilt example formerly in the Delmár collection in Budapest; another sold in Vienna in 1934 as cat. 63 of the Bloch collection; also Planiscig (1924) mentions an example that was sold in Paris in 1900 with the Miller von Aichholz collection and was with A.S. Drey in Munich in 1918. This had a round decorated base and may be identical with the example from the Crespi collection in the Museo Poldi-Pezzoli in Milan (inv. no. FC.25.68). The Kunsthistorisches Museum also possesses an old photograph of a statuette with the indication "Nat. Museum München". However, this version, the right hand of which is damaged, is not mentioned in H.R. Weihrauch's catalogue of bronzes in the Bayerisches Nationalmuseum. Another gilt version – perhaps that from the Delmár collection? – was sold by Sotheby Parke Bernet, New York, in 1973 (*Art at Auction – The Year at Sotheby Parke Bernet 1972–73*, p. 254).

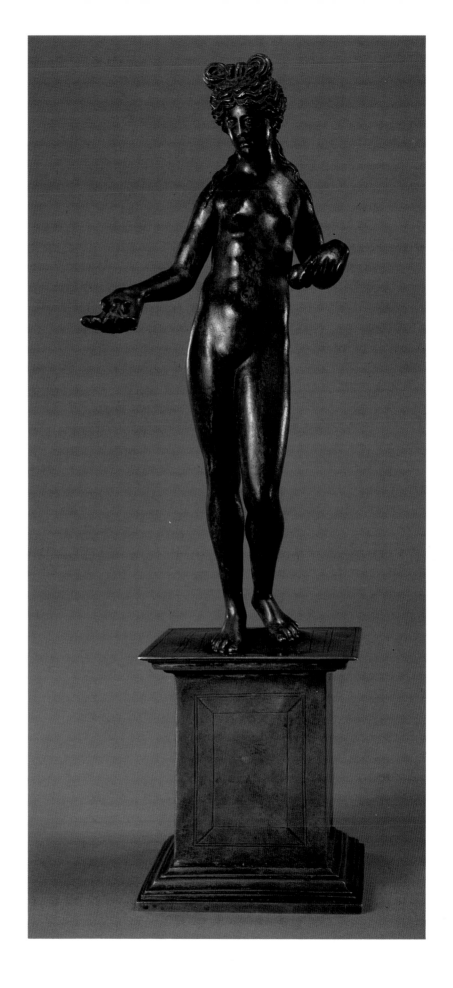

13. Seated female panther

North Italian, beginning of the
sixteenth century

Bronze statuette; hollow cast. The
eyes inlaid in silver. Large openings
underneath the paws. Blackish-
brown lacquer, remains of old
artificial green patination, brown
natural patina.
Height 29.5 cm.
Inv. no. Pl. 7339.

PROVENANCE
First mentioned in the inventory of the
Ambras collection in 1788, case VIII, no. 176:
"Das Weiblein eines Tygerthieres sizend,
vorne auf dem linken Fuß stehend, und den
rechten in die Höhe haltend. Von Erz, 9 Zoll
lang und beim Kopf 11 Zoll hoch." In 1847
transferred from the Ambras collection to the
Imperial and Royal Cabinet of Coins and
Antiquities. Transferred with the entire col-
lection to the Kunsthistorisches Museum in
1891. Transferred in 1919 from Antiquities to
the collection of Sculpture and Decorative
Arts at the Kunsthistorisches Museum.

BIBLIOGRAPHY
Primisser, A. 1819, p. 177.
von Sacken, E. and Kenner, F. 1866, p. 293,
 No. 1103.
von Sacken, E. 1871, pp. 120 and 122, Plate
 LIV/1.
Reinach, S. II, 1–2, 1897/1898, Plate
 DCCXXV, Nos. 4 and 5.
Sieveking, J. 1912, pp. 1–3.
Planiscig, L. 1924, p. 45, No. 76.
Planiscig, L. 1930, p. 19, Plate LXXXVII,
 No. 145.
Planiscig, L. and Kris, E. 1935, p. 56, Room
 X, No. 33.
Mahl, E. 1966, p. 28, No. 231.
Leithe-Jasper, M. 1973, No. 18.

The creature sits on its hind legs supporting itself with its left forepaw resting
on the ground, the right one raised and its head stretching upward; its jaws
are open and it is looking upward to its left. Its tail is curved forward with
the tuft resting on its right flank. The coat is indicated by small curls, and
therefore Planiscig (1924) identified it as a female panther, although old in-
ventories and the early literature describe it as a tigress.

The model was no doubt an antique bronze or relief of a tiger or panther
such as were depicted in the train of Dionysus. The present bronze may also
have belonged with a statuette of Dionysus, now lost, which would account
both for the animal's classical pose and for the fact that it is evidently gazing
at a companion figure. The companion might also have been Cupid, who
teases a female panther in Dionysiac sarcophagus reliefs, *eg* on the right-hand
side of an early Severan sarcophagus in the Ny Carlsberg Glyptotek in
Copenhagen (Matz 1968, vol. II, no. 75, pl. 85), and also in Pompeian wall
paintings.

The marked fidelity to classical style (it was compared by Sieveking (1912)
to the Roman bronze statuette in the Munich Antiquarium) caused this
bronze to be regarded as a genuine Roman work until as late as the early part
of this century. It was so published by Sacken and Kenner (1866) and Sacken
(1871). However, the evidence of the casting technique and the treatment of
the surface clearly point to a North Italian origin at the beginning of the six-
teenth century.

Several replicas are known, including one formerly in the Pourtalès collec-
tion, later the Milani collection, now thought to be lost (Reinach 1897/98);
and another in the possession of Baroness Alix de Rothschild, Paris, formerly
perhaps in the Goldschmidt-Rothschild collection in Frankfurt am Main.

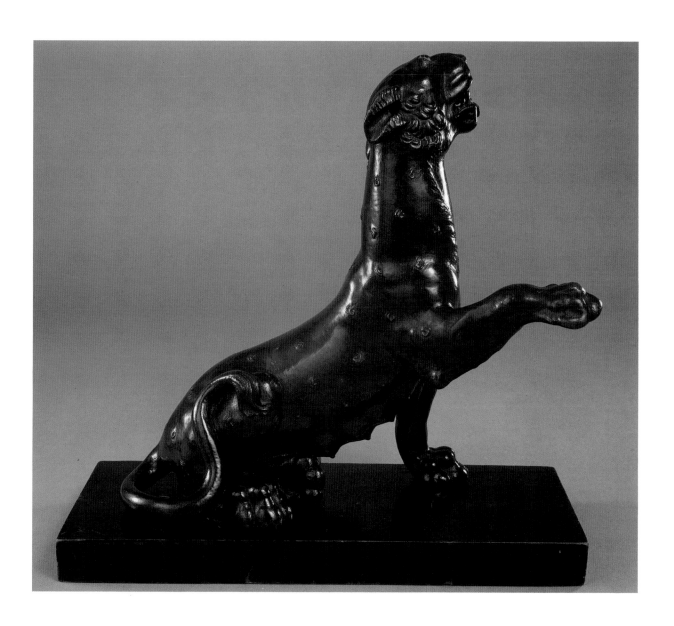

14. Ambling horse

North Italian (probably Padua),
*c.*1500

Bronze statuette; thick-walled cast.
Cracks in the left foreleg and the
right hindquarters; tip of the left ear
broken off. Black-brown lacquer
over light brown natural patina.
Height 18.5 cm.
Inv. no. Pl. 5703.

PROVENANCE
In the collection of Archduke Ferdinand II at
Schloss Ambras, described in the inventory of
1596, fol. 423, as follows: "mer ain metales
gossens rössl, steet auf 3 fuessen und hebt
den rechten über sich" (Boeheim 1888, p.
CCXCIX). Transferred with the Ambras collec-
tion to the Kunsthistorisches Museum in 1891.

BIBLIOGRAPHY
Planiscig, L. 1924, p. 41, No. 71.
Leithe-Jasper, M. 1973, No. 20.
Leithe-Jasper, M. 1976, No. 153.

The horse is ambling: the simultaneous movement of its two right legs in-
clines its body to the right, and its head is turned slightly in the same direc-
tion. The mouth is slightly open; the mane falls freely over its forehead and
neck. The tail, somewhat raised, is tied with a ribbon, and its lower end is
divided into two strands.

The first classicizing monumental equestrian statues to be erected since
ancient times were Donatello's monument to Gattamelata in Padua (1453)
and Verrocchio's to Colleoni in Venice (1496). The horses in these works
were modeled not so much on the statues of Marcus Aurelius in Rome or the
Regisole in Padua – where the animals are not amblers but are pacing in the
normal way – but rather on the four Hellenistic bronze horses that the
Venetians carried off from Constantinople in 1204 and placed in the center of
the façade of St Mark's. It is not surprising that, in the region of Venice and
Padua in particular, these monumental works of antiquity and of the
Quattrocento should have given rise to an abundant production of statuettes
of horses, in which the models were copied or varied more or less faithfully
on a small scale.

The present statuette is a striking example, inspired both by the horses
of St Mark's and, as the knotted tail indicates, by the horse of Donatello's
Gattamelata in Padua. However, the unknown artist has not depicted the
horse so individually as, for instance, Riccio in his *Shouting Horseman* in the
Victoria and Albert Museum in London. Rather, there is no classicism of
style nor, at the opposite extreme, any expressionism; the horse is realistic,
with nothing dramatic in its attitude. The details are correctly observed, and
in places there is something graphic about their execution. In this the horse is
reminiscent of the statuette of a bull (cat. 15) and, like it, may be dated to
about 1500.

No replicas or stylistically comparable variants are known, apart from the
statuette standing on a shelf in Carpaccio's picture of *St Augustine in his study*
in the Scuola di San Giorgio degli Schiavoni in Venice.

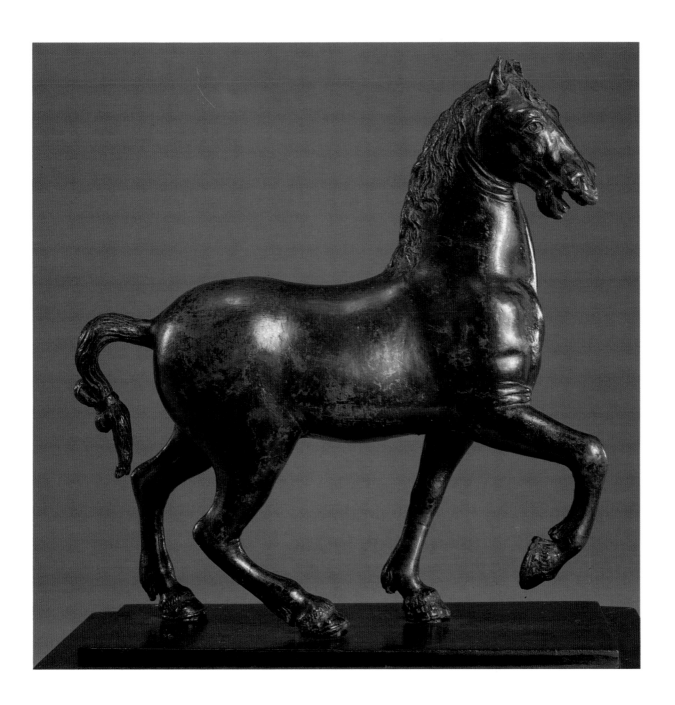

15. Bull

North Italian (probably Padua),
*c.*1500

Bronze statuette; fairly thick-walled cast. Flaws and cracks on the left side of the body. Cracks in the tail, the right hind leg and the left foreleg. Brown natural patina, covered by remains of dark brown lacquer. The figure 828 in white is an inventory number, prior to 1823, of the Imperial and Royal Cabinet of Coins and Antiquities.
Height 12.2 cm.
Inv. no. Pl. 5704.

PROVENANCE
Transferred in 1880 from the Cabinet of Coins and Antiquities to the Ambras collection; transferred with this collection to the Kunsthistorisches Museum in 1891.

BIBLIOGRAPHY
Bode, W. 1907, II p. 12, Plate CXV.
Goldschmidt, F. 1914, p. 17, No. 77.
Planiscig, L. 1924, p. 41, No. 72.
Planiscig, L. 1930, Plate LXXXV, No. 144.
Planiscig, L. 1942, pp. 9, 10, Nos. 7 and 8.
Weihrauch, H.R. 1967, p. 99, Ill. 106.
Mariacher, G. 1971, p. 24, No. 20.
Leithe-Jasper, M. 1973, No. 22.
Leithe-Jasper, M. 1976, p. 142.
Hunter-Stiebel, P. 1985, p. 60, No. 42.

The bull is ambling with its head slightly lowered and inclined to the right.

Together with horses, bulls were among the favourite subjects of animal bronzes of the Renaissance. They were no doubt inspired by antique small bronzes which had once served a religious, sacrificial purpose.

In the long succession of Renaissance bronzes of bulls, this example is of an early date. Its date is revealed by the impressive, unheroic and undramatic portrayal of the animal and the graphic reproduction of details, reminiscent of the statuette of *Europa* in the Bargello in Florence – which has been variously ascribed to Bellano, Riccio and Leopardi, but is probably by none of these artists. These stylistic qualities suggest a date in the late fifteenth century or *c.*1500 and an origin in Padua or Venice, though no individual artist can be suggested. The statuette of a *Horse* (cat. 14) may well be from the same workshop.

Two replicas are in the art collection of the Augustinian Monastery at Klosterneuburg. A similar statuette was in the Kaiser Friedrich Museum in Berlin (Inv. no. M.V. 33; Goldschmidt 1914, no. 77), and another is in private ownership in America. Planiscig's (1924) comparison with a wreathed sacrificial bull in the Bargello and a replica of it in the Ca' d'Oro in Venice is not convincing.

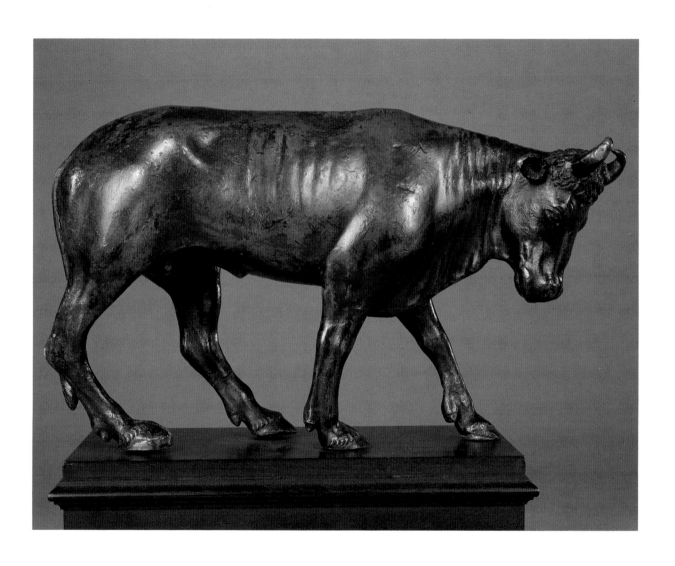

16. Crab

North Italian (probably Padua),
beginning of the sixteenth century

Bronze utensil. Thick-walled cast;
black-brown lacquer over dark
brown natural patina. The figure 957
in white on the animal's belly is the
inventory number, prior to 1823, of
the Imperial and Royal Cabinet of
Coins and Antiquities.
Width 18.6 cm.
Inv. no. Pl. 5927.

PROVENANCE
Probably from the collection of the Imperial
Treasurer Josef Angelo de France; bought in
1808 for the Imperial and Royal Cabinet of
Coins and Antiquities. The description in the
catalogue of the de France collection is not
sufficiently detailed for certain identification.
The Treasury, too, owned several bronze
crabs in the 18th century. Transferred to the
Ambras collection in 1880 and transferred
with the entire collection to the Kunsthistor-
isches Museum in 1891.

BIBLIOGRAPHY
Unpublished.

BIBLIOGRAPHY RELATING TO SIMILAR PIECES
Bode, W. 1907, I, p. 27, Plate XXXIX.
Bode, W. 1922, p. 45, Plate XLVIII.
Planiscig, L. 1924, p. 39, Nos. 64 and 65.
Planiscig, L. 1927, pp. 366, 367, Ill. 454, 455.
Pope-Hennessy, J. 1965, p. 138, No. 505.
Dhanens, E. 1967, p. 58, No. 39.
Schlegel, U. 1968, pp. 351–357.
Wilson, C.C. 1983, pp. 75, 76.
Hunter-Stiebel, P. 1985, p. 86, No. 69.

The cast was made from nature. The crab's front claws with the large pincers are raised, as though about to attack. The separately cast carapace is hinged to the body at the back, so that the figure serves as a lidded utensil or container. Such casts from nature were made in imitation of antique models. However, the large number of such utensils in the form of crabs surviving suggests, as Schlegel pointed out (1968), that their production was encouraged not only by antiquarian or scientific interest or by the enjoyment of the skilful imitation of nature, but that astrology also played a part, the design in question being favored by persons born under Cancer.

Bode (1907) attributed these casts of crabs from nature to Riccio, and Planiscig (1924 and 1927) to Riccio's workshop. However, since in Riccio's known *œuvre* there is hardly any indication that he made casts from nature, his name should not be connected with their production. This, however, does not rule out Padua as the place of origin; for example, shells cast from nature and serving as inkwells are quite common in bronzes of satyrs that are convincingly ascribed to Severo da Ravenna. It is quite possible that there were workshops in Padua that specialized in this genre but whose names are no longer known.

The present example is perhaps not the most elegant, but certainly the most powerful of the four now in the Kunsthistorisches Museum. There are numerous variants in other collections – *eg* the Bargello in Florence, the sculpture collection in Berlin-Dahlem, the Victoria and Albert Museum in London – also in private ownership in Belgium, and in the art trade; but no attempt has yet been made to ascertain whether these are all variants or whether two or more of them are replicas. A similarly powerful example, no less monumental in appearance, is in the Kress collection in the National Gallery in Washington.

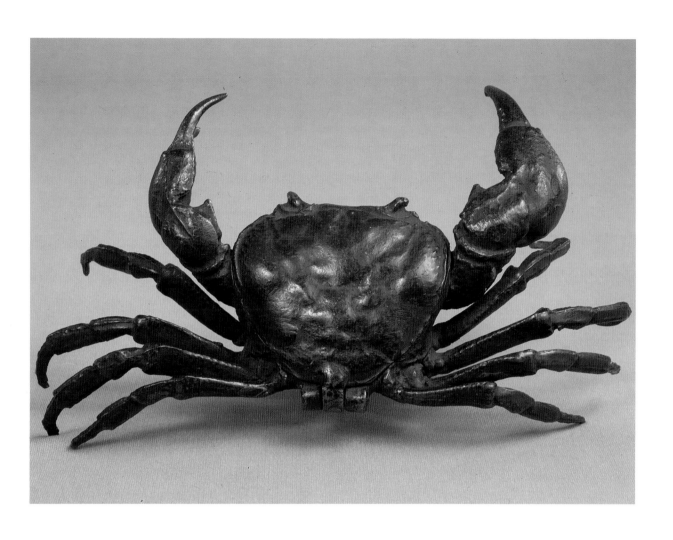

17. Toad

North Italian (Padua?),
beginning of the sixteenth century

Bronze, hollow cast. The outer
right toe of the right forefoot
broken off; on the underside of the
figure, a small round hole of later
date. Brown natural patina, with re-
mains of old dark brown lacquer in
the crevices of the animal's wrinkled
skin. The figure 537 in yellowish
white on its belly is the 1659 inven-
tory number of the Archduke
Leopold Wilhelm's collection.
Height 8.5 cm.
Inv. no. Pl. 5938.

PROVENANCE
Collection of Archduke Leopold Wilhelm;
mentioned in the 1659 inventory of his art
collection in Vienna, p. 473, no. 537: "Ein
Krott von Metall mit offenen Rachen"
(Berger 1883, p. CLXXVII). Later in the
Imperial Treasury, inventory of 1750, p. 573,
no. 27 (Zimmermann 1889, p. CCCX). Trans-
ferred from the Treasury in 1871 to the
Ambras collection and transferred with the
entire collection to the Kunsthistorisches
Museum in 1891.

BIBLIOGRAPHY
Bode, W. 1907, I, p. 27, Plate XXXIX.
Bode, W. 1922, p. 45, Plate XLVIII.
Planiscig, L. 1924, p. 39, No. 66.
Kris, E. 1926, p. 140.
Planiscig, L. 1927, pp. 366, 367, Ill. 453.
Leithe-Jasper, M. 1976, p. 105, No. 138.
Gamber, O. 1978, p. 30, Ill. 6.
Hunter-Stiebel, P. 1985, p. 82, No. 65.

The fat toad is cast from nature, with all details of the surface faithfully ren-
dered. It crouches with feet outspread; the raised head and wide-open jaws
indicate its use as an inkwell.

The Italian tradition of casting from nature went back to Cennino Cen-
nini in the fourteenth century and was a conscious imitation of antique
practice. It flourished especially in Padua, the center of scientific studies
around 1500, whence it spread to Germany and France: there its chief expo-
nents in the second half of the sixteenth century were the goldsmith Wenzel
Jamnitzer in Nuremberg and the potter Bernard Palissy in Paris.

The considerable number of such animal bronzes cast from nature testifies
to their great popularity over a long period. The eighteenth century con-
tinued to admire the skill and surprising effect of this imitation of nature.
This admiration is reflected even in a brief entry in the inventory of the Im-
perial Treasury: "Ein grosze krott von erstgenannte materie [bronze], so
wohl imitiert" (Zimmermann 1889, p. CCX, no. 27).

Bode (1907) ascribed the present work to Riccio, Planiscig (1924 and 1927)
to Riccio's shop. These attributions are doubtful, or at any rate cannot be
proved, as Riccio's known work affords hardly any evidence of his activity
in this genre.

A second example in the Kunsthistorisches Museum (inv. no. 5933; Plan-
iscig 1924, p. 39, no. 67) was sold in 1923. Other replicas are known in the
Kaiser Friedrich Museum in Berlin (formerly), the Bargello in Florence, and
elsewhere.

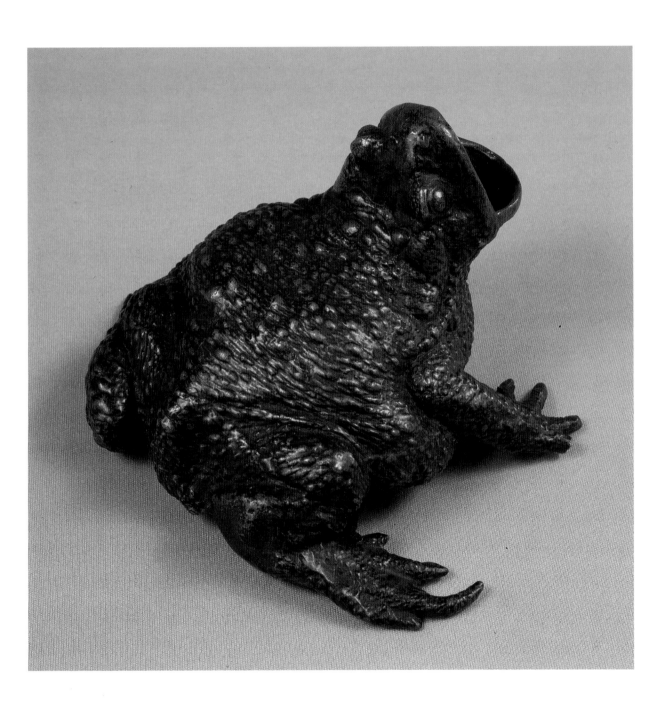

18. Armored horseman

North Italian (Padua or Venice),
first half of the sixteenth century

Bronze statuette, fairly thick-walled
cast. Brown natural patina, over it
traces of dark brown lacquer. The
right hand and wrist broken off and
filed away up to the forearm.
Height 14.7 cm.
Inv. no. Pl. 10010.

PROVENANCE
Collection of Dr Jantzen, acquired in 1941 for
the prospective Führer-Museum at Linz, taken
over by the Kunsthistorisches Museum in
1965.

BIBLIOGRAPHY
Bode, W. 1910, I, pp. 24, 27, No. 95, Plate
 LXII. (Only the specimen in the Morgan
 Collection, later Frick).
Planiscig, L. 1927, p. 208.
Planiscig, L. 1932, p. 901, Ill. p. 915.
Planiscig, L. 1942, p. 8, No. 4.
Maclagan, E. 1953, p. 45.
Hackenbroch, Y. 1962, pp. 9, 10, Figs. 18–20.
Pope-Hennessy, J. and Radcliffe, A.F. 1970,
 pp. 114–116.
Leithe-Jasper, M. 1973, No. 10.
Leithe-Jasper, M. 1976, No. 47.
Draper, J.D. 1977, pp. 161, 162, No. 302.
Draper, J.D. 1978, p. 178.

The warrior is to be imagined astride a horse, separately cast. His lowered
left hand presumably held the reins, and his raised right hand (which is now
lost) a sword. He wears armor "alla romana", and his curly hair is close-
cropped also in Roman fashion. His face expresses acute tension and
concentration.

The rider's half-open mouth indicates that he is shouting to encourage his
horse. His glance, somewhat lowered, is fixed on an imaginary, unmounted
opponent. His brow is furrowed, the pupils of his eyes pierced, the mouth
deeply excavated and the chin cleft. This makes the face still more lively and
expressive, while the hammered surface gives a vibrant effect. The lappets of
the armor are chased and thus acquire graphic sharpness.

In the collection of the Augustinian Monastery at Klosterneuburg there is
an almost identical replica in which the rider's upraised right hand still holds
a sword-hilt, and in which he is mounted on an ambling horse rather too
large for him. The horse derives from those of St Mark's in Venice, but its
action is somewhat looser, influenced perhaps by Verrocchio's Colleoni
monument. Another rider, also without his horse, is in the Ca' d'Oro in
Venice. Two weaker versions of the rider, both with their mounts, are in the
Metropolitan Museum (Robert Lehman collection) and the Frick Collection
in New York. In the Frick version the horse is somewhat shorter and the
stride less extended; it is bridled and there is a mask on its chest.

There is also a variant from the Donà delle Rose collection in Venice
which came in 1964 via the Untermyer collection to the Metropolitan
Museum in New York. The figures are slimmer and the general impression
smoother, the details more delicate and linear. The armor varies in several
details – it is fastened higher at the neck with an inner collar – and the rider
is wearing boots. The horse too is more delicate, slender and nervous-
looking, and does not derive from the horses of St Mark's. It is rearing in
fright at the sight of a snake which its rider is attacking. This group is some-
what closer to Riccio's famous *Shouting Horseman* in the Victoria and Albert
Museum in London.

The Klosterneuburg *Rider* was known before the Vienna example, to
which it is somewhat inferior. Planiscig (1927) believed it to be a product of
Riccio's workshop, dependent on the *Horseman* in London; later (1932) the
same historian thought the *Rider* from the Donà delle Rose collection to have
been the immediate model for the variant at Klosterneuburg. Pope-Hennessy
(1970) agreed, adding that "Whether or not the Undermyer group is the
direct source of the other bronzes, it is sufficient to establish that the model
is due to Riccio, not to 'one of the lesser Paduan artists of the early sixteenth
century' as suggested by Maclagan, and was evolved during the first phase of
work on the Paschal Candlestick (after 1507)."

Leithe-Jasper (1973 and 1976) emphasized that the type of the *Horseman* of
Vienna and Klosterneuberg was independent of Riccio's *Shouting Horseman*
in London; Draper (1977 and 1978) made the same point about the Donà
delle Rose *Horseman*. Both authors concluded that there must have been
common sources in classical art, Draper referring *inter alia* to antique cameos

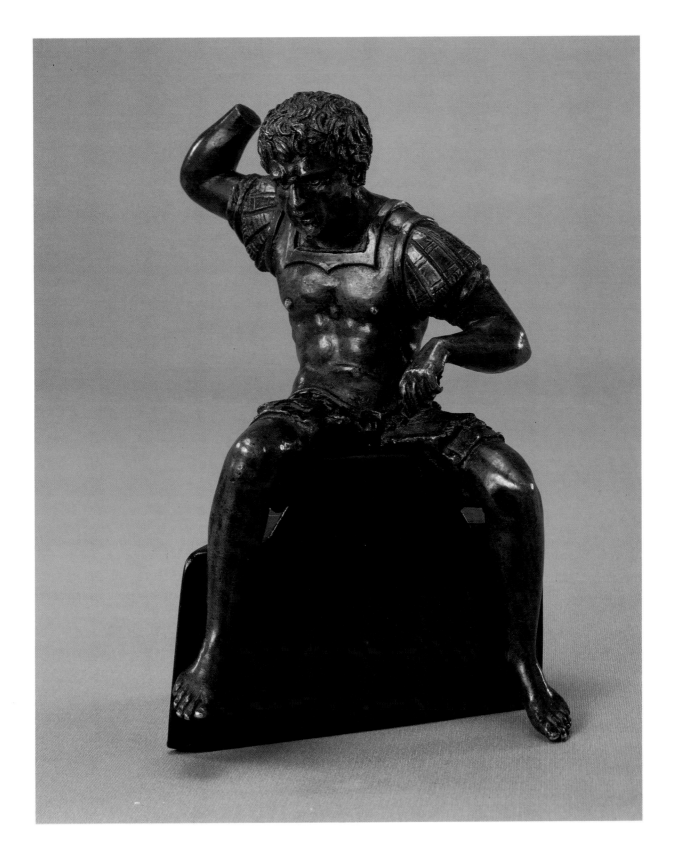

(Reinach 1885, Pl. 61, no. 573; A Furtwängler 1900, I, Pl. 19, no. 56, and Pl. 20, no. 35). We may agree with this, but hardly with Draper's attribution of the *Horseman* to the goldsmith Francesco da Sant'Agata, active in Padua in the early sixteenth century, whose only certain work is the signed boxwood statuette of *Hercules* in the Wallace Collection in London. None of the further attributions to this artist that have so far been proposed is satisfactory. A much closer relative to the Donà delle Rose *Horseman* is the rider on the left in one of Camelio's two reliefs of *Battle scenes* in the Ca' d'Oro in Venice.

The type represented by the *Horsemen* in Vienna and Klosterneuburg conforms most closely to antique models known from reliefs on sarcophagi and on the Arch of Constantine in Rome, or from Mantegna's paintings *all'antica*, such as the San Zeno altarpiece in Verona, or again from engravings by Marcantonio Raimondi and plaquettes by Moderno. This type is also the most "Mantegnesque" in facial expression. In contrast to Riccio, who uses similar models in a free and imaginative manner – for instance incorporated in a plaquette of a battle in front of a city gate – the Vienna/Klosterneuburg type is much more dynamic in movement and dramatic in expression, though not so original in detail. Perhaps the effect of the "shout" of Riccio's *Horseman* – whose mouth is wider open – is all the greater because it is the only dramatic thing about the figure, whereas in the Vienna and Donà delle Rose versions the drama is felt above all in the bodily movement.

Riccio's *Shouting Horseman* and the Donà delle Rose version are both unique; only late copies of them are known. The type of the Vienna *Horseman*, on the other hand, is known in five replicas, suggesting that it was made in a workshop specializing in multiple production and not by an individualist. Hence, despite many resemblances to figures by Camelio, it seems important to consider the affinity with works that are reliably ascribed to the workshop of Desiderio da Firenze, in which motifs of Riccio, Moderno and other artists were blended together. Reference should particularly be made to the candlesticks formerly in the Pannwitz collection (Falke 1925, Pl. I); the similar inkwell in the Widener collection in the National Gallery in Washington (Wilson 1983, pp. 73, 74) and the perfume burner in the Rijksmuseum in Amsterdam (Leeuwenberg and Halsema-Kubes 1973, pp. 385, 386, no. 652). Similar traits of modeling and physiognomy can be seen in the fettered satyrs at the corners of these works.

19. Seated bacchante with wreath

The naked *Bacchante* sits with bent legs – the left drawn up somewhat higher – and supports herself at the side with her right hand. The upper part of her body is inclined backward and to the left, but her head is turned fully to the right; she looks upward over her right shoulder, which is slightly raised. In her left hand, extended to the side, she holds a laurel wreath. Her hair is center-parted and tied above the brow into a loop in which vineleaves and grapes are fastened. The side hair is combed up into a roll, then knotted in the nape of the neck, whence it falls in three strands to the left shoulder. There is something instantaneous about her attitude: she appears to be starting violently as though taken unawares, an impression no doubt intended by the artist.

The statuette shows high quality in the modeling and great care in the execution of detail. The strands of hair and the grapes and foliage over her brow are drawn in a spontaneous and individual manner; the pupils of the eyes, the nostrils and even the chin are pierced so as to give them greater chiaroscuro and more life.

A gilt replica, very similar except for some variation in the angle of the hands and feet, was in the collection of Baron Paul Hatvany (sold at Christie's, 1980, lot 51). A crude replica, probably of later date, with unbound, shoulder-length hair and without a laurel wreath, is in store in the Kunsthistorisches Museum (inv. no. 5622, from the Ambras collection). Other versions are in the Landesgewerbemuseum in Stuttgart and the National Gallery of Art in Washington. A variant of the *Bacchante*, this time riding on a centaur, was in the Kaiser Friedrich Museum in Berlin, but is now unfortunately lost (Inv. no. 1802; cf Goldschmidt 1914, Part I, p. 8, no. 27). This *Bacchante* holds no wreath in her left hand, but clings with it to the centaur's back; her left leg is more bent at the knee, so that her two lower legs are almost parallel. In the Berlin version the attachment of the upper left arm to the shoulder seems more harmonious and natural, deriving from the effort with which she keeps herself from falling. Thus in all probability the model of the Berlin version was the original composition, which was then modified in the same workshop to form the variants in Vienna and the Hatvany collection. However, as far as execution and the rendering of detail is concerned, the Vienna version is in no way inferior to that in Berlin, in fact it is superior.

Bode (1907) identified the group as *Nessus and Deianira* – wrongly, since the adornment of the hair clearly shows the female figure to be a bacchante. He believed the work to be a reflection of a lost *Centaur* by Bertoldo, known from an inventory to have belonged to Lorenzo the Magnificent. This attribution cannot be upheld, as there is no basis for comparison with any of Bertoldo's known works; however, Lisner (1980) has once more attempted to revive Bode's theory.

More convincing is the attribution to Padua and the circle of Andrea Riccio, proposed by Schlosser (1910) and, following him, by Planiscig (1924 and later). Planiscig observed that the sitting motif might derive from the *Europa* statuette in Budapest, and that there was a resemblance to the groups

North Italian (probably Padua or Venice), beginning of the sixteenth century

Bronze statuette; hollow cast, a small casting flaw between the legs. Black lacquer over brown natural patina. Height 12.6 cm (this measurement is relative, as it depends on the angle at which the figure is seated; the distance from the right big toe to the vine-wreath is 15.7 cm).
Inv. no. Pl. 5529.

PROVENANCE
Transferred in 1748 from the Imperial gallery to the Imperial Treasury in Vienna, "ein sitzendes weibsbild mit einem Cranz" (Zimmermann 1889, p. CCXLVII). Probably mentioned in the Imperial Treasury as early as 1750, but erroneously as "Ein sitzender Bachus, so in der Hand ein lorberkranz, mehrmallen von pronse" (Zimmermann 1889, p. CCCX, p. 574, no. 32). From 1785 onward, what is presumed to be the same bronze is described in the inventories as "Eine Weibsfigur mit einem Kranz aus detto [bronze]"; in any case there is no further mention of Bacchus. In 1871 transferred to the Ambras collection (inv. no. VI, 145), and transferred with the entire collection to the Kunsthistorisches Museum in 1891.

BIBLIOGRAPHY
Bode, W. 1904, p. 5, No. 243.
Bode, W. 1907, Vol. I, p. 15.
Bode, W. 1910, p. 255.
von Schlosser, J. 1910, p. 3, Plate VI, No. 3.
Goldschmidt, F. 1914, p. 8, No. 27.
Bode, W. 1922, p. 15.
Planiscig, L. 1924, p. 15, No. 18.
Bode, W. 1925, pp. 107–109.
Planiscig, L. 1927, pp. 61 and 272.
Leithe-Jasper, M. 1973, No. 11.
Leithe-Jasper, M. 1976, No. 48.
Lisner, M. 1980, pp. 322 and 340, Note 87.
The Hatvany Collection, Rome 25 June 1980, p. 84, No. 51.

of *Ichthyocentaurs and Nereids* in New York, London and Berlin, which at that time he attributed to Riccio. His comparison was well founded as far as the classicizing typology was concerned. But, while the nereids are somewhat stereotyped and stiffly modeled, the *Bacchantes* show greater fluency of composition, spontaneity in the modeling of the body and in detail, and a lyrical expressiveness that also distinguishes them from Mantegna's highly expressive nereids in his *Battle of the Sea-gods* engraving, which are really the original model. Perhaps the lyrical element can be seen as an indication of Venetian origin, especially since the centaur in the Berlin variant derives from the horses of St Mark's in Venice.

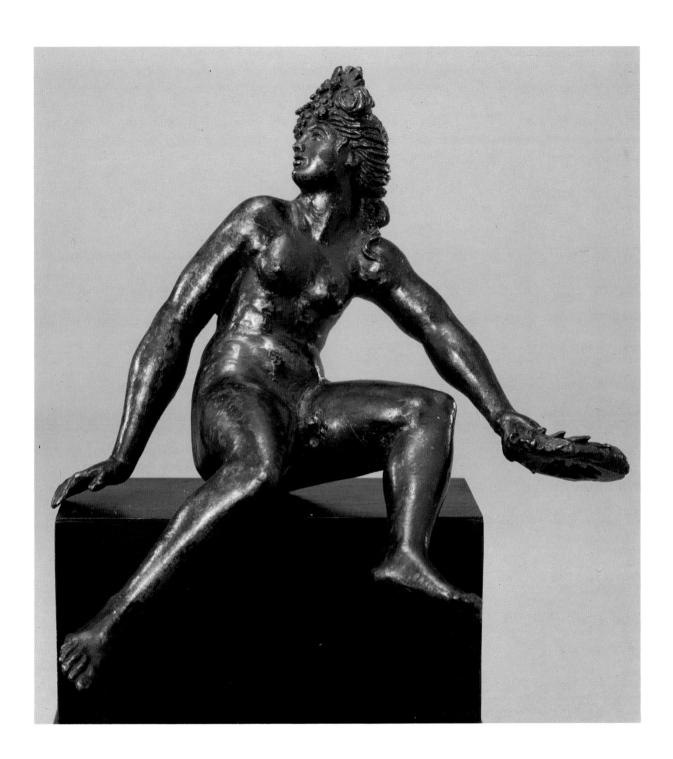

20. Seated satyr

Andrea Briosco, called **Riccio**

1470–1532

(See Biography, p. 281)

Bronze statuette; heavy, thick-walled cast. Under the right heel a small hole, drilled at a later period. Brown natural patina; over it, remains of old dark brown lacquer. The figure 852 in white on the baseplate behind the satyr's rump is a pre-1823 inventory number of the Imperial and Royal Cabinet of Coins and Antiquities.

Height 21.7 cm.

Inv. no. Pl. 5539.

PROVENANCE

In 1800 the statuette, which cannot be identified with certainty in the inventories before 1797, was transferred from the Imperial Treasury to the Cabinet of Coins and Antiquities. Documented before 1823 in the inventories of the Cabinet of Antiquities. Transferred to the Ambras collection in 1880 and transferred with the entire collection to the Kunsthistorisches Museum in 1891.

BIBLIOGRAPHY

Bode, W. 1907, I, Plate XLIII (erroneously described as part of the Wallace Collection).
Planiscig, L. 1921, p. 401 and Ill. 424.
Bode, W. 1922, p. 47, Plate XLIX (erroneously described as part of the Wallace Collection).
Planiscig, L. 1924, p. 90, No. 157.
Planiscig, L. 1927, pp. 343–346 and p. 484, No. 115, Ill. 415.
Moschetti, A. 1927, pp. 154–158.
Pope-Hennessy, J. 1961/1962, No. 67.
Pope-Hennessy, J. 1963, p. 21 (1968, p. 178).
Cessi, F. 1965, p. 102, Plate XLV.
Mariacher, G. 1971, p. 29, No. 77.
Jestaz, B. 1975, pp. 156–162.
Semenzato, C. 1976, p. 130, No. 90.
Leithe-Jasper, M. 1978, p. 127.
Distelberger, R. 1982, p. 73.
Jestaz, B. 1983, p. 33.
Leithe-Jasper, M. 1983, p. 376, No. S.21.

The satyr sits on a small mound, his torso turned slightly to the right. Below the knee, his outspread legs are those of a goat. With his right hand he lifts a drinking bowl to his mouth; his left hand rests on his left knee. The muscles of his strong body are clearly articulated; the sinews and arteries of the neck are visible, and one seems to see the swallowing movement. His expressive head is surmounted by two goat's horns over his brow. His ears are like ragged leaves. These and the shaggy goat legs are the only animal features; the figure is otherwise that of a mature man. The Roman nose gives a sharpness of expression; the forehead is wrinkled; the gaze of the narrow, cleanly carved eyes, with their heavy lids and clearly defined pupils, is wholly concentrated on the bowl at the satyr's lips. The treatment of the hair avoids all schematic linearity. Growing from the layered crown, short curls cover the head, with longer tufts framing the forehead and merging into the wavy beard, which covers the cheeks but leaves the lips and chin free. The longer hair on the legs follows their shape in harmoniously curved lines. The depressions between the strands of hair are punched, increasing the effect of chiaroscuro. The hammering of the surface has a similar effect, giving even greater warmth and vibrant life to the fresh modeling. These are characteristic features of autograph works by Riccio, and are seen to a special degree in the present statuette.

Bode (1907) published the statuette as an autograph of Riccio's, and it still seems unaccountable that Planiscig (1921 and 1924) did not at first follow this opinion but ascribed the work to Desiderio da Firenze, a follower of Riccio's. However, in his monograph on Riccio (Planiscig 1927) he accepted the statuette as autograph and ranked it with the maturest works of the artist's later period: the most convincing parallels are with the *Satyr* in the Bargello in Florence and the Gutekunst collection *Satyr*, now in the Metropolitan Museum of Art (Planiscig 1927, figs. 434 and 1417).

Among Riccio's autograph statuettes of satyrs, the type here represented seems to be the only one not serving a utilitarian purpose. All the others carry, or have attached to them, shells, vases or candle-sockets, constituting the decorative element of an inkwell, a candlestick or both in one. The Vienna *Satyr*, however, seems to have been conceived as a statuette in his own right. He is shown drinking, as befits one of Bacchus's ever-thirsty followers.

Two slightly modified replicas of almost the same size are in the Museo Civico in Padua and the Louvre in Paris. Jestaz (1975) first published the example in the Thiers collection in the Louvre, and investigated the relationship of all three to one another. Apart from the fact that the Vienna *Satyr* is in a perfect state of preservation – in both the other examples the legs have broken off and been incorrectly restored – it is also to be regarded as the original model. Of the three, it is the fullest of animal vitality in its composition, modeling and expression – this is not only because it is the only one to wear horns, and is not diminished by the fact that its penis is a human and not an animal one. Closest to it is the Padua example, which is ithyphallic and has no horns. However, the latter is not quite so relaxed, and such details

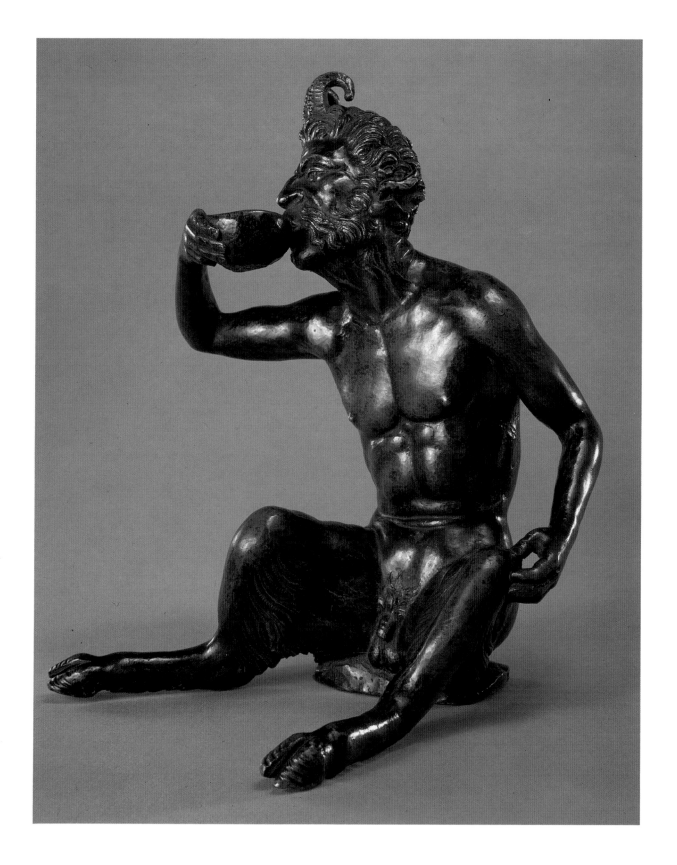

as the hair are more schematically treated: this was pointed out by Planiscig in 1927, and wrongly contested by Moschetti (1927) and Cessi (1965). The Padua version is also slightly smaller. The example in the Louvre shows further variation from that in Padua. Like the latter it has no horns; its penis is an animal's but is not erect; it is the only one to have tufts of hair on its neck like a he-goat; and, above all, its left hand does not rest on its knee but is raised and clenched, as if it once held some object like a cornucopia serving as a candle-socket. Thus the *Satyr* in the Louvre was, it appears, not an independent statuette but an article of use. Also its chest is not so crisply modeled as that of the other two statuettes, and the treatment of the hair is somewhat stereotyped and monotonous.

The *Satyr* in Vienna is a brilliant representation of the vital forces of nature.

21. Boy with a goose

The naked small boy is grasping a large goose round the neck with both hands and pressing it hard against his left side; the bird's right wing is caught under his left arm.

The boy and goose are resisting each other, with feet planted apart. The bird is nearly as strong as the boy, and it is all he can do to hold it. The dramatic action takes the form of a composition in two triangles; the interlocked figures are in a state of apparent equilibrium, in which the rotatory movement plays an important part. The effect can be properly gained only if the statuette is seen in the round; it thus seems to anticipate the late Renaissance demand for works intended to be viewed from all angles.

The artist shows masterly empathy in portraying the boy's light-hearted zest and the scared, aggressive bird. Their physical characteristics, too, are admirably brought out. The elegant lines of the goose contrast with the soft plumpness of the child's body, with the creases of fat in the groin: the boy's strength is undeveloped, and he relies more on weight than on muscle in his effort to overcome the animal.

The goose's beak is wide open, and it seems to be crying out in terror. The boy's mouth is open too, but to judge from the expression of his eyes he is laughing in loud triumph at his success. The perfect casting does full justice to the fresh modeling of the figures. The afterworking is also of the greatest subtlety. The surface of the boy's body is hammered, which relieves its smoothness and gives it warmth. The child's eyes are depicted sharply and accurately, and the pupils give them a liveliness of expression. His teeth can be seen through the parted lips. The short curly hair is freshly and spontaneously rendered. The differentiated treatment of the goose's feathers is a masterpiece of chiseling, full of life yet executed with precision as though by a goldsmith.

The bronze is based on one of the numerous replicas of the *Boy with a Goose* by Boethus of Chalcedon, the closest examples being those in Munich and Paris. However, it is more expressive and dynamic than the antique model, and more realistic in detail. Although the statuette was never itself regarded as an antique work, its evident link with antiquity made it difficult to classify, so that for a long time it was kept in the Cabinet of Coins and Antiquities. Frimmel (1883), Bode (1907) and Schlosser (1910) appraised it solely on its qualities as a copy of classical sculpture. The eventual attribution to Riccio was made by Planiscig (1924 and 1927), at first tentatively and afterwards with confidence, pointing out the resemblance to the *putti* on the Paschal Candlestick in the Santo in Padua. Still more like the child in the statuette, however, are the *putti* in the reliefs of the Della Torre monument in the Louvre. Moreover, the chiseling of the Pegasus in the relief representing humanistic Virtue on the same monument is exactly similar to that of the goose in the statuette.

Andrea Briosco, called **Riccio**
1470–1532
(See Biography, p. 281)

Bronze statuette; thick-walled cast. Holes under the goose's tail feathers, under the boy's buttocks, in his penis, under his right hand and both heels (the right one of later date). Dark brown natural patina, over it remains of old dark brown lacquer. The figure 907 in white on the boy's back is a pre-1823 inventory number of the Imperial and Royal Cabinet of Coins and Antiquities.
Height 19.6 cm.
Inv. no. Pl. 5518.

PROVENANCE
Collection of the Imperial Treasurer Josef Angelo de France in Vienna. (Martini, 1781, p. 31: Descriptio Signorum, Scrinium II, no. 262 "(Ser. 3. Cat. A.n. 409) PVER, utroque manu cygnum [sic], ala laeva et collo comprehensum, violenter premens. Opus artificis recent. Aes, 7 1/12 alt, et 7 1/12 long.".) Bought in 1808 with the de France collection for the Imperial and Royal Cabinet of Coins and Antiquities, and transferred to the Ambras collection in 1880. Transferred with the entire collection to the Kunsthistorisches Museum in 1891.

BIBLIOGRAPHY

Frimmel, T. 1883, p. 53, No. 902.

Bode, W. 1907, I, Plate CX.

von Schlosser, J. 1910, p. 9, Plate XXIV, No. 1.

Planiscig, L. 1924, p. 22, No. 32.

Planiscig, L. 1925, p. 16.

Planiscig, L. 1927, p. 312, Ill. 359.

Planiscig, L. 1930, p. 17, Plate LI, No. 79.

Planiscig, L. and Kris, E. 1935, p. 49, Room
 X, Case 2, No. 2.

Mahl, E. 1966, p. 32, No. 243.

Weihrauch, H.R. 1967, p. 106, Ill. 110.

Savage, G. 1968, p. 163, Fig. 138.

Leithe-Jasper, M. 1978, p. 127.

Distelberger, R. 1982, p. 73.

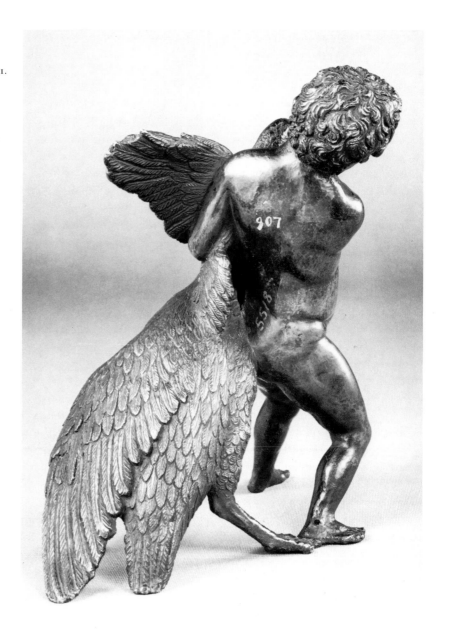

Boy with a goose, back view

It is therefore safe to date the statuette, one of Riccio's most mature cre-
ations, to the period after the execution of the Paschal Candlestick, *ie* the end
of the second decade of the sixteenth century.

The opening under the goose's tail feathers and the aperture in the boy's
penis suggest that the statuette was made as part of a fountain or was at least
adaptable for such a purpose. There is in Basle a later fountain statuette based
on this one or on the antique examples in Munich and Paris; no actual rep-
licas are known, however.

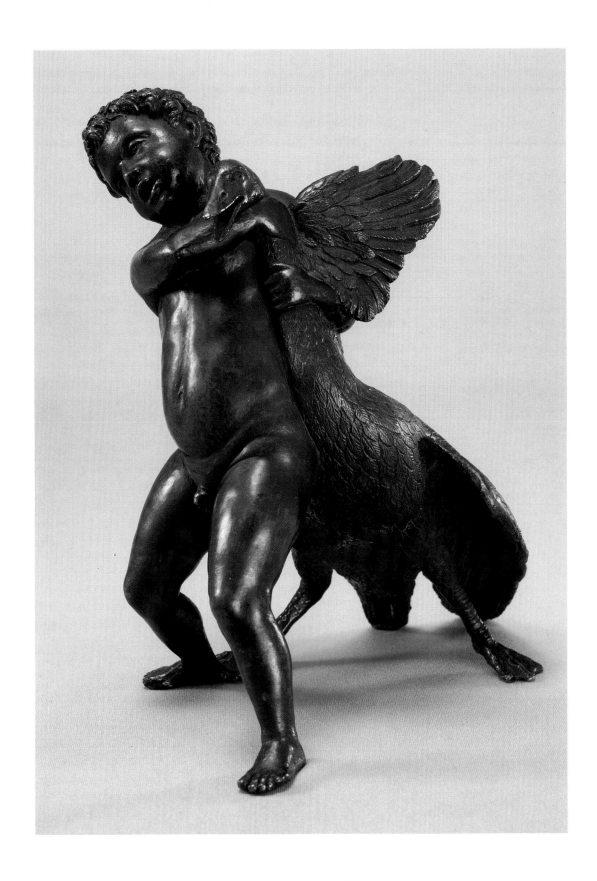

22. Marsyas

North Italian (Padua), first half of the sixteenth century

Bronze statuette; hollow cast with flaws in Marsyas's right groin, on his chest and the integrally cast base. Brown natural patina, over it traces of dark brown lacquer.
Height 12.3 cm.
Inv. no. Pl. 5628.

PROVENANCE
Collection of Archduke Ferdinand II at Schloss Ambras, mentioned in the inventory of 1596, f. 424 (W. Boeheim, Urkunden und Regesten aus der k.k. Hofbibliothek. In: Jahrbuch der Kunsthistorischen Sammlungen des Allerhöchsten Kaiserhauses, volume VII/part 2, 1888, p. CCXCIX.) Taken over with the entire Ambras collection by the Kunsthistorisches Museum in 1891.

The satyr Marsyas sits with crossed calves on a cylindrical socle out of which a leafless tree is growing. His arms are tied to the tree behind his back. His head is turned to the right; his ears resemble lobular leaves.

The goddess Athene, having invented the flute, threw it away because it distorted her face to play on it. Marsyas found it and became such a skilled performer that he challenged Apollo to a musical competition, which he lost. It had been agreed that the victor might treat the loser as he wished, and Apollo punished Marsyas for his presumption by having him bound to a withered tree and flayed alive (Ovid, *Fasti*, VI, 697 f. and *Metamorphoses*, VI, 382f.).

The statuette shows Marsyas about to be flayed, writhing in pain and apprehension. Apollo's instrument, the violin – here used in place of the usual cithern or panpipes – is fastened to the top of the tree as a sign of Apollo's triumph; the bow lies on the socle to the left of Marsyas.

The vivid composition of the seated figure of Marsyas, bound to the tree and looking up in despair, became extremely popular, as is shown by the many surviving replicas and variants. Its presumed original is the famous Roman cornelian intaglio in Naples which, according to an unprovable tradition, belonged to the Emperor Nero, and which at the end of the fifteenth century was owned by Lorenzo the Magnificent, as is proved by the 1492 inventory and its engraved inscription LAV.R.MED. The intaglio depicts Apollo, Marsyas bound to a withered tree, and his friend Olympus begging Apollo to show mercy. By 1500 there were already innumerable variants in circulation in the form of bronze plaquettes. The intaglio unquestionably served as a prototype for a free-standing bronze group which to all appearances originated in Padua: it shows Marsyas seated on a pyre, bound to a withered tree, with Apollo standing beside him and hanging the panpipes to a branch. A group of this type was in the collection of Jacobus de Wilde in Amsterdam in 1700 and is known through an engraving by his daughter Maria. Planiscig (1927) supposed the group to be a lost work of Riccio's. Weihrauch (1940) discovered a version of the group in the Schlossmuseum at Mannheim, but it was subsequently destroyed in the Second World War. Another version was acquired by the Metropolitan Museum in New York with the Untermyer bequest. Planiscig (1924) connected the *Marsyas* statuette with this group, but the satyr in the group bears only a broad resemblance to the Vienna statuette. Its legs are more bent, in accordance with the sitting posture, and its arms are not crossed but stretched out to either side of the tree to which they are bound.

Much more common, on the other hand, is the statuette of Marsyas as a single figure. As in the case of Riccio's bound satyr on the Paschal Candlestick in the Santo in Padua, this may also have been inspired by engravings by Nicoletto da Modena, based on grotesques in Nero's Domus Aurea in Rome (Enking 1941). The Vienna statuette is in itself the most complete version of this type, but the replica in the Frick Collection in New York, which resembles it very closely, attests the original use of such small bronzes as finials or lid-handles – in this case for an oil lamp, the flame being appro-

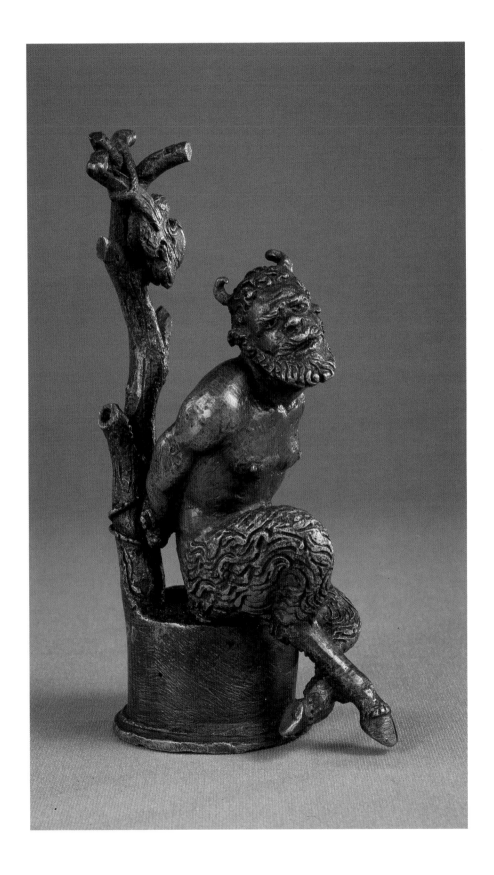

BIBLIOGRAPHY

Bode, W. 1907, vol. I, p. 28, Plate LI
(specimen from the Taylor collection, later
Widener); vol. III, p. 22, Plate CCXLVI
(specimen from the Morgan collection,
later Frick).

Bode, W. 1910, p. xv, Plate XXX, No. 38
(specimen Morgan–Frick).

Bode, W. 1922, p. 48, Plate LIX (specimens
Taylor–Widener and Morgan–Frick).

Planiscig, L. 1924, p. 25, No. 36.

Planiscig, L. 1927, pp. 333–337, Figs. 389, 390,
391, 395 and 396.

Planiscig, L. 1930, p. 18, Plate LXII, No. 98.

Weihrauch, H.R. 1940, p. 64.

Enking, R. 1941, p. 98, Ill. 28.

Pope-Hennessy, J. 1965, pp. 128, 129, No.
475, Fig. 497.

Hackenbroch, Y. 1962, pp. XIV, XV and
pp. 7, 8, No. 11.

Maclagan, E. 1953, V, p. 43.

Weihrauch, H.R. 1967, pp. 58–60.

Pope-Hennessy, J. and Radcliffe, A.F. 1970,
pp. 141–144.

Leithe-Jasper, M. 1973, No. 14.

Leithe-Jasper, M. 1976, pp. 78, 79, No. 54.

Munhall, E. *Severo Calzetta, called Severo da
Ravenna.* The Frick Collection, exhibtion
check list, New York, 1978, No. 3 and 12.

priate to the pyre on which Marsyas sits. The example in the Widener collection in the National Gallery in Washington serves as a handle to the lid of an inkwell. Finally the Bargello in Florence has a replica in which the satyr, bound to a withered tree, sits on a rock with lizards and toads crawling out of its crevices; this version may have been the lid of a perfume burner.

The bound satyr by himself, without a base or other attributes, exists in several examples of varying quality. One of the best, given its fluent execution and fresh state of preservation, is that in the Kress collection in the National Gallery in Washington. A nearly identical replica of the present statuette, of equal quality, is in the Museo Civico Medioevale in Bologna. There, however, the tree is somewhat less naturalistic; the violin is replaced by panpipes, and Apollo's lyre is hung at the back.

Bode (1907), Planiscig (1924 and 1927) and Pope-Hennessy (1965) regarded the type of this satyr as Riccio's invention: Planiscig believed the Vienna example to be autograph, Pope-Hennessy thought the Kress collection one to be by Riccio himself. Later, however, Pope-Hennessy (1970) attributed the oil lamp in the Frick Collection to Severo da Ravenna. He argued that the figure of St Paul surmounting a second version of this lamp was typical of that artist, as were the masks on the lamp itself; therefore both the lamps, as well as the satyrs surmounting them and the related statuettes in Washington and Vienna, must be by the same artist. However, this view, which Pope-Hennessy repeated in an exhibition catalogue of the Frick Collection in 1978, cannot be accepted. There is in fact not the least resemblance either to the satyrs or to other statuettes which have hitherto been ascribed with some reason to Severo da Ravenna (*cf* most recently Avery and Radcliffe 1983, pp. 107–122). Severo's figure style is basically different from that of the *Marsyas*, and his facial type with its wide open eyes contrasts with that of the *Marsyas* with its small depressed pupils. The fine-spun hair of the goatee beards of Severo's satyrs also bears no relation to that of the *Marsyas* and related figures. We may indeed agree with Pope-Hennessy in rejecting Riccio's authorship: there are no features in common except the motif of a bound victim. None of the many replicas and variants of the *Marsyas* statuette exhibits stylistic features that point directly to Riccio; and the bronze groups of *Apollo and Marsyas* in Mannheim and New York were or are of such poor quality that no conclusions can be drawn as to their authorship.

The *Marsyas* statuettes seem, on the other hand, to be very closely connected with the workshop which produced the inkwell in the Widener collection. This is today convincingly identified as that of Desiderio da Firenze, and in it motifs deriving from Riccio and other artists were taken up. The Vienna example is probably the best-preserved variant, though it is a fairly rough casting and shows correspondingly clear traces of surface working with the file. Nonetheless, as there is little chasing the freshness of modeling is clearly felt.

The base on which Marsyas sits is almost precisely the same as that in the Widener collection, and we may suppose that the Vienna statuette surmounted the lid of a similar type of vessel. It must soon have become detached, as in 1596 the statuette is already described in the posthumous inventory of the collections of the Archduke Ferdinand II at Schloss Ambras: "Ain von metal gegossner satiro, ist an ainem pämb gebunden, am pämb ist auch ain geigen bunden, siczt auf aim hülzen stöckhl."

23. Warrior

North Italian, beginning of the sixteenth century

Bronze statuette; thick-walled, if not cast solid. The helmet added subsequently (soft soldered). The big toe of the left foot broken off; likewise the right forefinger and the left thumb and forefinger, badly restored with solder. Many small casting flaws on all parts of the body, carefully repaired with rectangular bronze fillings. The crest of the helmet broken off. Remains of black-brown lacquer over light brown natural patina. Uninterpreted written marks on the inside of the dangling part of the cloak.
Height 28.8 cm.
Inv. no. Pl. 5656.

PROVENANCE
Documented in the inventory of the collection of Archduke Ferdinand II in 1596. (Boeheim 1888, p. CCXCVIII, fol. 420). Not described as *Apollo* until 1788 in the Ambras inventory (no. 1788, p. 99, case VIII, no. 7). Transferred with the entire Ambras collection to the Kunsthistorisches Museum in 1891.

BIBLIOGRAPHY
Bode, W. 1907, Vol. II, p. 8, Plates IIIC and XCVII.
von Schlosser, J. 1910, p. 9, Plate XXIII, No. 3.
Bode, W. 1922, p. 74, Plate LXXXV.
Planiscig, L. 1924, No. 109.
Planiscig, L. 1930, p. 23, Plate CII, No. 174.
Leithe-Jasper, M. 1973, No. 33.
Leithe-Jasper, M. 1976, No. 10.

The youthful athlete is almost naked. Part of a mantle is bunched over his left shoulder, where it is fixed with a trefoil clasp; thence it falls behind his back and is looped over his bent forearm.

Over his curly hair he wears a helmet with engraved decoration: this is of disproportionate size and probably not original, but is to all appearances contemporary and is known to have been part of the figure from the sixteenth century.

The artist was clearly acquainted with antique figures in the style of Polyclitus. There are analogies, for instance, with the so-called *Pompeius Spada* (cf Haskell and Penny 1981, pp. 296–300, and Reinach 1897/98, pl. 546, no. 3, and pl. 571, no. 6). This type of figure seems to have been used originally for Hermes but then adapted for statues of emperors. We cannot tell for certain whether the present figure is a particular divinity or merely an athlete, as the attributes that were in the hands are missing, and the actual position of the hands, unskilfully restored, scarcely admits of any reliable interpretation. Johann Primisser, in his 1788 inventory of the Ambras collection, wrongly identified the work as an *Apollo*; the large helmet rather suggests Mars or at any rate a warrior. Bode (1907), who took the model to be Polyclitus's *Oil-pourer*, described the figure merely as an athlete. Schlosser (1910) and Planiscig (1924) classified it as a gladiator from the stylistic circle of Antico. This view was shared by Leithe-Jasper (1973 and 1976), who however also drew attention to the extraordinary sharpness and perfect smoothness of the surface. He believed that the bronze cast was based on a carved boxwood model, and pointed out that its precisely afterworked surface bore a striking resemblance to a boxwood statuette of *Hercules* in the Wallace Collection in London, by the Paduan goldsmith Francesco da Sant'Agata. The largely engraved decoration of the helmet is also reminiscent of goldsmith's work. The fact that the helmet was not modeled and cast with the original figure but was added later is perhaps explained by the need to conceal a large casting flaw on the athlete's head.

The written signs on the dangling end of the cloak have so far resisted all interpretation; they may perhaps one day furnish a clue as to the artist's identity.

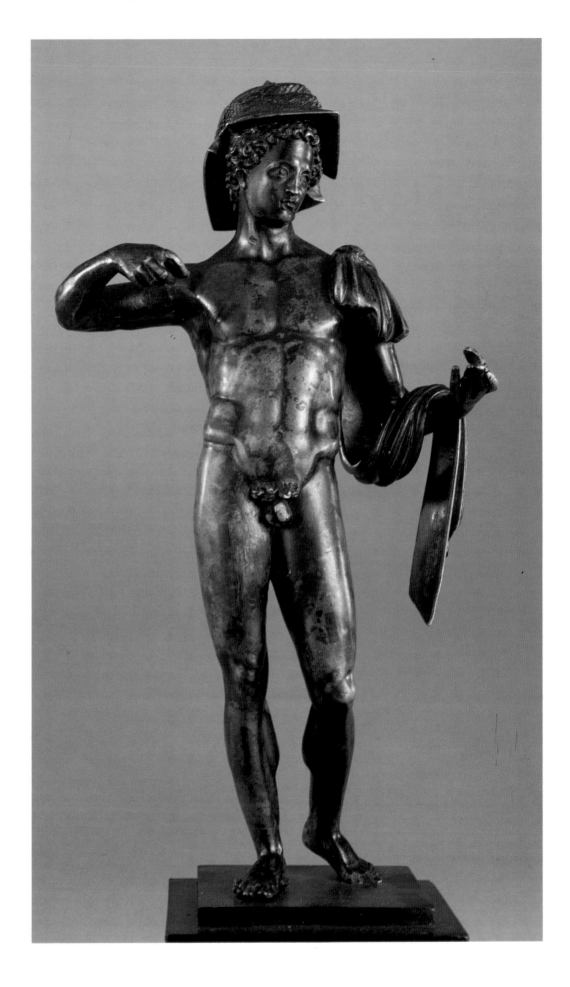

24. Pietà with angels

North Italian (Padua ?), second quarter of the sixteenth century

Tabernacle door. Bronze relief; thick cast. Beside the third angel from the right is a keyhole; on the back, sockets for two hinges and holes for the fastening of a lock and for mounting. On the front of the sarcophagus the inscription HVMANI / GENERIS / REDEN͞P TORI. Traces of gilding on the sarcophagus; the back or inside of the tabernacle door is also gilt. Otherwise dark brown patina and dark brown lacquer.
Height 21.3 cm, width 13.8 cm.
Inv. no. Pl. 8895.

PROVENANCE
Documented in 1883 as part of the estate of Prince Johann von und zu Liechtenstein; in 1892 donated by Prince Johann von und zu Liechtenstein to the Royal and Imperial Austrian Museum for Art and Industry. Transferred in 1935 to the collection of Sculpture and Decorative Arts at the Kunsthistorisches Museum in an exchange.

BIBLIOGRAPHY
Frimmel, T. 1883, p. 43, No. 749.
Ernst, R. 1914, p. 162.
Führer... Museum für Kunst und Industrie 1929, p. 18, Room IV, Case 6.
Mahl, E. 1966, p. 29, No. 234.

ADDITIONAL BIBLIOGRAPHY
Cope, M.E. 1965/1979, pp. 57–62.
Cessi, F. 1967, pp. 22–35, Plates 6–12.

The sarcophagus is shown in a rocky cave, with its lid resting against its right side. The body of Christ is in a seated position on the rear edge, supported by two angels; three other angels lament the Saviour's death. His hands are crossed in his lap, and his head is bowed to the right. Blood flows from the spear-wound in his side, inflicted by a soldier – traditionally Longinus – after the Crucifixion. In the background is a glimpse of a deserted Golgotha with the three crosses. Two clouds at the upper edge of the field. The inscription HVMANI / GENERIS / REDEN͞P TORI in Roman capitals on the front of the sarcophagus refers to Christ's redemption of mankind by His death on the Cross.

According to Catholic doctrine the Eucharist is a commemoration of the Last Supper of Christ and his disciples, at which, in accordance with Christ's words, bread and wine are transformed into his body and blood. On the door of the tabernacle or receptacle in which the consecrated host is kept, it was a frequent custom from the early fifteenth century to depict the Man of Sorrows, the body of Christ offered in sacrifice. In the present relief the sarcophagus, representing the tabernacle, is being opened in order that Christ's body may be removed. The scene is an allusion to the words "jube haec perferri..." in the Canon of the Mass: "Bid these things [the sacrifice of Christ] be carried by the hands of thy holy angel up to thy altar on high..."

The *Pietà*, combining the themes of lamentation, the Man of Sorrows and the mercy seat, with angels not so much sorrowing for Christ's death as upholding his sacramental body, appears to have originated in fourteenth-century France, and became extremely popular in northern Italy. Donatello may have given the impulse to this with his relief now behind the high altar of the Santo in Padua, considering that the door of the tabernacle of the altar is adorned with a relief of this theme by a pupil of Donatello's (*cf* also M.E. Cope 1965/79, pp. 58–62).

The composition of the relief with the indication of the cave of the sepulcher is based to some extent on Riccio's relief on the Paschal Candlestick in the Santo, and also Mantegna's engraving of the *Entombment*, from which comes the inscription on the sarcophagus. However, the artist of the Vienna *Pietà with angels* was a less talented sculptor, as is apparent particularly in the way in which the forms build up into ever higher relief instead of being treated perspectivally. The detail is handled minutely, giving a somewhat restless overall effect.

The relief was first classified by Frimmel (1883) as Italian, end of the fifteenth century; then ascribed to the school of Donatello (R. Ernst 1914); then more cautiously as Paduan, middle of the fifteenth century; and finally as Paduan, first quarter of the sixteenth century (Mahl 1966). Balogh (1975) emphasized its resemblance to a plaquette (Molinier I, no. 73) of which there is an example in the Kress collection of the National Gallery in Washington (Pope-Hennessy 1965, no. 344) and an enlarged example in the Museum of Fine Arts in Budapest. Balogh supposed a common prototype for these reliefs in a lost work by Bartolomeo Bellano.

The angels, however, are similar in type to those in the reliefs in the Cantoria of Santa Maria Maggiore in Trent, executed between 1534 and

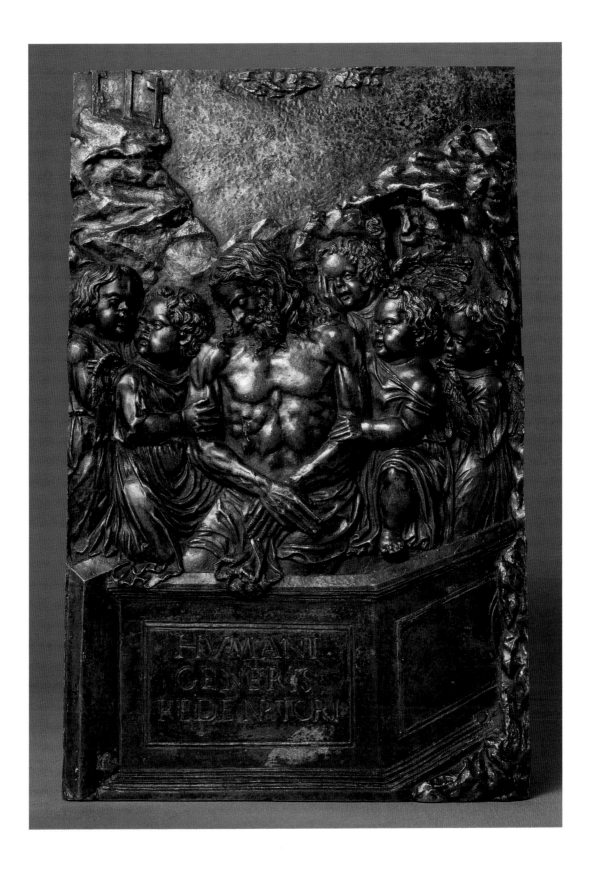

1542 by Vincenzo and Giovanni Girolamo Grandi. Moreover the very detailed, parallel, slightly creased folds of the drapery can be matched in the bronze busts of prophets in the same place, which are as expressively realistic as those in the *Pietà with angels*.

Accordingly I propose tentatively to attribute the tabernacle door with its relief of the *Pietà with angels* to the highly productive workshop of the Grandi in Padua, Trent and Vicenza. No replicas are known.

25. Flagellation of Christ

In a classical pillared hall, part of the vault of which has caved in, Christ is held bound to a column, writhing in pain under the scourgers' blows. On the right, behind him, a soldier draws the bonds tighter. A naked warrior on the right in front of him, a man in armor on the left behind him, and a mounted man behind the center column, swing back with their scourges in order to strike more violently. Looking on are a man standing, another crouching, and a warrior lying on the ground to the left; to the right, three warriors on foot and another crouching. Strewn on the ground are a corslet, two shields and a helmet.

A remarkable number of antique models are used. The figure of Christ bound to the column is directly based on the Vatican *Laocoön*. The two men wielding scourges on either side of Christ were related by Ilg (1890) and Bange (1922) to the *Horse-tamers* of Monte Cavallo. Planiscig (1924), more correctly, compared the figure of the naked warrior with that of a *Tyrannicide* in the courtyard of the Palazzo Medici-Madama in Rome at the beginning of the sixteenth century; and Pope-Hennessy (1965) pointed out that, at about the same time, Marcantonio Raimondi used similar motifs in his engraving of the *Massacre of the Innocents*. The soldiers in armor are from battle scenes on Roman sarcophagi. Blume (1985) has rightly pointed out that "there is more behind this unusual composition than mere enthusiasm for the antique". The marble sculpture of *Laocoön*, which Pliny the Elder regarded as the finest of all works of art, was seen in Renaissance times as expressing the quintessence of pain and sorrow, as an *exemplum doloris*. During the Counter-Reformation, which in general was somewhat hostile to antiquity and the pagan world, the *Laocoön* group was held up to the artist as a model for the representation of Christian themes. It was thus possible to equate the suffering Christ with the Trojan priest and to compare his sacrificial death with Laocoön's cruel end. A further point noted by Blume is that Laocoön sacrificed himself for Troy: the fall of Troy and Aeneas's flight led eventually to the foundation of ancient Rome, and a parallel was drawn with the mission of the Apostles, especially Sts Peter and Paul, which made Rome the center of the Christian world.

This work and its counterpart (cat. 26) are Moderno's largest plaquettes, and are in higher relief than is usual with him. The powerful figures, too, are unusually monumental for Moderno. They point to a direct study of ancient models, so that – although Mantegna's influence can be felt in the warriors' expressive features – it must be supposed that the plaquettes were executed in Rome. Pope-Hennessy (1964) considered that Moderno used as models only the engravings of Giovanni Antonio da Brescia and Marco Dente, but this is probably not correct. An engraving by Giovanni Antonio da Brescia, dated 1509 (Hind 1948, pl. 535) might, as Pope-Hennessy (1965) supposed, have suggested the architecture of the relief, but it can equally well be related to Bramante (Ilg 1890).

The execution is extremely precise and delicate. The background seen behind the pillared hall is differentiated by roughening so that it gives the effect of clouds, while the polished architecture stands out with a three-

Moderno.
Active *c.*1490–*c.*1540
(See Biography, p. 281)

Silver plaquette in high relief. Firegilt except for the flesh parts. On the column above the figure of Christ the Vienna reassay mark C.A. for 1805–07. On the base of the column at Christ's feet the inscription OP MODERNI.
Height 13.8 cm, width 10.2 cm.
(Planiscig's measurements (1924) are wrong).
Inv. no. Pl. 1105.

BIBLIOGRAPHY
Cicognara, L. II, 1816, p. 433.
Schottky, M.J. 1821, Fol. 153 v.
Ticozzi 1831, II, pp. 463.
Schmidt, A. 1837, Band II, Section II, p. 159.
Molinier, E. 1886, I, pp. 126–128, No. 170.
Rizzini, P. 1889, No. 39.
Ilg, A. 1890, pp. 100–110.
Jacobsen, E. 1893, p. 65, No. 7.
Bode, W. 1904, c. 269.
von Schlosser, J. 1910, p. 5, Plate x/1.
Gábor, I. 1923, No. 716.
Planiscig, L. 1924, p. 247, No. 408.
Planiscig, L. 1925, pp. 28, 29, Ill. 15.
Cordonnier, E. 1927, p. 182.
Bange, E.F. 1929, p. 192, No. 112.
Planiscig, L. 1930, p. 604.
Planiscig, L. 1931, No. 68.
de Ricci, S. 1931, p. 132, No. 169.
Planiscig, L. and Kris, E. 1935, p. 52, Room x, Case 7, No. 18.
Middeldorf, U. 1944, pp. 33, 34, Nos. 130, 131.
Imbert, E. and Morazzoni, G. p. 54, No. 99 and No. 100.
Cott, P.B. 1951, p. 103, No. 174.
Pope-Hennessy, J. 1964[2], pp. 197–200.
Santangelo, A. 1964.
Pope-Hennessy, J. 1965, pp. 42, 43, No. 134.
Mahl, E. 1966, pp. 22, 23, No. 217.
Leeuwenberg, J. and Halsema-Kubes, W. 1973, pp. 406, 407, No. 707.
Rossi, F. 1974, pp. 37, 38, No. 49.
Balogh, J. 1975, p. 275, No. 417.
Wixom, W.D. 1975, Nos. 34, 35 with list of replicas.
Hirsch Collection 1978, II, p. 193, No. 366.
Cannata, P. 1982, p. 50, No. 26.
Blume, D. 1985.
Lewis, D. 1984/1986.

PROVENANCE
In 1802 documented in the Imperial Collections at the Franzensburg in Laxenburg near Vienna; in 1872 transferred from Laxenburg to the Ambras collection and transferred with the entire collection to the Kunsthistorisches Museum in 1891.

REPLICAS AND VARIANTS, following F. Rossi 1974, p. 38, W.D. Wixom 1975, nos. 33/34, J. Balogh 1975, no. 417 and others.
Amsterdam, Rijksmuseum, 13.5 × 10 cm, with the vault broken (Leeuwenberg 1973, pp. 406, 407, no. 707).
Berlin, Kaiser-Friedrich-Museum, 13.9 × 10.2 cm, with the vault broken (Bange 1922, no. 453) now Berlin, Staatliche Museen.
Berlin, Collection E. Simon, 13.6 × 10.2 cm, with the vault broken (Bange 1929, p. 192, no. 122).
Berlin, formerly L. von Schacky Collection (Berlin, R. Lepke 1914, no. 237).
Brescia, Civico Museo, 14.5 × 10.7 cm, without background (Rizzini 1889, no. 39; Rossi 1974, pp. 37, 38, no. 49).
Budapest, I. Gábor Collection, (Gábor 1923, no. 716).
Budapest, Museum of Fine Arts, 14.3 × 10.8 cm, with the vault intact (Balogh 1975, p. 275, no. 417).
Cleveland, Museum of Art, 14 × 10 cm, with the vault intact (Wixom 1975, no. 33).
Cleveland, H. Schneider Collection, 13.3 × 9.8 cm, with the vault broken (Wixom 1975, no. 34).
London, British Museum, (F. Rossi 1974, p. 38).
Milan, E. Imbert Collection, 15 × 11.5 cm, without background (E. Imbert n.d., p. 54, no.99).
Milan, E. Imbert Collection, 14.2 × 11 cm, with the vault broken (E. Imbert n.d., p. 54, no. 100).
Milan, Museo Civico del Castello Sforzesco (F. Rossi 1974, p. 38).
Oxford, Ashmolean Museum.
Paris, Cabinet des Medailles (F. Rossi 1974, p. 38)
Paris, Musée de Cluny (F. Rossi 1974, p. 38).
Paris, formerly Baron de Théis collection (Paris May 6 1874, no. 898).
Paris, formerly Spitzer collection, 13.5 × 10 cm (Molinier 1892, p. 135, no. 13).
Prague, formerly A. Von Lanna collection, 13.4 × 9.8 cm, with the vault broken; Lepke sale, Berlin 1911, no. 323.
Rome, Museo di Palazzo Venezia, formerly Auriti collection, 14.8 × 11.3 cm, with the vault broken (P. Cannata 1982, p. 50, no. 26).

dimensional effect. The plaquette is a counterpart to cat. 26 and, as Blume (1985) suggests, the two together may have formed a devotional diptych.

The discovery of the *Laocoön* group in Rome in January 1506 must be a *terminus post quem* for the Flagellation relief, while the *terminus ante quem* is Montorsoli's completion of the *Laocoön* figure with outstretched right arm (1532/33). Numerous bronze replicas are known. Variants in which the vaulting is intact instead of being half in ruins as in the silver relief were described by Middeldorf (1944) as representing a later state. In some later casts, *eg* in the Museo Civico in Brescia, the background arches are cut away. Electrotype reproductions made from the 1860s onward by the Vienna firm of C. Haas for the Austrian Museum of Decorative Art, are frequently met with: they can be recognized by the integrally cast Vienna reassay mark of 1805–07 with the letters C.A. (actually a half moon followed by A.).

The present plaquette and cat. 26 were first noticed and appreciated for their true importance by Gaetano Cattaneo, director of the Cabinet of Medals of the Zecca in Milan, during a journey through Austria and Hungary in 1813. He informed L. Cicognara, who wrote as follows in 1816:

"Ma il signore Cattaneo, direttore del gabinetto di medaglie nella zecca Milanese, dottissimo literato e versatissimo nello studio della numismatica non meno che nell'arte del disegno che egli professa, ci rese conto d'aver osservato nella cappella del castello di Luxemburgo [*sic*: 'Laxenburg' is intended] due bassi rilievi in argento di un lavoro sommamente accurato, e di un merito d'arte squisito. L'uno rappresenta la flagellazione in cui Cristo è imitato dal Laocoonte, l'altro la Madonna sedente fra varj Santi in cui fra altre molte figure si distingue un San Sebastiano per somma bellezza; non v'è altra iscrizione che la seguente: OP-MODERNI."

It is notable that it was Cattaneo and not Molinier who first noticed that the figure of Christ was imitated from the *Laocoön*, whereas J.M. Schottky (1821) wrote only: ". . . the subject of one [relief] is taken from Roman history and the other from Scripture"; A. Schmidt (1837) actually spoke of "casts of mythological scenes".

Santa Barbara, University of California Art Galleries, Morgenroth collection, 16.7 × 12.1 cm, with the vault broken.
(U. Middeldorf 1944, p. 33, no. 230.)
Santa Barbara, University of California Art Galleries, Morgenroth collection, 13.9 × 10.6 cm, with the vault intact
(U. Middeldorf 1944, p. 34, no. 231.)
Turin, Museo Civico, (F. Rossi 1974, p. 38).
Venice, Museo Correr, (E. Jacobsen 1893, p. 65, no. 7).
Vienna, Kunsthistorisches Museum, 14.5 × 11.2 cm, with the vault intact (Planiscig 1924, p. 248, no. 410).
Vienna, Austrian Museum for Applied Art.

Vienna, formerly Collection Z. (Dorotheum sale, no. 339, 1923, no. 285.)
Vienna, formerly A. Walcher von Molthein collection, 14.1 × 10.6 cm (M. Bernhart 1926, p. 5, no. 30).
Vienna, Private collection, formerly Robert von Hirsch collection, 13.5 × 10 cm; sale catalogue Sotheby's London 1978, II, p. 193, no. 366, close to the example in Amsterdam.
Washington, National Gallery, Kress collection, 13.4 × 9.9 cm, with the vault broken (J. Pope-Hennessy 1965, no. 134, fig. 171).
Washington, National Gallery, Widener collection, 14.5 × 10.5 cm, with the vault broken.

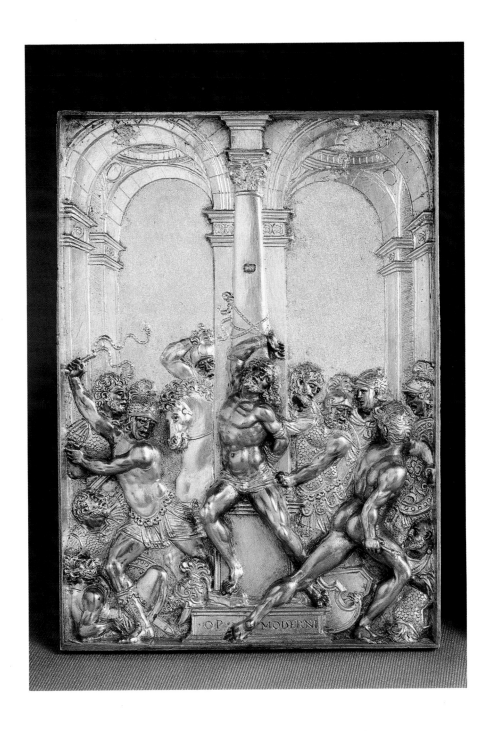

26. Madonna and Child with saints

Moderno.

Active *c.1490–c.1540*
(See Biography, p. 281)

Silver plaquette. The figures of St
George and St Sebastian in the fore-
ground separately cast and riveted
on. Firegilt except for the flesh parts.
In the center of the upper border of
the frame the Vienna reassay mark
of 1805/07; a truncated pin visible on
each side.
Height 13.9 cm; width 10.2 cm.
(Planiscig's (1924) measurements are
wrong).
Inv. no. Pl. 1107.

PROVENANCE
First documented in 1802 in the imperial col-
lection at Schloss Laxenburg near Vienna. In
1872 transferred from Laxenburg to the
Ambras collection. Transferred with the en-
tire collection to the Kunsthistorisches
Museum in 1891.

The Virgin sits on a throne on a high pedestal, the front of which represents
a classical scene of sacrifice. She holds the Christ child to her left side, and ex-
tends her right hand to protect or bless two figures standing beside her in the
background to her right. Both the Virgin and child are gazing toward the
infant St John the Baptist, who kneels on the pedestal at their left and shows
them a lamb. Behind the pedestal, St Joseph stands on the Madonna's left.
This central group is flanked by four more saints, two on each side. In the
foreground on the Madonna's right is the soldier St George, resting his right
foot triumphantly on the dragon's head. With his left hand he offers the
Madonna fruit, probably pomegranates. The old, bearded saint behind him
cannot be certainly named, owing to the lack of an attribute. It may be St
Anthony Abbot, who is often portrayed together with St Jerome: the latter
can be recognized in the bearded man opposite, leaning on a stick and identi-
fied by the small lion at his feet. In front of him is St Sebastian: though not
pierced by arrows he is easily identified in this case as the only youthful saint
to be portrayed naked. In front of the pedestal two *putti* are inciting two
cocks to fight. An extremely detailed piece of grotesque work closes the
scene as with a backdrop.

The strikingly antique character of the relief in general and the figures in
particular, excepting only the two aged, bearded saints, has recently been
convincingly explained by Blume (1985). The clue lies in the attempt to syn-
thesize different religions by means of hermetism, which was an unfulfilled
dream of scholars at the beginning of the sixteenth century. In this case, as
Blume shows, it is not a question of an occult iconography under cover of a
Christian theme, but of a combination of figures from ancient mythology
and from the Christian story, whose affinity with one another only becomes
clear in Christian terms.

The Madonna *Theotokos* in her antique robe brings to mind represen-
tations of Isis with her son Harpocrates, but also of Venus and Cupid. The
sacrifice of a bull, depicted on the pedestal, refers to the bloody sacrifice of
Christ, as does the lamb offered by the infant St John.

St George, as a knight, wears the armor of a Roman general or *imperator*,
but his pose is based on a statue of Hercules that was in the Palazzo dei
Conservatori in Rome from the end of the fifteenth century. Hercules-
George offers to Venus-Mary the apples of virtue from the garden of the
Hesperides, having slain the dragon (symbolizing vice) that was on guard
over them.

St Sebastian – one of the finest nude figures of the period – derives direct-
ly from an antique figure, probably the Farnese *Hermes* now in the British
Museum, which was in the courtyard of the Casa Sassi in Rome around
1500, and which Antico had already used for Mars on the reverse of his
signed medal of Gianfrancesco Gonzaga. However, from the vineleaves in
his hair St Sebastian also bears the appearance of Dionysus. As Planiscig
noted in 1924, his head resembles that of Tullio Lombardo's *Bacchus* in
Vienna. Dionysus's attribute is a wreath of vineleaves, signifying initiation
into divine mysteries. In the case of the Christian martyr, Blume argues, it

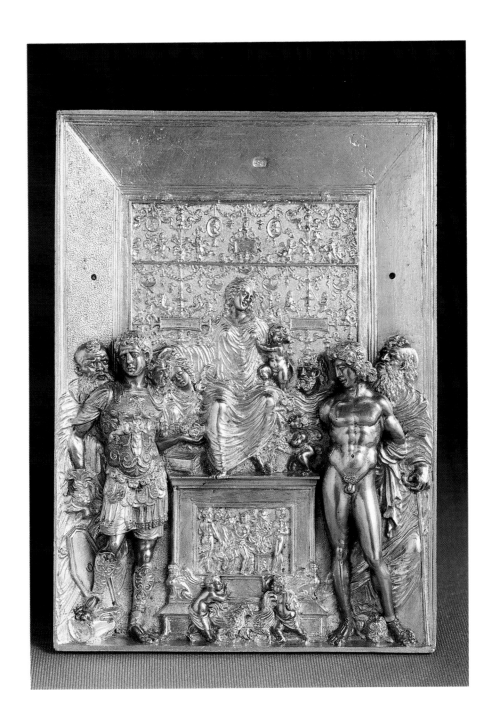

BIBLIOGRAPHY
Essentially as cat. 25, however:
Molinier, E. 1886, I, pp. 122–124, No. 166.
Planiscig, L. 1924, No. 409.
Mahl, E. 1966, No. 218.
Lewis, D. 1986.

refers to the Eucharistic transformation of Christ's blood into wine, so that the figure of St Sebastian here expresses a parallel between pagan worship and Christian rites.

Finally Blume draws attention to the young woman in the background, who has presumably placed the casket on the pedestal and who, with closed eyes, leans her head against that of the man seen in profile beside her. This figure, sheltered by the sanctifying hand of the Mother of God, is allegedly Psyche, Cupid's earthly beloved, whom Venus sent to Proserpine, queen of the underworld, to fetch a casket containing the gift of divine beauty. However, on her return from Hades, overcome by curiosity, she opened the box and fell into a deadly sleep, from which only Cupid could awaken her. In the Christian setting, according to Blume, this can only be seen as a metaphor of the resurrection and the immortality of the soul. Symbolized by the still sleeping figure of Psyche, the soul waits to be awakened by the god of love, or by Christ, and in this way to rise again – and the Madonna's gesture already gives assurance that it will be so. As to the figure against whom Psyche is leaning, according to Blume this is the donor of the two reliefs, who in this way entrusted his soul, not yet redeemed, to the Virgin's intercession.

More curious than convincing is Cordonnier's (1927) suggestion that the two figures represent Lucrezia Borgia and Alfonso d'Este and that the plaquette was commissioned by the Borgia Pope Alexander VI on the occasion of their betrothal in 1502. This overlooks the fact that the companion relief (cat. 25) cannot have originated before the discovery of the *Laocoön* group in January 1506. It is particularly clear in the plaquette of the Virgin that, apart from antique models, Moderno must have been strongly influenced by Antico's works, which he must have seen while active in Mantua (Lewis 1984/86).

This plaquette also displays extraordinary skill in the subtle rendering of all the details and the textural variation of the surface. Thus the delicately roughened background contrasts clearly and sharply with the decoration of St George's armor or the detailed grotesque work with its graceful candelabras, festoons, dancing cupids and satyrs, horse-tamers and so on. The somewhat coarsely roughened left-hand border of the frame, which is at the same time part of the architecture, suggests shadow and thus gives an effect of depth. The height of the relief is also striking. The figures of St George and St Sebastian are separately cast and attached by riveting, which is unique in Moderno's large *œuvre* of plaquettes and also shows that he must have executed small independent works of sculpture. The present plaquette is therefore the only possible basis for any research in that direction.

Although the borders are quite different, this plaquette is certainly a pendant to that of the *Flagellation*: the two depict respectively the Incarnation and the Passion, the twin poles of redemptive theology.

Blume (1985) supposed that the two reliefs were originally mounted to form a devotional tiptych, the full meaning of which, however, would have been discernible only to scholars.

A *terminus post quem* for the plaquette of the *Flagellation*, and therefore for the present plaquette, its counterpart, is the discovery of the *Laocoön* group in Rome in 1506. The number of quotations from antique sculptures then in Rome makes it certain that the plaquette was executed during Moderno's stay in that city, even though, as Pope-Hennessy (1965) observed, he could have known some of these models from very early graphic copies. As with the copy of the *Laocoön* in the *Flagellation* relief, the extraordinarily sculptural quality of the figures in the present plaquette is evidence of Moderno's direct acquaintance with antique monumental sculpture.

Unlike the relief of the *Flagellation*, no early replicas of this one are known. Since the two foreground figures were cast separately there seems to have been no reproducible model in the present case. This also gives the important indication that the replicas of the Flagellation plaquette were not made from the silver relief itself but from the model. Decorative details that are missing from the bronze versions were added to the silver plaquette at the afterworking stage.

It is not unusual, on the other hand, to encounter forgeries after the electrotype reproductions made in the 1860s by the firm of C. Haas for the Austrian Museum of Decorative Art. A variant, perhaps of somewhat earlier date, is seen in the plaquette Molinier no. 164.

Although the present plaquette is unsigned, Moderno's authorship has never been questioned, and the work has always been regarded as a pendant to cat. 25. The first documentary mention of the two works is by L. Cicognara (1816), referring to an enthusiastic report by G. Cattaneo, director of the museum of the Zecca in Milan, who saw them in about 1813 on a visit to the Franzensburg in the park of the imperial palace at Laxenburg near Vienna (*cf* cat. 25).

27. Artemis, as Protector of Young Wild Animals

North Italian (Padua), beginning of the sixteenth century, probably from a model by Giovanni Maria Mosca active 1507–73 (See Biography, p. 281)

Bronze relief; fairly thick cast. At the back, cavities behind the goddess and the bear. Two holes at the level of the cornice of the niche; only the right-hand one is visible from the front. Casting flaws on the left upper arm and right knee. Dark brown lacquer over brown natural patina. Height 21.8 cm, width 11.8 cm. Inv. no. Pl. 9019.

PROVENANCE
Spitzer collection, Paris, Vente 1893, Lot. no. 1611. Gustav von Benda collection, Vienna. Bequeathed by Gustav von Benda to the Kunsthistorisches Museum in 1932.

BIBLIOGRAPHY
Molinier, E. 1893, Vol. II, p. 15, No. 1611.
Planiscig, L. 1927, p. 89, Ill. 77.
Braun, E.W. 1954, pp. 784, 785.
Mahl, E. 1966, p. 29, No. 233.

The relief does not depict Circe or Ops, as is sometimes maintained (E.W. Braun 1954 and, following him, E. Mahl 1966; E. Molinier 1893 and L. Planiscig 1927 do not indicate the subject), but Artemis in her role as fosterer and protector of wild creatures. The bear and stag are exclusively her attributes, while Circe is as a rule associated with Odysseus's companions, turned into swine.

The goddess is standing in front of an architectural niche. Her hips are draped only with a cloth which falls to the ground behind her. Her left foot rests on a pedestal, and the upper part of her body leans forward. Her left hand is raised to her breast; in her lowered right hand she holds out a bunch of fruit or foliage to a young deer and a young bear crouching at her feet. The foreground is depicted as a meadow with springing tufts of grass and fruits. The relief may be based on a graphic model: this would account for the flatness of its design despite its unusual height of relief, and also the unclear spatial position of the deer, which is within the apse of the niche yet seems to come out from behind the side pier. The supposition is also borne out by the way the goddess's hair is blown out behind her, as if by a puff of wind.

Molinier (1893) ascribed the relief to Peter Vischer. Planiscig (1927) rightly assigned it to Padua, but his dating (late fifteenth century) is too early. Stylistically the work is close to Giovanni Maria Mosca. The figure's uncertain pose, and the knotted folds of the drapery laid over each other crosswise, can also be seen in his relief of the *Judgment of Solomon* in the Louvre, or his *Portia* in the Ca' d'Oro in Venice. The windblown hair recalls his *Venus Anadyomene* in the Victoria and Albert Museum in London, and the niche with its delicate ornament of tendrils resembles the arch in the relief of *Lucretia* in the Walters Art Gallery in Baltimore.

A certain similarity between Artemis's head and Riccio's female satyrs, on the one hand, and the above mentioned uncertainties in the spatial arrangement and also in the foreshortening of the goddess's right foot on the other suggest that this was a youthful work of Mosca's. Such evident weaknesses are rather unusual for a relief of Paduan origin, and are only explicable in a juvenile work. It was perhaps on their account that Molinier (1893) ascribed the relief to Peter Vischer rather than to any artist in Italy, where problems of perspective had been thoroughly mastered.

According to Marcantonio Michiel, the founder Guido Aspetti, known as Lizzaro, possessed some clay models of Mosca's. Perhaps he was the caster of this relief?

Technical characteristics, above all the cavities at the back of the relief behind the raised figures, connect the Vienna *Artemis* with the fine relief of a *Satyress* in the Cleveland Museum of Art (inv. no. 68.25; Wixom 1975, cat. 91) and with the relief of *Dido's Suicide* in the Museo di Palazzo Venezia, Rome (inv. no. P.V. 10824, formerly in the Auriti collection; Cannata 1982, cat. 45). The Vienna relief also shows marked similarities of style to these small reliefs, the attribution of which to Riccio is hardly tenable.

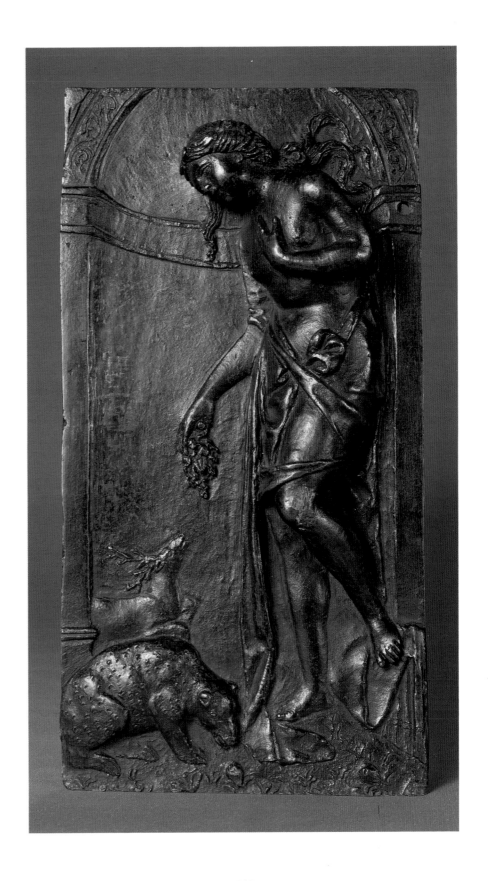

28. Head of a girl

Antonio Lombardo (?)

c.1458–1516

(See Biography, p. 280)

Bronze; hollow cast. Brown natural
patina, over it scanty remains of
brown lacquer.
Height 17.3 cm.
Inv. no. Pl. 9098.

PROVENANCE

Gustav von Benda collection, Vienna. In 1932
bequeathed to the Kunsthistorisches Museum
by Gustav von Benda.

BIBLIOGRAPHY

Bode, W. 1907, I, p. 38, Plate LXXVI.
Goldschmidt, F. 1914, p. 3, No. 10.
Planiscig, L. 1921, p. 254.
Bode, W. 1922, p. 54, Plate LXIX.
Planiscig, L. 1930, p. 26, Plate CXXIV, Nos.
 216, 217.
Mann, J.G. 1931, with supplement 1981.
 p. 26, No. 5, 62.
Planiscig, L. 1932, p. 914.
Planiscig, L. 1937, p. 115.
Pope-Hennessy, J. 1961–1962, No. 83.
Pope-Hennessy, J. 1963, p. 22.
Jantzen, J. 1963, p. 110.
Montagu, J. 1963, p. 41, Fig. 40.
Weihrauch, H.R. 1967, p. 128.
Leeuwenberg, J. and Halsema Kubes, W.
 1973, p. 385, No. 653.
Ruhmer, E. 1974, p. 71.
Sheard, W.S. 1978, No. 85.

The girl's head is slightly inclined to the right; the very fine, wavy hair is center-parted, taken back, plaited and wound into a wreath shape at the back of her head. The truncation of the bust cuts half way through the shoulders, scarcely below the base of the neck. The shoulders are draped with a garment, the surface of which is roughened with a fine file. This detailed differentiation in the texture of the hair and garment contrasts with the smooth skin of the face and neck, lightening these and giving the bust a naturalistic look. The inclination of the head, the small parted lips, the finely carved almond eyes with the slightly shadowing lids and the powerfully drawn pupils that seem to gaze into an indeterminate distance, all combine to give the subject a poetic, dreamy expression.

The bust belongs to a group of similar bronzes of which there are two variants in the Museo Estense in Modena and another in the Wallace Collection in London. These are of equally high quality. The truncation is somewhat lower, and the busts therefore a little higher than the one in Vienna. The bust in the Wallace Collection, and one of the two in Modena, have the head turned to the left. A somewhat larger replica of this version was in the Kaiser Friedrich Museum in Berlin. In the Fortnum collection in the Ashmolean Museum in Oxford there is a head without the bust (previously Spitzer collection, sale catalogue Paris 1893, lot 1495); the Smith College Museum, Northampton, Massachusetts possesses a similar head, but with a ribbon and jewel in the hair.

Bode (1907) and Planiscig (1927) attributed the girls' heads to Tullio Lombardo on the strength of analogies to his double portraits in the Ca' d'Oro in Venice and the Kunsthistorisches Museum in Vienna, as well as other works which are not quite certainly his. Later, however, Planiscig (1937) ascribed the group to Tullio's younger brother Antonio Lombardo, as the "sensitive features" reminded him of the child Jesus in the latter's *Madonna della Scarpa* on the altar of the Zen Chapel in St Mark's in Venice. Pope-Hennessy (1963) agreed with this view, observing that "the form of the eyes and the modeling of the cheeks suggest a connection with Antonio"; earlier (1961/62) he had assigned the busts to Tullio. Weihrauch (1967) and Ruhmer (1974) similarly decided for Antonio Lombardo.

Pope-Hennessy compared the group with the bust of a man in the Rijksmuseum in Amsterdam (inv. no. N.M. 12080). The similarity of expression to the Christ child in Antonio Lombardo's *Madonna della Scarpa* cannot be disputed; but the work was not cast and completed under Antonio's supervision, as he had left Venice in 1506 for the service of Alfonso I d'Este in Ferrara, leaving his brother Tullio to supervise the completion of the Zen Chapel. There seems to be a much closer resemblance between these busts and Tullio's works dating from the end of the fifteenth century and beginning of the sixteenth – such as the portrait of a young couple as *Bacchus and Ariadne* in Vienna, the *Adam* from a Vendramin tomb now in the Metropolitan Museum in New York, and the figures on the tomb of Giovanni Mocenigo in Santi Giovanni e Paolo in Venice – than with works by Antonio. Apart from the *Madonna della Scarpa* and some other details of the

altar of the Zen Chapel, we know as few works of Antonio's designed expressly to be executed in bronze as of Tullio's. Antonio's bronze reliefs of *Mars*, *Venus* and *Cupid* in Berlin, and the *Peace* in Washington, which are connected with his name, are based on works originally executed in marble. However, the women's heads in these reliefs clearly differ from the group under consideration.

It is noteworthy, and at first sight an argument for Antonio's authorship, that two of these busts (the ones at Modena) belonged to the Este family; but Tullio as well as his brother may have had connections with the court at Ferrara. This is probably also the reason why Ruhmer dated the busts to Antonio's years of activity in Ferrara, since his argument on grounds of style is not convincing. Above all, the *modelli* for the busts cannot have had a "*bozzetto*-like quality", since even the ablest chaser could not then have imparted the perfect smoothness of the skin and the admirable delicacy of the coiffure which are the busts' main distinguishing marks.

The motif was highly popular, as is shown by the comparatively large number of extant replicas and variants. This was probably because the busts were inspired by a Roman portrait type of the Severan period rather than by any corresponding contemporary antiquarian taste. Among many examples we may cite the marble head of a Roman woman (AD 200) in the Ny Carlsberg Glyptothek in Copenhagen (V. Paulsen 1974, no. 159, cat. 717), or the portrait of Faustina the Younger. The variant in the Smith College Museum is unique in that the girl is in contemporary dress. Sheard (1978) dates it, no doubt rightly, earlier than the girls in classical garb.

It seems worth considering whether these busts are not based on a model by Tullio or Antonio Lombardo, but afterworked by Severo da Ravenna. Arguments for Severo would be, *inter alia*, the fine-strandedness of the hair, which goes beyond what is known to have been usual with the Lombardo, and the number of replicas, which is characteristic of Severo's workshop. However, no survey of Severo's larger works at present exists.

29. Head of a child

The child's longish hair is center parted and enframes his face in a wreath of curls. The eyes, now empty, were probably originally inlaid with a different material, perhaps silver or more likely glass paste, in a technique described by Pomponius Gauricus in 1504 and that can be seen in a similar child's head in the Ca' d'Oro in Venice. (In a replica of this in the Kunsthistorisches Museum, Planiscig 1924, no. 140, the eyes are integrally cast in bronze.) In using different material for the eyes the unidentified artist followed a custom that was not unusual in Greek, Etruscan and Roman bronze sculpture. Schlosser (1901) dated the head not later than the fifteenth century. Bode (1907) classified this group of heads as very free imitations of classical models, probably executed in northern Italy at the beginning of the sixteenth century; Planiscig (1921 and 1924) concurred. Planiscig (1924) pointed out similarities to the work of Simone Bianco, active in Venice in the first half of the sixteenth century. Following this suggestion, and in view of the similarly forceful and three-dimensional modeling of the face and hair, Leithe-Jasper (1976) compared the child's head with the bust of a Roman (cat. 30), attributed to Simone Bianco by P. Meller (1977).

Venetian, first half of the sixteenth century, close to Simone Bianco, recorded 1512–1553
(See Biography, p. 279)

Bronze, thick-walled cast. The eyes hollow; the neck probably cut off at the model stage. Small casting flaws on the forehead, by the left eye and on the right cheek. Remains of blackish-brown lacquer; intensive dark brown natural patina. The inside of the head is largely filled with a substance for mounting purposes.
Height 15.5 cm.
Inv. no. Pl. 5597.

PROVENANCE
From the collection of Josef Angelo de France (Martini 1781, p. 107, Capita et Imagines, Scrinium VII, no. 202. (Ser. 3. Cat. A.n. 933) "Pueri ignoti caput, sine collo, et oculorum loce foramina. Aes, 5 1/4 alt, 5 1/18 crass." Acquired in 1808 for the Imperial and Royal Cabinet of Coins and Antiquities; transferred to the Ambras collection in 1880 and transferred with the entire collection to the Kunsthistorisches Museum in 1891.

BIBLIOGRAPHY
von Schlosser, J. 1901, p. 13, Plate XVIII.
Bode, W. 1907, Vol. II, p. 10, Plate CIX.
Planiscig, L. 1921, p. 243 and Ill. 351.
Bode, W. 1922, p. 77, Plate XCI.
Planiscig, L. 1924, No. 141.
Planiscig, L. 1930, p. 25, Plate CXX, Ill. 206.
Weihrauch, H.R. 1967, p. 129.
Leithe-Jasper, M. 1973, No. 37.
Leithe-Jasper, M. 1976, No. 39.

30. Head of a man

Simone Bianco

recorded 1512–1553
(See Biography p. 279)

Bronze, the eyes inlaid in silver. Openings at the ears and nostrils; a hole where the neck joins the chest, another on the back, and a third, stopped by a screw, at the top of the head. Two more very small holes in the head, probably where casting pins or plugs have fallen out. The letter A scratched on the inside, above the small hole in the back. Black lacquer over green artificial patina and dark brown natural patina.

Height 17.4 cm.

Inv. no. Pl. 5615.

PROVENANCE

From the collection at Schloss Ambras, possibly documented as early as 1596 in the inventory of Archduke Ferdinand II (Boeheim 1888, p. CCXVII, fol. 421, "Mer ain metales prustbild, khert den Kopf auf die rechte seiten!") Documented with certainty in the unpublished Ambras inventory of 1788, compiled by Johann Primisser (p. 118, case VII, no. 126. "Ein antiker Kopf mit den Schultern, auf deren Linken ein Stück Kleid festgemacht ist. Ich halte es für das Bildnis des großen Pompejus. Die Augen sind weiß. v. Erz. 6 1/2 Z. hoch".) Transferred with the entire Ambras collection to the Kunsthistorisches Museum in 1891.

BIBLIOGRAPHY

Meller, S. 1917, No. 6.
von Baldass, L. 1917, pp. 396, 397.
Bode, W. 1922, p. 31.
Planiscig, L. 1924, No. 107.
Planiscig, L. 1930, p. 23, Plate CII, Fig. 177.
Jantzen, J. 1963, p. 110.
Balogh, J. 1965, p. 70.
Aggházy, M. 1968, No. 3.
Leithe-Jasper, M. 1973, No. 6.
Balogh, J. 1975, No. 186 (with additional bibliography relating to the Budapest specimen).
Leithe-Jasper, M. 1976, No. 37.
Meller, P. 1977, p. 202.

The bust is of a middle-aged, beardless man. His head is turned to the right; his hair, close-cropped at the back, is longer on the crown and curls over his forehead and temples. The eyes are inlaid in silver, but the whites and pupils are not differentiated. The drapery over his left shoulder is fastened with a disk-shaped brooch.

Primisser (Ambras inventory, 1788) thought the bust, which was believed to be antique, represented Pompey. As Baldass (1917) conjectured, his opinion was based on a superficial resemblance to the colossal statue in the Palazzo Spada in Rome, which was for a long time erroneously supposed to be the one at the foot of which Caesar was murdered in the Capitol. From the mid-sixteenth century onward, if not before, this statue was one of the best-known in Rome; it was frequently published in the latter part of the eighteenth century (cf Haskell and Penny 1981, pp. 296–299), and was doubtless known as far afield as Ambras.

A variant of the bust in the Budapest Museum of Fine Arts has a deeper bust but no drapery and is less differentiated in detail. It belonged to the sculptor István Ferenczy, who in 1847 described it as a work of Greek antiquity. However, Simon Meller (1917), who first published the bust, regarded it as Florentine, c.1500. Baldass (1917), in his review of Meller, was the first to draw attention to the Vienna example; he assigned both busts to North Italy and proposed a date c.1480, while Bode (1922) ascribed them to "Padua, c.1500". Planiscig (1924), who was the first to publish the Vienna bust, described it as "North Italian, c.1500", which he modified (1930) to "North Italian, beginning of the sixteenth century, close to Antico in style". Balogh (1965), followed by Aggházy (1968), attributed the Budapest example to Antico, while Leithe-Jasper (1973 and 1976), following Planiscig, classified the Vienna bust as North Italian, beginning of the sixteenth century, and on stylistic grounds ascribed it to a follower of Antico.

Peter Meller (1977), attempting to establish an œuvre of the sculptor Simone Bianco – active in Venice in the first half of the sixteenth century, and highly praised by Pietro Aretino – attributed the Vienna bust and the Budapest variant to that artist and compared them with a signed marble bust in Stockholm; he discerned an additional Venetian aspect in a resemblance to the classical so-called *Vitellius* in the Grimani legacy to Venice now in the Museo Archeologico. If the detailed rendering of the short hairs on the back of the head in the bronze busts is compared with that of the "Pseudo-*Julius Caesar*" – a marble bust in the Ca' d'Oro in Venice, which Meller also attributed to Simone Bianco – there is further confirmation for the suggested Venetian origin of the busts.

There is also some resemblance to the *Head of a Child* (cat. 29), in which Planiscig (1924) already noted a similarity to Simone Bianco's work.

There is a further, much later variant in the Metropolitan Museum, New York (from the Untermyer collection). This is probably the example previously in the Pannwitz collection, and perhaps earlier in the E. Chappy collec-

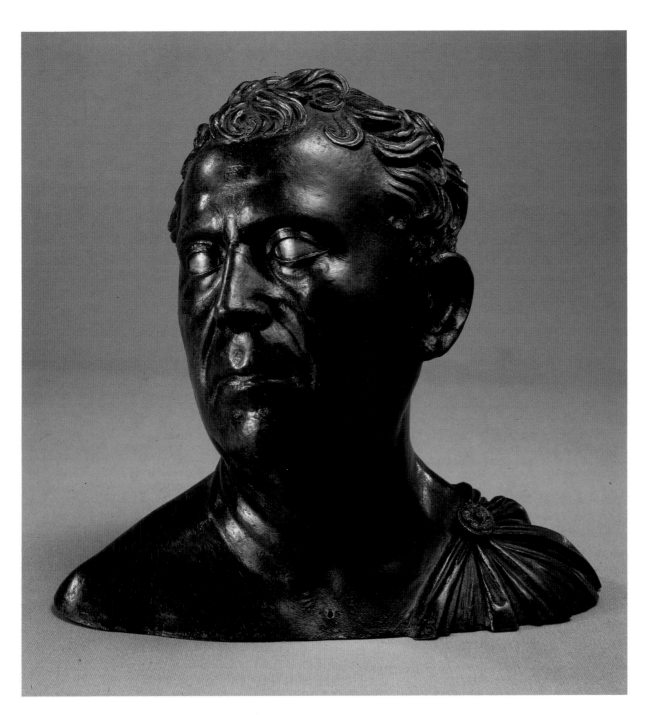

tion (sale 1907, cat. 1721). Like the variant in Budapest it shows no drapery;
in height of bust profile it lies between the Budapest and Vienna versions.
According to Ybl, there is an example in the Lyons Museum, and another in
Madrid (letter from A. Radcliffe).

31. Alexander the Great

North Italian, mid-sixteenth
century

Bronze bust. Thick-walled cast with
slight casting flaws in the breastplate
and on the base. The base is separate-
ly cast and soldered on. On the back
of the brace from the socle to the
bust, the integrally cast letters AL.,
which were incised in the wax
model. Blackish-green lacquer;
beneath it in places brown natural
patina. The figure 229 in white
which can be discerned on the car-
touche of the base is the 1659 inven-
tory number of the collection of
Archduke Leopold Wilhelm in
Vienna; the figure 876 in white at
the back of the base is that of the
Imperial and Royal Cabinet of Coins
and Antiquities prior to 1823.
Height 32.7 cm.
Inv. no. Pl. 5603.

PROVENANCE
Collection of Archduke Leopold Wilhelm,
where it is documented in the inventory of
1659 (Berger 1883, p. CLXXIII, fol. 458, no.
229). Illustrated (1735) in the *Prodromus* (Zim-
mermann 1888, plate 27). In 1661 bequeathed
by Archduke Leopold Wilhelm, together
with the other contents of his *Kunstkammer* to
his nephew Emperor Leopold I and from the
Archduke's death in 1662 in Imperial pos-
session. At first in the Stallburg, then transfer-
red to the Imperial and Royal Cabinet of Coins
and Antiquities at the beginning of the 19th
century, then, in 1880, to the Ambras
collection and transferred with the entire
collection to the Kunsthistorisches Museum in
1891.

BIBLIOGRAPHY
Planiscig, L. 1924, No. 173.
Leithe-Jasper, M. 1973, No. 35.
Leithe-Jasper, M. 1976, No. 43.
Natur und Antike, 1985/86, p.341, No. 28.

In all probability the bust represents the youthful Alexander, his hair falling
in long curls to his shoulders. The front of his helmet is decorated with a
mask, and each of its sides with a volute of foliage. The crest consists of a
griffin, in allusion to the assumption into heaven of Alexander the Great,
with a plume on its back and a long tail falling to the neckplate. The breast-
plate is decorated by a winged mask, with tendrils growing out of its mouth
and extending to the shoulder-straps. Over the right shoulder is a lion mask,
over the left shoulder a drapery held by a round clasp.

It has not been determined to what degree the bust derives from a specific
antique model. Antique coins and cameos may have served as inspiration, in
which case the bust may well be a modification of an effigy of Minerva, of
the kind taken up in plaquettes. In Renaissance times Athene's head on the
gold staters of Alexander the Great was taken to represent the king himself
(G.F. Hill 1910, pp. 259…; *cf* Pope-Hennessy 1965, cat. nos. 259 and 261). In
any case the present bust is a monumental piece in the classical style, with
what seems to be an intentional contrast between the majestic overall effect
and the detailed work: the latter is modeled with almost sketchlike freshness
and yet with a precision typical of the goldsmith's art.

Planiscig (1924), who believed the monogram AL. to be an artist's initials,
tentatively ascribed the bust to Aurelio Lombardo, and compared it to the
life-size bronze bust of a man, signed by Ludovico Lombardo, in the collec-
tion of the Reigning Prince of Liechtenstein in Vaduz. He considered that
the bust displayed features characteristic of Venetian art in general. But,
apart from the fact that Aurelio Lombardo's work, especially his bronze
sculpture, is far too little known, and an attribution to him can only be
hypothetical at the present time, there seem very little grounds for compa-
rison with the bust by Ludovico Lombardo. The formal repertoire of the
present bust is much more reminiscent of Leone Leoni. The monogram,
moreover, need not necessarily signify Aurelio Lombardo. There is no stop
after the A, and the two letters could well be the abbreviation of a forename
such as Alessandro or Alfonso, or of a surname. It is even possible that the
AL. refers to Alexander himself, although the traditional place for this would
be the cartouche in the base. Gramaccini (1985) believes Alfonso Lombardo
to be the author.

The bronze can first be identified in the 1659 inventory of the *Kunstkam-
mer* of Archduke Leopold Wilhelm (p. 458, no. 229): "Ein antic romanischer
Manszkopf von Metall, gewaffnet vnndt mitt einem Casquet, drauff ein
Federbuschen. Auff einem rondten Postament, ist alles von einem Stückh.
Hoch 1 1/2 Spann."). Our present knowledge of the inventories is not suffi-
cient to determine whether the bust was among the pieces from Mantua that
belonged to Charles I of England and were acquired by the Archduke.

Several replicas of inferior quality exist, mostly identified as *Minerva*.
Virtually identical to the Vienna bust is the example in the Victoria and
Albert Museum in London (inv. no. 967-1882, height (bust alone) 25.6 cm).

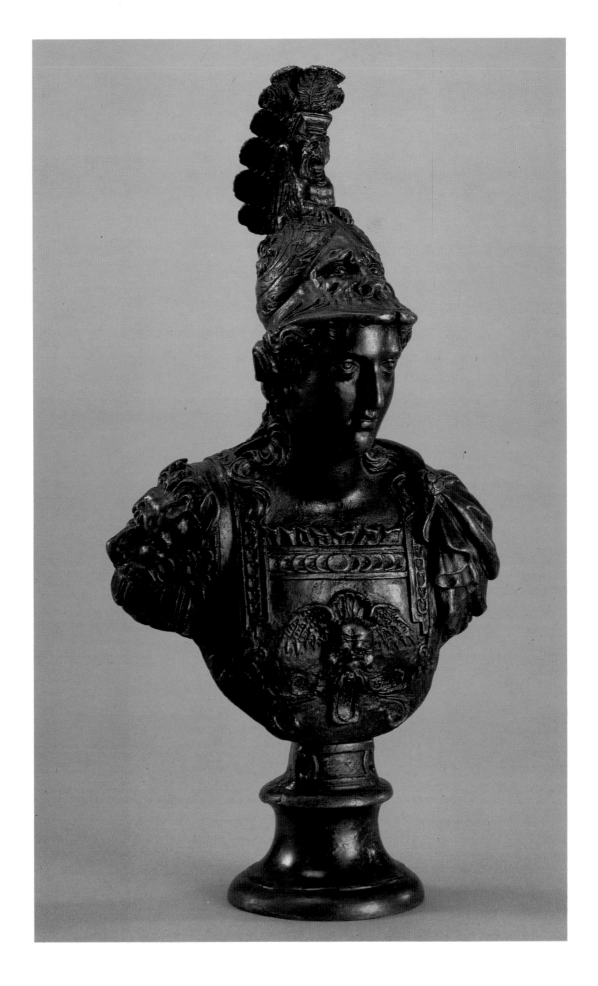

Further examples are in the collections of the Reigning Prince of Liechtenstein in Vaduz (without a base, like the London example) and in the Museo Poldi-Pezzoli in Milan (inv. no. 746, height 33 cm, as pendant to a *Minerva*, inv. no. 747, height 31 cm).

32. Fat man

The statuette represents an entirely naked, corpulent, elderly man with a laurel wreath on his head. He is gazing straight in front of him. His right hand rests on his hip; his open left hand is extended in a rhetorical gesture.

The statuette is remarkable for its unsparing realism. The flesh hangs flabbily; the fat cheeks and neck contrast with the face, which is itself not un-refined, the small eyes, the delicate, slightly snub nose and the thin lips.

The casting, but above all the afterwork, is somewhat rough.

There is a counterpart of almost the same size in the Castello Sforzesco in Milan, but in that example the man wears a pair of briefs and has a bathing cap instead of a laurel wreath. Based on the Milan example is a very crude variant from the Guido von Rhò collection in Vienna, now in the Museum für Kunst und Gewerbe in Hamburg: there the man holds a tub-like receptacle for soap in his left hand.

The Vienna statuette was originally believed to be antique and, not wholly without reason, to represent the Emperor Vitellius. It was so de-scribed by the compiler of the Ambras inventory of 1788, the *Schlosshaupt-mann* (Steward) Johann Primisser (*Kasten* VIII, no. 38, "Ein mit Lorbeeren gekrönte nackende Figur mit einer übertriebenen Wanst. Das Gesicht ist off-enbar das Portrait des Kaisers Vitellius. Wenn also diese Figur antik ist, so ist sie sicher eine Satyre auf dieses Kaisers Gefrässigkeit. Von Erz, 7 Zoll hoch.") (". . . If the figure is antique, it is evidently a satire on the Emperor's gluttony . . .").

Bode (1907 and 1922), in the captions to his illustrations, assigned both the Vienna statuette and the Milan variant to Padua "round 1500"; in the text, however, he favored Mantua or Ferrara, "where sport with dwarfs and tum-blers" (which he took the statuette to represent) "was especially popular". Schlosser (1910), on the other hand, compared the Vienna "pot-belly", of which he offered no further classification, with a statuette in Berlin of a seated dwarf angler (Bange 1930, no. 182) and with the *Morgante* from Giambologna's workshop, known in many replicas. Planiscig (1921, 1924, 1927 and 1930) finally decided for Andrea Riccio as the author of both statuettes; he believed them to be autograph, and rejected the attempt of Braun (1908) and Sauerlandt (1929) to assign the Hamburg variant to Nuremberg. Planiscig compared the statuettes with figures in the relief of *Elysium* from Riccio's Della Torre monument in the Louvre, Paris, and also with figures in Mantegna's engraving of a *Bacchanal with Silenus*. He believed that these paunchy figures were typical of Riccio's modeling and the sharp-ness of his faces. But it is precisely the treatment of the surface that is incom-patible with Riccio's hammered, vibrant and painterly surfaces. This is the main ground of Pope-Hennessy's (1961/62 and 1963) criticism of Planiscig's attribution to Riccio. After studying the Milan version (which he believed to be a candlestick, on account of the hole at the top of the head), Pope-Hennessy opted for a Florentine origin *c.*1540, for which he thought the "livid" surface a strong argument.

Peter Meller – so far only orally – has suggested a quite new approach. He claims to perceive a relationship between the statuettes and the work of

North Italian or Nuremberg(?), first third of the sixteenth century

Bronze statuette; hollow cast. On the top of the head a larger hole for removal of the casting core; on the belly and in the small of the back, small hole where core-support pins have been removed. The right foot is broken off, the left somewhat turned up. Remains of black lacquer; traces of an artificial reddish-brown patina on the legs, and brown natural patina.
Height 17.3 cm.
Inv. no. Pl. 5528.

PROVENANCE
Possibly identifiable in Archduke Ferdinand II's *Kunstkammer* at Schloss Ambras near Innsbruck (inventory of 1596, fol. 425) "ain clains naggets metalles mansbilt, hat ain laura-cranz auf, hebt den lingen armb über sich und etwas in her Hand" (Boeheim 1888, p. CCXCIX). The Ambras inventory of 1666 fol. 33 mentions an object held in the right hand. The reference to an object held in the right hand but which has vanished without trace renders the identification with this statuette uncertain. It is, however, mentioned with cer-tainty in the Ambras inventory of 1788 in case VIII, no. 38 (see above). Transferred in 1880 from Schloss Ambras to the Ambras collec-tion in Vienna, the statuette entered the Kunsthistorisches Museum together with the entire collection in 1891.

BIBLIOGRAPHY

von Schlosser, J. 1901, p. 12, Plate XVII/1.

Bode, W. 1907, I, pp. 31, 32, Plate LXIII.

Braun, E.W. 1908, p. 19, Plate XXI/a.

von Schlosser, J. 1910, p. 2, Plate III/3.

Planiscig, L. 1921, p. 141, Ill. 149.

Bode, W. 1922, p. 31.

Planiscig, L. 1924, pp. 22, 23, No. 34.

Planiscig, L. 1927, p. 396 and p. 481, No. 72 Ill. 493.

Sauerlandt, M. 1929, Plate XLVI.

Planiscig, L. 1930, Plate LV (the example in Milan).

Pope-Hennessy, J. 1961/62, No. 69.

Pope-Hennessy, J. 1963, p. 21.

Belloni, G.G. 1966, p. 67, No. 110 (the example in Milan).

Leithe-Jasper, M. 1973, No. 9.

Leithe-Jasper, M. 1976, p. 75, No. 46.

Bode, W., and Draper, J.D. 1980, p. 94, Plate LXIII

Albrecht Dürer, especially his studies on the proportions of the human figure. Thus the Vienna statuette with its laurel wreath might represent the humanist and poet Willibald Pirkheimer, whom the figure resembles to some extent in its corpulence and facial traits. However, some doubt is cast on Meller's theory by Professor J. Riederer's metallurgical analysis of the statuette, carried out in Berlin in 1981. The alloy (75.46 Cu; 5.40 Sn; 11.00 Pb; 6.95 Zn; 0.36 Fe; 0.27 Ni; 0.08 Ag; 0.13 Sb; 0.35 As) is, according to Riederer (written communication), untypical of Nuremberg, but not yet locatable. The Hamburg variant, on the other hand, is apparently of brass.

There is no connection with the statuettes in the Castiglioni and R. Gutmann collections in Vienna, mentioned by Schlosser (1910) and Planiscig (1924), as these are paraphrases of the *Morgante* statuettes from Giambologna's workshop.

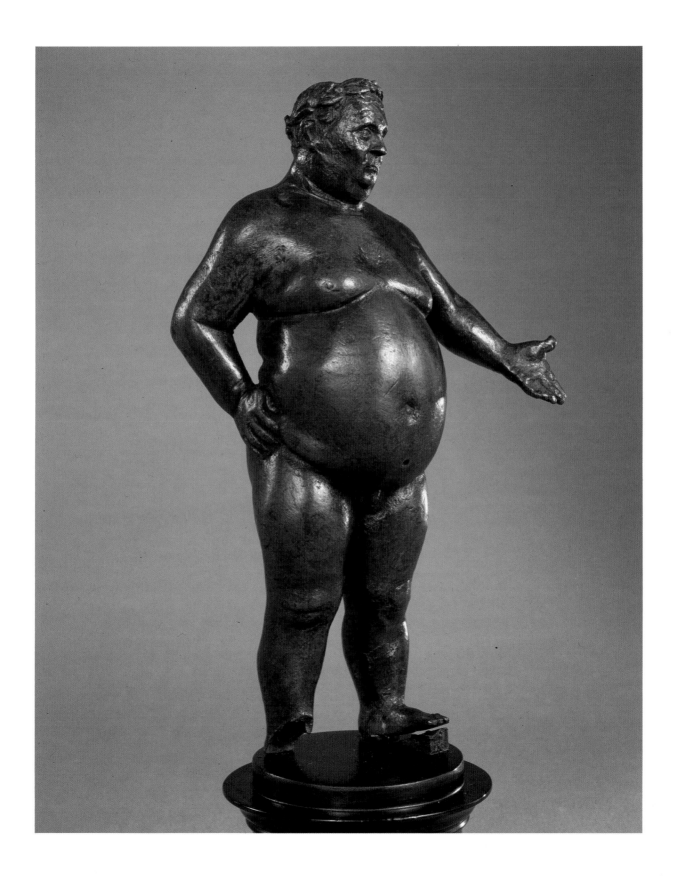

33. Venus

North Italian, end of the fifteenth century

Bronze statuette; solid cast. The feet, and the integrally cast base, broken off and resoldered. Small casting flaws all over the surface. Remains of a later, blackish-brown lacquer and, under it, a reddish-brown artificial patina, but no gilding as stated by Planiscig (1924). In the worn places the metal is bright.
Height 23.1 cm.
Inv. no. Pl. 5600.

PROVENANCE
Collection of Archduke Ferdinand II at Schloss Ambras (inventory of 1596, fol. 421) "Ain metales naggets frauenbild ohne armb, steet auf aim hilzen fuesz" (Boeheim 1888, p. CCXCVIII). Transferred in 1821 from Schloss Ambras to the Ambras collection in Vienna and entered the Kunsthistorisches Museum together with the entire collection in 1891.

BIBLIOGRAPHY
von Sacken, E. 1855, p. 96.
Courajod, L. 1886, pp. 324, 325.
Ilg, A. 1891, p. 219, Room XXIV, Case 1, No. 90.
von Schlosser, J. 1901, p. 13, Plate XX/3 (4).
von Fabriczy, C. 1902, p. 225.
Bode, W. 1907, p. 39.
von Schlosser, J. 1910, p. 2, Plate IV/4.
Planiscig, L. 1921, p. 254, Ill. 269.
Bode, W. 1922, p. 70, Plate LXXX.
Planiscig, L. 1924, p. 82, No. 149.
Planiscig, L. 1925, pp. 21, 22, Ill. 11.
Planiscig, L. 1930, p. 26, Plate CXXIII, No. 215.
Planiscig, L. and Kris, E. 1935, p. 52, Room X, Case 8, No. 1.
Ladendorf, H. 1953, p. 36, Ill. 98.
L'Europe humaniste, 1954/55, p. 105, No. 143.
Weihrauch, H.R. 1956, p. 119, No. 149.
Montagu, J. 1963, p. 41, Ill. 39.
Radcliffe, A.F. 1966, p. 48, Ill. 23.
Mahl, E. 1966, pp. 20, 21, No. 213.
Weihrauch, H.R. 1967, p. 465.
Bode, W., and Draper, J. D. 1980, p. 97, Plate XCVII
"NOEL" catalogue, Christie's, London, December 9, 1980, p. 65, No. 193.

ADDITIONAL BIBLIOGRAPHY
Stix, A. and Spitzmüller, A. 1941, No. 13.

The extremely slender female form stands in a lightly *déhanché* attitude on a small round base. The head is bent somewhat to the figure's left; the face is refined and expressive. The center-parted hair is combed in a roll around the head. The arms are missing.

The statuette was modeled as a torso, but is not necessarily a "forged antique" (Ladendorf 1953): it seems rather to reflect an antiquarian interest in reproducing the fragmentary state of the numerous antique statues discovered as torsos. Radcliffe (1966) supposed that the statuette might have been made for a collector as a pendant to an antique bronze, preserved in a fragmentary state. Weihrauch (1956) pointed out a number of similar paraphrases of the antique conceived as torsos; the youthful *Dionysus* in the Bayerisches Nationalmuseum in Munich (Weihrauch 1956, no. 149), though it is clearly a forgery of the antique, resembles the present figure particularly in its stance and the truncation of the arms. Montagu (1963) compared the statuette with that of the *Maiden of Beroa* by a pupil of Polyclitus in the Staatliche Antikensammlung in Munich.

In nineteenth-century inventories the statuette was classified as German, sixteenth century, possibly from the Innsbruck foundry – no doubt because the head bears some resemblance to that of Elizabeth of Tyrol in the funeral monument to the Emperor Maximilian I in Innsbruck. Sacken (1855) called it "in the style of Dürer". The first art critic to devote particular attention to the work was Courajod (1886), who assigned it to Venice and compared it with Antonio Rizzo's (he calls him Bregno) Eve from the Arco Foscari of the Doge's Palace. More important would seem to be his reference to some drawings by Francesco Francia in the Albertina in Vienna. Bode (1907) described the statuette as "Bellinesque". Schlosser (1920) referred to Antonio Rizzo, following Courajod. Finally Planiscig (1921 and 1924) ascribed the statuette to Tullio Lombardo, comparing it especially with figures by that artist on the Vendramin tomb in Santi Giovanni e Paolo in Venice. This attribution was followed by Montagu (1963), Mahl (1966) and Radcliffe (1966): the last-named suggested that Tullio Lombardo's lost statue of *Eve* on the Vendramin tomb, the appearance of which is not known, might have served as a model.

However, the elongated proportions of the statuette are not typical of Tullio Lombardo, nor is the completely unclassical hairstyle, which is instead in a style fashionable at the end of the fifteenth century. The attribution, which has become current, should therefore be reviewed. Courajod's (1886) reference to Francesco Francia's drawing of the *Judgment of Paris* (Albertina inv. no. 4859, Stix and Spitzmüller 1941, no. 14) is of importance here, as the goddesses in the drawing display the characteristics just mentioned. The question arises therefore whether the statuette did not originate in Francesco Francia's circle in Bologna or Ferrara rather than in Venice.

A replica was sold at Christie's in London in 1980.

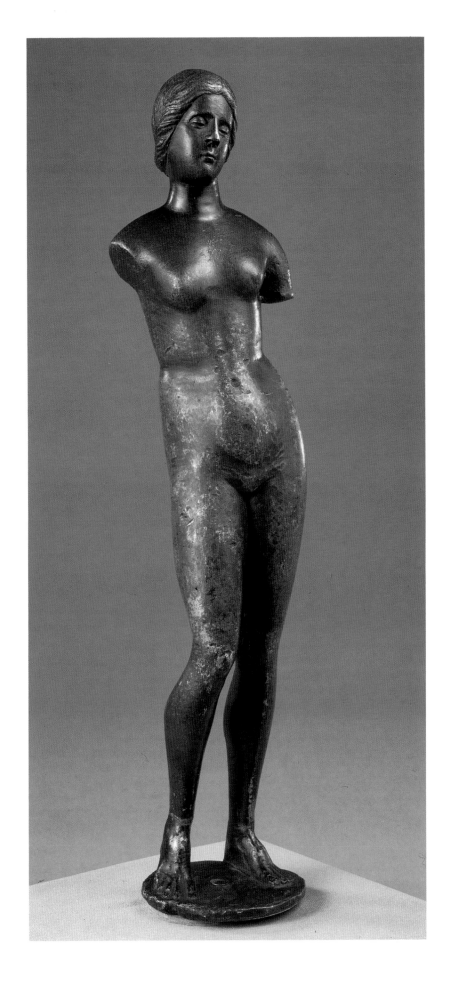

34. Dead Christ with an angel

North Italian (Padua or Venice), *c.*1525

Bronze plaquette; thick cast. Blackish-brown lacquer over dark brown patina. The figure 15 in white on the front side is its number in an inventory drawn up in 1916, when the Este collection was taken over by the Kunsthistorisches Museum.
Height 8.7 cm, width 8.5 cm.
Inv. no. Pl. 7733.

PROVENANCE
From the Este collection, but its provenance from Cataio not documented. Came to the Kunsthistorisches Museum in 1916.

BIBLIOGRAPHY
Planiscig, L. 1919, p. 182, No. 372.
Leithe-Jasper, M. 1976, p. 206, No. 276.

The body of Christ is in a seated position, with the head turned to the right, and leans against an angel who supports Him from that side. The angel's left hand can be seen on Christ's left shoulder, and his right hand is round Christ's right arm. In the background is the Cross, with Longinus's lance resting against it on the extreme right. The lower edge of the plaquette, which cuts off Christ's body at the hips, is to be understood as the edge of a sarcophagus, on which the body reposes and on which the angel has placed his right foot.

This small work is of exceptional quality; the high relief is unusual for a plaquette. It is remarkable for the balance of composition and the care and freshness of modeling. The representation is very compact, with a strong emphasis on the diagonal from upper left to lower right. The concentration of motifs on the left side is balanced by the empty space above on the right, and the Cross and spear in the background provide an orthogonal contrast. The monumentality of Christ's body, the painterly values achieved by highly differentiated modeling, and the depth of feeling expressed by the work, suggest an origin in Padua or, still more probably, Venice, in the third decade of the sixteenth century.

Planiscig's (1919) reference to stylistic analogies with Riccio and Moderno, and his consequent dating to *c.*1500, is questionable. The only similarity of motif in Moderno is a plaquette showing Christ's body supported by the Virgin, St John and a small angel. It may have been among the models for this relief, which is already wholly in the spirit of the High Renaissance, but no stylistic resemblance to Moderno or Riccio can be discerned. The angel in the Vienna relief is more reminiscent of the figures of Virtues on one of the candlesticks cast by Maffeo Olivieri in St Mark's in Venice, though this comparison is not intended as an attribution of the relief.

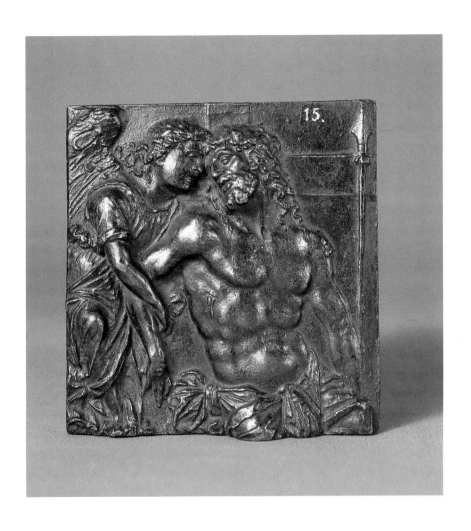

35. Negro Venus

Italian(?), second half of the sixteenth century

Bronze statuette; hollow cast, the casting core not removed. Rectangular fillings over the left knee, on the right lower leg, on the left shoulderblade and under the left shoulder. Many cut off core support pins visible. Remains of dark brown lacquer, light brown natural patina. The figure 23 on the front of the integrally cast oval base is its number in the 1750 inventory of the Imperial Treasury.

Height including base 32.5 cm.
Height of base 1.9 cm.
Inv. no. Pl. 5533.

PROVENANCE
Collection of Archduke Leopold Wilhelm in Vienna. Described in the inventory of this collection in 1659, fol. 442, 442': "Nr. 64 Ein kleine Bild von Metal einer nackendten Frawen gantzer Postur, hat in der rechten Hand ein Stuckh von einem Staab und in der linckhen ein Trüchel [sic!]. Auf einem Postament von Ebenholcz, hoch 1 Span 4 Finger" (Berger 1883, Reg. 495, p. CLXVIII). Later in the Imperial Gallery at the Stallburg in Vienna, illustrated in the *Prodromus* of 1735, on plate 30. (Zimmermann 1888, Plate 30). Probably transferred in 1748 to the Imperial Treasury; mentioned in the Treasury's inventory of 1750 on p. 573: "Nr. 23. Eine stehende deto [Venus] von obiger materie [bronze]" (Zimmermann 1889, p. CCCX). Since the number 23 is still visible on the base of the statuette, this identification is certain despite the meagre description! Transferred from the Treasury in 1871 to the Ambras collection in the Lower Belvedere and transferred with the entire collection to the Kunsthistorisches Museum in 1891.

The figure of Venus, on an integrally cast oval base, is naked except for a piece of material wound round her head like a turban. The body is extremely tall and slim, with long legs, a high waist, a short torso, a long neck and a small head. The figure is balanced and posed as if she were turning and about to break into a run. In her raised right hand she holds the handle of a mirror, which has survived in other examples; in her lowered left hand, a piece of cloth. The hair is curly and the face negroid. Her eyes are fixed on the mirror, and the type is thus that of Venus performing her toilet after bathing.

The artist appears to have subordinated the lines of the human figure to the harmony of an abstract decorative ideal. Typical features are the outstretched arms and the somewhat unstable pose. The numerous fillings and file marks on the surface suggest that the cast was not wholly successful and that intensive afterworking was necessary. From this point of view the New York, Paris and Frankfurt examples are of better quality.

Bode (1907) assigned the model to Florence and to Giambologna's circle, but described the present statuette as much more delicate in its observation of nature, more expressive and individual than that artist's work. Schlosser (1910) agreed in principle: he assigned the statuette to Florence and described it as similar in style to Giambologna but closer to the preceding generation of artists, especially Cellini. Sponsel (1915) ascribed it to Bartolomeo Ammanati. Planiscig (1921 and 1924) rejected the ascription to Florence and declared for a Venetian origin, classifying the statuette with the certain work of Alessandro Vittoria. Montagu (1963) and Weihrauch (1967) agreed with this view, while Landais (1958), followed by Cessi (1960), firmly upheld the theory of Florentine origin. Pope-Hennessy (1961/2 and 1963) proposed a compromise solution, ascribing the invention to Danese Cattaneo, a Tuscan pupil of Sansovino's who worked with him in Venice. This view was followed by Keutner (1962) and the compilers of the sale catalogues of the Hirsch and Linsky collections. Leithe-Jasper (1973) also noted the combination of Florentine and Venetian stylistic elements, favoring a Venetian origin but not specifying any particular artist. The statuette seems to be especially influenced by Giambologna's type of *Fortuna*; but there is no parallel in Giambologna to the abstract treatment of the human form and its subordination to a decorative schema. In this respect Bode's remarks are unjustified.

A comparison with the known work of Danese Cattaneo, which consists at present solely of large sculpture, cannot lead to a solution either. There is little basis for such a comparison, other than the figure's expansive gesture. In any case Cattaneo's œuvre has been very little explored and is too much encumbered with ill-founded attributions to be useful for comparative purposes. The only Venetian artist who might be expected to distort human anatomy like this is Alessandro Vittoria; but the style of the *Negro Venus* is so different from his that the attribution seems out of the question. His figures are typically spindly in composition, and the open pose of the *Negro Venus* would be alien to him.

The question therefore arises: can any Italian artist have been the author of

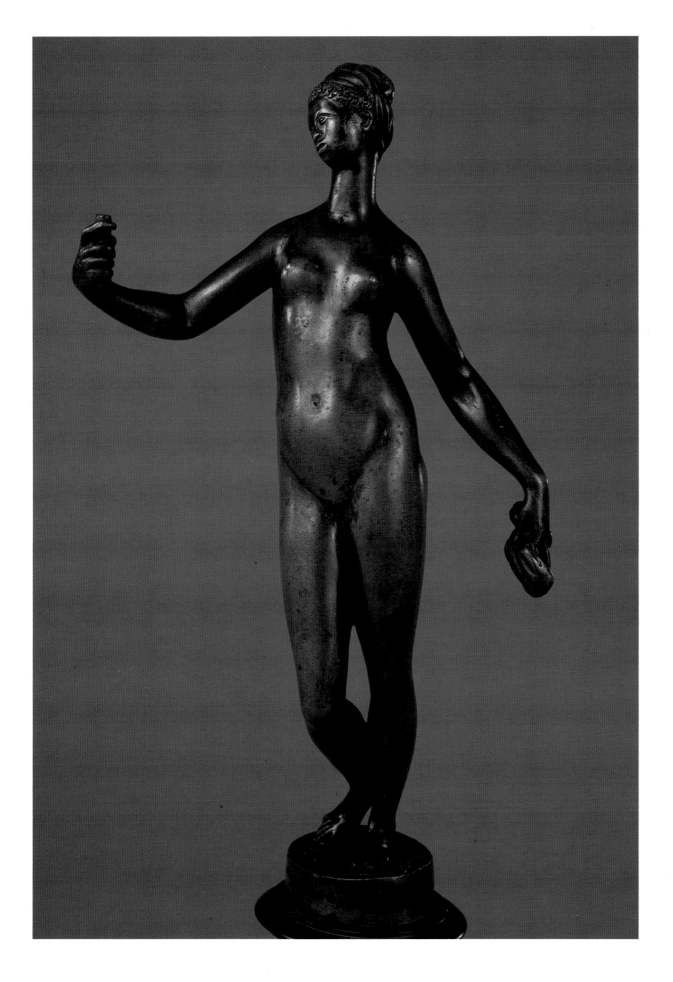

BIBLIOGRAPHY

Ilg, A. 1891, p. 218, Room XXIV, Case I, No. 23.

Bode, W. 1906, I, p. 43, Plate LXXXIII.

von Schlosser, J, 1910, p. 12, Plate XXXIV.

Sponsel, J.L. 1915, p. 321.

Planiscig, L. 1921, pp. 494, 495.

Planiscig, L. 1924, p. 103, No. 178.

Landais H. 1958, p. 65, and p. 116, Plate XXII.

Cessis, F. 1960, p. 57.

Pope-Hennessy, J. 1961/1962, No. 141.

Keutner, H. 1962, p. 176.

Pope-Hennessy, J. 1963, p. 56.

Montagu, J. 1964, pp. 47, 48, No. 47.

Pope-Hennessy, J. 1964, No. 16.

Weihrauch, H.R. 1967, pp. 145, 146.

Leithe-Jasper, M. 1973, No. 47.

Bode, W., and Draper, J.D. 1980, p. 95, Plate LXXXIII

Beck, H. 1982, pp. 181, 182. No. 113.

Lempertz sale, Cologne, 22 November 1975, No. 1771, Plate 147.

Hirsch sale, II – Works of Art, Sotheby Parke Bernet & Co, London, 22 June 1978, No. 344.

Linsky sale, Sotheby Parke Bernet & Co, New York, 21 May 1985, No. 87.

a work which appears to embody both Florentine motifs and Venetian stylistic elements, which none the less must be regarded as of independent inspiration and which hitherto has been impossible to classify with any certainty. Should we not think of a Netherlandish artist such as Elias de Witt called Candido, whose statuette of *Mercury* or *Perseus*, of which there are examples in Amsterdam, Paris and Berlin, bears some resemblance to the rather stilted figure of the *Negro Venus*? The extremely long-legged statuettes of the "Master of the Genre Figures" are likewise closer to the *Negro Venus* than are the works of Giambologna, Vittoria or Cattaneo. Weihrauch (1967) drew attention to a drawing by Albrecht Dürer in the Lubomirski collection at Lvov which might have served as a model for the *Negro Venus*. An example of the statuette apparently served for the nude rear view of *Minerva/Bellona* in Jacques de Backer's picture in Kronborg Castle at Elsinore. Müller-Hofstede's supposition (1973) that Caraglio's engraving of *Juno* was the prototype for the painting does not seem fully convincing. The statuette belonged originally to the collection of the Archduke Leopold Wilhelm, who was governor of the Habsburg Netherlands from 1646 to 1656, and this is an additional reason for assigning the work to a Netherlands artist.

The *Negro Venus* exists in several replicas of very diverse quality. Besides the Vienna example, which is traceable furthest back in time, there are replicas in the Herzog Anton Ulrich Museum in Brunswick (height 30.3 cm); in the Grünes Gewölbe in Dresden (30.4 cm); in the Liebieghaus in Frankfurt am Main (formerly in the Hirsch collection, Basle, and previously in the Pfringsheim collection, Munich; 30.5 cm); in the Grenoble Museum; in the Metropolitan Museum, New York (formerly in the Castiglioni collection, Vienna; 30 cm); and in the Louvre in Paris (formerly collection of the Marquise de Ganay; 32 cm).

Other examples in the sale of the Maurice Kann collection, Paris, 1910; Galerie Heim, Paris, 1970 (31 cm) (*The Burlington Magazine*, 1970, p. 254, fig. 90); Lempertz, Cologne, auction 22 November 1975 (30 cm); and Sotheby Parke Bernet, New York, May 1985, from the collection of Jack and Belle Linsky, New York (formerly Madame d'Yvon, Paris, sold by Galerie Georges Petit, Paris, 1892, then Pannwitz collection, Berlin, Rosenberg and Stiebel, New York; 30 cm).

36. Hercules or Cain(?)

Florentine, mid-sixteenth century

Bronze statuette; almost solid cast.
Small casting flaws in the integrally
cast base-plate and on the left arm.
Sprues between the left forearm and
breast, and between the club and
right thigh. An opening at the but-
tocks for removal of casting core
from the thorax. Remains of
blackish-brown lacquer, with traces
of artificial, reddish-brown patina
and brown natural patina.
Height 30.8 cm.
Inv. no. Pl. 5658.

PROVENANCE
From the *Kunstkammer* of Archduke Ferdin-
and II at Schloss Ambras: inventory of 1596,
fol. 420' "Von metal ain gossner Hercules, hat
in baiten henden ain kolbm, steet auf ain
metalen fuesz." (Boeheim 1888, p. CCXCVIII).
In 1821 Ambras collection in the Lower
Belvedere in Vienna and transferred with the
entire collection to the Kunsthistorisches
Museum in 1891.

The athletic youth stands on an integrally cast, clover-shaped base-plate, with
his feet on two of the lobes and his club resting on the third. The body, with
its strong rotatory movement, is poised between a standing and a walking
position. The impending change of direction is indicated by the glance and
the sharp backward turn of the head. The body weight is about to be shifted
to the left leg, after which the right leg and the club will be swung round.
The impression conveyed is of latent strength and a moment of transition
from one movement to another.

Schlosser (1913/14), who believed that the statuette represented Cain and
not Hercules, interpreted the movement in the opposite sense, however.
"The true motif of the figure comes to light on closer inspection: the youth
striding forward, dragging the heavy cudgel in both hands as if hesitatingly,
is drawn aside and backward, half against his will, by a sudden and violent
emotional pull. This must represent Cain, the fratricide in Genesis – not,
however, Cain before the deed, when the terrible thought forms in his mind
and causes him to finger his club, but the guilty man after the murder, as the
awful voice of the Lord rings in his ear: 'Where is Abel thy brother?' " The
interpretation is striking, but it leaves some questions unanswered. Would
not Cain look upward on hearing the Lord's voice? Would he be of such
Herculean physique? And, finally, was Cain ever a subject of Renaissance
bronze sculpture? At all events, the Ambras inventories from 1596 to 1821
invariably identify the statuette as Hercules; the designation *Cain* first occurs
in 1877, with no reasons given but probably because of the figure's youthful
appearance. Radcliffe has suggested (orally) "Hercules at the Crossroads".

There is certainly an apparent contradiction between the youth's powerful
torso and identification as Hercules or Cain and the dreamy, poetic ex-
pression of the fine head, and the slender hands with long fingers. Altogether
the statuette has something artificial about it. The extraordinary twist of the
body around an axis that lies almost completely outside it is scarcely feasible
in reality and makes a singularly contrived impression. It involves a spiral
upward movement from the trefoil base, with the three lines apparently in-
tersecting somewhere at the level of the athlete's slender waist. The compo-
sition seems to culminate in the hero's bowed head, whence the line descends
once more as the figure completes its turning movement.

Inasmuch as the statuette is designed to be seen in the round, it resembles
an echo, if not actually an illustration, of the "paragone" instigated by
Benedetto Varchi in 1546. Varchi challenged several Florentine artists to say
whether painting or sculpture was the nobler art. Benvenuto Cellini replied
that sculpture was superior if only because a statue had to be seen from eight
directions, a painting only from one. Later Cellini raised the eight to forty,
in effect establishing a criterion of sculpture in the round.

Not only does the present statuette meet this criterion, but it goes some
way beyond it, as to be fully comprehended it seems to postulate something
that is not yet visible. The spectator is almost obliged to anticipate the turn-
ing movement: as Schlosser put it, quoting Hildebrandt, he is "driven
round" the figure.

BIBLIOGRAPHY

Bode, W. 1907, II, p. 18, Plate CXXXV (in the plates erroneously described as being in Modena).

von Schlosser, J. 1910, p. 7, Plate XVII.

Bombe, W. 1913, p. 386.

von Schlosser, J. 1913/1914, pp. 73–86, Plates XVII and XVIII.

Grünwald, A. 1914, p. 21.

Planiscig, L. 1924, pp. 134, 135, No. 233.

Planiscig, L. 1925, pp. 34–36, Fig. 20.

Planiscig, L. 1930, p. 45, Plate CXCIV, No. 335.

Planiscig, L. and Kris, E. 1935, p. 85, Room XIII, No. 15, Fig. 40.

Keutner, H. 1958, p. 427, Note 1.

Weihrauch, H.R. 1967, p. 185, Fig. 226.

Middeldorf, U. 1970, p. 82.

Leithe-Jasper, M. 1978, p. 179.

Scheicher, E. 1978, p. 116, Fig. on p. 93.

Summers, J.D. 1979, p. 476.

Bode, W., and Draper, J.D. 1980, p. 100, Plate CXXXV

Distelberger, R. 1982, p. 84.

To all appearances the statuette was cast by the lost-wax process. This is indicated by the almost solid casting, the sprues between the left upper arm and the chest and between the club and the right thigh; and, last but not least, the sketchlike spontaneous modeling, preserved in the cast, of the hands, head and hair, of which the luxuriant locks are bound in a fillet.

The lower part of the club, the feet, hands and left arm and the hair are scarcely afterworked; the rest of the figure was very carefully cleaned and polished with the file and the surface of the chest was also given vibrant life by hammering.

The statuette is certainly one of the finest of late Renaissance bronzes. Bode (1907) attributed it, surely correctly, to the school of Michelangelo. Schlosser (1910 and 1913/14) ascribed it to Vincenzo Danti and compared it particularly with the terracotta model for that artist's *Honor overcoming Deceit* in the Bargello in Florence. Bombe (1913), Planiscig (1924, 1925 and 1930) and Weihrauch (1967) followed Schlosser's attribution; Grünwald (1914), Keutner (1958) and Summers (1969/79) rejected Danti's authorship, but, except for Keutner, offered no alternative. Keutner suggested in a footnote that the work must belong to the circle of the Venetian sculptor Alessandro Vittoria, but this is quite unacceptable: there is no similarity whatever to Vittoria's works and those adduced for comparison by Keutner, who has since abandoned his theory (oral communication). Middeldorf (1970) also raised the question of attribution: from the context he appears to have had in mind a Roman workshop, but he did not pursue his argument.

Bode's provisional attribution to the circle of Florentine sculptors strongly influenced by Michelangelo is still valid. There are compositional echoes in Niccolò Tribolo's candle-bearing *Angels* in Pisa Cathedral, completed by Silvio Cosini; in Cellini's works after his return from France to Florence; and in Vincenzo de Rossi's *Dying Adonis* figures in Berlin and Florence. Rossi's statuette of *Vulcan* in the *studiolo* of the Palazzo Vecchio in Florence has a somewhat similar base. Too little is known of the small-scale work of all these masters to warrant a fresh attempt at attribution without documentary evidence. It seems right, however, to reject Schlosser's ascription of the statuette to Danti. His comparison with the statuette of a *Stone-thrower*, formerly in the Zeiss collection in Berlin (A. Zeiss 1900, no. 17), and a *David* in Berlin (F. Goldschmidt 1915, no. 105) is not tenable, either.

No replicas are known.

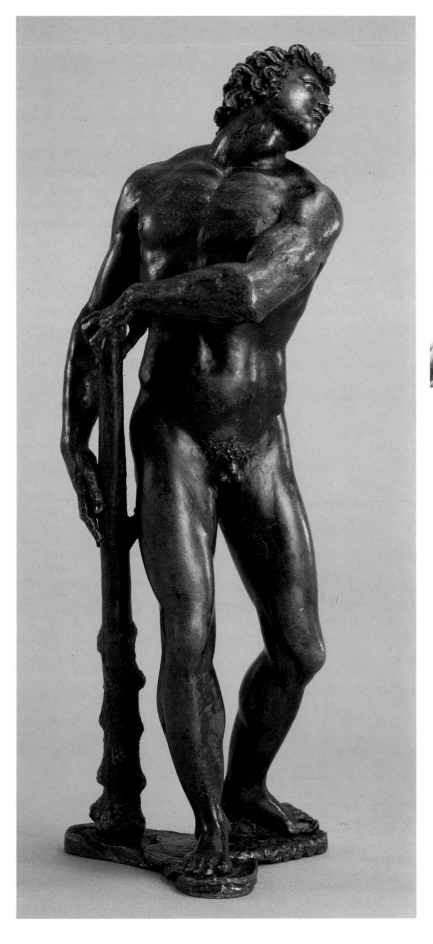

37. Satyr

Florentine, mid-sixteenth century:
Niccolò Tribolo?
1500–1550
(See Biography, p. 282)

Bronze lamp; thick-walled, in parts
solid cast, very little afterworked.
Artificial green patina, with brown
patina beneath. The figure 528 in
white on the *Satyr's* right hip is a
pre-1823 inventory number of the
Imperial and Royal Cabinet of Coins
and Antiquities.
Height 15.6 cm.
Inv. no. Pl. 5917.

PROVENANCE
Collection of the Imperial Treasurer Josef
Angelo de France (Martini 1781, p. 182, Des-
criptio reliquiae supellectilis et instrumen-
torum, no. 186 "(Eod. loc. Cat. A. n. 704a)
Alia [= Lucerne], forma larvae Fauni os mul-
tum aperientis, et maximo mento, quam Saty-
rus, humi sedens, intra pedes coactam dextra
tenet, laeva sublata, quasi illam feriturus. Aes,
6 1/8 alt. 5 1/2 long. Hanc promulgavit Khel.
l.c. 18.62.100.164, alibi, et descripsit p. XI.")
Reproduced as a vignette on the above ment-
ioned pages and described on p. XI in Jos.
Khell e S.J. *Ad Numismata Imperatorum
Romanorum Aurea et Argentea A Vaillantio
edita, a Cl. Baldinio aucta ex solius Austriae
utriusque, iisque aliquibus museis Supplementum a
Julio Caes. ad Comnenos.* (Vindabonae 1767.)
Acquired in 1808 for the Imperial and Royal
Cabinet of Coins and Antiquities; transferred
in 1880 to the Ambras collection and thence
in 1891 to the Kunsthistorisches Museum.

BIBLIOGRAPHY
Bode, W. 1907, II, Plate CLXIX.
Planiscig, L. 1924, pp. 92, 93, No. 161.
Planiscig, L. 1930, Plate CXLVI, No. 255.
Leithe-Jasper, M. 1973, No. 88.
Leithe-Jasper, M. 1976, pp. 79, 80, No. 57.
Bode, W., and Draper, J.D. 1980, p. 103,
 Plate CLXVIII

The goat-legged satyr, seated on the ground, holds a mask between his
knees: its wide open mouth is the aperture of an oil lamp concealed in the
lower part of the satyr's body. With his outstretched right hand the satyr
pulls down the lower lip of the mask, from which the wick protruded when
inserted into the lamp. His left hand is raised as if about to deal a blow: this
gesture can no longer be interpreted, as the object once held in the hand has
been broken off.

The satyr's muscular body is boldly yet compactly modeled; in spite of its
small size the figure makes a monumental impression, and the movement is
full of dramatic power. Although the casting is somewhat rough, the details
communicate the freshness and spontaneity of the model. The statuette was
worked scarcely at all after casting, so that the rough surface gives a more
painterly impression than was probably first intended.

Bode (1907) classified the statuette as "Venetian, c.1575". Planiscig (1924)
saw it as the work of a follower of Riccio such as Desiderio da Firenze or
Tiziano Minio, active in Venice around 1550 and influenced by the Floren-
tine Mannerism of Bartolomeo Ammanati. However, on stylistic grounds
the statuette must be of Florentine, not Venetian origin. The influence of
Michelangelo can be felt generally in the *Satyr's* Herculean physique, which
surely derives ultimately from the antique Belvedere *Torso* in the Vatican; it
can also be perceived directly in the mask, which seems to have been taken
over, almost unaltered, from the similar decoration by Michelangelo in the
Medici Chapel in San Lorenzo in Florence. This suggests that the artist, so
evidently under Michelangelo's influence, could well be one of the sculptors
who helped with that decoration. The one that comes readily to mind as the
author of this small, but powerful and original bronze is Niccolò Tribolo:
both the idea and the facture are comparable with a work of his in the
Bargello in Florence, a youthful *Satyr* sitting on a vase designed as an
inkwell.

A slightly smaller, somewhat modified and weaker variant was in the col-
lection of Dr Eduard Simon in Berlin (sale catalogue, vol. 1, Berlin 1929,
p. 161, no. 81; described, following Bode, as Venetian, second half of the six-
teenth century).

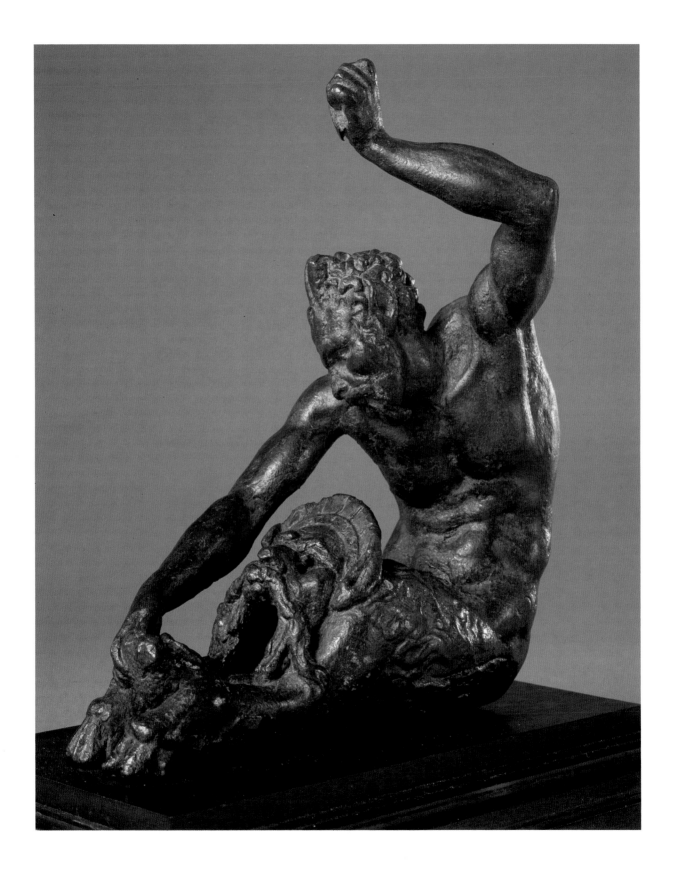

38. Pegasus

North Italian, second quarter of the sixteenth century

Bronze statuette; somewhat rough hollow cast. Various small round holes for core-support pins. Blackish-green lacquer; dark brown patina.
Height 6.5 cm.
Inv. no. Pl. 5731.

PROVENANCE
Collection of the Imperial Treasurer Josef Angelo de France (Martini 1781, p. 40, Descriptio Signorum, Scrinium III, no. 350. "(Ser. 2. Cat. A.n. 764) PEGASVS, alis expansis currens. Aes, 3 1/4 alt. 3 long.") Acquired in 1808 for the Imperial and Royal Cabinet of Coins and Antiquities; transferred to the Ambras collection in 1880 and transferred with the entire collection to the Kunsthistorisches Museum in 1891.

BIBLIOGRAPHY
von Schlosser, J. 1901, p. 31.
Bode, W. 1907, II, Plate CLXVIII.
Planiscig, L. 1924, p. 146, No. 248.
Leithe-Jasper, M. 1973, No. 64.
Leithe-Jasper, M. 1976, p. 110, No. 155.
Bode, W., and Draper, J.D. 1980, p. 103,
 Plate CLXVIII.

Pegasus, the winged horse sacred to Jupiter (*cf* cat. 2), is here seen with wings outspread, about to strike the ground with his hoofs. The small size of the statuette suggests that it was made as a finial to some utensil, perhaps an inkwell (in allusion to the Hippocrene, the spring of poetic inspiration that gushed forth when Pegasus stamped the ground of Mount Helicon, sacred to the Muses). In this sense, the work may be compared with the reverse of the medal to Cardinal Pietro Bembo, or Andrea Riccio's relief from the Della Torre tomb in the Louvre, Paris, glorifying humanistic *Virtue*.

The "painterly" handling of the very compact little statuette suggests a Venetian master of the second quarter of the sixteenth century, and not of about 1575 (Bode, 1907). The work may be compared with the sea-horses drawing Neptune's chariot in the group by Tiziano Minio (cat. 43).

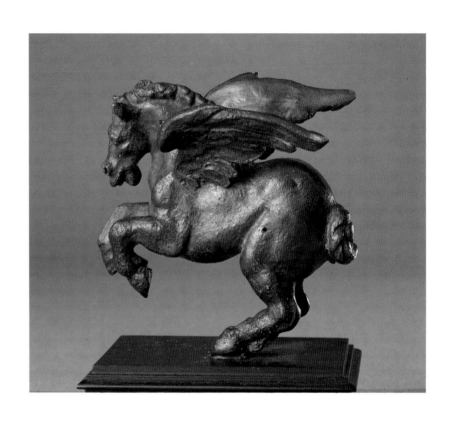

39. Crouching gladiator I

North Italian, first half of the six-teenth century

Bronze statuette. Heavy, probably solid cast, blackish-brown lacquer, brown natural patina. The ring fin-ger of the left, raised hand is broken off, and a sword is missing from the lowered right hand. Uninterpreted figure 63 in white on the right calf. Height 17.3 cm.
Inv. no. Pl. 5583.

PROVENANCE
Entered the Kunsthistorisches Museum in 1880 from the Imperial and Royal Cabinet of Coins and Antiquities. Documented in the in-ventory of modern bronzes in 1863 at no. 54 (formerly no. 13) "Athlet mit knappem Helm, in die Knie sinkend, die Arme aus-breitend. Sehr gute Arbeit. 6″3″′." Probably transferred in 1800 from the Treasury to the Cabinet of Antiquities and therefore in imper-ial possession for some time, probably even in the *Kunstkammer* of Emperor Rudolf II.

BIBLIOGRAPHY
Bode, W. 1907–1912, III, Plate CCLVII (version in the Widener collection).
Planiscig, L. 1924, p. 228.
Planiscig, L. 1927, pp. 554–558.
Planiscig, L. 1930, p. 45, Plate CXCV, Fig. 337, 338.
Santangelo, A. 1964, pp. 26, 32.
Weihrauch, H.R. 1967, p. 249.
Aggházy, M. 1969, pp. 743–746.
Aggházy, M. 1972, pp. 94–95.
Hall, M. 1973, pp. 16–19.
Leithe-Jasper, M. 1973, No. 69.
Leithe-Jasper, M. 1976, pp. 90, 91, No. 93.
Androssow, S.O. 1977, No. 24.
Androssow, S.O. 1978, pp. 36, 37, No. 22.
Radcliffe, A.F. 1979, p. 23, No. 6.
Bode, W., and Draper, J.D. 1980, p. 110, Plate CCLVII.
Wilson, C.C. 1983, p. 134, No. 25 (version in the Widener collection).

The gladiator, naked except for a close-fitting helmet, is seen with knees slightly bent, as if about to lunge forward. In his right hand, lowered and slightly advanced, he held a sword; his left hand is raised for defense and balance. He looks slightly upward, as if at a standing opponent.

The composition is full of movement, elasticity and tension. The twist of the body, the bent legs and outstretched arms indicate a position from which the gladiator can either spring forward or recoil instantaneously. The modeling of the slim yet athletic body shows great mastery and is hardly imaginable without a knowledge of antique models, such as the Belvedere *Torso* in the Vatican or sarcophagus reliefs, as well as earlier works by Michelangelo such as the designs for the fresco of the *Battle of Cascina*. The anatomical details are rendered carefully and without exaggerated distortion; the afterworking shows a strong feeling for "painterly" surface values. The details of the helmet, which fits closely like a cap but stands out slightly at the neck, are also carefully executed. It is not really a contradiction that the man's face, though portrayed in detail, has no particular expression. The artist was concerned first and foremost to depict the movement of the young warrior with formal precision, rather than to convey the expression of his features.

There are two replicas of the statuette, in the Hermitage in Leningrad and the Auriti collection in the Palazzo Venezia in Rome; however, the latter especially does not attain the high level of execution of the Vienna example. A slightly modified version – in which the warrior has a somewhat more elaborate helmet, a shield in his raised left hand, and a more expressive face – exists in two examples, in the David Daniels collection in Minneapolis (where three fingers, and also the shield, are broken off) and in the Widener collection in the National Gallery in Washington. A more altered version, in which the warrior has a mustache and an elaborate *all'antica* helmet, exists uniquely in the Kunsthistorisches Museum in Vienna (see cat. 40).

Bode (1912) described the statuette in the Widener collection as the work of a Paduan artist *c.*1530. Planiscig (1924 and 1927) at first connected the whole group with Leone Leoni and compared them with the caryatid figures in Leoni's portrait bust of the Emperor Charles V in Vienna. This view was accepted by Santangelo (1964), Weihrauch (1967) and Wilson (1983). Leithe-Jasper (1976), agreeing that the present statuette was by Leone Leoni, first drew attention to the stylistic difference between the two variants in Vienna. He compared the one with the elaborate helmet with the 1567 equestrian figures of *Marcus Curtius* by Josefus de Vici on a steel cabinet from Milan in the Kunsthistorisches Museum in Vienna, formerly in the possession of the Emperor Maximilian II.

Radcliffe (1979) was the first critic to divide the group into three distinct types. The earliest of these, which he attributed to Andrea Riccio, was in his opinion that represented by the examples in the Daniels and Widener collections.

Aggházy (1972) attempted, without differentiation, to connect the group of *Gladiators* with the statuettes of warriors and horses commonly grouped

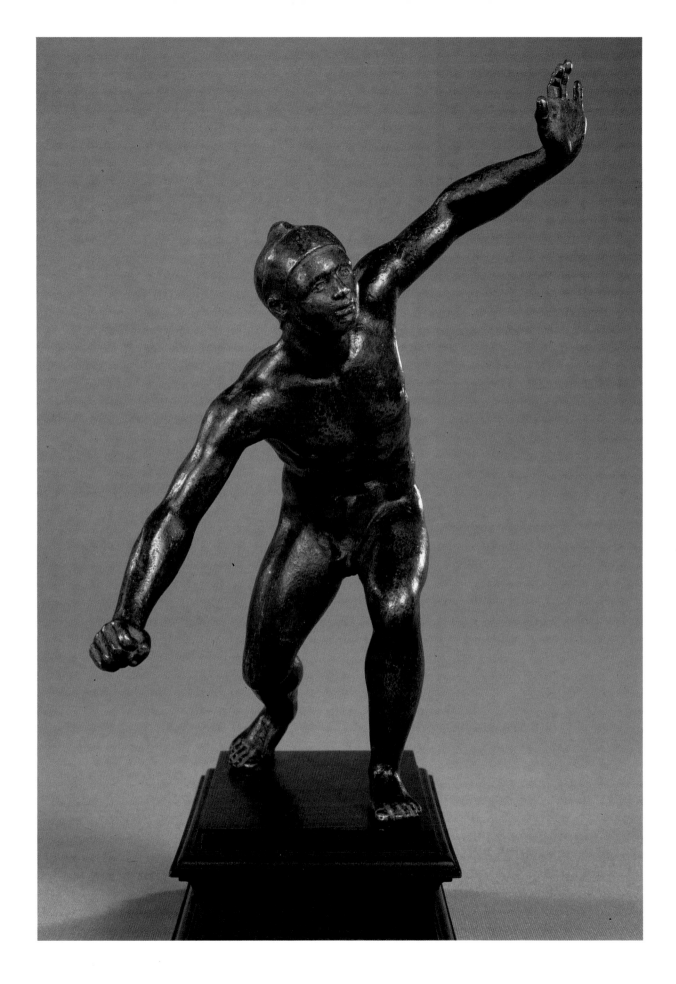

around the equestrian statuette in Budapest ascribed to Leonardo da Vinci; she believed that they were surviving pieces from a representation of a tournament by Leone Leoni, based on an original scheme by Leonardo.

As regards Radcliffe's second type, to which the present statuette belongs, Radcliffe again rejected the ascription to Leoni and questioned Planiscig's view of the resemblance to the figures below the bust of Charles V. On the other hand, he endorsed Leithe-Jasper's proposal of a later date for the third type, which he suggested might have originated in Venice in the circle of Tiziano Aspetti.

Radcliffe is certainly right in rejecting Leoni's authorship. The resemblances to works known to be by that artist are of a very general kind, and the detail of the statuettes is not in his smooth and precious style. On the other hand, Radcliffe's comparisons with works by Andrea Riccio do not seem convincing. Riccio's figures are in general bulkier and less elastic in movement. Common features with Camelio and Moderno might be pointed out instead, though this comparison is intended only to suggest a possible dating.

The greater wealth of detail in the Daniels/Widener type, and the thin-walled casting, is not necessarily evidence of its priority, as Radcliffe maintains, but rather suggests that these examples are variants of the Vienna type, which is a thick-walled cast, slightly larger, and more concisely formulated.

It is probably correct to assign the work to northern Italy and – as Radcliffe rightly says, following Bode – to the first third of the sixteenth century. A more precise location, and a particular artist, cannot at present be suggested for either the Vienna or the Daniels/Widener type. The third type, on the other hand, is by the Dutch artist Adriaen de Vries (see cat. 40).

40. Crouching gladiator II

This is an almost exact repetition of cat. 39. The chief differences are in the modeling, the unhammered surface, the differentiated treatment of the face, the more elaborate helmet, and the artificial smoke patination. In this example the sword blade has survived.

Like cat. 39 (q.v.) and four other examples in Leningrad, Rome, Minneapolis and Washington, this statuette of a *Gladiator* belongs to a group of similar figures that Planiscig (1924 and 1927) ascribed to Leone Leoni on the strength of resemblances which he saw between them and the caryatid figures on the base of the bronze bust of the Emperor Charles V in the Kunsthistorisches Museum in Vienna.

Critics have since followed this attribution. However, Leithe-Jasper (1976) first pointed out that on stylistic grounds this statuette should be distinguished in date from the rest of the group. He believed it to be Milanese work of about 1570, and compared it with the equestrian statuette of *Marcus Curtius* by Josefus de Vici on a steel cabinet from Milan in the Kunsthistorisches Museum, formerly in the possession of the Emperor Maximilian II. Radcliffe – who in 1979, following a suggestion of Bode's (1912), attributed to Riccio the variants in the Daniels collection in Minneapolis and the Widener collection in the National Gallery, Washington – concurred in Leithe-Jasper's view as to the later dating of the present work, and suggested a possible origin in Venice in the circle of Tiziano Aspetti.

It appears, however, from an examination of this suggestion that while there is a resemblance in many details of motif to the statuette by de Vici and to works by Aspetti, the evidence is insufficient as regards style. In fact the present work is only Italian in the sense that it is a copy of an Italian model. The copyist was the Dutch artist Adriaen de Vries.

Compared to the other statuettes, the modeling of this one is softer, not to say vague. It frees the form in a painterly fashion instead of determining it as a sculpture – a typical feature of Adriaen de Vries's work after 1600. The warrior's face beneath the helmet not only displays the fashionable beard and mustache of the late sixteenth century and onward (seen in Leoni's figures cited by Planiscig), but is notable for the small eyes and extremely pursed lower lip that are found again and again in small sculptures by de Vries. Equally characteristic of his work are the elegantly formed hands with their long, well articulated fingers; the oval extremity of the thumb is especially noticeable.

Typical of de Vries is the form of the *Gladiator's* helmet: no longer the simple, close-fitting type as in the model, or the "Roman" soldier's helmet seen in Minneapolis and Washington, but a variant of the ornamental helmet *all'antica* as it developed in Italy after Leonardo's time. The dragon, it is true, does not rear up in the usual threatening attitude, but lies flat with its feet stretched out in front, as though creeping forward slowly and unobtrusively. The mask on the front of the helmet, and the ornament over the ears, have a zoomorphic form such as is frequently met with in de Vries. Almost identical helmets are worn, for instance, by Minerva in the relief in the Kunsthistorisches Museum in Vienna with an *Allegory* of Rudolf II's wars against

Adriaen de Vries
*c.*1545–1626
(See Biography, p. 283)

Bronze statuette; the sword blade of steel. Hollow cast. Reddish-brown, matt smoke varnish over light grayish-brown natural patina. A round hole under the left buttock. Height 18.9 cm.
Inv. no. Pl. 5819.

PROVENANCE
Imperial possession; in the Imperial Treasury and probably also in the *Kunstkammer* of Emperor Rudolf II.

Adriaen de Vries: detail from *Rudolf II's War against the Turks* (relief), showing Minerva's helmet for comparison

BIBLIOGRAPHY

a. For the inventories

Zimmermann, H. 1889, p. CCX.

Zimmermann, H. 1905, p. XXXII.

Bauer, R. and Haupt, H. 1976, pp. 100, 102 (The other inventories mentioned are unpublished).

b. For the bronze statuette

Planiscig, L. 1924, No. 229.

Planiscig, L. 1927, pp. 554–558.

Planiscig, L. 1930, p. 45, Plate CXCV, Fig. 338.

Santangelo, A. 1964, p. 26.

Weihrauch, H.R. 1967, p. 249, Note 291.

Agghàzy, M. 1969, pp. 743–746.

Agghàzy, M. 1972, pp. 94, 95.

Hall, M. 1973, pp. 16–19.

Leithe-Jasper, M. 1976, p. 91, No. 94.

Androssow, S.O. 1977, p. 23, No. 24.

Androssow, S.O. 1978, pp. 36, 37, No. 22.

Radcliffe, A.F. 1979, pp. 24–27, No. 6.

c. Comparable examples

Larsson, L.O. 1967, Figs. 76 and 117 (*Allegory of Rudolf II's Wars against the Turks*, and the *Martyrdom of St Vincent*).

Suermann, M.-T., 1983, pp. 67–90, Fig. 15 (Third guardian at the mausoleum of Prince Ernst von Schaumburg-Lippe at Stadthagen).

Volk, P. 1974, pp. 52, 53, No. 34 (The *Forge of Vulcan* in the Bayerisches National-museum in Munich).

the Turks in Hungary; by a torturer in the relief of the *Martyrdom of St Vincent* in Breslau (Wroclaw) Cathedral; and by the third guardian of the Holy Sepulcher in the mausoleum of Prince Ernst von Schaumburg-Lippe in Stadthagen. There is also a similar helmet in the relief of *Vulcan's smithy* in the Bayerisches Nationalmuseum in Munich.

The 1607–11 inventory of the Emperor Rudolf II's *Kunstkammer* in Prague mentions two bronze statuettes of a gladiator: no. 1900, "Ein einzele figur von bronzo, ist ein Gladiator", and no. 1942, "Ein gladiator von Metal, ist nacket und hatt ein schwert in der hand, von Adrian de Fries" (Bauer and Haupt 1976). The incomplete Prague inventory of 6 December 1621 mentions only one gladiator: no. 558, "Ein nackender Mann von Metall, Gladiator genannt".

Several bronzes from the collection of Rudolf II, especially smaller ones, found their way to the Imperial Treasury in Vienna when the court returned to that city after his death. The Treasury inventory of 1750, the earliest to have survived, mentions at folio 574, no. 35, "Ein sitzender gladiator mit einem Schwert in der Hand von pronso". The present statuette in fact has a hole under the left buttock as if it was once intended to be a seated figure. The Treasury inventory of 1797, p. 314, again mentions two bronze statuettes of gladiators: no. 25, "Ein Gladiator aus detto" [*sc.* bronze] and no. 26, "Ein detto aus detto, steht der vorigen gegenüber auf dem Kasten". Later Treasury inventories again mention only one gladiator, that by Adriaen de Vries. In 1871 this statuette was transferred to the Ambras collection, with which it became part of the Kunsthistorisches Museum in 1891.

The inventories of the various imperial collections are numerous, but not exhaustive. As a rule they mention works of sculpture very summarily and do not indicate their size. Hence the above list of inventory items can only be regarded as a probable, not a certain indication that the statuette of a *Gladiator* by Adriaen de Vries in the Kunsthistorisches Museum is identical with the same artist's statuette of a gladiator in the inventory of the Emperor Rudolf's *Kunstkammer*. If it should also be the case – which is at present even less provable, but may at least be supposed – that the earlier statuette of a *Gladiator* (cat. 39), which was transferred in 1880 from the Imperial and Royal Cabinet of Coins and Antiquities to the Ambras Collection, was also from the Imperial Treasury, then that version might be identical with the anonymous statuette of a gladiator first mentioned in the inventory of the Emperor Rudolf's *Kunstkammer*. In that case it would actually have been the model for Adriaen de Vries's statuette.

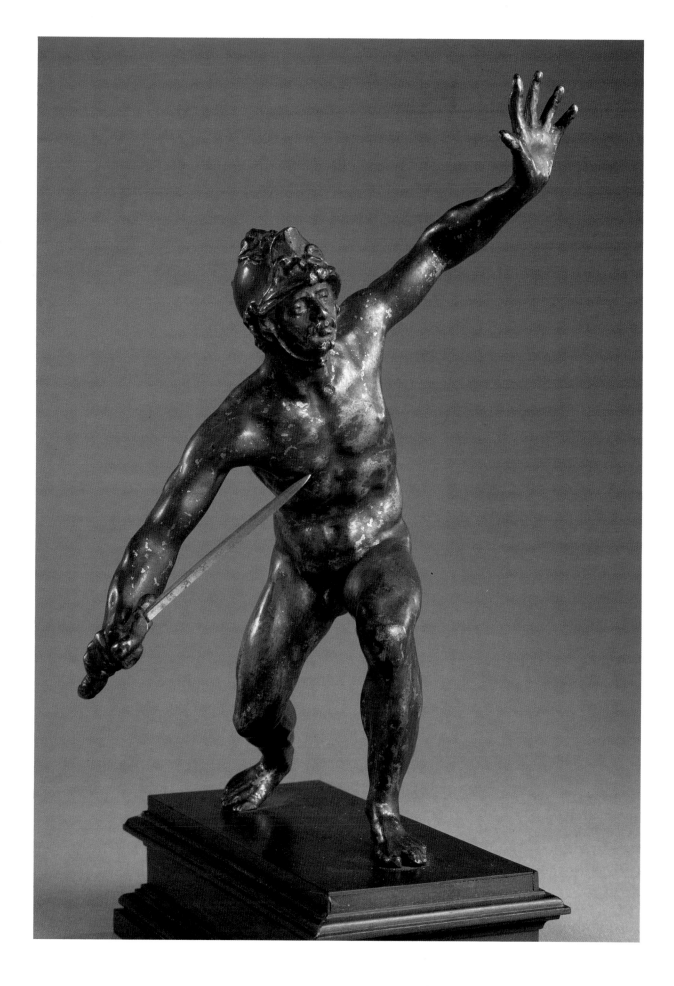

41. Barbarian on horseback

Milanese(?), end of the sixteenth century

Bronze group, hollow cast. Not only are the horse and rider separately cast and screwed together at a point in the drapery, but the horse itself is also cast in several parts. A join can be clearly seen at the middle of the horse's body. A large round opening on the horse's back, underneath the rider, allows one to see that the two halves of the body were mounted so as to overlap. Screwed joints are also visible on the inside. The horse's forelegs seem to have been cast separately and attached to the body; likewise probably the tail, as the crack at its base suggests. Many casting flaws on the horse's body are repaired with fillings. Black lacquer; reddish-brown patina. Height 30.2 cm.
Inv. no. Pl. 5768.

PROVENANCE
From the Collection of the Imperial Treasurer Josef Angelo de France (Martini 1781, p. 78, Descriptio Signorum, Super Scrinio VII et VIII, no. 670. "(S. Scrin V. et VI. n. 50. Cat. A. n. 601) SENEX incognitus, barbatus, maximo cursu equitans. Est nudus, pubem tectus panno. qui pro stragula simul servit: capillis atque ac barba non crispis. Utraque manu pugnum fecit, nec, quid eis tenerit, perspici potest. Equus hinnire videtur. Aes, 11 1/2 alt. 10 1/2 long. In b. lign. affabre facta.")
Acquired in 1808 with the de France collection for the Imperial and Royal Cabinet of Coins and Antiquities, transferred in 1880 to the Ambras collection in Vienna and transferred with the entire collection to the Kunsthistorisches Museum in 1891.

The bearded old man is clothed only in a loincloth which is tucked into a baldric and also serves as a saddle-cloth. He sits in an animated, unstable pose on the back of a galloping horse. His right leg is sharply drawn up; the upper part of his body and head are turned to the right, as though to confront an opponent. His arms are swung to the left in violent *contrapposto* to his body: it is not clear whether he is stringing a bow, or holding the reins with his right hand while his raised left hand holds a bow or some other object out of his opponent's reach.

Not only is the exact subject enigmatic, but the place of origin and attribution of the statuette is still a puzzle. Planiscig (1921) classified it with the work of the supposed "Master of the Haggard Old Men" – a sculptor whom he conjectured to have been active in Venice in the circle of Alessandro Vittoria and to have specialized in depicting old men of this type. However, there is no evidence of this sculptor's existence. Of the bronze statuettes that Planiscig attributed to him, no two are by the same hand. In the present case there is not even any trace of Venetian style. Later (1935) Planiscig ascribed the group, without giving reasons, to Guglielmo della Porta.

The lively composition of the statuette goes back to sketches and perhaps models by Leonardo da Vinci. The horse is of the heavy, solid type favored by that artist, so that a Milanese origin is conceivable. The fresh, almost sketch-like modeling of the horse and especially of the rider calls to mind the figures on the bronze candelabra after models by Annibale Fontana in the Certosa at Pavia. Accordingly Leithe-Jasper (1973 and 1976) with all due caution proposed Fontana as the artist, although his work in small sculpture has as yet been very little studied. However, A.P. Valerio was unable to accept this suggestion (oral information). On the other hand, the somewhat vague structuring of the bodies may also bring to mind the painterly values of works by Adriaen de Vries. The horse resembles horses by that artist, although one cannot find parallels in his work for its massive body, the luxuriant wavy tail or the nailed horseshoes with calkins. It should also be noted that the *Barbarian* shows some resemblance to the river god in the foreground of de Vries's large relief *Allegory* of the Turkish wars in the Kunsthistorisches Museum, Vienna.

The Germanisches Nationalmuseum in Nuremberg possesses an altered, probably later replica of the *Barbarian*, on loan from a private collection. In that version he is accompanied, not very happily, by a female whom he is trying unsuccessfully to hold in his arms and who looks as if she were about to jump over his left knee. The group, mounted on a globe, is in a badly fragmented state. Bräutigam (1982) assigned it to South Germany and to a Nuremberg master, *c.*1600. Previously the same group was held to be from Augsburg and dated about 1620 (*Aufgang der Neuzeit*, 1952, p. 85, no. K 69).

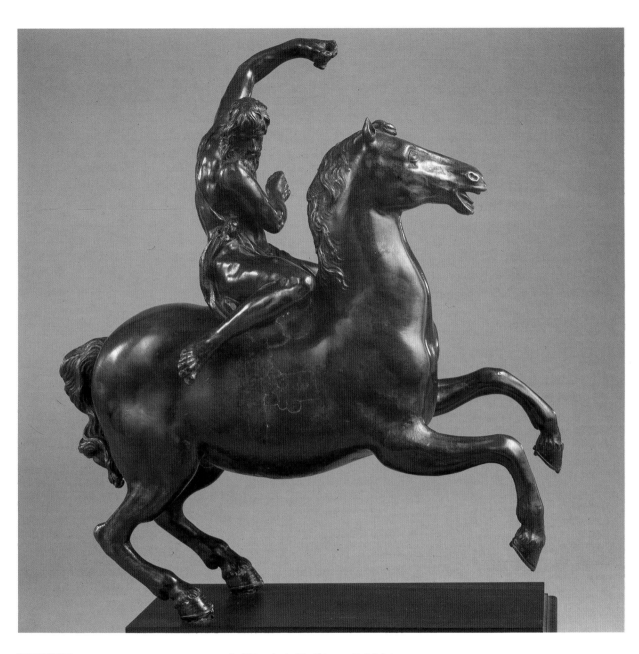

BIBLIOGRAPHY

von Sacken, E. 1866, p. 480, No. 9.

Ilg, A. 1891, p. 22, Room XXIV, Case II,
 No. 103.

von Schlosser, J. 1910, p. 17, Plate XLIV,
 No. 2.

Planiscig, L. 1921, pp. 471–475.

Planiscig, L. 1924, p. 108, No. 186.

Planiscig, L. and Kris, E. 1935, p. 91, Room
 XIII, Case 38, No. 3.

*Le Triomphe du Maniérisme – De Michelange
 au Greco*, 1955, p. 174, No. 338.

Weihrauch, H.R. 1967, p. 238.

Leithe-Jasper, M. 1973, No. 70.

Leithe-Jasper, M. 1976, No. 156.

Bräutigam, G. 1982, pp. 111–112, Fig. 5.

42. Jupiter

Attributed to Jacopo Sansovino
1486–1570
(See Biography, p. 282)

Bronze statuette; thick-walled hollow cast, the base-plate integrally cast. The 1659 inventory of the art collections of the Archduke Leopold Wilhelm mentions an eagle at Jupiter's feet; this is now missing, and was not reproduced in the *Prodromus* of 1735. Casting flaws on the left knee; a filling above the right knee, cracks at the back of both knees; a small hole under the right shoulder. In the hair and the thunderbolt, remains of plaster of later date. Later black lacquer covers older dark brown artificial patina. The figure 1007 in white at the back of the base-plate is that of a pre-1823 inventory of the Imperial and Royal Cabinet of Coins and Antiquities.
Height 43 cm.
Inv. no. Pl. 5655.

PROVENANCE
Collection of Archduke Leopold Wilhelm in Vienna. In the inventory of 1659, fol. 448, no. 127: "Eine kleine von Brunzo gegossene Statua desz Jupiters mit einer feyrigen Flamben in der rechten Handt vnd haltet die linckhe in die Höche, vndt stehet neben ihme bey den Füessen ein Adler mit aufgethane Flügel. Hoch 2 Span genaw." (Berger 1883, p. CLXIX). In 1735 still in the gallery at the Stallburg, as it is illustrated in the *Prodromus* on plate 30 (Zimmermann 1888). Later transferred to the Imperial Treasury. Transferred to the Imperial and Royal Cabinet of Coins and Antiquities in 1800 and in 1880 transferred to the Ambras collection. Entered the Kunsthistorisches Museum in 1891.

The naked figure of the god stands in a firmly balanced attitude, in *contrapposto*, on an integrally cast, flat oval baseplate. His left shoulder is advanced and the right drawn back. The head is inclined to the left, and the eyes are gazing in the direction indicated by the raised left hand; the lowered right hand holds the thunderbolt. The finely stranded hair, bound by a fillet, grows outward from a crown on the top of the head and falls in profuse curls at the back and around the face. The short, full beard is finely stranded also. Additional life has been given to the hair by fine hammering. The god's slender and rather flaccid-looking body is softly modeled, and the surface smoothed.

The bronze, previously regarded as an anonymous work of the Italian Cinquecento, was first attributed to Jacopo Sansovino by Schlosser (1910), who considered the mouth and nose to be especially characteristic of that artist. Bode (1907) also believed it to be Venetian, from Sansovino's circle. Planiscig (1921 and 1924), following Schlosser, compared the body with that of *Apollo* in the Loggetta in Venice, and the head with that of the early *St James* in Florence. He also called attention to a statuette of *Neptune* in the Kaufmann collection in Berlin, attributed to Sansovino by Goldschmidt (1917), while at the same time emphasizing the unique character of the Vienna statuette and the absence of other parallels for it. Weihrauch (1935, 1938 and 1967) also firmly supported the attribution to Sansovino, pointing out the unmistakable similarity of the figure's gesture to that of the Loggetta *Mercury* and the resemblance of the head to that of the *St James* in Florence. Weihrauch further noted the realism with which "the god's age is expressed in the flabby muscles of the breast and belly"; on this account he compared the statuette with Sansovino's tabernacle door and sacristy door in St Mark's in Venice, and the variants of the former in Florence and Berlin.

Pope-Hennessy, on the other hand (1961/62 and 1963), emphasized the similarity of the *Jupiter* statuette to Sansovino's marble *John the Baptist* in the Frari church in Venice. Radcliffe (1966) saw it as an outstanding example of Sansovino's lyrical style. Timofiewitsch (1972) thought it possible that the Vienna statuette was made by Sansovino's workshop after a model by him; but the extraordinary care taken in the execution argues against this. Timofiewitsch further supposed that Sansovino's model was used for the composition of Girolamo Campagna's statue of *St Francis* on the high altar of the Redentore in Venice.

The first critic to express some reservation as to Sansovino's authorship was Boucher (oral information), whose view was reflected in the catalogue of the exhibition *The Genius of Venice* in London in 1983, which described the statuette as "attributed to Jacopo Sansovino". Finally Davis (1984) in somewhat polemical terms rejected any connection with Sansovino, while not suggesting any alternative.

A silver-gilt crucifix in the Ecclesiastical Treasury in Vienna – believed by Gramberg (1981) to be the one presented to Maximilian II by Guglielmo della Porta in 1569 – shows many points of resemblance to the *Jupiter*. The softly modeled muscles are not dissimilar, the head in both cases is treated in

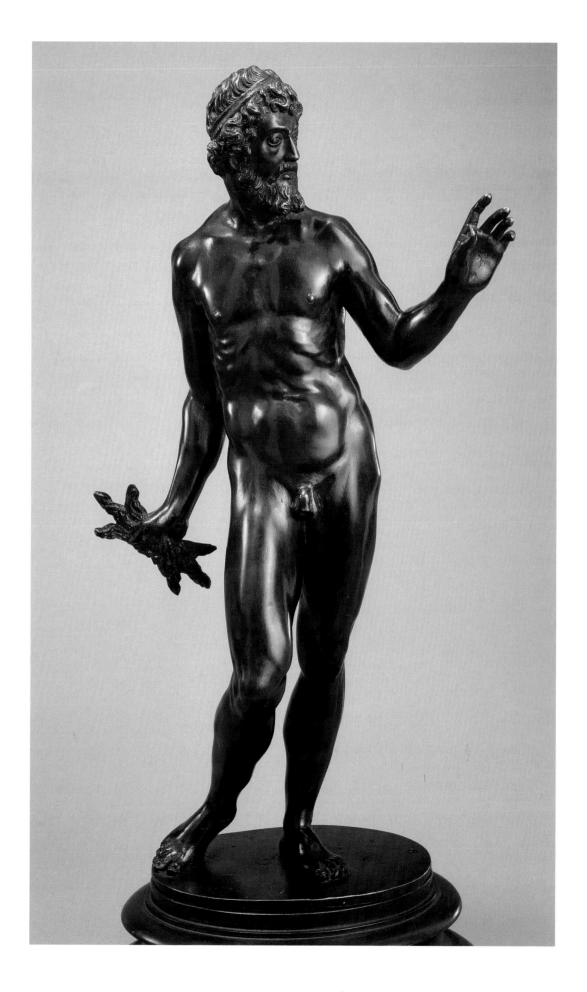

an idealized fashion that almost recalls the Quattrocento, and there is a similarity in the way the hair grows in fine strands from the top of the head and falls in serpentine curls over the temples.

However, since no bronze statuettes of secular subjects can be attributed with certainty either to Jacopo Sansovino or to Guglielmo della Porta, so as to form a basis of comparison, it appears that at present no further conclusions can be drawn from the analogies noted above.

BIBLIOGRAPHY
von Frimmel, T. 1883, p. 56, No. 1014.
von Schlosser, J. 1910, p. 7, Plate XVIII/1 and 2.
Bode, W. 1907, III, p. 14, Plate CCXXXI.
Pittoni, L. 1909, pp. 222–227, Fig. 55.
Lorenzetti, G. 1913, p. 151.
Goldschmidt, F. 1917, p. 22, No. 228.
Planiscig, L. 1921, pp,. 379–381.
Planiscig, L. 1924, p. 85, No. 152.
Planiscig, L. 1925, p. 31, Fig. 16.
Planiscig, L. 1930, p. 32, Plate CXLII, Fig. 248.
Planiscig, L. and Kris, E. 1935, p. 55, Room x, No. 25, Fig. 43.
Weihrauch, H.R. 1935, p. 68.
Weihrauch, H.R. 1938, p. 467.
Pope-Hennessy, J. 1961/1962, No. 136.
Pope-Hennessy, J. 1963, p. 58.
Pope-Hennessy, J. 1963[2], p. 109, Plate CXVIII.
Montagu, J. 1963, p. 44, Fig. 44.
Ciardi Dupré, M.G., 1966, p. 123, Fig. 54.
Radcliffe, A.F. 1966, p. 77, Fig. 48.
Weihrauch, H.R. 1967, p. 139, Fig. 159.
Timofiewitsch, W. 1972, pp. 67, 68, Fig. 139.
Bode, W., and Draper, J.D. 1980, p. 108, Plate CCXXXI.
Gramberg, W. 1981, pp. 95–114.
Distelberger, R. 1982, p. 84.
Leithe-Jasper, M. 1983, p. 383, No. S. 31.
Davis, C. 1984, p. 86.

43. Neptune in his chariot

Neptune, god of the sea, stands naked in a chariot drawn by two sea-horses. He no doubt held the reins in his left hand and a trident in his right. The god and the horses are both facing right, indicating the direction of their course over the wind-lashed waves. The storm is blowing full into Neptune's face, sweeping his beard to one side. With the (supposed) trident in his slightly raised right hand he is commanding the waves to be still: for the bronze represents the famous *Quos ego* scene in the first book of Virgil's *Aeneid*. Juno, Aeneas's implacable enemy, has stirred up the winds to wreck the ships in which the hero and his companions are fleeing from the sack of Troy; Neptune, angered at the intrusion into his domain, comes to the rescue by rebuking the winds and calming the waves.

The strong, somewhat thickset figure of the god is portrayed in a bold, not to say rather vague manner. The details, however, such as the hair and beard, the horses' heads with their curly manes, and the waves are modeled with great freshness. These qualities were present in the cast itself, for the statuette shows only slight traces of afterworking and underwent scarcely more than a cleaning of the surface after casting.

The mention of *Neptune* and the chariot as two separate items in the inventories and literature down to 1973 is presumably due to the fact that *Neptune*'s right foot was broken off at a very early date and the figure was not remounted on the chariot thereafter. However, the two pieces belong together and have the same provenance (see below).

Bode (1907 and 1913) ascribed the model to Jacopo Sansovino, and considered that the best version was that in the Otto Beit collection in London. He thought it one of Sansovino's most successful compositions, superior in any case to the monumental figure on the Scala dei Giganti of the Doge's Palace. Planiscig (1921) first attributed the statuette to Sansovino's pupil Tiziano Minio; later, however (1924), he agreed with Bode in assigning it to Sansovino, pointing out comparable features in figures in the Cantoria reliefs of 1537 and 1544 and the four *Evangelists* on the choir-screen of St Mark's in Venice. Weihrauch (1935 and 1967) rejected the attribution to Sansovino and ascribed the work to Tiziano Minio as Planiscig had done formerly. Pope-Hennessy (1961/62) at first favored Minio but then gave the preference to Sansovino's workshop. Montagu (1963), Leithe-Jasper (1973 and 1976), and Wixom (1975) opted for Tiziano Minio, agreeing with Weihrauch and with Planiscig's original view.

It can certainly not be disputed that the statuette presents analogies with Sansovino's known work. The model was clearly a successful one, as is shown by the number of replicas still extant: this is not proof of Sansovino's authorship, but is certainly not an argument against it, as shown for example by the many replicas of the model of the Madonna in the monument to Bishop Gelasio Nichesola in Verona. What does appear to argue against Sansovino is the somewhat casual structuring of the rather ponderous figure and the additive and genre-like effect of the chariot with the sea-horses. This relative lack of connection between the two elements of the composition serves to explain why they were kept separately for centuries in the Ambras

Tiziano Minio
1511/12 – 1552
(See Biography, p. 281)

Bronze statuette; hollow cast. Neptune and the chariot cast separately, the present mounting perhaps not quite correct. In the floor of the chariot, two early fastening holes for Neptune's right foot and a larger hole in the center, which no doubt originally served to fasten the chariot to a base. Neptune's right foot broken above the ankle and re-attached; a large casting flaw on the right shoulder; on the crown of the head and on the buttock, a large irregularly-shaped hole for removal of the casting core. Black lacquer over dark brown natural patina. Height of *Neptune* alone 30.1 cm, with chariot 34.5 cm. Inv. nos. Pl. 5748 (*Neptune*) and 5911 (*Chariot*).

PROVENANCE

Kunstkammer at Schloss Ambras; first docum-
ented with certainty in the inventory of 1788,
p. 98, case VIII, no. 5 (Neptune), no. 75
(chariot). Transferred in 1880 from Schloss
Ambras to the Ambras collection in Vienna
and in 1891 with the entire collection to the
Kunsthistorisches Museum.

BIBLIOGRAPHY

Bode, W. 1907, II, p. 22, Plate CLVII.
Bode, W. 1913, p. 62, Inv. No. 260.
Planiscig, L. 1921, p. 405.
Planiscig, L. 1924, p. 86, Nos. 153–155.
Planiscig, L. 1930, p. 32, Plate CXLIV, No. 252.
Weihrauch, H.R. 1935, p. 97.
Planiscig, L. and Kris, E. 1935, p. 61, Room
X, Case 58, No. 15 (Hippocampus chariot
only).
Pope-Hennessy, J. 1961/1962, Nos. 142 and
143.
Pope-Hennessy, J. 1963, p. 58.
Montagu, J. 1963, pp. 44–46, Fig. 21.
Weihrauch, H.R. 1967, pp. 329, 330, Figs.
400–402.
Leithe-Jasper, M. 1973, No. 43.
Wixom, W.D. 1975, No. 114.
Leithe-Jasper, M. 1976, pp. 91, 92, No. 95.
Bowron, E.P. 1978, pp. 55, 56.
Bode, W., and Draper, J.D. 1980, p. 102,
Plate CLVII.

collection; only after the discovery of the complete example in the Otto Beit collection was it realized that *Neptune* and the chariot belonged together, or even that the figure represented Neptune at all. The question is whether Sansovino himself would have been guilty of such an evident weakness of composition. By contrast, Alessandro Vittoria, Sansovino's most gifted pupil, treated the same motif in a quite different way in a statuette, now in the Victoria and Albert Museum in London, which fully expresses the force and drama of the situation.

It is not so much unique artistic achievements that lend themselves to re-production, as second-hand ideas. The great exceptions to this general rule are Antico and Giambologna, as they and their shops saw to the replication of their own works. In Venice the division between sculptors and casters was much stricter and, as Weihrauch (1967) has shown, models were farmed out to foundries to be published.

The merit of the present statuette lies not so much in the conception of *Neptune* as in the details. The extremely fresh modeling of the sea-horses and the waves might well be ascribed to Tiziano Minio, who was trained as a worker in stucco, whereas the allusions to Sansovino's works in the figure of *Neptune* are unsuccessful and the result less convincing. A certain crudeness in the figure makes us hesitate to attribute the composition to Sansovino himself and incline to ascribe it to a member of his workshop or a master very close to him. According to all our present information, Tiziano Minio was Sansovino's closest collaborator on the Cantoria reliefs in St Mark's and the sculptural decoration of the Loggetta, and at that stage of his activity his own commissioned works were especially close to Sansovino's style. We may thus endorse Planiscig's references to comparable works by Sansovino, and also his perception of the close resemblance between the statuette of *Neptune* and the *Sea-god* reliefs in the Loggetta, which are known to be workshop products and are generally attributed to Minio.

Weihrauch (1967) demonstrated that the model was popular north of the Alps as well: thus the *Neptune* was copied in reverse direction by the work-shop of Pankraz Labenwolf, the figure being made somewhat more supple and the play of muscles more visible. The chariot was left unaltered. Later the Labenwolf model was taken over by the workshop of Benedikt Wurzel-bauer in Nuremberg, where it was combined with a different chariot.

Neither the chariot in the Kunsthistorisches Museum nor that in the Otto Beit collection have the integrally cast base-plate which is to be found in the Brunswick and Cleveland replicas. The latter must presumably be later casts, after the mold of a statuette with its base. A version of this kind was also the model used by the Labenwolf workshop. However, a final determination as to priority can only be made after direct comparison.

Replicas: Brunswick, Anton Ulrich Museum (Weihrauch 1967, pp. 329, 330, fig. 400; with chariot and integrally cast base-plate); Cleveland, Cleve-land Museum of Art (Wixom 1975, no. 114; formerly collection of Hugo Oelze, Amsterdam; with chariot and integrally cast base-plate); Florence, Museo Nazionale del Bargello (Pope-Hennessy 1961/62, no. 143; formerly

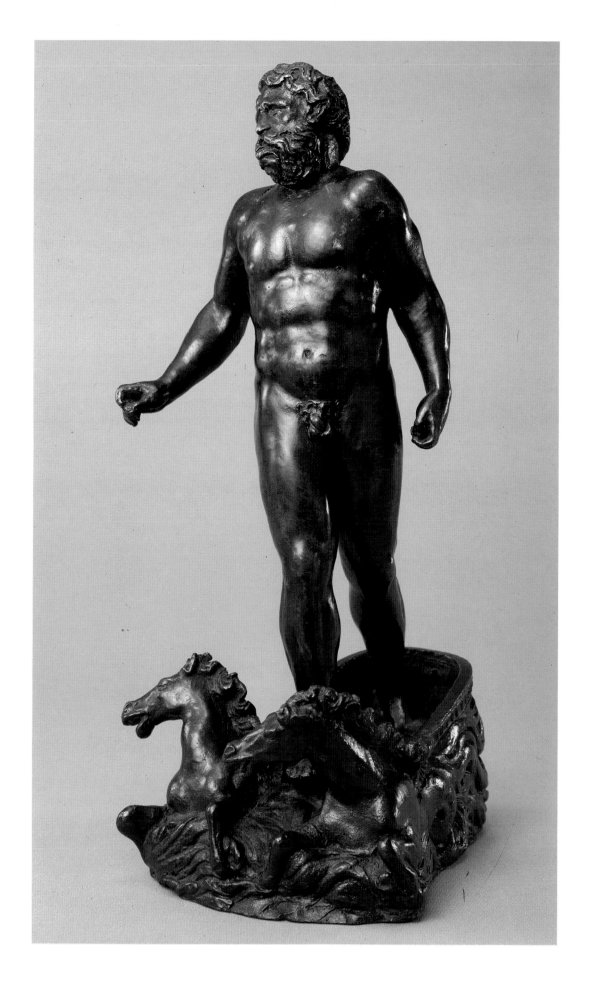

Carrand collection; the chariot alone); London, Victoria and Albert Museum (Pope-Hennessy 1961/62, no. 142; formerly Cassell and Eckstein collections; without chariot); formerly London, collection of Sir George Leon (Pope-Hennessy 1961/62, mentioned in connection with no. 142); formerly London, Otto Beit collection (Bode 1907, p. 22, pl. CLVII, and Bode 1913, p. 62); Vienna, Kunsthistorisches Museum (Planiscig 1924, no. 154; without chariot).

Variant from the Labenwolf workshop in Nuremberg: Baltimore, Walters Art Gallery (Weihrauch 1967, pp. 329, 330, fig. 401; Bowron 1978, pp. 55, 56); variant from the Wurzelbauer workshop in Nuremberg: New York, Blumka collection (Weihrauch 1967, pp. 329, 330, fig. 402).

44. Allegory of winter *or* A philosopher

The statuette represents an aged man with a long beard. He is enveloped in a long, fur-lined and fur-embroidered cloak, one end of which is thrown over his left shoulder, while the other end falls to the ground at his right side. He wears long, close-fitting trousers, bound below the knee, and shoes, also a cap drawn down over both his ears.

The figure is shown as if taking a small step on the round base-plate, itself so small that the man's left foot and the edge of his cloak project over it. His hip is advanced leftward over the leg which carries his weight; the upper part of his body is turned sharply to the right and bent somewhat forward; his head and eyes are bent downward over his right shoulder. His arms are folded on his breast underneath the cloak. The torsion of the body is emphasized by the bunched drapery. The deeply wrinkled brow, hook nose and long curly beard give a certain grimness to his expression.

The statuette is known today as an allegory of *Winter*, no doubt because of the thick fur-lined clothing and the way the subject holds his arms clasped together as if feeling the cold. However, in an 1863 inventory of the Imperial and Royal Cabinet of Coins and Antiquities he is designated as an *Augur*, and by Ilg (1891) as a *Barbarian*. In the catalogue of the collection of the Imperial Treasurer Josef Angelo de France (Martini 1781) the figure is said to represent Anacharsis, the Scythian prince and philosopher who allegedly visited Athens in Solon's time and was later reckoned as one of the Seven Sages. This identification seems also to have been based on his costume.

The statuette has a pronouncedly monumental character, but also displays intensity and elegance thanks to the elongation of the figure and the flowing, spiral movement of the body and the bunched drapery. The clear construction of the figure and the remarkable corporeality of the drapery, its massive folds unobscured by petty detail, point to a sculptor with a keen sense of large and concisely expressive form. At the same time, the modeling of the face, the gently curled beard and the shaggy fur-trimming of the cloak show that the artist was gifted both in portrait-like characterization and in "painterly" modeling.

While the figure is ultimately based on the monumental forms of Michelangelo, which dominated late Renaissance art as a whole, the model is freely developed and is subordinated to a quite different style of decorative abstraction. The "Michelangelisms" of the statuette have been noticed, but also misinterpreted, in the past. Thus Schlosser (1910) and Bode (1906–12) classified it as the work of an anonymous Tuscan or Florentine follower of Michelangelo. Planiscig (1918) correctly assigned it to Venice but, again overstressing the "Michelangelisms", named Jacopo Sansovino as the artist. He adduced for comparison works by Sansovino dating from the 1540s, such as certain figures in the second series of Cantoria reliefs and the frame of the sacristy door of St Mark's in Venice, but these show no similarity of style as opposed to motif. The statuette represents a completely new type of figure *vis-à-vis* Sansovino's works. The torsion and vertical thrust of the body, from its small round base to the hips, shoulders and head, give it a characteristic

Alessandro Vittoria
1525–1608
(See Bibiography, p. 282)

Bronze statuette; thick-walled hollow cast. Core-support pins visible here and there, *eg* under the left elbow. Blackish-brown lacquer; dark red-brown patina. The figure 859 in white on the hem of the cloak at the back is that of a pre-1823 inventory of the Imperial and Royal Cabinet of Coins and Antiquities. Height 33.2 cm, including the integrally cast base.
Inv. no. Pl. 5664.

PROVENANCE

Collection of the Imperial Treasurer Josef
Angelo de France (Martini 1781, p. 12, Des-
criptio Signorum, Scrinium I, no. 99 "(Ser. 3.
Cat. A. n. 333) SENEX, admodum barbatus, in
capite, terram versus converso, ubi quidquam
attente considerat, mitram gestat, in corpore,
praeter femoralia, tibialia et calceos, pallium
pellibus, ut videtur, duplicatum. Est, qui *Ana-
charsin* suspicetur. Opere probo. Aes, 12 1/3
alt. In b. aen. simul fusa, infixaque lign.").
Acquired in 1808 with the de France collec-
tion for the Imperial and Royal Cabinet of
Coins and Antiquities. Transferred in 1880 to
the Ambras collection and with the entire col-
lection to the Kunsthistorisches Museum in
1891.

BIBLIOGRAPHY

Ilg, A. 1891, p. 220, Room XXIV, Case I,
 No. 154.
von Schlosser, J. 1910, p. 8, Plate XXIII, 2.
Bode, W. 1906–1912, III, p. 12, Plate CCXXV.
Planiscig, L. 1918, pp. 1–6.
Goldschmidt, F. 1919, Columns 237–240.
Planiscig, L. 1921, p. 475, Figs. 495, 496.
Planiscig, L. 1924, pp. 102, 103, No. 177.
Planiscig, L. 1925, pp. 33, 34, Fig. 18.
Planiscig, L. 1930, p. 35, Plate CLV, Fig. 269.
Planiscig, L. and Kris, E. 1935, p. 91, Room
 XIII, Case 39, No. 2.
Vollmer, H. 1940, p. 439.
Landais, H. 1958, p. 58.
Cessi, F. 1960, p. 45, Fig. 15.
Pope-Hennessy, J. 1961/1962, No. 147.
Keutner, H. 1962, p. 176.
Pope-Hennessy, J. 1963, II, p. 61, Fig. 25.
Montagu, J. 1963, pp. 46, 47, Fig. 45.
Leithe-Jasper, M. 1963, pp. 207–209.
Weihrauch, H.R. 1967, p. 147, Fig. 173.
Distelberger, R. 1982, p. 87.
Bode, W., and Draper, J.D. 1980, p. 107,
 Plate CCXXV.

spindle-shaped outline. Such an effect cannot be found in Sansovino, but it can in his chief pupil, Alessandro Vittoria.

The credit for perceiving this goes to Goldschmidt (1919), who rightly ascribed the statuette to Vittoria and compared it with two figures of *Prophets*, now lost(?), formerly in the Feist collection in Berlin. Planiscig (1921 and 1924) accepted this attribution, and it has not been questioned by later authors: the only uncertainty concerns the date of the work.

Goldschmidt (1919) made no specific proposal but seems to have assumed a late dating, as he connected the *Prophets* in the Feist collection, to which he compared the statuette, with the figures executed by Vittoria in the early 1580s for the Cappella del Rosario in Santi Giovanni e Paolo in Venice. Planiscig (1921 and 1924) appears to have favored an earlier dating, as he compares the statuette with works executed by Vittoria in the 1560s. Cessi (1960) believed it to be an early work of the artist's, and even dated it *c.*1560. Pope-Hennessy (1962/63), followed by Weihrauch (1967), proposed a date around 1570–75, without giving reasons; Leithe-Jasper (1963) amended this dating to "about 1585".

The basic elements of the composition are to be found, in the first place, in the figures executed between 1566 and 1576 for the altar of the Zane family in the Frari in Venice: here, for the first time in Vittoria's work, we find figures of similar proportions and intensity of expression in similar poses of torsion. Apart from this, the statuette reflects Vittoria's acquaintance with the pictures of philosophers in the reading room of the Biblioteca Marciana in Venice. His inspiration appears to have come not so much from the paintings by Andrea Schiavone and Paolo Veronese, dating from about 1560 – although the motif of folded arms and the heavy fall of drapery over the hips seems to be derived from Veronese – as from the figures by Jacopo Tintoretto, which show a similar vertical torsion but which were not painted until 1570–72. However, compared to the figures on the Zane family altar, the bronze statuette is more restrained in its emotional appeal, while the drapery is smoother, less detailed and thus more sculptural. This again may be linked with Vittoria's known tendency, in the second half of the 1570s, toward abstract stylization and the simplification of forms, restricting painterly expressiveness and concentrating on purely sculptural values. Avoiding in this way the danger of excessive dissolution of form, Vittoria laid the basis for his culminating achievements of the 1580s. These represented a synthesis and harmonization of several elements in his previous work: the abstract sculptural form of the human body, subordinated to ornamental and decorative aims; intensity of expression, pre-Baroque pathos of gesture, and the warmth of a decidedly "painterly" treatment of the surface. Thus the present statuette, in its monumental effect, its artistic maturity and its quality of execution, can stand beside Vittoria's finest achievements of the early 1580s: the *Madonna* on the gable of the Scuola di San Fantin, the figures on the altar of the Scuola dei Merciai in San Giuliano, and the *Addolorata* on the Holy Cross altar of Santi Giovanni e Paolo in Venice.

The careful casting and execution suggest that the statuette was a work in

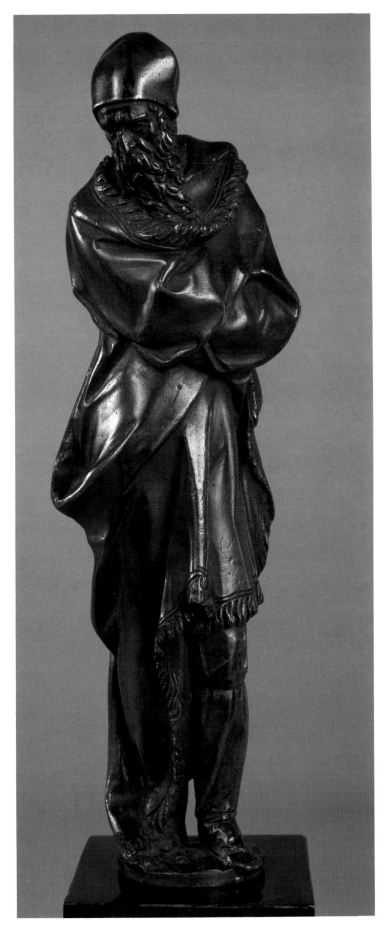

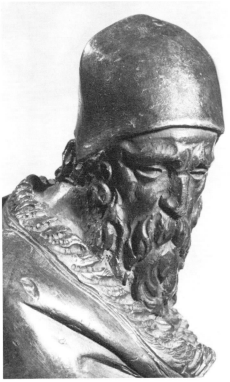

Allegory of Winter, detail of head

its own right and not merely intended to decorate an andiron, as might be thought from its subject – an old man wrapped in a thick coat against the cold, which led to its being given the title *Winter*. Moreover an andiron figure would naturally have a pendant, and none such can be found among extant statuettes attributed to Vittoria. On the other hand, there are no other statuettes by Vittoria that appear to represent seasons; the only ones of about the same size as the present example are of Jupiter and Juno, and thus have no thematic connection with winter. The statuette seems in fact to have been an individual figure from the outset, not one of a series, and this must throw some doubt on its identification as an allegory of winter. Hence the eighteenth-century identification with the philosopher Anacharsis deserves attention, the more so as Vittoria was clearly inspired in this work by the pictures of philosophers in the Biblioteca Marciana. It may well be that the statuette is a genre representation of a philosopher rather than an allegory of winter.

A somewhat weaker and slightly varied replica is in the Museo Estense in Modena. Larger variants are known, much simplified and cruder in style: an example from the Rosenfeld-Goldschmidt collection was sold in Amsterdam in 1916 (cat. 49). Pope-Hennessy (1963) connected the statuette with two bronzes: one, in the Victoria and Albert Museum, London, of an old man sitting and warming himself at a brazier (a replica in the Royal Ontario Museum in Toronto); the other, a girl sitting and warming herself in the same way, in the Museo Nazionale di Capodimonte, Naples. These, however, have nothing in common with the Vienna statuette or with Vittoria's work.

45. Venus Marina

The naked goddess stands with her right foot only on a globe resting upon a shell awash with water. Her left arm is raised and her right lowered; she holds in both hands a drapery that encircles her head and torso like a sail blown by the wind.

The body is tall and slender, yet firmly built; the pose slightly *déhanché* and inward-turned. The head is turned to the left, and the glance somewhat raised. The flow of linear movement is extremely elegant; the bold modeling gives a painterly effect of vibration to the surface. The carriage of the head is proud yet gracious. The refined features are enframed by sweeping tresses; the eyes shaded by rather prominent lids, the irises and pupils marked with delicate lines. In the nape of the neck a lock has been modeled in negative relief, an example of the artist's spontaneous manner of working.

These artistic qualities of the model are not quite matched by the somewhat negligent afterworking. The whole surface bears the marks of rather coarse filing: these are partly covered by the black lacquer, which, however, also conceals many refinements of modeling.

The bronze represents the mythological scene in which Venus, born of the sea-foam, was wafted by the winds to Cyprus, standing on a scallop shell – as already depicted for instance by Botticelli in his *Birth of Venus* in the Uffizi, Florence. However, notably in the globe which reposes in the middle of the shell and in the sail-like drapery, the bronze also reflects representations of the goddess Fortune. Such a representation of *Fortuna* can be seen in a sketch by Baccio Bandinelli in the Louvre, Paris, for a monument to Andrea Doria; Vasari took over the motif and used it for a *Venus* standing on a shell in a fresco in the Palazzo Vecchio in Florence.

As shown by Avery and Watson (1973) and confirmed by Jestaz (1978), the definitive formulation of this type of *Fortuna*, on which the composition of the present *Venus* is based, derives from an invention by Giambologna, who designed it as a pendant to his *Flying Mercury*. Giambologna's model is preserved in casts by Antonio Susini, Pietro Tacca and Massimiliano Soldani; it was also used in a slightly modified form by Giovanni Francesco Susini for his statuette of *Venus chastising Cupid*. In the Vienna statuette the figure is less contorted than in Giambologna's model, the body softer and modeled in a decidedly "painterly" fashion. The same can be said of the details, the goddess's hair and the sail, though the sail has not survived or was never part of the versions derived directly from Giambologna. In the Vienna *Venus Marina* it functions as a decorative drapery.

These artistic features suggest that the Vienna statuette is unlikely to have originated in Giambologna's immediate circle, but was more probably executed in Venice or at any rate by a Venetian artist. The island of Cyprus belonged to Venice from 1489 to 1571; Venus, who landed from the sea upon its shores, played a prominent part in Venetian iconography as a personification of the island and also as a symbol of copper, which was produced there abundantly in ancient times.

Schlosser (1910) and Bode (1907/12) assigned the statuette to Venice. Planiscig (1921 and 1924) attributed it to Danese Cattaneo, a Tuscan pupil of

Venetian(?)

(Tiziano Aspetti?)
c.1559–1606
(See Biography, p. 279)

Bronze statuette; thin-walled hollow cast. The figure and the shell-shaped base with a pearl globe are separately cast and held together with pins. Seams are visible at the junction of Venus's arms and legs with her body, and also at the attachment of the sail, indicating that the statuette was probably cast in five or six pieces which were then welded together. It is less likely that the seams are those of piece-molds, as no openings can be seen for the removal of the casting core, and the bronze is quite evidently hollow. Only in Venus's head and the palm of her right hand can very small holes be seen where the core-support pins have fallen out when being cut off. Black lacquer covering light brown natural patina. The figure 1002 in white on the globe and the sole of the left foot is that of a pre-1823 inventory of the Imperial and Royal Cabinet of Coins and Antiquities. Height 55.5 cm.
Inv. no. Pl. 5885.

PROVENANCE
There is some uncertainty about the early provenance. The statuette was probably in the possession of Emperor Matthias, whose inventory of 1619 mentions such a bronze: "Allerlei schone stuckh von messing: no. 36. 1 Fortuna mit der fahnen." (Köhler 1906–07, p. xv). But in 1755 a *Fortuna* was transferred from the gallery in Prague to the Treasury in Vienna (Zimmermann 1895, Regest 12620). In 1802 the Cabinet of Coins and Antiquities took over from the Imperial Gallery at the Belvedere Palace 28 bronzes, including no. 20, "Fortuna". In 1880 the statuette passed from the Cabinet of Antiquities to the Ambras collection in the Lower Belvedere and was transferred to the Kunsthistorisches Museum in 1891.

BIBLIOGRAPHY

von Schlosser, J. 1910, p. 7, Plate XVIII/1.

Bode, W. 1907–1912, p. 14, Plate CCXXXII.

Planiscig, L. 1921, pp. 411–415. Figs. 432, 433.

Planiscig, L. 1924, p. 93, No. 162.

Planiscig, L. 1930, p. 33, Plate CLII, Fig. 264.

Planiscig, L. and Kris, E. 1935, p. 92, Room XIII, Case 39, No. 7, Fig. 57.

Seymour Jr., C. 1962, p. 17, Fig. 15.

Montagu, J. 1963, p. 44, Fig. 46.

Pope-Hennessy, J. 1963[1], Cat., p. 110.

Weihrauch, H.R. 1967, pp. 142, 143, Fig. 162.

Milkovich, H. 1970, pp. 168, 169, No. S. 10.

Leithe-Jasper, M. 1973, No. 55.

Watson, K. and Avery, C. 1973, pp. 501–507.

Montagu, J. 1975, pp. 24, 25, Cat. No. 110.

Androssow, S.O. 1978, pp. 49, 50, No. 34.

Hirsch sale, II – Works of Art, Sotheby Parke Bernet & Co, London, 22 June 1978, pp. 214, 215, No, 385.

Jestaz, B. 1978, pp. 48–52.

Leithe-Jasper, M. 1978, p. 220.

Avery, C. and Leithe-Jasper, M. 1978/79, Cat. Nos. 13–15b.

Macchioni, S. 1979, p. 452.

Bode, W. and Draper, J.D. 1980, p. 108, Plate CCXXXII.

Sansovino who was active in Venice; this view was endorsed by Pope-Hennessy (1963[1]), Weihrauch (1967) and Androssow (1978). Planiscig believed it to have been the model for one of Cattaneo's three deities for the fountain in the court of the Zecca (Mint) in Venice, where *Apollo, Diana* and *Venus* were to symbolize gold, silver and copper respectively; only Apollo was in fact executed. However, we know far too little of Danese Cattaneo's work to be able at present to assemble an *œuvre* of his small sculpture. In any case it seems clear on stylistic grounds that the *Venus* cannot be the work of Cattaneo, whose roots were in an older tradition. It is also unlikely that Cattaneo, who died in 1572, would have been acquainted with Giambologna's model, on which the present work is certainly based.

The facture of the statuette, however, calls to mind a younger Venetian sculptor, Tiziano Aspetti, who was active in Padua and Venice and also, in his later years, in Pisa and Florence. He might have seen the prototype in Florence, a possibility reinforced by the stylization of the scallop shell which is reminiscent of Buontalenti. In the modeling, typology of the head and treatment of the hair, the statuette shows points of similarity to Aspetti's bronze figures of *Virtues* on the balustrade of the choir of the Santo at Padua, and also to a somewhat smaller *Apollo* in the Statens Museum for Kunst, Copenhagen, attributed to Aspetti by Olsen (1980). Perhaps a comparison of casting techniques would be useful here. Certain stylistic features, it is true, also recall works by Giovanni Francesco Susini and even Ferdinando Tacca; but the latter at least can be excluded, as the statuette in all probability figures in the 1619 inventory of the Emperor Matthias.

No replicas are known. For the Giambologna prototype *cf* Avery (1978/79). The *Fortuna* types derived from Giambologna were assembled and compared in the catalogue of the *Giambologna* exhibition in Vienna (1978/79). The most similar variants are representations of *Venus* in which the goddess advances over the waves but holds a shell instead of a sail in her raised left hand. These, however, seem to be of later origin. Examples are in the Hermitage in Leningrad, the National Museum of Wales in Cardiff, and the Yale Art Gallery. A terracotta variant of this type in the Hirsch collection was sold in 1978.

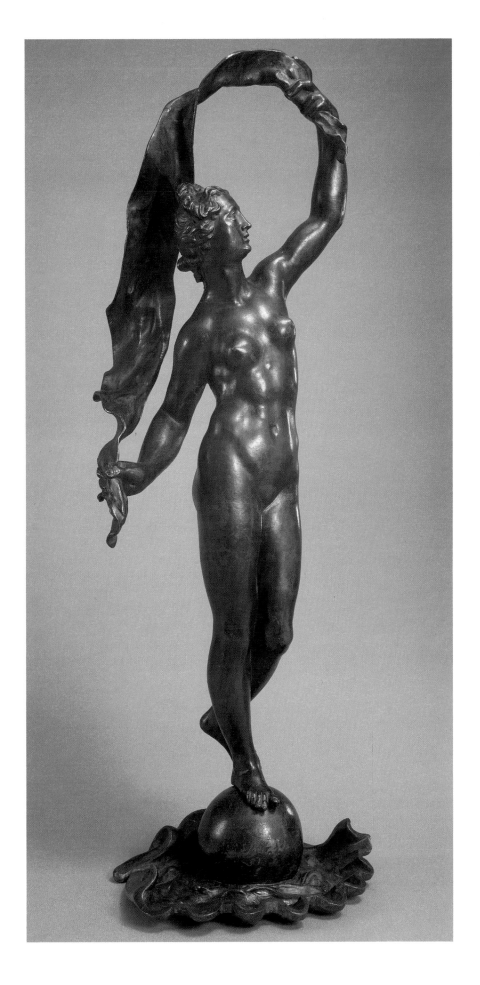

46. Adam and Eve

Attributed to Nicolò Roccatagliata

Documented between 1593 and 1636
(See Biography, p. 281)

Bronze group; hollow cast, the casting core not removed. Several small casting flaws in the figures. A hole at the back of *Adam's* head; several small round holes where core-support pins have fallen out. Two fillings in *Eve's* right shoulder. Blackish-brown lacquer; light brown natural patina.

Height 23.2 cm.

Inv. no. Pl. 5530.

PROVENANCE

Collection of the Imperial Treasurer Josef Angelo de France. (Martini 1781, p. 42, Descriptio Signorum, Scrinium III, no. 367 "(Ser. 3. Cat. A.n. 805) ADAMVS et EVA, pubem tecti fronde ficulnea, et dolorem ex lapsu prodentes. Op. ingenioso et pulcro. Aes, 8 11/12 alt. In lamina ovali simul fusa et caelatis figuris ornata."). Acquired in 1808 with the de France collection for the Imperial and Royal Cabinet of Coins and Antiquities. Transferred to the Ambras collection in 1880 and transferred to the Kunsthistorisches Museum in 1891.

BIBLIOGRAPHY

Ilg, A., and Boeheim, W. 1882, p. 86, No. 51.
von Frimmel, T. 1883, p. 58, No. 955.
Ilg, A. 1891, p. 218, Room XXIV, Case I, No. 20.
von Schlosser, J. 1901, p. 14, Plate XXI/3.
Bode, W. 1907, II, p. 23, Plate CLX.
von Schlosser, J. 1910, p. 8, Plate XX/2.
Planiscig, L. 1921, pp. 619, 620, Fig. 695.
Planiscig, L. 1924, pp. 120, 121, No. 210.
Planiscig, L. 1930, p. 39, Plate CLXXX, No. 312.
Planiscig, L. 1934, p. 444.
Planiscig, L. and Kris, E. 1935, p. 134, Room XVI, Case 8, No. 13.
Venturi, A. 1937, X/3, pp. 388–392.
Pope-Hennessy, J. 1961/62, No. 165.
Pope-Hennessy, J. 1963, p. 61.
Weihrauch, H.R. 1967, p. 60.
Leithe-Jasper, M. 1973, Nos. 61 and 62.
Leithe-Jasper, M. 1976, Nos. 109 and 110.
Bode, W., and Draper, J.D. 1980, p. 102, Plate CLX

Adam and Eve, nude except for a girdle of figleaves, are depicted as if walking, on an integrally cast oval base-plate representing a grassy mound in naturalistic fashion.

The scene is that of the Expulsion from Paradise. Adam wrings his hands in despair and gazes upward with a look full of pain, but not without pride, as he hears the voice of God or the angel. Eve nestles against Adam as though seeking protection. Her left arm is around Adam's shoulder and her head rests on his right shoulder as she contemplates the apple, held in her raised right hand. Adam's gesture of despair seems to be taken from Quattrocento representations of St John at the foot of the Cross.

The group with its sketch-like modeling is highly expressive. Great skill and insight are shown in the differentiation of male and female reactions to the horror of exile, with Eve humbly seeking protection and Adam desperate yet defiant. The harmonious movement of the figures is full of melodic grace, and their relation to each other is especially sensitive and natural. Their ideal forms in no way conflict with their expressive realism.

As so often in Venetian statuettes of the late Renaissance, the casting is not executed with great care. However, much of the original freshness of the model is preserved, as details such as the faces, hair and figleaves are not chased – only the flesh parts have been smoothed with the file.

Ilg (1882) believed the group to be Venetian work of the Cinquecento. Frimmel (1883) classified it as "Florentine school(?), sixteenth century". Schlosser (1901 and 1910) first attributed the group to Nicolò Roccatagliata and compared it with figures from a late work of his, the antependium dated 1633 in San Moisè in Venice. The expressiveness of the figures is reminiscent of Tintoretto, and Schlosser explained this by the fact that the two artists sometimes worked together. Roccatagliata, as his biographer Soprani tells us, made small models for studies of movement. Bode (1907), without discussing Schlosser's attribution, attributed the group to an anonymous Venetian sculptor, close to Tintoretto and active around 1570. Planiscig (1921, 1924 and later) agreed with Schlosser in all respects, and subsequent critics have followed this view.

The *Adam and Eve* group contains only a distant echo of the long stylistic tradition of High Renaissance Venetian sculpture that began with Sansovino. This is chiefly apparent in the harmonious depiction of movement and the graceful idealism of the figures, whereas the expressive content and psychological penetration are a reaction to late Renaissance mannerism. The work already belongs to the Counter-Reformation and the Baroque era, and accordingly it can only be the fruit of Roccatagliata's later years. Schlosser's remarks concerning the affinity to certain figures in the antependium in San Moisè of 1633 are quite correct, and Bode's dating is about half a century too early. The group bears little or no relation to Roccatagliata's early works, but like the antependium displays a new spirit with its evident reminiscences of late medieval or Quattrocento models. However, there is room for a clarification of the roles played by Nicolò and his son Sebastiano respectively in the output of the Roccatagliata workshop in the first third of the seventeenth century.

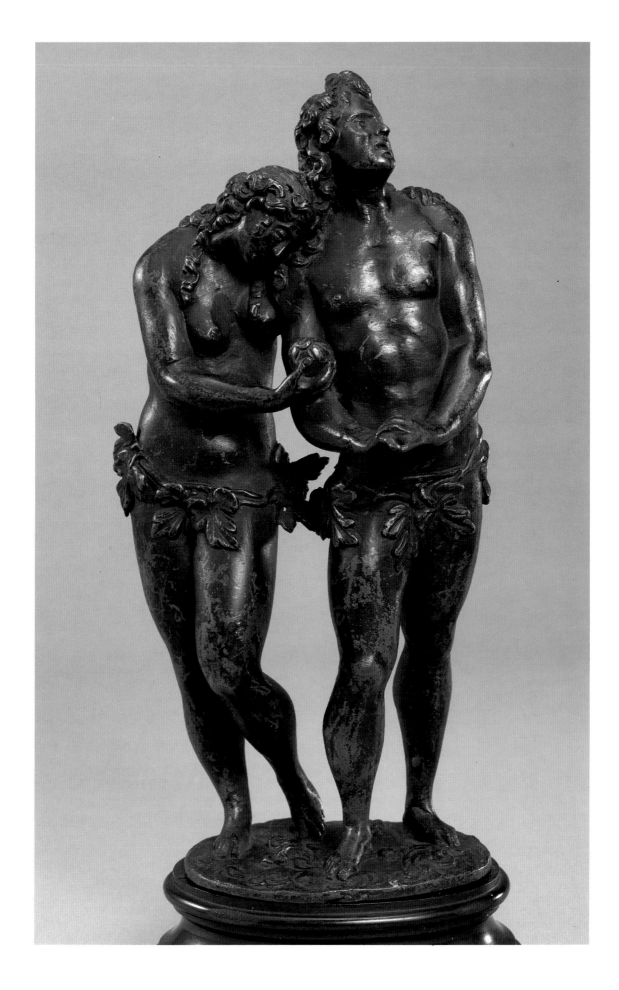

The Museo Civico in Belluno possesses a badly preserved variant of the *Adam and Eve* group, in which the relationship of the two figures is not so close and the movement more violent. The Kunsthistorisches Museum also possesses separate figures of *Adam* and *Eve*. Here *Adam's* pose is almost the same as in the group, but *Eve* looks at him and points seductively at the apple which she has just plucked: the episode represented is therefore the Fall and not the Expulsion.

47. Putto with drum and flute

The naked *putto* stands on a small, round, integrally cast base; his right leg is somewhat advanced and his head turned to the left. A small drum is hung on his left lower arm; he holds it against his side and beats it with the drumstick in his right hand. With his left hand he holds the end of a flute, the mouthpiece of which is raised to his lips.

See further cat. 48.

Nicolò Roccatagliata
Documented between 1593 and 1636
(See Biography, p. 281)

Bronze statuette; thick-walled hollow cast. Black lacquer; dark brown patina.
Height 28.2 cm, including the integrally cast base.
Inv. no. Pl. E.7579.

PROVENANCE
As No. 48.

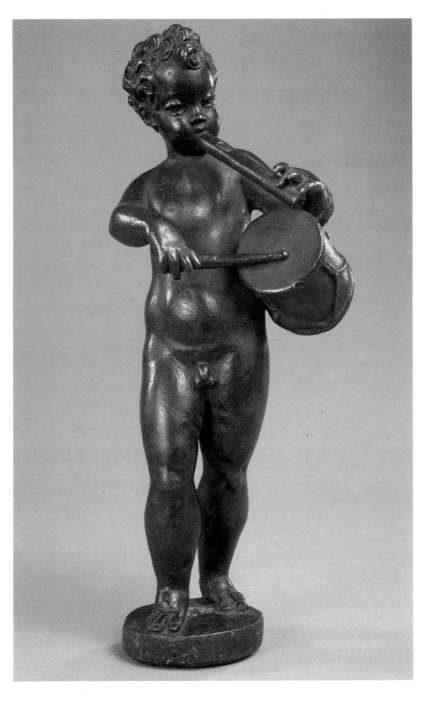

48. Putto playing the flute

Nicolò Roccatagliata
Documented between 1593 and 1636
(See Biography, p. 281)

Bronze statuette; thick-walled hollow cast. A small crack on the left knee. A piece broken off the lower end of the flute. Black lacquer; dark brown patina.
Height 28.6 cm, including the integrally cast base.
Inv. no. Pl. E.7578.

PROVENANCE
Collection of the Marchese Tommaso degli Obizzi at the castle of Il Cataio near Padua. Inventory compiled by F.A. Visconti in 1806, no. 2036 "Due Genj moderni in bronzo, uno che suona il flauto e l'altro il tamburo, 1." (Documenti inediti per servire alla storia dei Musei d'Italia, III, 1880, pp. 29–80, Museo Obiziano). Bequeathed with his collection in his will of 1803 by Tommaso degli Obizzi to the Este Dukes of Modena or in the case of the extinction of their male heirs, to the house of Austria-Este, a younger branch of the Habsburgs. Transferred at the end of the 19th century from Cataio to Vienna and taken over in 1923 by the Kunsthistorisches Museum.

BIBLIOGRAPHY
Hermann, H.J. 1906, pp. 13, 14, Fig. 17b and c.
Planiscig, L. 1919, pp. 141, 142, Nos. 217 and 218.
Planiscig, L. 1921, pp. 617, 618, Fig. 685 and 686.
Planiscig, L. and Kris, E. 1935, p. 134, Room XVI, Case 8, Nos. 1–10.
Venturi, A. 1937, X/3, pp. 387, 388, Fig. 313.
Pope-Hennessy, J. 1961/62, No. 167.
Mariacher, G. 1971, p. 41, No. 180.
Androssow, S.O. and Faenson, L.I. n.d., p. 69, Nos. 54, 55.

The naked *putto* stands on a small, round, integrally cast base: in contrast to cat. 47, his right leg is somewhat advanced. He holds a transverse flute to his mouth with both hands. The statuettes form a pendant pair and are clearly related to each other by gesture and musical theme. Despite a somewhat careless finish (not an unusual feature in Venetian bronzes of the late Cinquecento), both statuettes well express the childlike charm and grace of their subject. The curves of the plump body and the fresh, unaffected gestures are rendered in all their spontaneity. *Putti* of this kind are an additional proof of the influence that Venetian art of this period exercised over the development of Rococo.

The two statuettes belong to a Venetian tradition of long standing, originated in the 1540s by the Florentine Jacopo Sansovino with the *putti* on his tabernacle reliefs and the border of his sacristy doors for St Mark's, and developed by his pupils, especially Alessandro Vittoria. This characteristic Venetian type of *putto*, in its many variations, is one of the most commonly reproduced products of Venetian foundries, and innumerable examples survive. Critics have assigned them too exclusively to Nicolò Roccatagliata, a native of Genoa who was active in Venice in about 1600 and has been called "the Master of the Putti". As closer inspection shows, by no means all of them are from his workshop.

However, in the case of the two music-making *putti* in the Vienna collection, the facial expression and the treatment of the short but abundantly curly hair closely resembles Roccatagliata's bronze figure of *St George* in San Giorgio Maggiore in Venice, an early work of 1593. Since Hermann's time (1906) it has rightly been supposed that these two *putti*, among the most charming of their kind, must be based on an autograph model entrusted by Roccatagliata to the foundry for reproduction and distribution.

What decorative function the *putti* were intended for is no longer clear: they seem too large for the figurative elements of candelabra and too small to surmount fireirons.

Four similar music-making *putti*, some with wings indicating them to be *Cherubs*, were formerly in the Mme Rosenfeld-Goldschmidt collection (sale, Amsterdam, 1916, cat. 45). A replica, with wings, of the *putto* playing the transverse flute is in the Museo Correr in Venice (Mariacher 1971, no. 180); two similar, but singing *Cherubs* are in the Hermitage, Leningrad (Androssow n.d., nos. 54 and 55).

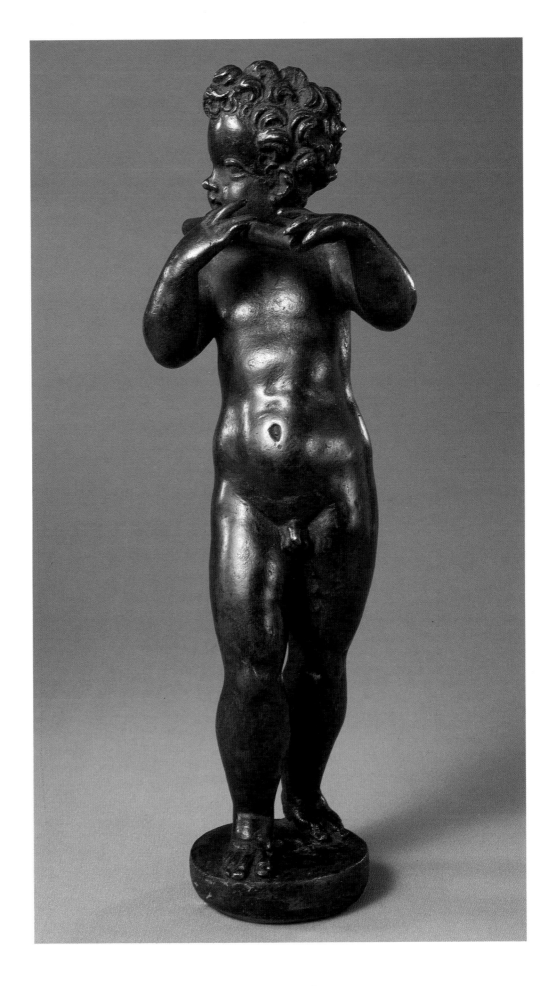

49. Mercury

Johann Gregor van der Schardt
*c.*1530, last mentioned 1581
(See Biography, p. 282)

Bronze statuette; thick-walled hollow cast. The base integrally cast; the caduceus separately cast and mounted. A slight casting flaw on the front of the base. Dark brown lacquer; light brown patina.
Height 53 cm.
Inv. no. Pl. 5900.

PROVENANCE
Probably long an imperial possession (Rudolf II?). The statuette comes from the Imperial Treasury, Vienna, but cannot be identified with certainty among the various statuettes of *Mercury* mentioned there since 1750. Transferred from the Treasury to the Ambras collection in Vienna in 1871 (Journal of acquisitions of the Ambras collection 1871–77, p. 3): "1871 Diese und die folgenden Gegenstände aus der k.k. Schatzkammer, *Merkur*, schreitend, in her R. den Caduceus, die L. halb erhoben, nackt, nur mit Flügelhut und Flügelschuhen. 1′ 7″. detto [bronze]." Transferred with the entire Ambras collection to the Kunsthistorisches Museum in 1891.

Mercury is represented as a naked youth with winged sandals, hastening forward. In his right hand, partly outstretched and lowered, he holds the caduceus; his left arm is raised as if pointing to a companion. He wears the winged cap or *petasus* on his short wavy hair; his head is turned to the left and his glance follows the direction of his left hand. The composition is distinguished by a harmonious flow of line and a movement which seems to require no effort, as the figure turns gently on its axis and opens its pose upward.

The statuette does not seem designed to be viewed in the round; the best aspect is diagonally from the front. The modeling of the body is precise but soft, the hands formed with great delicacy. The details, while sharply rendered, are not hard or graphic, and the modeling is "painterly". The facial expression is highly poetical, harmonizing to an exceptional degree with the gently flowing movement and the open gesture.

The statuette for a long time resisted classification, and was the subject of conflicting attributions. Ilg (1891) regarded it as a work from Giambologna's school. Schlosser (1910) hesitated between an artist of Cellini's circle, such as Guglielmo Fiammingo, and one in the circle of Jacopo Sansovino in Venice – induced to think of Venice because he took the letters v.s.f. in the signature J.G.V.S.F. on the base of the large variant in the National Museum in Stockholm (which was also known to Ilg) to signify "Venetus Sculptor fecit". Bode (1906–12, III) also attributed the work to Cellini's circle. In 1909 there appeared in London a statuette of *Minerva*, probably from a Stuttgart collection, which Lippmann in that year attributed to Cellini; it was sold at Sotheby's in 1982 and is now in the collection of Mr Robert Smith in Washington DC. Loeser (1909) pointed out its resemblance to the Vienna statuette of *Mercury*, and to the replica of *Mercury* in the Württembergisches Landesmuseum in Stuttgart; he disputed Cellini's authorship of the Vienna bronze and ascribed it to Jacopo Sansovino, in which opinion he was followed by Schlosser (1910, II, and *Übersicht* 1916/17). Planiscig (1921) initially also favored a Florentine origin and suggested Vincenzo Danti as a possibility. It was left to Peltzer (1916–18) – followed by Planiscig (1924) and subsequent writers – to connect the inscription on the Stockholm *Mercury* with documents meanwhile published in Vienna in the *Jahrbuch der Kunsthistorischen Sammlungen des Allerhöchsten Kaiserhauses* and to interpret the letters J.G.V.S.F. as "Johann Gregor van der Schardt fecit". In addition Peltzer convincingly connected both the statuettes of *Mercury* and the *Minerva* with bronzes and terracottas by van der Schardt which had belonged to the *Kunstkabinett* of the Nuremberg patrician Paulus von Praun (1548–1616) – which had been catalogued by Murr in 1791 shortly before it was broken up in 1801. Peltzer believed that the Stuttgart *Mercury* and the *Minerva* in the Smith collection were from von Praun's *Kabinett*, whereas the Vienna *Mercury*, which came from the Imperial Treasury, had presumably belonged to the imperial house from an earlier date.

Paulus von Praun lived for many years in Bologna and could have met van der Schardt there. We know that the latter – who in 1569 entered the

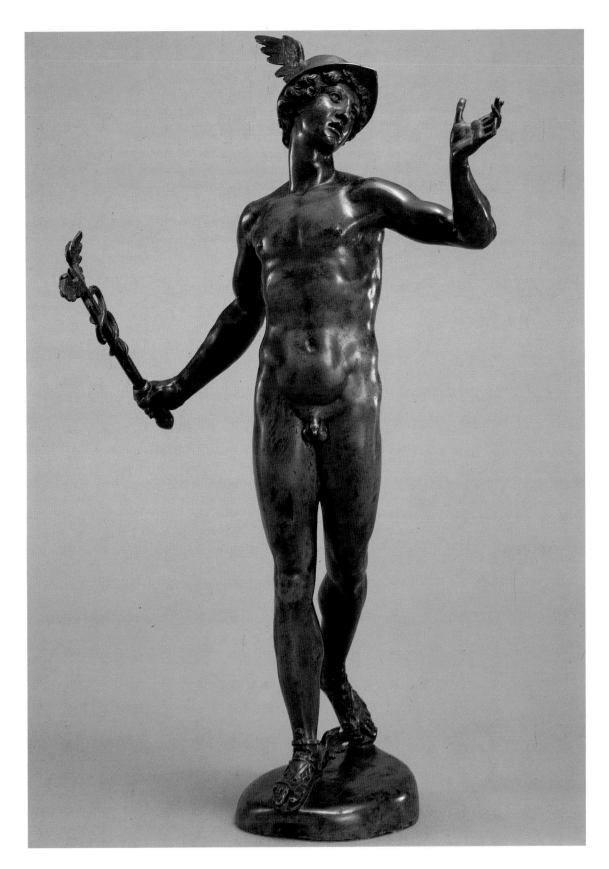

service of the Emperor Maximilian II in Vienna, and from 1570 worked for
him in Nuremberg – previously stayed in Rome, Bologna and Venice, and
presumably also in Florence. This would account for the traces of Florentine
and Venetian influence in his work, and the consequent uncertainty of

BIBLIOGRAPHY

Ilg, A. 1891, p. 226, Room XXIV, Case 4,
 No. 48.
von Schlosser, J. 1910, p. 12, Plate XXXIII,
 No. 1.
von Schlosser, J. 1910, II, p. 17 (addendum).
Bode, W. 1906–1912, III, p. 12, Plate CCXXIII.
Übersicht 1916/17, p. 192, Room XXIV, Case 3,
 No. 61.
Peltzer, R.A. 1916–1918, pp. 198–216.
Planiscig, L. 1921, p. 381.
Planiscig, L. 1924, p. 199, No. 323.
Planiscig, L. 1925, p. 34.
Frankenburger, M. 1925, p. 373.
Feulner, A. 1926, pp. 11–13.
Meller, S. 1926, pp. 34, 35.
Bange, E.F. 1949, pp. 149, 150.
*Le Triomphe du Maniérisme – De Michelange
 au Greco* 1955, p. 181, No. 366.
Valentiner, W. 1956, pp. 46–49.
Möller, L.L. 1964, pp. 191–204.
Vienne à Versailles 1964, p. 30, No. 38.
Weihrauch, H.R. 1967, p. 321, and p. 348.
Leithe-Jasper, M. 1974, p. 187, No. 494.
Fleischhauer, W. 1976, p. 100.
Bode, W. and Draper, J.D. 1980, p. 107,
 Plate CCXXIII.
Distelberger, R. 1982, p. 106.
Larsson, L.O. 1984, pp. 62–66, No. 21.
Bruegels Tid 1984, pp. 25–28, No. 18.
Radcliffe, A.F. 1985, pp. 97, 98.

Schlosser, Bode and Loeser in the classification of the statuette of *Mercury*. It would seem, however, that van der Schardt was not especially influenced by his near-contemporary Giambologna, although he must have seen his early works in Bologna and Florence. At any rate van der Schardt's *Mercury* bears no resemblance to Giambologna's *Flying Mercury* (cat. 51); indeed one cannot resist the impression that he was at pains to ignore Giambologna's epoch-making invention, which was then already in Maximilian II's collection. At most there is a certain similarity between van der Schardt's *Mercury* and Giambologna's *Bacchus* made for Lattanzio Cortesi; but here again there is a closer parallel to van der Schardt in another bronze of *Bacchus* by an anonymous Florentine(?) artist in the Stuttgart Museum (inv. no. WLM KK 64; Weihrauch 1967, p. 177, fig. 215). Schardt appears to have aimed at a more classically ideal figure and thus to have been more inspired by the work of Baccio Bandinelli; he may also have been impressed by Cellini, especially the figures on the base of his statue of *Perseus*. The least important influence seems to have been that of Venetian sculpture, emphasized by Loeser, Schlosser, Weihrauch and most recently Radcliffe (1985). Here the name that chiefly comes to mind is Danese Cattaneo; Alessandro Vittoria's figures are much more abstract, and their outlines more self-contained.

Frankenburger, as early as 1925, compared the Vienna *Mercury* and the *Minerva* statuette with the caryatids, also in the Kunsthistorisches Museum, representing the Four Seasons, which belonged to the silver ornamental fountain commissioned from Wenzel Jamnitzer by the Emperor Maximilian II and completed for his son Rudolf II: the fountain itself was melted down in 1747 by order of the Imperial Treasurer Josef Angelo de France. Frankenburger argued convincingly that van der Schardt might have provided the models for these figures. His view was adopted by Feulner (1925), Meller (1926) and Leithe-Jasper (1974), but opposed by Bange (1949) and Weihrauch (1967). At that time it was only possible to compare directly the *Mercury* and the two male figures of *Autumn* and *Winter*. In 1982, however, when the *Minerva* statuette reappeared on the London art market, it could be compared to the female allegories of *Spring* and *Summer*, and the theory was dramatically confirmed. (See also Radcliffe 1985.) It was also confirmed that *Mercury* and *Minerva* were conceived as a pair.

The replica of *Mercury* in Stuttgart is scarcely inferior in quality to the Vienna statuette. Its provenance is not wholly clear (Fleischhauer 1976), but Peltzer (1916–18) and E. Wilson (1982) supposed that, like the statuette of *Minerva*, it came from von Praun's collection in Nuremberg. It varies in small details, especially the interior measurements. The stride of the figure in the Vienna bronze is considerably longer (68 mm; Stuttgart 62 mm), giving it a more dynamic and decisive air.

Another version of this format seems to have been owned by Tycho Brahe, as supposed by Larsson (1984).

The signed variant in the National Museum in Stockholm is more than twice as high (114 cm), more softly modeled and has a less differentiated surface.

50. Venus Urania

The naked figure of a young woman stands on a very small round base. Her left foot rests on a prism, leaning against which is an armillary sphere. Engraved on the sphere are emblems of the Zodiac, degrees of latitude and longitude, and numerous small stars; punched on it are the words VENNVS, SOL and LVNNA, with S and N written backwards. Lying on the base is a plummet together with other instruments, not all clearly identifiable. The upper part of the goddess's body is inclined slightly forward and turned sharply to the left. Her left hand, holding a ruler and compass, rests on a straightedge supported, somewhat unstably, by the prism; on this again is a setsquare wrapped in a drapery, on which she rests her right elbow. With her right hand, raised almost to the left shoulder, she holds a girdle that encircles the upper part of her body and bears, engraved at the back, the artist's signature —: GIO BOLONGE :— (sic).

In contrast to the pose of the upper part of her body, the goddess's noble head is turned sharply to the right, as she looks downward over her right shoulder. Her hair with its profuse curls is woven into plaits that cover the top of her head and are knotted over the brow. The hair is bound by a double fillet, but a wavy strand falls down over the back of the neck to the right shoulder.

The otherwise flawless perfection of the figure is marred by cracks due to the cooling of the casting mold, which have had to be repaired by a series of fillings and were probably the reason for the gilding. In other respects the figure reproduces all the refinements of the modeling with superb freshness. The surface was carefully smoothed after the repair had been made; the details are chased with great subtlety. The material of the drapery is differentiated by punching, the accessories and inscriptions are engraved or punched. Finally the statuette was firegilt, so that the fine layer of gold almost concealed the repairs; however, the cracks have widened in the course of time and now appear through the gilding. In old inventories the statuette, now often known as *Astronomy*, bore the appropriate name *Venus Urania*: it represents, first and foremost, a beautiful woman, and the scientific attributes are secondary.

The pose of the figure, standing on an extremely small base and with its left foot sharply drawn up, means that it has to be *déhanché* to an extreme degree to retain its equilibrium; even so, the figure required additional support. This support is provided by the instruments which lend the work its allegorical significance.

The composition involves a repeated change of direction in the pose of the beautiful, slender body. The varying angles of the body and its limbs produce a structure of parallel lines that constantly change position as the figure is turned round. These varying parallelograms constitute a tall slender polyhedron by which the figure is enclosed. The framework of parallels and the tension between the parts and the whole give the composition optical stability and harmony despite a complexity which is almost artificial. Keutner (1978/79) aptly described this result as "active repose". The composition glides in flowing lines from each element to the next. Starting from a base

Giambologna
1529–1608
(See Biography, p. 280)

Bronze statuette; thick-walled cast with numerous flaws. A large crack, with many fillings, runs from the left shoulder across the back to the right hip. Further cracks at the back between the lower legs and at the junction of body and drapery, visible especially at the left foot, the left hip and the right elbow. The base is closed at the bottom with a second piece riveted on, and a wedge inserted between the two. The decoration of the armillary sphere is partly engraved, partly punched; the inscription GIO BOLONGE on the girdle is engraved. Old firegilding; on the rubbed areas many, often quite extensive, later retouchings with gold paint.
Height 38.8 cm.
Inv. no. Pl. 5893.

PROVENANCE

Long an imperial possession. However, not one of Francesco de' Medici's gifts to Emperor Maximilian II. First documented with certainty in the inventory of the Imperial Treasury in 1750, p. 577, no. 53: "Ein figur, so die Venus Uranie repraesentiert, aus obiger materi [bronze] verfertigt." (Zimmermann 1889, Reg. 6253, p. CCCX); first described as being gilt in the inventory of 1785, set high on the cornice, no. 41: "Ein Venus aus vergoldeter Bronze"; after 1815 moved from the cornice into case no. IXI/2: inventory of 1826: "Venus Urania, aus Bronze vergoldet." In 1871 transferred from the Treasury to the Ambras collection in Vienna and in 1891 transferred with the entire collection to the Kunsthistorisches Museum.

which is little more than a point, the figure seems to spiral unendingly upward, only to revert to its origin in an S-shaped curve indicated by the goddess's downward glance. These observations illustrate that the composition is by no means designed to be seen mainly from the front, as Keutner thought (1978/79), but is contorted in such a manner that no single view does justice to it. It can only be fully comprehended in the totality of its viewpoints. The spectator is compelled to look round it, because at each point there seem to be a few degrees lacking to the angle of vision. No other figure by Giambologna asserts its manysidedness so inescapably as the *Venus Urania*.

As Keutner (1978/79) has shown, several elements of the composition are foreshadowed in other works by Giambologna, especially the *Fiorenza* on Tribolo's columnar fountain in the garden of the Medici villa at Castello near Florence. As Keutner observed, Giambologna drew on his early stock of inventions to create a repertoire of forms which he afterwards constantly varied in an economical fashion. Thus the statuette of *Apollo* which he made in 1573/74 to decorate the *studiolo* of Francesco de' Medici practically repeats the composition of *Venus Urania* in reverse. The only difference is that Apollo's arm has a higher support and is turned more to the side than *Venus*'s and is thus more visible from the front; this quietens the composition, giving the figure a frontal aspect. In the *Venus* of the Grotticella in the Boboli gardens in Florence (*c.*1575–76) Giambologna once again varied the theme he had created in the *Venus Urania*, giving it an increased, almost classical sense of repose; the spectator is afforded a perfect, self-contained view on which he can dwell at leisure from any standpoint. Here there seems to be an avoidance of all conflict between the three-dimensional nature of the figure and the fact that it can only be looked at from one angle at a time. We can understand Filippo Baldinucci's enthusiasm for the Grotticella *Venus*: "fece una bella femmina, che fu posta sopra la tazza d'una fonte; figura attitudinata per modo, che osservata da quante vedute si vogliano, apparisce in atto meravigliosamente grazioso". The *Venus Urania*, by contrast, demands to be seen in its entirety, all at once. In this work Giambologna has taken sculpture to its uttermost limit, if not beyond it into the fourth dimension where space is supplemented by time.

As Keutner observed, the *Venus Urania* marks the beginning of a new phase in Giambologna's style. The striving after enrichment of form and liveliness of expression is manifested to an extreme, perhaps even excessive, degree. Then, in the *Apollo* and especially the Grotticella *Venus*, comes a harmonization and a rediscovered regard for the laws of statics on which sculpture depends. But it was not only in formal respects that Giambologna pushed his art to extremes, in the *Venus Urania* as in the *Flying Mercury*; the sensual effect of the present figure is unsurpassed in any other of his works.

None of the many versions of *Venus Urania* in bronze or other materials comes anywhere near the quality of the Vienna statuette. They are all smaller and differ from it not only in the quality of execution and in details – in none, apparently, does the figure wear a girdle – but also in rhythmic

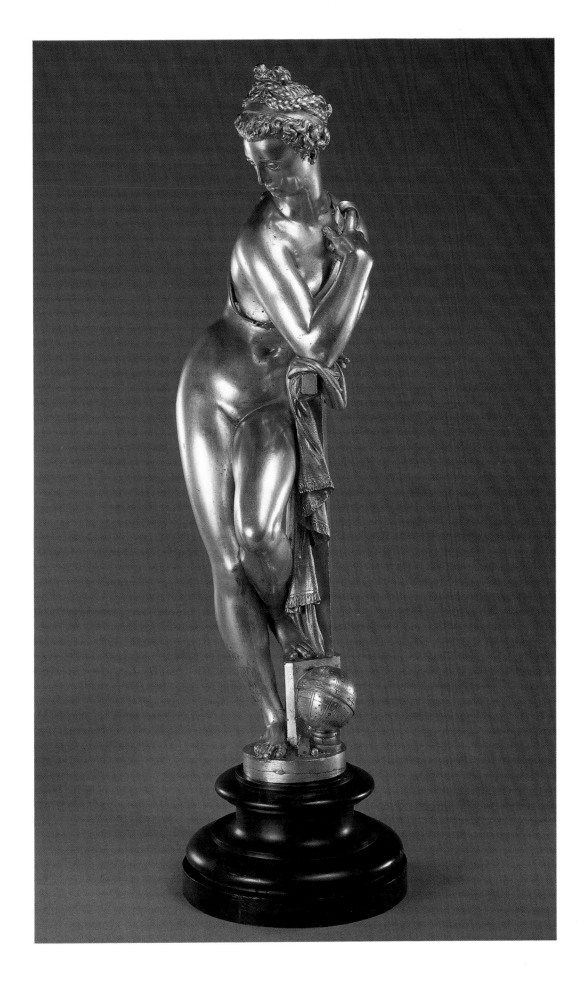

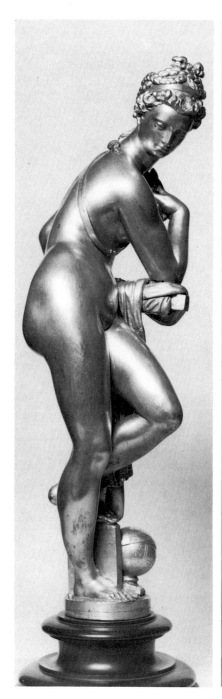
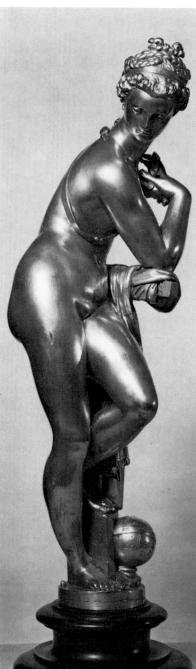
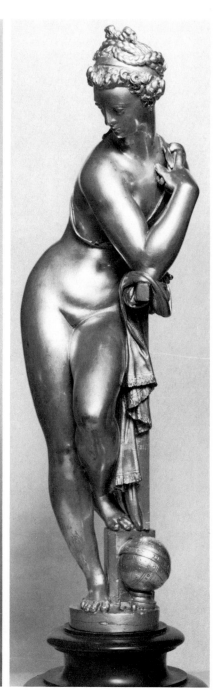

Venus Urania, six alternative views

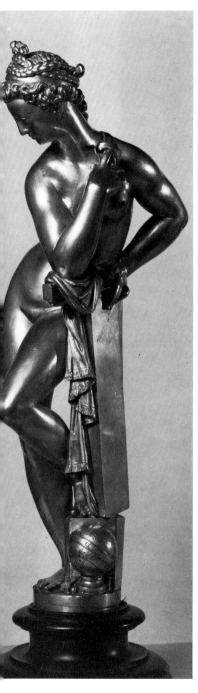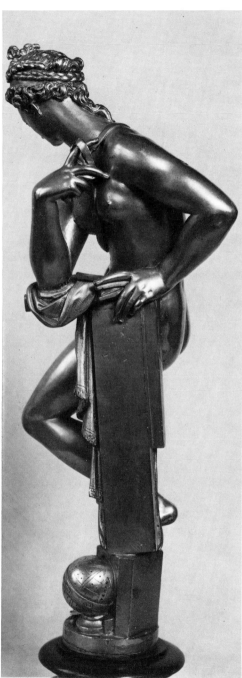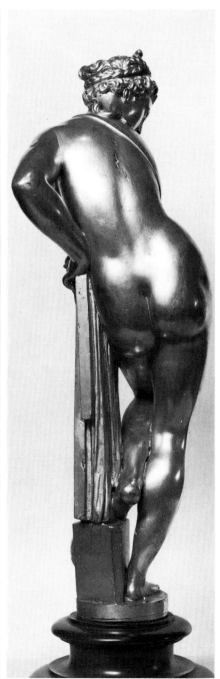

BIBLIOGRAPHY

Ilg, A. and Boeheim, W. 1882, p. 86, Room v, Wall Cabinet 5, No. 46.

von Frimmel, T. 1883, p. 59, No. 959.

Ilg, A. 1886, pp. 40, 41.

Ilg, A. 1891, pp. 225, 226, Room XXIV, Case 4, No. 41.

von Schlosser, J. 1901, p. 17, Plate XXVI/3.

Renaissance exhibition catalogue, Berlin, 1908, Plate XXXIII/5.

von Schlosser, J. 1910, p. 10, Plate XXVII/2.

Bode, W. 1906–1912, III, p. 4, Plate CXCIV.

Bode, W. 1911, pp. 635, 636.

Übersicht 1916/1917, p. 190, Room XXIV, Case 3, No. 4.

Planiscig, L. 1924, p. 148, No. 250.

Planiscig, L. 1930, p. 47, Plate CCII, Fig. 349.

Bode, W. 1930, pp. 32, 33, No. 152.

Planiscig, L. and Kris, E. 1935, p. 90, Room XIII, No. 30, Fig. 52.

Planiscig, L. 1942, p. 16, No. 31.

Kriegbaum, F. 1952, pp. 37–66.

Dhanens, E. 1956, pp. 184, 185.

Landais, H. 1958, p. 71.

Holderbaum, J. 1959/1983, p. 141.

Pope-Hennessy, J. 1963, Fig. 130.

Montagu, J. 1963, p.77, Fig. 82.

Ciardi Dupré, M.G. 1966, pp. 99, 100, Fig. 42, and p. 112.

Weihrauch, H.R. 1967, pp. 206–208, Fig. 248.

Savage, G. 1968, pp. 172, 173, Fig. 150.

Avery, C. 1970, p. 247, Fig. 183.

Fock, C.W. 1974, p. 140.

Larsson, L.O. 1974, Fig. 102.

Hibbard H. 1977, p. 222, Fig. 71.

Leithe-Jasper, M. 1978, p. 195.

Keutner, H. 1978/79, p. 27.

Leithe-Jasper, M. 1978/79, pp. 12, 13, Nos. 12, 12a, 12b.

Bode, W., and Draper, J.D. 1980, p. 105, Plate CXCIV.

Jestaz, B. 1985, p. 158.

movement. Hence they cannot be designated as replicas or independent variants, but only as weaker, later copies. Early copies are mentioned in the Augsburg collection of Marcus Zeh in 1611 (Doering 1894, p. 97) and the 1684 inventory of the French royal collections (Courajod 1882, p. 222, no. 66). Later copies include those in the collection of the Augustinian monastery, Klosterneuburg (inv. no. KD.31, height 34.5 cm; *Giambologna* 1978/79, no. 12a); Palazzo Schifanoia, Ferrara (inv. no. C.G.F. 8540, height 34.6 cm; Varese 1974, no. 127); Thiers collection, Musée du Louvre, Paris (inv. no. 91); sculpture collection, Staatliche Museen, Berlin-Dahlem (inv. no. M.71, height 34.9 cm, gilt; Bode 1930, pp. 32, 33, no. 152); formerly collection of E. Simon, Berlin (height 37.5 cm; Bode 1906–12, III, p. 4, pl. CXCIV); Museo Nazionale del Bargello, Florence (Supino 1898, p. 395, without measurements); the Uffizi, Florence; formerly Hainauer collection, Berlin (Renaissance exhibition catalogue, Berlin 1908, pl. XXXIII/5). A small variant in reverse direction, probably by a northern artist, in the Kunsthistorisches Museum, Vienna (inv. no. 5891, height 18.6 cm; Leithe-Jasper 1978/79, p. 93, no. 12b). A variant in ivory, *c*.1660, in the Kestner Museum, Hanover.

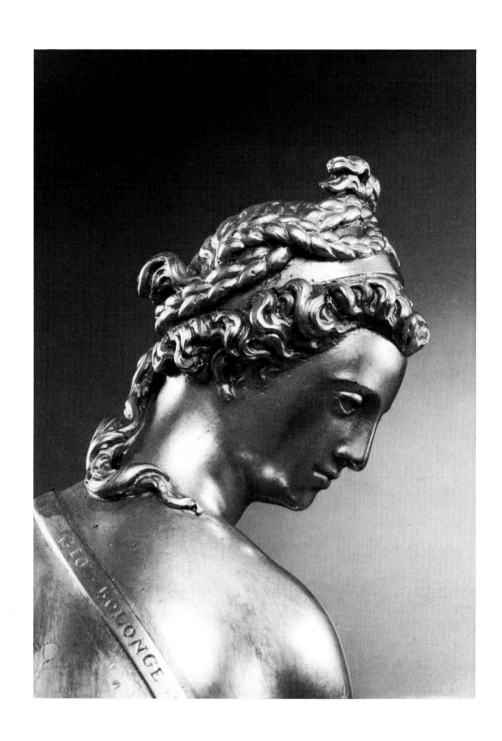

Venus Urania, detail of head and signature

51. Flying Mercury

Giambologna
1529–1608
(See Biography, p. 280)

Bronze statuette; hollow cast. A small hole in the lock of hair on the brow; cracks on the right elbow, the right shoulder joint and the left upper arm. A filling on the outside of the right knee, another on the in-side of the left knee. From 1973 a crack on the left shin (repaired in 1978) at the place of an old filling. An orange tone in places, probably due to yellow-burning of the sur-face; traces of brown lacquer, light brown patina, verdigris here and there. Over the forehead, at the peak of the *petasus* on either side, a sig-nature, the engraved initials ·I· ·B· (= Johannes Bologna). The figure 1003 in white on the left calf is a pre-1823 inventory number of the Imperial and Royal Cabinet of Coins and Antiquities.
Height 62.7 cm.
Inv. no. Pl. 5898.

Mercury is shown naked and in flight. The toes of his left foot scarcely touch the ground; his right leg is bent at the knee. His right arm is raised vertically, the forefinger pointing upward; in his lowered left hand he holds the handle of the caduceus. Apparently the caduceus was never complete, since there is no trace of a shaft apart from a slight depression at the upper end of the handle. Each of Mercury's ankles is winged on the outside, as is the *petasus* or cap on his head.

Mercury is here depicted as the messenger of the gods and executor of Jupiter's commands; with his upraised right hand and forefinger, in a striking gesture, he points to the supreme deity who has sent him. As Gramberg (1936) pointed out, this could be referred to Homer's *Odyssey* v, 45–46 or to the famous description of Mercury in the fourth book of Virgil's *Aeneid*. The iconographic roots of the pointing gesture, as Herklotz (1977) showed, can be traced to *Annunciations* by Leonardo da Vinci and Garofalo. More signifi-cant, however, seems to be the suggestion made by Vermeule (1952) and in-dependently by Keutner (in a lecture, 1967) that the immediate prototype was the reverse of a medal of the Emperor Maximilian II struck by Leone Leoni in 1551. This shows Mercury hastening over the clouds and pointing upward with his raised right hand; the inscription QVO.ME.FATA.VOCANT. (Whither fate calls me) may be taken as a humanistic variation on Maximilian's motto *Deus providebit*. Thus Mercury is the announcer of a supreme decree and the interpreter of divine Providence.

As Tuttle pointed out in a lecture in 1978, in the symposium for the open-ing of the Giambologna exhibition in Edinburgh, Pier Donato Cesi, Bishop of Narni and papal vice-legate in Bologna from May 1560 to January 1565, planned to have a column, surmounted by a figure of Mercury, erected in the courtyard of the newly built Palazzo del Arciginnasio of Bologna University. In an unpublished manuscript discovered by Tuttle and certainly dating from before 1565 (P.D. Cesi, *De rebus praeclaris a Pio IV gestis et monu-mentis Romae ac Bononiae relictis*, MS A 111 inf., Biblioteca Ambrosiana, Milan, f. 38 r. and v.), Cesi describes this plan and explains its significance as fol-lows: "... statutum esse in medio compluvio supra paratam iam ex vermicu-lato lapide columnam Mercurij e coelo labentis simulachrum aereum poni; ut cum illo significata sit antiquitus ratio, et veritas, sapientiam e coelo manasse, eamque veluti Dei donum esse summo studio ac veneratione suspiciendam scholares facile, posito ibi signo in memoriam revocarent" (It was decided that in the middle of the courtyard a bronze statue of Mercury descending from heaven be placed atop a column of variegated stone already prepared. Since in antiquity reason and truth were signified by this god, he was to be placed here in order that students might readily recall that wisdom comes down from heaven and is a gift of God and must be regarded with the greatest attention and veneration). As Tuttle observed, the motif might have been suggested to Bishop Cesi by the emblem of the Venetian printer Giovanni de Rossi, then active in Bologna: this showed Mercury with one foot on a globe and pointing to heaven with the caduceus, the motto being "Demissus ab alto coelo" (A. Sorbelli, n.d., pp. 39–43).

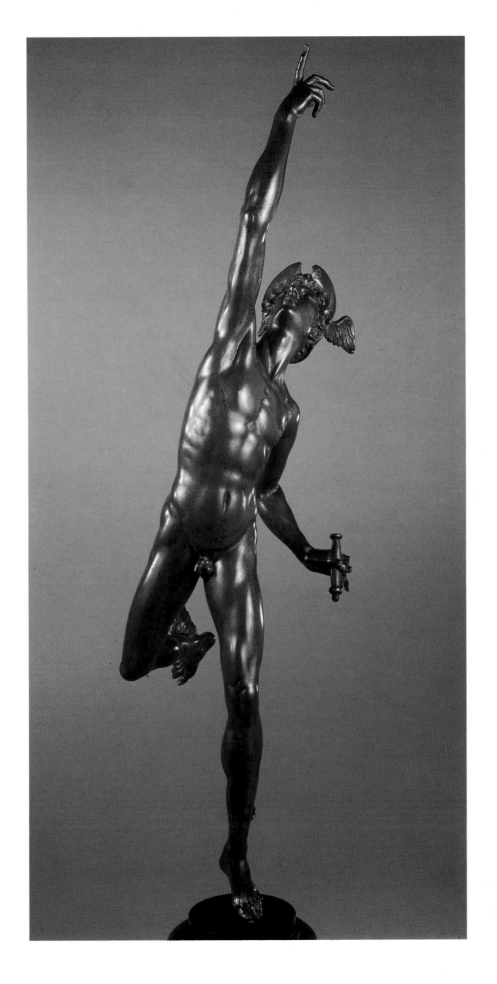

Probably in the possession of Emperor Rudolf
II. Inventory of the *Kunstkammer* of Emperor
Rudolf II in Prague of 1607–11, fol. 320, no.
1970. "Uff dem schreibtisch von ebinholtz
mit no. 80. steht zu oberst ein Mercurius,
nach des Jo: Bolonia, von bronze." (Bauer
and Haupt 1976, p. 103). Presumably brought
to Vienna under Emperor Matthias before
1619, later displayed at the Imperial Gallery.
Transferred before November 30, 1799 from
the Imperial Gallery – then at the Belvedere
Palace - to the Imperial and Royal Cabinet of
Coins and Antiquities. F.d.P. Neumann, *Der
k.k. Sammlung moderner Monumente und Kopien
alter Kunstwerke von Erz und Stein . . :* "Auf
dem Petasus unseres sich in die Höhe
schwingenden Merkurs stehen di Buchstaben
I.B. Ich halte sie für di Anfangsbuchstaben
eben dieses Joannis Bononiensis." (Manuskript
Convolut, Museum C.R., archive no. 13,
p. 116, in the Antiquities collection of the
Kunsthistorisches Museum); J. Gruber, *Zu den
allerneuesten Acquisitionen,* Nov. 30, 1799: 9.
Auf dem Helme des komischen Merkurs steht
I.B., wie N: (Neumann) bemerkt, Giovanni
da Bologna" (Manuskript Convolut, archive
no. 4, in the Antiquities collection of the
Kunsthistorisches Museum.) Transferred in
1880 from the Cabinet of Antiquities to the
Ambras collection in Vienna and in 1891
transferred with the entire collection to the
Kunsthistorisches Museum.

The proposed column seems never to have been erected, but Bishop Cesi,
who also commissioned from Giambologna the monumental fountain of
Neptune in Bologna, could have asked the artist to produce a model for the
purpose. In view of the document discovered by Tuttle it now seems practi-
cally certain that the statuette of *Mercury* in the Museo Civico in Bologna is
not only, as Gramberg (1936) suggested, an early work of Giambologna's,
executed in Bologna in 1563/64, but the model for the figure intended to
surmount the pillar in the courtyard of the Arciginnasio (see *Giambologna*
1978/79, no. 33). This somewhat rough cast and little afterworked statuette
shows every sign of being a first sketch-like model. Although it was appa-
rently never taken further in Bologna, Giambologna was able to revert to
this initial idea immediately after his return to Florence in 1565, when the
ducal court decided to present Maximilian II with a bronze *Mercury* and
entrusted the commission to him. The gift of this and two other works by
Giambologna was intended to expedite the negotiations for a marriage
between Francesco de' Medici, heir to Cosimo I, and the Emperor's sister,
Joanna of Austria. As Leone Leoni's medal shows, the choice of a *Flying
Mercury* was bound to appeal to the Emperor's taste. It is noteworthy that
Pastorino, for his 1560 medal of Francesco de' Medici, again used the reverse
of Leone Leoni's medal of Maximilian II, showing that the court of Florence
had adopted this imperial *impresa* for its own use.

The gift to the Emperor is recorded by Giambologna's earliest biogra-
phers, Vasari (1568), Borghini (1584) and Baldinucci (1688). Vasari wrote:
"E di bron(n)zo ha fatto & un Mercurio in atto di uolare, molto
ingegnoso, reggendosi tutto sopra una gamba & in punta di piè, che è stata
mandata all'Imperatore Massimiliano, come cosa che certo è rarissima."
Borghini: "In questo medesimo tempo" [*ie* when he made the Neptune
fountain in Bologna] "fece vn Mercurio di bronzo grande come vn fanciullo
di 15 anni, il quale insieme con vna historia di bronzo, & vna figurina di
metallo fu mandato all'Imperadore." Baldinucci: "Incomminciandosi dunque
a cagione di tali opere a sparger la fama di lui per l'Italia, non andò molto,
ch'egli fu chiesto da' Bolognesi al Granduca per fare siccomo fece, la bellis-
sima fonte che è nota; ed in questo tempo gettò di bronzo un Mercurio che
insieme con altri suoi getti fu mandato a donare all'Imperadore."

From Schlosser (1910) to Leithe-Jasper (1978/79) the signed statuette in
Vienna was repeatedly identified with that mentioned by Vasari, Borghini
and Baldinucci as having been presented to Maximilian II. The apparent in-
consistency of Borghini's description of it as being "as big as a lad of 15"
was dismissed by Schlosser (1910) and Gramberg (1936) as a mistake on
Borghini's part. Leithe-Jasper (1978/79) offered the explanation that Borghini
meant that the figure looked like that of a boy, since he would normally
when giving the size of the statuette have used the term "alto" with a
measurement based on the ell or *braccio*. A further reason for identifying the
Vienna bronze with the early work by Giambologna was that the Vienna
bronze was the only signed statuette of *Mercury* which can show a proven-
ance in the imperial collections reaching back to an early date, perhaps even

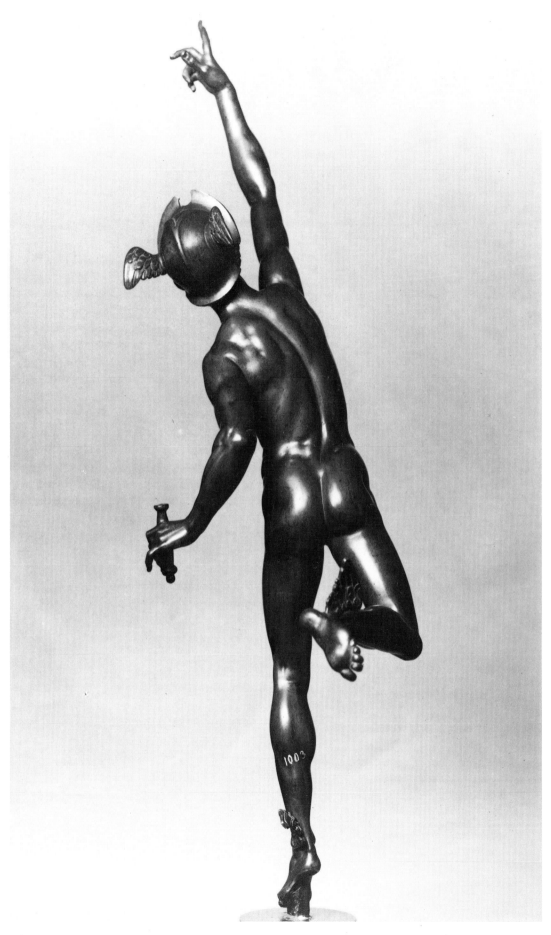

Flying Mercury, alternative view

as far as the *Kunstkammer* of Rudolf II. No life-size figure of Mercury can be traced in old inventories of the imperial collections, including the *Kunstkammer* of Rudolf II, though the latter, being an ardent collector of Giambologna's work, would certainly have laid hands on such a statue on the death of his father, Maximilian II.

Those who have disputed the identification of the two works, most recently Dhanens (1959) and Keutner (1978/79), relied in the first place on the argument of language. Borghini, they argued, must have been talking of the size of the statuette, since he spoke of a subsequent "small" figure (*figurina*) to distinguish it from the "large" Mercury. In addition they advanced weighty stylistic arguments. The strongest was that even so inventive an artist as Giambologna simply could not have gone through such an evolution of style in a single year as that between the Bologna *Mercury* of 1563/64 and the statuette in Vienna. It is indeed hardly possible to imagine a greater stylistic difference between any two representations of an identical theme by a given artist. The stoutly built *Mercury* in Bologna, with his massive and almost ponderous proportions, can hardly be thought to be flying or descending from heaven, but is shown in a running posture. He points upward with his right hand, but his eyes do not follow the gesture: he seems to have a message to deliver to those below. This cannot have been a suitable model for Bishop Cesi's project, and perhaps that is why it was never taken further in Bologna. In the Vienna statuette, on the other hand, the figure of the running *Mercury*, which Giambologna no doubt took over from the reverse of Leone Leoni's medal, is replaced by a markedly vertical one. There Mercury seems to be taking off from the ground; in a true balancing act he seems to be wholly absorbed in the upward gesture of his own index finger, pointing like a spire in the direction from which heavenly inspiration is expected. Every muscle of his slim, youthful body is tensed. The somewhat diagonal position of the thorax gives the necessary balance to the vertical thrust which extends from the tips of the toes of his left foot to his right forefinger.

Dhanens (1956) argued that it was not until the 1570s that Giambologna achieved such a stylization of the human figure as is shown in this statuette of *Mercury* and by other, smaller variants, whereas his early works are marked by greater naturalism and softer modeling. She therefore concluded that the *Mercury* presented to the Emperor must have been a life-size statue of which no replica has survived, so that the design must be presumed lost. Keutner (1978/79 and 1984), however, supposed that the life-size *Mercury* now in the Museo Nazionale del Bargello was a replica of the statue sent to the Emperor in Vienna in 1565. But all we know of the bronze in the Bargello is that it was transported from Florence to Rome in 1580 to decorate a fountain in the garden loggia of the villa of Cardinal Ferdinando de' Medici. It appears in several inventories of the villa from 1589 onwards, and its site is exactly recorded in an engraving by G.F. Venturini. Two hundred years later, in 1780, this *Mercury* was returned to Florence by command of Pietro Leopoldo of Habsburg, Grand Duke of Tuscany. In any case, an unassailable argument

against Keutner's identification is that neither Vasari, Borghini nor Baldinucci mention a highly characteristic and conspicuous feature of the large Florentine *Mercury, viz* that the figure's foot is speeded along by the breath of the wind-god Zephyr, whose head forms the base of the statue. This feature did not escape the notice of the compiler of Ferdinando de' Medici's inventory in 1580 (Dhanens 1956, p. 129, n. 4).

Some years ago, Larsson discovered a life-size bronze *Mercury* in private ownership in Sweden. The figure is poised over a globe, and the composition and movement are very similar to those of Giambologna's statuette in the Museo Civico in Bologna, except that Mercury's head is lowered and he is looking downward. His physique is fairly massive – less so than that of the Bologna version, but more than the Florence *Mercury* and of course more than the one in Vienna. This bronze figure is 185 cm high; it has stood out of doors as a garden ornament in Sweden for more than 300 years, and the surface is much corroded. It is not known when and how it reached Sweden; probably as war booty, and in that case most likely from Prague in 1648. The only puzzle is that there is no inventory record of its disappearance from there. Larsson (1985) was inclined to regard it as an early work by Adriaen de Vries, but was not certain. The figure has not yet undergone a thorough stylistic analysis.

Perhaps it is not too far-fetched to see in this statue Giambologna's final design for the figure of Mercury that, according to Bishop Cesi's plan, was to surmount the column in the courtyard of the Arciginnasio in Bologna, though the figure was never actually delivered or erected. The motif of Mercury poised on a globe would correspond to the emblem of the printer Giovanni de Rossi, which Tuttle (1978) suggested as a possible iconographic model. The figure's downward glance would be logical in view of its position on a column, symbolizing the communication of divine wisdom to those athirst for knowledge. If the figure was already executed or available as a model for casting, Cosimo de' Medici could have taken the opportunity to offer it as a suitable gift to the Emperor. As Larsson (1985) observed, an argument for supposing it to have been in Prague is that Adriaen de Vries clearly used it as a model for his small statuette of *Mercury* now at Stift Lambach (see also *Giambologna* 1978/79, no. 35c). However, the resemblance here, though considerable, is of motif only; it is difficult to imagine Adriaen de Vries, even in his youth, as the author of the large figure of *Mercury* in Sweden. In any case he cannot have seen the figure in Florence. Possibly it was already standing in a garden and for that reason is not mentioned in the inventory of Rudolf II's *Kunstkammer* or those of the Hradčany castle. The only question is whether this *Mercury*, represented as a strong, fully grown young man, could be referred to as a youth of 15, whose physical proportions would be different.

Dhanens (1956) and Keutner (1978/79) place the Vienna *Mercury* in a group with the statuettes in the Museo Nazionale di Capodimonte in Naples and the one in the Grünes Gewölbe in Dresden. Of the first we know only that it must have existed before 1579, since in a letter dated June 13 of that

BIBLIOGRAPHY

Vasari, G. 1568 (1878–1885), VII, p. 629.
Borghini, R. 1584, p. 587.
Baldinucci, F. 1688 (1770), p. 92.
von Sacken, E. and Kenner, F. 1866, p. 481, No. 24.
von Frimmel, T. 1883, p. 63, No. 994.
Ilg, A. 1886, pp. 44, 45.
Ilg, A. 1891, p. 223, Room XXIV, Case 3, No. 38.
von Schlosser, J. 1901, p. 17.
von Schlosser, J. 1910, p. 10, Plate XXVIII.
Bode, W. 1906–1912, III, p. 3, Plate CLXXXVII.
Tietze-Conrat, E. 1910, p. 249.
Übersicht 1916/17, p. 191, Room XXIV, Case 3, Nos. 51, and 53.
Brinckmann, A.E. 1917, p. 138.
von Schlosser, J. 1922, pp. 19–22.
Planiscig, L. 1924, p. 148, No. 251.
Brinckmann, A.E. 3rd edition (n.d.) pp. 90, 91.
Bode, W. 1930, p. 35, No. 164.
Planiscig, L. 1930, pp. 46, 47, Plate CCI, Fig. 347.
Holzhausen, W. 1933, pp. 54–62.
Planiscig, L. and Kris, E. 1935, p. 89, Room XIII, No. 28, Fig. 51.
Gramberg, 1936, pp. 72–78.
Planiscig, L. 1942, p. 17, No. 33.
Vermeule, C. 1952, p. 506–510.
Kriegbaum, F. 1952–1953, p. 45.
Dhanens, E. 1956, pp. 125–135.
Landais, H. 1958, pp. 68, 69.
Pope-Hennessy, J. 1961/62, No. 119.
Pope-Hennessy, J. 1963, Cat. p. 80.
Montagu, J. 1963, p. 80, Fig. 91.
Ciardi Dupré, M.G. 1966, p. 108.
Weihrauch, H.R. 1967, pp. 199–203.
Wixom, W.D. 1975, No. 147.
Watson, K.J. 1975–76, pp. 59–71.
Leithe-Jasper, M. 1976, p. 87, No. 83.
Menzhausen, J. 1977, p. 58, Fig. 25.
Herklotz, J. 1977, pp. 270, 274.
Androssow, S.O. n.d. (1978) pp. 44, 45, No. 29.
Tuttle, R. 1978 (handout).
Keutner, H. 1978/79, pp. 23, 24, and pp. 112–119, Nos. 33 and 35 (Exkurs).
Leithe-Jasper, M. 1978/79, pp. 113–119, Nos. 33a, 34, 35a, 35b, 35c.
Radcliffe, A.F. 1978/79, pp. 117, 118, No. 35.
Jestaz, B. 1979, pp. 77–78.
Olbricht, K.H. 1979, Fig. 3.
Bode, W., and Draper, J.D. 1980, p. 104, Plate CLXXXII.
Distelberger, R, 1982, p. 88.
Holderbaum, J. 1959/1983, pp. 29–34 and pp. 116–132.
Keutner, H. 1984, pp. 27–34.
Jestaz, B. 1985, p. 157.
Larsson, L.O. 1984/85, pp. 117–126.

year, addressed to Ottavio Farnese, Duke of Parma, Giambologna mentions having sent it to the Duke. It passed by inheritance from Parma to Naples. The statuette in the Grünes Gewölbe, on the other hand, is mentioned for the first time in the first (1587) inventory of the *Kunstkammer* of the Elector of Saxony, where it is stated to have been a gift from the Duke of Tuscany to the Elector Christian I. Francesco de' Medici visited Dresden in 1577 and could have taken with him the works by Giambologna that are now there. A group of *Nessus and Deianira*, still in Dresden and also recorded there in 1587, is signed, like the Vienna *Mercury*, with the initials ·I· ·B·. Of all the statuettes of *Mercury*, the one in Dresden most closely resembles that in Vienna, though its height (61 cm: Menzhausen 1977) is 1.7 cm less. The Naples example, on the other hand, differs from that in Vienna in important respects. The composition is less taut; the lines, and all the details, are softer. The fingers of the raised hand are more curled up. The forefinger is broken off, but replicas show that it did not point so dramatically upward. The difference of size is considerable: the statuette in Naples is only 57 cm high, that is, 5.7 cm less than that in Vienna. This cannot be due to metal shrinkage, but must signify the use of a different model. It is noteworthy that most of the existing statuettes of *Mercury* are based on the Naples version. In view of the considerable differences, the Vienna and Naples statuettes cannot have originated in immediate succession.

As Jestaz (1979) rightly observed, the Vienna statuette marks the culmination of the compositional development of Giambologna's motif of the *Flying Mercury*. It alone is the perfect *studiolo* piece – as is expressed by the place it occupied on top of an ebony writing desk in the *Kunstkammer* of Rudolf II. The inevitable question, as Jestaz further noted, is whether – if the statuette is regarded as an early work of Giambologna's – he was capable in 1565 of such a perfectly balanced artificial composition, and, if so, whether it is conceivable that a genius of his caliber, treating the same theme in later years, could have produced only weaker versions. This point requires consideration, even though the quality of an artist's work does not always develop in an ascending line. Nonetheless, Jestaz later (1985) took the view that the statuette in Vienna was in fact the early work of Giambologna's presented to Maximilian II in 1565.

The life-size figure in the Bargello of *Mercury* sped by the breath of Zephyr – whether it dates from 1565, as Keutner (1978/79 and 1984) proposed, or *c*.1580, as Dhanens (1956) believed – is a good deal closer to the version in Bologna than to the Vienna *Mercury*. The body is more massive – not muscular like that in Bologna, but fatter – and is less erect than in the Vienna version. The torso is not inclined sideways to the same extent as in that version, but leans further forward. Like the earlier version in Bologna, the Bargello example gives little sense of spiral movement. The caduceus is in a different position from the other versions, and functions as an aid to optical equilibrium: it is evident that the figure is intended to be seen from two main angles, from the front and especially from the side. The composition lacks the tension that is so evident in the Vienna version: Mercury is more

like a dancer, remaining earthbound despite the breeze that urges him on, whereas in the Vienna example he seems on the point of taking wing in a circling motion. There is a resemblance to *Venus Urania* (cat. 50) in the tense composition that seems to consist of acute-angled triangles, the sides of which relate to each other in constant alternation. Should we suppose for this reason that, like (presumably) the *Venus Urania*, the *Mercury* was a later gift to Rudolf II from the Medici or even from Giambologna himself? The artist did make a personal present of a statuette of *Mars* to Christian I of Saxony. Can there be a connection with the fact that Giambologna was ennobled by Rudolf II in 1588? The whole problem of his statues and statuettes of *Mercury* seems to require exhaustive reconsideration.

Replicas and variants are legion. Only a few are of the Vienna *Mercury*; most follow the Naples version or are reductions of the large *Mercury* in Florence. These are probably the later ones. It does not seem useful simply to enumerate the replicas and variants before they have been more thoroughly studied. See, however, the attempts by Wixom (1975, no. 147), Androssow (1978, no. 29), and nos. 33, 34, 35, 35a, 35b and 35c in the catalogue of the *Giambologna* exhibition, Vienna 1978/79.

52. The centaur Nessus abducting Deianira

Antonio Susini after Giambologna
Active from *c.* 1580, died 1624
(See Biography, p. 282)

Bronze group; thick-walled cast.
Cracks in Deianira's left upper arm,
and above the carpus of Nessus's
right foreleg. A rectangular filling
on the back of Nessus's right hand.
The middle and ring finger of
Deianira's right hand broken off.
Reddish brown lacquer, translucent
in places; light brown patina.
Height 42.4 cm (the measurements in
Planiscig 1924 and in the catalogue
of the *Giambologna* exhibition,
Vienna 1978/79, are incorrect).
Inv. no. Pl. 5847.

The subject is the abduction of Deianira, wife of Hercules, by the centaur Nessus. The centaur holds the struggling, frightened Deianira on his back as he gallops away with forelegs outstretched. His right arm clasps the upper part of Deianira's body, his right hand firmly gripping her left shoulder. On his back is a large drapery, a long end of which dangles to either side; he has wound part of it round Deianira's breast, pulling it firmly toward him with his left hand. The contortion of the upper part of his body, and the taut muscularity of his arms, express simultaneously pressure and onward movement: as Deianira gesticulates wildly, Nessus seems to be wresting her toward him in the same moment as he leaps forward. Thus the group embodies two different movements, blending them into a unity: the forward gallop and the upward spiral that begins with Nessus's lifted forefeet continues with the sideways-inclined torsos of the two figures and culminates in Deianira's upraised right hand. Nessus's waving tail, and the fluttering ends of the drapery falling obliquely against his flanks, intensify the effect of a headlong flight.

Baldinucci, in his *Life* of Giambologna, mentions among the models cast as statuettes in bronze "Il Centauro, che rapisce Deianira". He also states in the *Life* of Antonio Susini that the latter executed a bronze after Giambologna's model, which Giambologna himself so admired that he sent Pietro Tacca to purchase it for 200 *scudi* – with the result that Susini proceeded to cast several replicas and sold them at the same price. Baldinucci also says that Antonio Susini's nephew, Giovanni Francesco Susini, made aftercasts of the same model by Giambologna. The large number of surviving replicas and variants is thus explained. There is also said to have been a further model of this subject by Giambologna, which was not cast in his lifetime.

The date of Giambologna's composition can be approximately inferred from documents in the archives of the Salviati family (Keutner 1978/79, Radcliffe and Avery 1978/79). According to these the casting and afterworking of "un Centauro che rapisce una donzella di Bronzo di Giambologna" were in progress from the end of December 1575. On April 30, 1577 Giambologna received payment from the Salviati for a bronze centaur which was probably this one. In a letter of October 27, 1581 to the Duke of Urbino the agent Simone Fortuna mentions statuettes of *Centaurs* by Giambologna in the possession of Cavaliere Gaddi and Jacopo Salviati, about half a *braccio* in height (Dhanens 1956). The posthumous inventory (1609) of Jacopo Salviati's son Lorenzo contains an exact description of the centaur mentioned by Fortuna: "Un centauro, di bronzo con una femina addosso, di mano di Gio. Bologna". However, the same inventory also mentions another such group: "Un centauro di bronzo con una femina in braccio di mano del Susini, e detto centauro è di altezza di braccia 1/2 incirca" (Watson and Avery 1973).

Thus in the first group Nessus carries Deianira away on his back, while in the second he holds her in his arms. There is a clear distinction of two types, the former by Giambologna and the latter by Antonio Susini. The first version can be connected with three *Nessus and Deianira* groups signed by

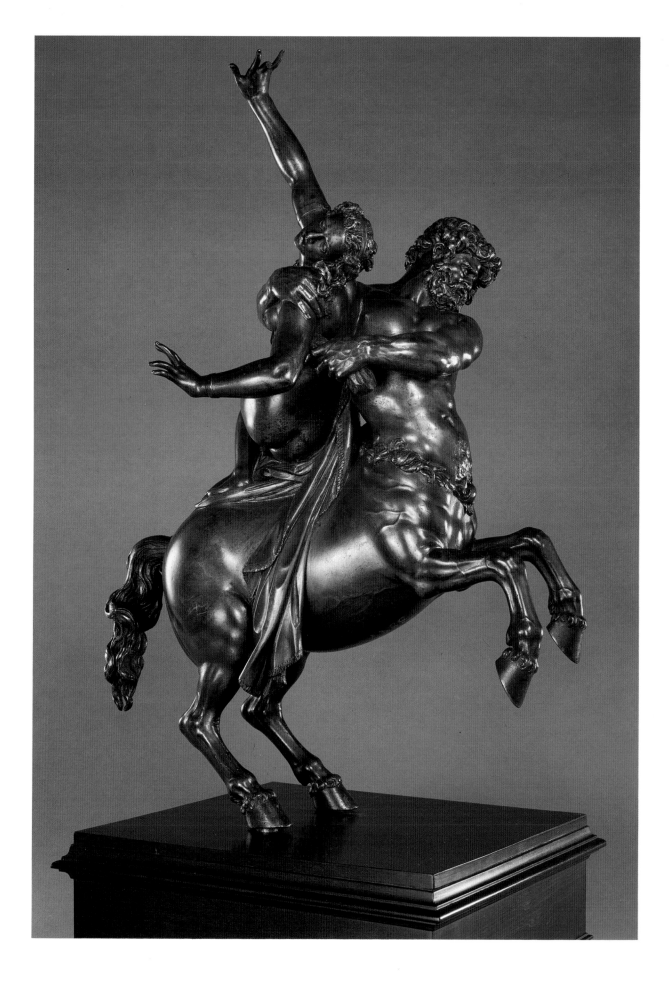

207

PROVENANCE

Probably in the *Kunstkammer* of Emperor
Rudolf II in Prague (Bauer and Haupt 1976,
p. 100, no. 1882, or no. 1896), then probably
in the possession of Emperor Matthias and de-
scribed in the fragmentary inventory of his
collection at the Vienna Hofburg of 1619,
now at the Wolfenbüttel library, as follows:
"Allerlei schone stuckh von messing. 4. 1
Centurus mit einer frauenbildnus auf einem
fuess (Sockel)" (Köhler 1906–07, p. xv). The
Hercules statuettes listed in this inventory after
the *Nessus and Deianira* group were certainly
at an earlier time in the possession of Rudolf
II. Documented in 1750 in the inventory of
the Imperial Treasury in Vienna, p. 573
"Nunmehro folget nach denen Numeris, was
sich in der ersten Gallerie auf denen
Gesümsern darweiset, als . . . Nr. 31 Ein
Centarus, wie er die Diana [sic] entführet, von
pronso!" (Zimmermann 1889, p. cccx).
Transferred in 1871 from the Treasury to the
Ambras collection in Vienna and transferred
in 1891 with the entire collection to the
Kunsthistorisches Museum.

BIBLIOGRAPHY

Baldinucci, F. 1688 (1770); VII, pp. 112, 126;
 XII, pp. 194, 203.
Ilg, A. 1886, p. 41.
von Schlosser, J. 1910, p. 11.
Planiscig, L. 1924, p. 162, No. 264.
Planiscig, L. and Kris, E. 1935, p. 90, Room
 XIII, Case 33, No. 8.
Dhanens, E. 1956, pp. 200–203, 346.
Weihrauch, H.R. 1967, pp. 220, 221.
Leithe-Jasper, M. 1973, No. 93.
Watson, K. and Avery, C. 1973, p. 504.
Leithe-Jasper, M. 1976, p. 87, No. 84.
Leithe-Jasper, M. 1978/79, p. 152, Nos. 62 and
 62a.
Radcliffe, A. and Avery, C. 1978/79, pp.
 147–149 and 150–159, Nos. 60, 63, 64, 65
 and 66.
Keutner, H. 1978/79, p. 151, No. 61.

Giambologna, and numerous replicas thereof. These, authenticated by the signature, are now in the Louvre in Paris, the Henry E. Huntington Library and Art Gallery in San Marino, California, and the sculpture collection of the Staatliche Kunstsammlungen, Dresden.

The second group mentioned in the Salviati inventory of 1609, apparently an invention by Antonio Susini after the prototype by Giambologna, is nowadays identified with a group in which Deianira is not seated on Nessus's back, but lies obliquely across his back and is held in his arms; in this version she does not support herself with her left foot. Replicas of this model are in the Louvre and formerly with Cyril Humphris in London (Radcliffe and Avery 1978/79, pp. 155, 156, no. 66).

It is not known whether the original bronzes of variants A (Giambologna) and B (Antonio Susini), mentioned in the Salviati inventory of 1609, have themselves survived. The example of variant A of which the provenance can be traced furthest back is the one in Dresden: the first inventory (1587) of the Dresden *Kunstkammer* states that Duke Christian I of Saxony received it as a present from the Duke of Tuscany. The signed example in the Louvre was bequeathed by André Le Nôtre in 1693 to Louis XIV of France. The one in the Huntington Library was acquired from the collection of J. Pierpont Morgan; it had belonged to the Duke of Marlborough (Wark 1959) and might therefore have an earlier English provenance. The Emperor Rudolf II possessed three versions of this subject (*Kunstkammer* inventory of 1607–11, Bauer and Haupt 1976), an example in silver, no. 1734 "Der Centaurus mit dem weiblin", and two in bronze, no. 1882 "Item ein Centaurus von bronzo, welcher ein nacket weiblein hinder sich fiert" and no. 1896 "Ein Centaurus, welcher ein weiblein rubirt und empfiert, von bronzo"; one of the latter is presumably the version now in the Kunsthistorisches Museum.

Of the signed examples, that in the Louvre is now regarded as the earliest; at least it varies most from the other versions of type A. Next, to all appearances, comes the example in the Huntington Library; that in Dresden is tighter in composition and therefore seems to be the latest of the three. Closest to it is the variant in Vienna, whose main differences from the signed examples are that Nessus is leaping at a slightly sharper angle; the torsion of the two bodies is somewhat different; and the drapery falls in tauter lines. The modeling of the figures also appears tauter and in places sharper. Thus the Vienna example seems to represent the end result of a process of increasing economy, visible also in the signed examples which are no doubt of earlier date, and intended to produce a model suitable for reproduction. This development can only have taken place in Antonio Susini's workshop: his handiwork can be seen in the precise, somewhat sharp-edged modeling of details and the brilliant, but never pedantic or schematic, afterworking of the surface. The present Vienna version was presumably the one used for repro-duction in quantity. A replica also in the Kunsthistorisches Museum (inv. no. Pl. 5849, height 40.3 cm; Planiscig 1924, no. 263; Leithe-Jasper 1978/79, no. 62a; from the collection of Josef Angelo de France) is clearly distinguishable

as a workshop product by the more schematic and graphically harder afterworking.

Keutner (1978/79) supposed that Giambologna's invention of Nessus standing on his hind legs and about to gallop off was based on earlier works of his own, especially the four leaping horses, larger than life size, executed in stucco in 1565 for the *quadriga* of a triumphal arch erected on the occasion of the marriage of Francesco de' Medici to Joanna of Austria. However, the *Nessus and Deianira* groups stand at the beginning of a series of abduction groups that was to culminate in the *Rape of the Sabine* in the Loggia dei Lanzi in Florence, completed in 1583.

For the many replicas and variants see Dhanens (1956, pp. 200–202), and the catalogue of the *Giambologna* exhibition, Vienna 1978/79, nos. 60–67.

53. Allegory of Prince Francesco de' Medici

Giambologna

1529–1608

(See Biography, p. 280)

Bronze relief; small casting flaws, as shown by soldering on the reverse side, on Francesco's back and between his legs, on Mercury's back and on the architectural columns to the right. Light red-brown patina; an eighteenth-century coating of silver was removed in 1978.

Height 30.7 cm, width 45.6 cm.

Inv. no. Pl. 5814.

PROVENANCE

Possibly one of the three works by Giambologna presented in 1565 to Emperor Maximilian II by Francesco de' Medici and to be identified with "una historia di bronzo" mentioned by Borghini in 1584 in his *Life of Giambologna* as given by the Prince to his future brother-in-law, together with a *Mercury* and a "*figurina*". Later among the Este possessions at Modena and given to Emperor Rudolf II in 1604 by Cesare d'Este. Documented in the inventory of the *Kunstkammer* of Emperor Rudolf II in Prague in 1607–11 (Bauer and Haupt 1976, p. 90, no. 1686 and p. 104, no. 1979). The two reliefs then arrived at the Imperial Treasury in Vienna and are described in the inventory of 1750 as follows (p. 612, no. 8): "Ein groszes viereckiges deto [bas-relief] von pronso und versilbert, worauf abermahl eine unbekante Ovidische historie" (and no. 11) "Ein grosz viereckiges basrelief von getriebenem [sic!] Silber, so den vorbeschrieben unter no. 8 gleichförmlich" (Zimmermann 1889, p. CCCXIV). The bronze relief was probably painted silver for the new organization of the Imperial Treasury around 1750, to make it a pendant to the silver relief. Transferred in 1890 together with the silver copy from the Treasury to the Kunsthistorisches Museum.

The central figure is a youth in antique costume, whom Mercury is leading by the hand toward a handsome woman of ample figure, raised on a pedestal and reclining her right arm on a bowl of fruit. The scene is depicted on a platform in front of a columned hall extending into the distance; on its left side the hall is partially in ruins. Cupid, flying down from the upper right corner, aims an arrow at the couple. The left half of the relief, outside the architecture, is occupied by a group of many figures. At the extreme left is an old man warming himself at a brazier; in front of him a dog; behind him an old woman on a crooked stick. Formally, and perhaps thematically as well, these form a counterpart to the group on the right including Mercury. Behind the aged pair is seated a river-god, identified by the large water-pot on his left shoulder. Next to him, on the extreme left, stands Saturn (Chronos), with a scythe in his left hand; on his right arm is a child, which he is devouring. Approaching him are two trios of women, each led by a Hora bearing an hourglass. One of the beauties in the first group is naked and has turned to face the second group, who are on the further bank of a river. In the background are two more figures.

No fully satisfactory interpretation of the relief has yet been offered. The only point generally agreed at the present time is that the youth led by Mercury must be Francesco de' Medici (1541–87). Tietze-Conrat (1918), followed by Dhanens (1956), supposed the relief to be a courtly allegory, with mythological embellishments, of Francesco's wooing, the prince being led towards his bride by Mercury in the role of Hymenaeus. Keutner (1978/79) suggested more convincingly that the theme was that of Francesco as future ruler of Tuscany. Mercury would thus be leading the young prince toward a personification of Florence, resembling Ceres or Copia (Abundance), who gazes at him expectantly while Cupid fans the flames of mutual attraction. It is still unclear, however, whether, as Keutner thought, the figures on the left symbolize merely time, the seasons and the natural activity and decay of temporal things, or whether they have some specific connection with Francesco. The naked beauty among the long-robed Horae might perhaps represent the prince's future spouse, who will be led to him in due time.

Four versions of the relief are known. Besides the present bronze, the Kunsthistorisches Museum possesses a replica in silver. In the Museo Nazionale del Bargello in Florence is a further replica in bronze, described as *Il Parto di Cibele*, and in the Prado in Madrid an alabaster version under the title *Las cuatro estaciones*. Keutner (1978/79) believed the alabaster relief in Madrid to be the first version of the *Allegory of Francesco de' Medici*. It is the only one in which the young prince's head shows the features of a portrait, rather than being idealized. Only in the Madrid version does the dais on which Abundance reclines extend to the right-hand edge of the relief, partially blocking the window on the right. In the other three reliefs the perspective of the architecture is incorrect at this point. In the two bronze versions the landscape is not visible at the end of the colonnade in perspective; the landscape in the silver relief differs from the one in the alabaster re-

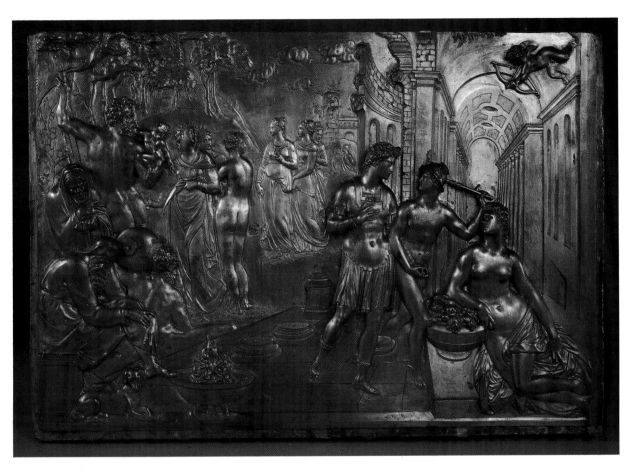

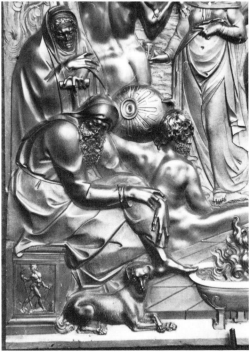

Francesco de' Medici, copy in silver (detail) of
the bronze relief in the exhibition

BIBLIOGRAPHY

Borghini, R. 1584, p. 587.

Venturi, A. 1885, p. 18.

Ilg, A. 1891, p. 223, Room XXIV, Case 3,
No. 40.

von Schlosser, J. 1901, p. 18, Plate XXVII.

von Schlosser, J. 1910, p. 10, Plate XXIX.

Übersicht 1916/17, p. 187, Room XXIV,
Nos. 53 and 54.

Tietze-Conrat, E. 1918², pp. 25-32.

Planiscig, L. 1924, p. 155, No. 256 and
pp. 152-155, No. 255.

Planiscig, L. and Kris, E. 1935, p. 87, Room
XIII, No. 22.

Dhanens, E. 1956, pp. 136-138.

Bauer, R. and Haupt, H. 1976, p. XII and
p. 90, No. 1686, and p. 104, No. 1979.

Keutner, H. 1978/79, pp. 206, 207, No. 118.

Leithe-Jasper, M. 1978/79, pp. 73-77 and
pp. 207-210, Nos. 119 and 120.

Avery, C. 1978/79, p. 210, Nos. 121.

Arnaiz, P.M. 1979, p. 57.

lief. Only in the alabaster relief are the two small figures in the background clearly identified as wayfarers by the corded bundles which they carry.

In all the reliefs Francesco de' Medici is beardless, as in the first medal of him, struck by Pastorino in 1560; in Poggini's medal of 1564 he wears a beard. This suggests that the relief dates from before 1564, probably 1560-61.

Francesco de' Medici stayed at the Spanish court for 15 months in 1562-63, and it may be that he presented the alabaster relief to Philip II at that time. The courts of Florence and Madrid were negotiating between 1560 and 1562 for a marriage between Francesco and Juana of Spain. However, as the relief seems to be a tribute to Francesco rather than an allegory of marriage, it may – as Keutner (1978/79) believes – have been presented to Francesco by the artist as a mark of gratitude for his definite appointment as court sculptor in 1561. This appointment was secured for Giambologna by Bernardo Vecchietti, his first patron in Florence, and by Francesco's influence with his father, Cosimo I. The relief might afterwards have reached Spain, but this is unlikely. It certainly did not number among the possessions of Christina of Sweden, as it cannot be traced in the *Kunstkammer* of Rudolf II.

It is hard to say whether the two bronze reliefs are casts from the alabaster relief. The projecting recessed border at the bottom and sides indicates that the bronze relief in Vienna was molded from an existing relief. However, since the differences in the Madrid relief, noted above, are all improvements, it could be that the two bronze reliefs and the alabaster relief in Vienna are all based on an original wax model, while the improvements were only carried out in the Madrid version. The dimensions of the Vienna bronze relief are less than those of the alabaster relief by 3 or 3.5%; the difference is due to the normal shrinkage of bronze when it cools after casting, but it does not necessarily mean that the bronze was molded from the alabaster relief rather than the wax model (there is naturally no shrinkage when the model is exactly transferred to a relief in stone). The alabaster relief in Madrid is closer to the Vienna bronze relief than to the one in Florence, which is of equal quality; it may be inferred from this that the artist reworked the wax model for the second casting.

Since Schlosser (1901) the Vienna bronze relief has traditionally been regarded as one of the three gifts that Francesco de' Medici presented to his future brother-in-law, the Emperor Maximilian II, on his visit to Vienna in 1565. All that is known, however, is that in 1604 Rudolf II received it as a gift from Cesare d'Este, Duke of Modena; exclaiming "Now it's mine!", he carried it off to his private apartments and set it on top of a cabinet (Venturi 1885). The relief most probably came into Este possession through Barbara of Austria, sister of Maximilian II and wife of Alfonso II d'Este. Rudolf II caused a silver copy to be made from the bronze version; this is the one still in the Kunsthistorisches Museum (inv. no. Pl. 1195, height 29.7 cm, width 43.3 cm; Planiscig 1924, pp. 152-55, no. 255; Leithe-Jasper 1978/79, pp. 209, 210, no. 120). Planiscig (1924) supposed that it was the original, and the

bronze version a copy of it; however, the inventory (1607–11) of Rudolf II's *Kunstkammer* is unambiguous (f. 323): "Grosse bassarilievi von Bronzo. Nr. 1979. Ein quadretto di bassarilievo von Joh: de Bolonia, da vornean ein alter man beim kolfewr sich wermt, uff der anderen seitten ein Venere nacket und Mercurius dabey, haben I. May: von silber abgiessen lassen, such vornen fol: 276.b."; f. 276: "Ein zimblich gross silbern quader und histori abgegossen nach einem von metal, so der Johan Bolonio gemacht, darinn vornean ein alter man beim kolfewr sich wermet, uff der anderen seiten ein Venere nackhendt und Mercurius dabey" (Bauer and Haupt 1976, pp. 90 and 104). Rudolf may have have had the silver relief cast in 1604, after he acquired the bronze version from Cesare d'Este, or at an earlier date. An earlier date seems to be indicated by a report from Manzuolo, the envoy from Modena to the court in Prague, which is in the Archivio di Stato in Modena and was published by Venturi in 1885. According to this report, the Emperor possessed the copy before he was able to acquire the original. The silver relief must therefore have originated either in Italy or even in Vienna, if the bronze relief was really the one which Francesco de' Medici presented to Maximilian in 1565 and which then presumably went to the house of Este with Barbara of Austria. According to Venturi (1885), Manzuolo spoke of the silver copy having been made by a pupil of Giambologna's, which would suggest that it originated in Italy. The stylistic features, especially the chasing and ornamental additions, that clearly distinguish the copy from the original argue for a goldsmith from the north but do not necessarily prove that the copy was made in Prague or Vienna, since northern artists worked as goldsmiths at Italian courts. A more decisive argument against Planiscig's theory is raised by the fact of the shrinkage of metal when it cools after casting, since the dimensions of the silver relief, as a whole and in detail, are less than those of the bronze version. Apart from this, an attempt has been made to extend the edges of the prototype of the silver relief slightly toward the borders. In this the silver relief also differs from the alabaster version in Madrid. The bronze relief in Florence is presumably old Medici property, but its provenance is not clear.

54. Christ at the column

Adriaen de Vries

*c.*1545–1626

(See Biography, p. 283)

Bronze statuette; thick-walled cast.
A cock which formerly surmounted
the capital has been broken off.
Light, grayish-brown patina.
Height 86.5 cm; to the top of
Christ's head, 64.7 cm. These
measurements include the base-plate,
width 19.2 cm, depth 21.4 cm,
height 1.7 cm.

Inv. no. Pl. 8908.

PROVENANCE
Said to have been excavated near Lobositz in
Bohemia from a hoard of Swedish loot.
Collection of Mrs Leokadia Hirschmann,
Budweis; collection of Dr Albert Figdor,
Vienna; acquired in 1935 from the Figdor
Trust.

BIBLIOGRAPHY
Tietze-Conrat, E. 1917, p. 56, Fig. 43.
Brinckmann, A.E. 1917, pp. 171, 172.
Brinckmann, A.E. 1923, p. 37, No. 85.
Planiscig, L. and Kris, E. 1935, p. 113, Room
 XIV, No. 39.
Strohmer, E.V. 1947/48, pp. 118, 119,
 No. 57.
Amsterdam 1955, p. 188, No. 388.
Larsson, L.O. 1967, pp. 55–57, Cat. No. 41.
Leithe-Jasper, M, 1978/79, p. 188, No. 95a.
Larsson, L.O. 1985, pp. 125, 126.

Christ, naked except for a loincloth, is bound by the arms to a column behind him, which projects above his head. The rope binding him is looped through a ring held in a lion's mouth on the reverse side of the column shaft. The feet of a cock, now missing, remain on the abacus of the Composite capital.

The column is not in the center of the small square base, but displaced to the right rear corner. Christ stands at the front on the left, his left foot projecting over the edge. In this way frontality is avoided, and the verticality of the composition is softened: it acquires a flowing S-shaped movement, giving a three-dimensional effect.

Adriaen de Vries, to whom the statuette is unquestionably ascribed on stylistic grounds, here combines two versions of the same theme from Giambologna's workshop, *viz* the body of the *Christ* in the Museo Nazionale del Bargello in Florence and the head and arms of the *Christ* in the sculpture collection of the Staatliche Museen, Berlin-Dahlem (*Giambologna* 1978/79, nos. 94 and 95). However, by so doing he abandons the logic of the *contrapposto* that is so evident in the two statuettes from Giambologna's workshop, so that, as Larsson (1967) aptly remarked, "one side is bound while the other twice swings free." The weight is now counterbalanced, and support provided, only by the column acting as a corrective. Adriaen de Vries's statuette is conceived much more from a fixed point of view than its prototypes, and in this it already foreshadows the Baroque.

There could hardly be a clearer demonstration of what unites and what separates Giambologna and Adriaen de Vries, master and pupil, than this statuette and its prototypes. The tall, somewhat smooth and cool elegance of Giambologna's figures, and the concise firmness with which all details are rendered, contrasts with the weightiness of the body in Adriaen de Vries's work and his sketchy modeling, which gives the surface of his figures a vague, painterly, shimmering appearance. Notable too is his broad treatment of details, such as the hairs of the beard, which were only partially scratched on the surface of the model and, after casting, were given a vibrant surface by punching.

Larsson (1967) dates the statuette *c.*1613–15. A bronze *St Sebastian* in the collection of the Reigning Prince of Liechtenstein in Vaduz closely resembles the figure of *Christ* in composition and is probably of the same date.

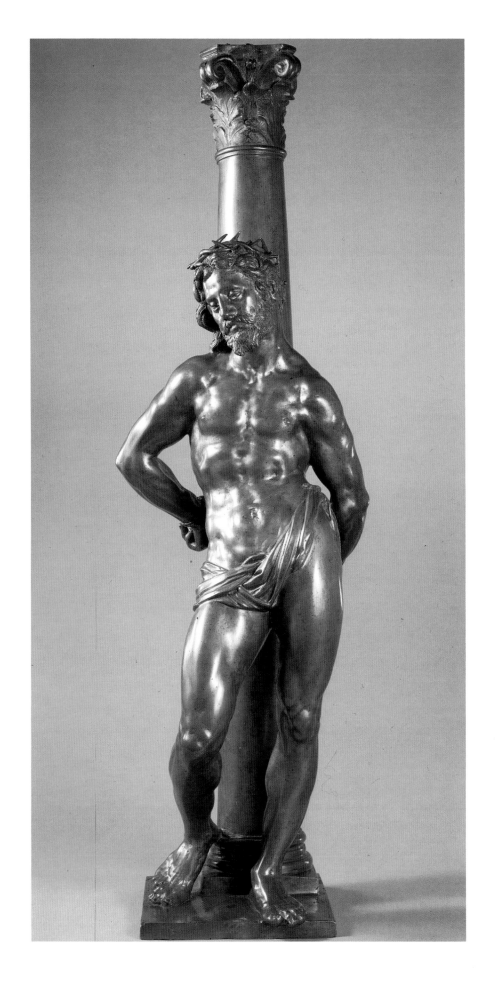

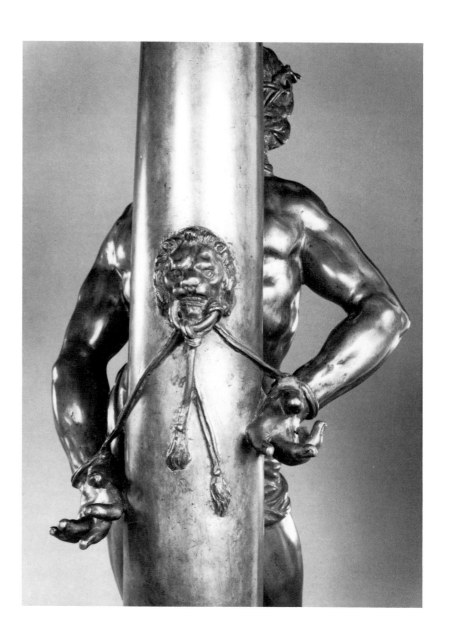

Christ at the column, back view (detail)

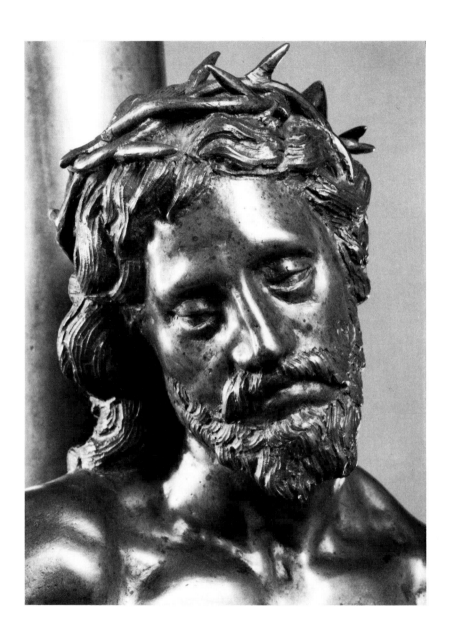

Christ at the column, detail of head

55. Pacing lion

Antonio Susini(?) after
Giambologna
Active from *c.* 1580, died 1624
(See Biography, p. 282)

Bronze statuette; especially thick-
walled hollow cast. Reddish-brown,
translucent lacquer; brown patina.
Height without base 13.5 cm; height
of base 1.2 cm, length 15.2 cm,
width 7.3 cm.
Inv. no. Pl. 5876.

PROVENANCE
This *Lion* and its gilded replica were in the
collection of Emperor Rudolf II. Inventory of
the *Kunstkammer* of Emperor Rudolf II in
Prague from the years 1607–11, fol. 318′, no.
1593: "1.1. Zwen lewen von metal, darunter
der eine im fewer vergult." (Bauer and Haupt
1976, p. 103). Then owned by Emperor Mat-
thias and documented in 1619 in his collection
of art objects at the Vienna Hofburg; frag-
ment 1 of an inventory of effects preserved at
the Wolfenbüttel library: "Allerlei schone
stuckh von messing – Nr. 45, 1 vergulter lew
auf einem fuess. – Nr. 46, 1 deto, ohn ver-
gult." (Köhler 1906–07, p. xv, Regest 19449,
1). The next documented mention of the two
Lions can be found in the inventory of the
Imperial Treasury in Vienna from 1750, p.
570: "Nunmehro folget nach den Numeris,
was sich in der ersten Gallerie auf denen
Gesümsern darweiset, als: . . . 3. Zwei mittere
löwen von pronso. (Zimmermann 1889, p.
CCCIX). Described as such in all subsequent in-
ventories of the Treasury. Transferred in 1871
to the Ambras collection in Vienna. In the in-
ventory of 1874 the *Lion* (inv. no. 8565) is
listed for the first time again as gilded. Trans-
ferred in 1891 with the entire Ambras collec-
tion to the Kunsthistorisches Museum.

BIBLIOGRAPHY
Planiscig, L. 1924, p. 163, No. 266, mention-
 ing the replica inv. No. 5852 (sold) and the
 firegilt replica.
Planiscig, L. and Kris, E. 1935, p. 90, Room
 XIII, Case 33, No. 5.
Leithe-Jasper, M. 1973, No. 105.
Leithe-Jasper, M. 1976, p. 108, No. 149.
Leithe-Jasper, M. 1978/79, pp. 259–260, Nos.
 175 and 175a.
Avery, C. 1978/79, p. 260, No. 176.

ADDITIONAL BIBLIOGRAPHY
Tietze-Conrat, E. 1918, p. 89, Fig. 68.
Haskell, F. and Penny, N. 1981, pp. 247–250.

The lion is seen pacing on a separately cast oval base-plate; three of his paws,
and his limply falling tail, extend over its edge. The statuette was no doubt
based on ancient Roman animal sculptures. In the late 1580s and early 1590s
antique lions were used in new adaptations by artists in Rome, the best-known
example being the "Medici Lions" of the Villa Medici, now in the Loggia
dei Lanzi in Florence; one of these is a restoration and adaptation of an antique
lion, the other a copy by Flaminio Vacca (*cf* Haskell and Penny 1981, pp.
247–50). In 1588 Giambologna was in Rome with Antonio Susini (Dhanens
1956, p. 41), and we know that he encouraged Susini to make copies after
antique statues. The present statuette shows every sign of being a bronze
from Giambologna's studio. Baldinucci (1770 edition, vol. VII, p. 126) men-
tions a "Leone camminante" among the models by Giambologna that con-
tinued to be cast after the master's death, and in his *Life* of Antonio Susini
(edition of 1770 and 1772, vol. XII, p. 204) he states that Antonio's nephew
Giovanni Francesco made casts of this model among others. Since Tietze-
Conrat (1918) and Planiscig (1924) it has been supposed, surely rightly, that
these references by Baldinucci relate to the present statuette.

As Avery (1978/79) observed, the best-quality examples of animal bronzes
from the workshop of Giambologna and Antonio Susini are distinguished by
being mounted on an oval base-plate. It is noteworthy – and this also applies
to Giambologna's large bronzes, particularly his two-figure *Abduction* groups
– that the extremities of the figures always project slightly over the edge of
the base, so that the static effect of the base is outweighed by the dynamic
sense of movement.

Animal bronzes of this kind are frequently found in the collections of old
princely houses that were more or less closely connected with the Medici.
The present example, of high quality both in modeling and execution,
together with a somewhat weaker gilt replica also in the Kunsthistorisches
Museum, is from the *Kunstkammer* of the Emperor Rudolf II, who particular-
ly admired Giambologna's work. A replica of comparable quality in the
Museo Nazionale del Bargello in Florence is from the Medici collections.
The extremely precise and sharp modeling and execution, expressive in
every detail, of the Vienna and Florence examples are most probably the
work of Antonio Susini. The *Lion* in the Liechtenstein collection, on the
other hand (Tietze-Conrat 1918, p. 89, fig. 68), is characterized by the more
delicate strands of the mane, which suggests a later origin in the workshop of
Giovanni Francesco Susini. This *Lion* does not possess an oval base of its
own; the same is true of a further example in the Kunsthistorisches Museum,
sold in 1923 (Planiscig 1924, no. 266).

The *Lion* in the Simon collection in Berlin (Bode 1906–12, III, plate
CCXLVII) mentioned by Planiscig in this connection (1914, no. 266) is earlier
and has nothing to do with Giambologna's workshop.

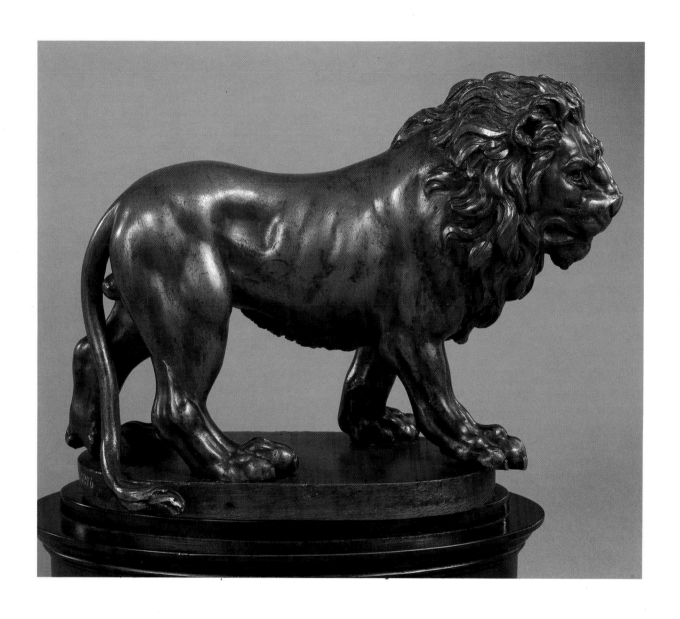

56. Triton

After Giambologna

Bronze statuette; thick-walled hollow cast. The statuette was intended as an ornament to a fountain, and a massive hollow bolt in the base is for connecting it to the water supply. The raised right arm with the horn seems to have been cast separately. A crack at the join of the right arm to the shoulder has been plugged. A further crack on the *Triton*'s right foot. Thick, layered brown lacquer. Height 44.8 cm.
Inv. no. Pl. 9115.

PROVENANCE
Gustav von Benda collection, Vienna. In 1932 bequeathed to the Kunsthistorisches Museum by Gustav von Benda.

BIBLIOGRAPHY
Wiles, B.H. 1933, pp. 88, 89 and 131.
Le Triomphe du Maniérisme – de Michelange au Greco 1955, p. 169, No. 316.
Jestaz, B. 1969, I, p. 81.
Pope-Hennessy, J. 1970, pp. 203, 204.
Leithe-Jasper, M. 1973, No. 90.
Leithe-Jasper, M. 1976, pp. 88, 89, No. 88.
Keutner, H. 1978/79, pp. 123, 123, No. 41.
Radcliffe, A.F. 1978/79, pp. 123, 124, No. 41.
Leithe-Jasper, M. 1978/79, p. 124, No. 41a.
Jestaz, B. 1979, p. 78 and p. 82, Notes 5 and 6.

ADDITIONAL BIBLIOGRAPHY
Desjardins, A. 1883, p. 190.
Blanc, C. 1884, p. 30, No. 95.
Müntz, E. III, 1895, p. 426.
Bode, W. 1906–1912, II, Plate CXLIX.
Strohmer, E.V. 1950 (1947–1948), p. 120, No. 63.
Larsson, L.O. 1967, p. 127, No. 26.
Utz, H. 1973, pp. 38, 60, 61.
Draper, J.D. 1979, p. 155.

The triton is seated in a corkscrew pose on a base consisting of a shell resting on a triangular plate and, above it, three dolphins whose tails are upraised and intertwined. In his lowered left hand he holds the shell of a sea-snail; with his raised right hand he holds a horn to his mouth. His head is thrown back as he looks directly up toward the mouth of the horn.

The statuette was evidently intended as the finial and outlet of a small domestic fountain, with water spouting from the horn and the three dolphins' mouths. The upward spiral movement of the figure is a preparation for the jet of water in which the composition culminates. The statuette is based on an invention by Giambologna. Though not mentioned in any literary source of the time, it appears in a contemporary document noted by Desjardins (1883, p. 190) and Müntz (III, 1895, p. 426) but first published by Keutner (1978/79, pp. 123, 124, no. 41), which reads: "Addi 19 di Luglio 1598. Copia d'un Inventario di robe che S.A. ha mandato in Francia ... Un tritone con delfini che getta aqua, di mano di gian bologna. libbre 110 –". This triton weighing 110 *libbre* (about 36 kilograms or 80 pounds) is now generally identified with a bronze, 91 cm high, in the Altman collection in the Metropolitan Museum, New York, which from its style is clearly by Giambologna (and not Adriaen de Vries, as Strohmer thought (1950, p. 120, no. 63)). However, Giambologna's model must have been considerably earlier than 1598, as its design can already be seen in the tritons in his relief of the *Triumph of Neptune* on the column of the Oceanus fountain (1567–75) in the Boboli gardens in Florence; it was also used in 1574 by Battista Lorenzi for his larger-than-life marble *Triton*, now in the Museo Nazionale in Palermo (Wiles 1933, pp. 88, 89).

Related to the *Triton* in the Metropolitan Museum, but of somewhat more elongated proportions and less detailed modeling, are, besides the present work, a statuette from the Thiers collection in the Louvre, Paris (inv. no. Th. 95, height 42.3 cm) and a *Triton* in the Frick Collection, New York (inv. no. 16.2.44, height 44.1 cm). All three are reductions; the variant in Vienna is the largest, and also departs most freely from the model. In it the left hand does not rest on the dolphin's tail behind the figure's back but is freely extended, grasping a snail-shell. This gives a better optical balance and appears less unstable than the other versions; it comes even closer to the composition of Giambologna's *Flying Mercury*.

Wiles (1933) had already supposed that these statuettes were based on a model by Giambologna and that Battista Lorenzi's marble figure in Palermo was based on a prototype by him; she also drew attention to Desjardins's and Müntz's references to the document quoted above. Nevertheless Weihrauch (1967) attributed to Lorenzi the Altman *Triton* and also the Louvre, Frick and Vienna versions. Jestaz (1969) questioned this view, but it was accepted by Pope-Hennessy and in principle by Leithe-Jasper (1973 and 1976); the latter, however, emphasized the stylistic resemblance of the Altman *Triton* to Giambologna and suggested that it formed the model for the smaller versions. Keutner (1978/79) was then the first to claim the three small bronzes for Giambologna. He believed the version in the Thiers collection in the

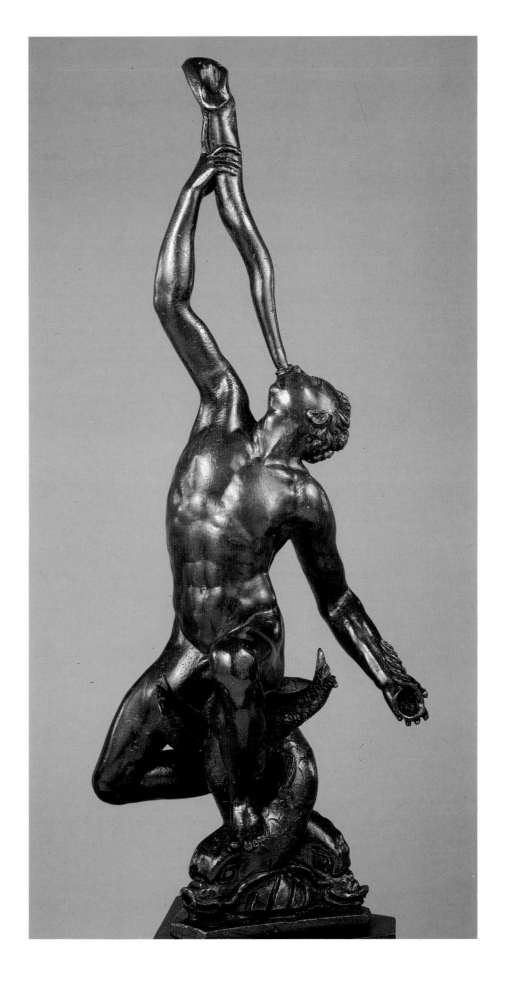

Louvre to be the one which most faithfully represented Giambologna's in-
vention – which was probably of early date and comparable with the *Flying
Mercury* of 1562–65 – and which must therefore have been cast during the
master's lifetime. On the other hand, the large *Triton* in the Altman collec-
tion was, in Keutner's opinion, much more summarily modeled and thus
comparable with Giambologna's late work. Draper (1979) disagreed, regard-
ing the Altman *Triton* as an early work also.

In the late eighteenth century there existed in England a plaster cast of the
Altman *Triton* of about the same dimensions, probably a product of the St
Martin's Lane Academy. This is recorded in a drawing of 1779 by E.F.
Burney in the Royal Academy, London, and was described by Baretti in
1781 as a work by Giambologna that might have served to decorate a garden
fountain (Radcliffe 1978/79, pp. 123, 124, no. 41).

The example in the Frick Collection, attributed by Bode (1910) to Ben-
venuto Cellini, is today regarded as a late seventeenth-century cast (Keutner
1978/79). The Vienna statuette resembles that in the Frick Collection in hav-
ing a triangular plinth with bevel edges and in the treatment of the dolphins'
scales, but it does not have the same polished surface. Keutner (1978/79) sup-
posed it to be a reduction of Giambologna's model by Pietro Tacca. Adriaen
de Vries, too, modified Giambologna's invention in his tritons for the
Neptune fountain at Frederiksborg, now in Drottningholm. A silver replica
was in the collections of Louis XIV.

57. Crane

The muscular-looking wader stands on its left leg; the right leg is bent, its forepart raised and the claws spread. This pose gives the figure an aggressive look that was not the artist's intention. The crane is supposed to be holding a round stone in its claws, in accordance with its iconography as a symbol of watchfulness: if it were to fall asleep, it would drop the stone, and immediately wake itself up.

The artist has correctly perceived that, to keep a balance on its left leg, the crane's body must be shifted from its axis. For the same reason the wings are partly spread, the right more than the left; the long, thin neck is raised in an S-curve, while the head, with the small tuft and long, half-open beak, is lowered. Thus the figure is pervaded by a kind of swaying movement which produces a dynamic effect.

The modeling and afterworking show great care, but there is something schematic and smooth about the details: the bird is stylized, decorative and not wholly naturalistic.

The Kunsthistorisches Museum possesses a companion figure of an *Ostrich* (Planiscig 1924, no. 270). Several replicas or variants of both birds are known. In the Hermitage at Leningrad there is an *Ostrich* and a *Stork*: the latter resembles the *Crane* but has both feet on the ground (Androssow 1978, nos. 26 and 27, and 1980). The Louvre in Paris possesses a *Crane* (Migeon 1904, no. 188) and an *Ostrich* from the Thiers collection (Blanc 1884, no. 119); the latter, however, differs from the rest of the group in its aggressively dynamic pose and its general configuration. An *Ostrich* and a *Stork* similar to those in the Hermitage have appeared on the London art market (Christie's, May 15, 1984). Individual examples of varying quality are in the Museo Estense in Modena, the Galleria Franchetti in the Ca' d'Oro in Venice, the Victoria and Albert Museum in London (inv. no. A41–1956), and in a private collection in Paris.

The crane, stork and ostrich were symbols of different virtues, generally connected with an allegory of justice. The ostrich itself stood for Justice, the crane for Vigilance and the stork for Filial Piety. The figures are linked by iconography as well as form and style.

This group of long-legged birds was originally regarded as a product of Giambologna's workshop, and was linked with the monumental figures of birds that he executed in 1567 for a grotto in the garden of the Medici villa at Castello near Florence (Schlosser 1910, Planiscig 1924, Weihrauch 1967, and Androssow 1978 and 1980). However, Dhanens (1956) firmly excluded them from Giambologna's *oeuvre*, and Avery (1984) even attributed them to Caspar Gras. Avery based his opinion on the facture of the birds, which cannot be directly related to Giambologna's style, and on the architectural form of the base of the two sold at Christie's in 1984: the base of the *Ostrich* in the Paris private collection is similar to this, and the bases of the birds in Leningrad are not unlike it. These bases, according to Avery, point to a later origin; they resemble the base of a statuette of a *Bird-catcher* (Avery 1978/79, no. 134) which derives from Giambologna but was probably executed by a northern follower. Avery also perceived points of similarity to birds by

Florentine(?), first half of the seventeenth century

Bronze statuette; hollow cast. The tip of the left wing cast separately and attached. A large flaw on the edge of the left wing, smaller ones at the base of the right wing and the neck. Greenish-brown patina. The figure 830 in white on the outside of the raised right claw is the pre-1823 number of the Imperial and Royal Cabinet of Coins and Antiquities. Height 28.9 cm.
Inv. no. Pl. 5840.

PROVENANCE

Collection of the Imperial Treasurer Josef Angelo de France, described erroneously as a *Stork*, together with its pendant, the *Ostrich* (Martini 1781, p. 64, Descriptio Signorum, Scrinium VII, no. 561, "(Ser. 3. Cat. A.n. 77a) CICONIA alas, in primis dextram, movens, pede d. alte sublato, digitisque curvatis, quasi nonnihil comprehensura. Aes, 11 alt. In b. marm. multicolore, 3 1/2 alt, long et lat. (Est quasi socius n. 555)" referring to the *Ostrich*). Acquired in 1808 with the de France collection for the Imperial and Royal Cabinet of Coins and Antiquities; transferred in 1880 to the Ambras collection in Vienna and transferred with the entire collection to the Kunsthistorisches Museum in 1891.

BIBLIOGRAPHY

Ilg, A. 1891, p. 224, Room XXIV, Case 3, No. 66.
von Schlosser, J. 1910, p. 13, Plate XXXVII, 3.
Übersicht 1916/17, p. 188, Room XXIV, No. 75.
Planiscig, L. 1924, p. 166, Nos. 271 and 270.
Planiscig, L. 1930, p. 49, Plate CCXVIII, Fig. 372.
Planiscig, L., and Kris, E. 1935, p. 135, Room XVI, Case 14, No. 2.
Dhanens, E. 1956, p. 161.
Androssow, S. 1978, pp. 41, 42, Nos. 26 and 27.
Androssow, S. 1980, pp. 153, 154.
Avery, C. Christie's Sale, London, 15 May 1984, No. 142.

ADDITIONAL BIBLIOGRAPHY

Blanc, C. 1884, No. 119.
Migeon, G. 1904, p. 178, No. 188.
Weihrauch, H.R. 1967, p. 223.

Caspar Gras in Innsbruck (those on the pillars of the monument to the Archduke Maximilian III?). However, neither stylistic arguments nor those of provenance are really in favor of Caspar Gras, who has recently been credited with many bronzes that clearly date from the first half of the seventeenth century but cannot be assigned to any artist. None of these statuettes of birds appears in any inventory of the Habsburg collections in Innsbruck or Schloss Ambras; and Avery's comparison with the crane or heron of Caspar Gras's *Moosgöttin* (moss goddess) on the Leopold fountain at Innsbruck does not go beyond general typological features. As to the *Crane* in the Louvre, it is known to have been sent there from Rome in 1798 (Migeon 1904).

While the birds are of similar design, the markedly inferior quality of some of them suggests that a considerable time elapsed between individual replicas, so that caution is required as regards attribution and dating. By far the most impressive of the group, for its modeling and spontaneity of movement, is the *Ostrich* in the Thiers collection in the Louvre; this, *pace* recent critics, must belong to the immediate succession of Giambologna's bird bronzes and is close in style to Pietro Tacca. But the two birds in the Vienna collection, with their careful though rather bland execution and finely chased and hammered surfaces, in facture also recall Florentine bronzes by later followers of Giambologna in the first half of the seventeenth century.

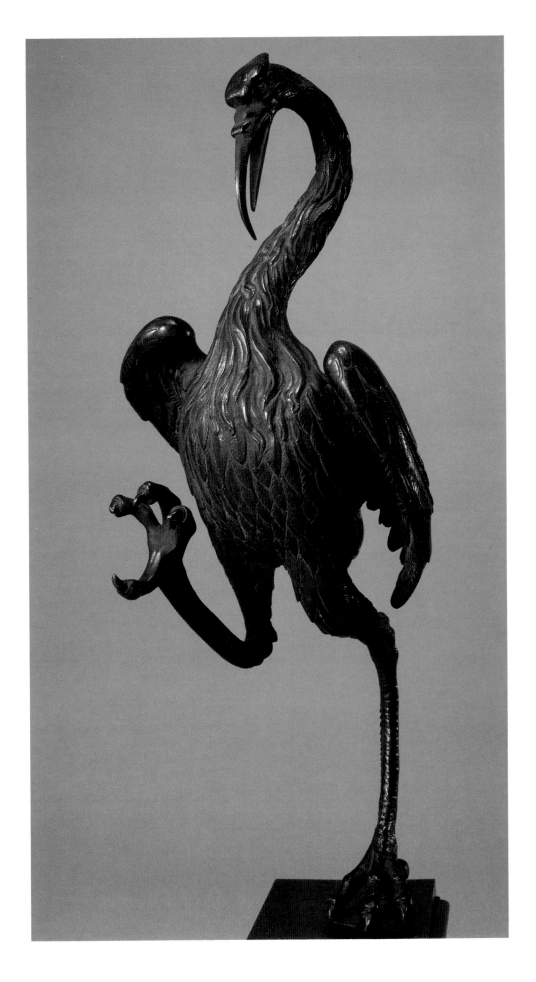

58. Lion attacking a bull

Antonio Susini(?) after
Giambologna
Active from *c.* 1580, died 1624
(See Biography, p. 282)

Bronze group, hollow cast. Golden
brown lacquer; light brown patina.
The figure 986 in white on the
upper part of the lion's right leg is a
pre-1823 inventory number of the
Imperial and Royal Cabinet of Coins
and Antiquities.
Height 20.1 cm, width 26.6 cm.
Inv. no. Pl. 5837.

PROVENANCE
Long in imperial possession, but can only be
traced back to 1802, when the group was
transferred from the Belvedere Palace which
then housed the Imperial Gallery to the
Cabinet of Coins and Antiquities (Act. 130
1/2 from 1802: "Aus dem Belvedere erhalten,
Bronzi: Nr. 18. Löwenkampf mit einem
Stier."). Transferred in 1880 from the Cabinet
of Antiquities to the Ambras collection in
Vienna and transferred with the entire collec-
tion to the Kunsthistorisches Museum in 1891.

The lion has hurled itself on the bull, whose forefeet have collapsed under
the impact of the sudden attack and the teeth and claws tearing at its flesh.
The bull's head is thrown back; its panic is expressed in its eyes, and it is
bellowing with mouth wide open.

The composition of this group must be considered together with a pend-
ant representing a *Lion attacking a horse*. Early sources attribute both works to
Giambologna. In 1611 Philipp Hainhofer reported to the Duke of Pomerania
that the Augsburg councillor Markus Zeh possessed, among other works by
Giambologna, "Un gruppo d'un lione ch'ammaza un cavallo" and "Un
gruppo d'un lione ch'uccide un toro" (Doering 1894). Baldinucci in his *Life*
of Giambologna mentions "Il cavallo ucciso dal Leone" and "Il Toro uccso
dal Tigre" among works cast in his time after models by Giambologna; and
in his *Life* of Antonio Susini he states that Antonio's nephew Gianfrancesco
Susini made aftercasts of Giambologna's models including "Il Cavallo ucciso
dal Leone" and "Il Toro morto dalla Tigre". The "tiger" here probably sig-
nifies a lion, unless the reference is to a group in the Liechtenstein collection
of a leopard attacking a bull (*Giambologna* 1978/79, no. 173c).

The inspiration for these works is drawn from classical art. The group of
the lion attacking a horse is a free imitation of the colossal Greco-Roman
marble sculpture, said to have been admired by Michelangelo, which is now
in the courtyard of the Palazzo dei Conservatori in Rome. In Giambologna's
time it consisted only of a torso but was restored and completed by Ruggero
Bescapè in 1594. To the horse's body, which at that time had neither legs nor
head, Bescapè added a neck stretched out to one side and a head looking for-
ward (Haskell and Penny 1981, and compare a drawing in the print room at
Berlin-Dahlem showing the group in the late fifteenth century; *Zeichner
sehen di Antike* 1976, no. 6). All bronze variants showing these features must
date from after the restoration of the marble group in 1594, while
Giambologna's model differs in precisely these respects, and his composition
represents an attempted completion of his own. The backward turn of the
horse's head toward the lion gives the group a greater drama, and
Giambologna's invention is generally much more animated than the antique
prototype or Bescapè's restoration. It was evidently composed before 1594.
The *Horse and lion*, and still more the *Lion attacking a bull*, are reminiscent of
the *Hercules and Nessus* dating from 1576 (see *Giambologna* 1978/79, no. 81).
The lion and bull theme also occurs in ancient art, but in this case
Giambologna's composition seems not to be based on any specific prototype,
but to have been freely invented as a pendant to the group with the lion and
horse.

None of the many surviving groups of a *Lion attacking a horse* or *bull* can
be attributed to Giambologna with certainty and designated as his original
version. So in the present case the investigation of replicas is complicated by
the fact that it must be based not on an original but on the replicas signed by
Antonio Susini. There are signed *Lion and horse* groups by Susini in the
Detroit Art Institute and the Museo di Palazzo Venezia in Rome; *Lion and
bull* groups also in the Palazzo Venezia and in the Louvre in Paris. Both

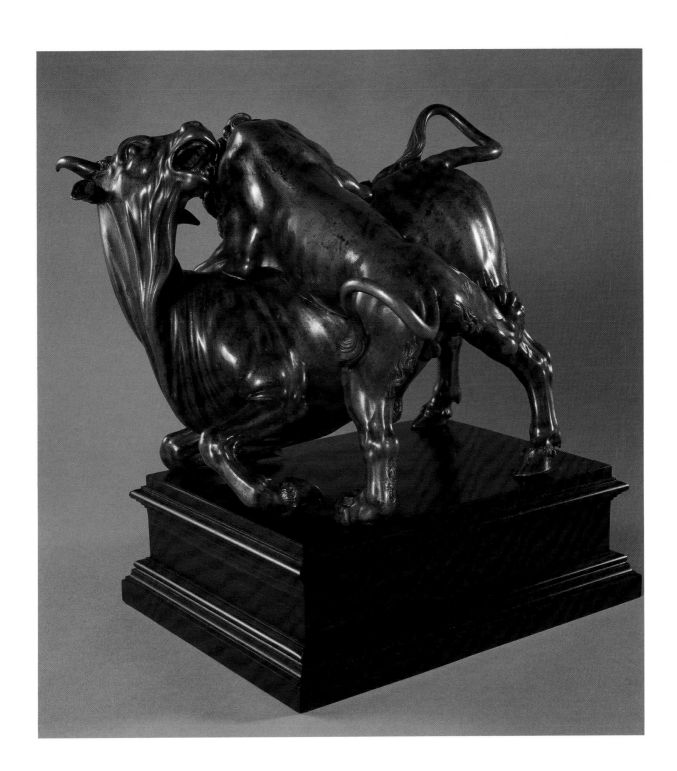

BIBLIOGRAPHY

Baldinucci, F. 1688 (1770) VII, p. 126 and XII, pp. 203, 204.

Ilg, A. 1883, p. 141.

von Frimmel, T. 1883, p. 62, No. 979.

Ilg, A. 1891, p. 224, Room XXIV, Case 2, No. 63.

Doering, O. 1984, pp. 96, 97.

Buchwald, C. 1899, p. 114, note 48.

Planiscig, L. 1924, p. 165, No. 268.

Planiscig, L. and Kris, E. 1935, p. 90, Room XIII, Case 33, No. 9.

Weihrauch, H.R. 1956, pp. 96–98, Nos. 121, 122.

Dhanens, E. 1956, pp. 215, 216.

Weihrauch, H.R. 1967, pp. 221, 227 and 429.

Leithe-Jasper, M. 1973, No. 106.

Leithe-Jasper, M. 1976, p. 122, No. 161.

Avery, C. 1978/79, pp. 254–256, Nos. 171, 172, 173.

Leithe-Jasper, M. 1978/79, pp. 255–258, Nos. 172a, 173a, 173b, 173c, 174.

ADDITIONAL BIBLIOGRAPHY

Haskell, F. and Penny, N. 1981, pp. 250, 251, No. 54.

compositions exist in numerous replicas of the most varying quality (*cf* *Giambologna* 1978/79, nos 170, 171, 172, 172a, 173, 173a, 173b, 173c, and 174). They also vary, though for the most part only slightly, in detail, indicating that the piece-molds were not always combined in the same way and that the wax model was often reworked before casting. In later aftercasts the *Lion and bull* group was often given a mound-like base to match Susini's *Lion and horse* group; but it was originally designed without a base, as the bull is still standing and not recumbent like the horse. The quality of the casting and the sharp and precise afterworking of the Vienna example are hardly inferior to the signed versions, so it too may be regarded as a product of Antonio Susini's workshop.

Replicas and variants: Musée du Louvre, Paris, inv. no. O.A.6062, height 21 cm, width 26.5 cm, signed ANT-/SVSI/NI.F., with the engraved number 19 of the French Crown inventory of 1684 (*Giambologna* 1978/79, p. 254, no. 171); Museo di Palazzo Venezia, Rome, inv. no. F.N. 172, height 20.4 cm, engraved ANT./SVSINI/F. and P.C., for Piero Corsini, to whose collection this group and a companion belonged (Pope-Hennessy 1961/62, no. 128; *Giambologna* 1978/79, p. 256, no. 173); National Museum, Stockholm inv. no. NMsk 341, height 21 cm (Larsson 1984, no. 22); collection of the Augustinian monastery, Klosterneuburg, inv. no. KG 34, height 20 cm (a weak example; *Giambologna* 1978/79, p. 256, no 173b; Herzog Anton Ulrich Museum, Brunswick, inv. no. Bro. 115 (Bode 1906–12, III, p. 5, pl. CC; Jacob 1972, p. 12, no. 16 and 1976, p. 8, no. 6): for this the form and afterworking of the base suggest a later date; Bayerisches Nationalmuseum, Munich, inv. no. R.3229, height 25.5 cm (Weihrauch 1956, pp. 97, 98, no. 122): later in execution, to judge from the form of the base; Staatliche Museen, Berlin-Dahlem, inv. no. 338, height 24.5 cm (Bode 1930, pp. 36, 37, no. 172): later in execution, to judge from the base; Royal Ontario Museum, Toronto, inv. no. L971,23.12b, height 26.6 cm (Avery and Keeble 1975, p. 15; Keeble 1982, pp. 56, 57, no. 24): to judge from the form of the base, the different shape of the bull's horns and the hair on its neck, probably of later date, but whether actually Netherlandish seems questionable.

Giambologna's design was also used in Florence, with greater variations, in the late seventeenth and early eighteenth century, *eg* by Massimiliano Soldani in a group in the Bargello, Florence (Weihrauch 1967, p. 429, fig. 507).

A further variant, in which the lion's mane is altered and the bull's posture is notably different, is in the Bayerisches Nationalmuseum, Munich, inv. no. 69/32, height 20 cm, width 34 cm (*Bayerisches Nationalmuseum, Bildführer* 1, 1974, p. 45, no. 28; attributed to Johann Gregor van der Schardt).

Groups of a *Leopard attacking a bull*: collection of the Reigning Prince of Liechtenstein, Vaduz, inv. no. 544, height 18 cm (Tietze-Conrat 1917, p. 84, fig. 66, and *Giambologna* 1978/79, p. 257, no. 173c; probably by Giovanni Francesco Susini); Museo Nazionale del Bargello, Florence. The version illustrated in Desjardins 1883, p. 135, is that of the Liechtenstein collection.

59. Putto riding a dolphin

A *putto* sits sideways on a dolphin, which is swimming with its tail fin up-raised. The boy holds to his side a shell, which rests on the dolphin's head. The shell, probably cast from nature, indicates the purpose of the group as an inkwell. It belongs to a group of similar inkwells in the collections of the Reigning Prince of Liechtenstein in Vaduz; the Victoria and Albert Museum, London; the Fitzwilliam Museum, Cambridge; and formerly the Cheney and Capel Cure collection. These differ slightly from one another as regards the dolphin's pose and, more particularly, the attitude of the *putto* and his seat on the dolphin.

In the example in the Liechtenstein collection (Bode 1906–12, II, Pl. CLXX, wrongly designated as in the Benda collection; Leithe-Jasper 1978/79, no. 253) the *putto* sits sideways as in the Vienna bronze, but the upper part of his body is turned more to the front and he holds a staff in his raised right hand. His hair is not, as in the Vienna example, knotted over his brow and bound with a fillet, but is simply curled. In the London example, on the other hand (Radcliffe 1978/79, no. 252), the *putto* is seated, facing forward, on a raised fin on the dolphin's head, and holds in his raised right hand a "Morning Star" mace; in his case too the hairstyle is simpler. The example from the Cheney and Capel Cure collection (sold at Christie's, London, May 4, 1905, no. 164) is similar to that in the Victoria and Albert Museum, according to Radcliffe 1978/79, no. 252. These variants differ less from the present example than the one in Cambridge (Bode 1906–12, III, Pl. CCLXI, where it is wrongly stated to be in the Victoria and Albert Museum). There, instead of the *putto*, the dolphin bears on its back a smaller dolphin, balancing a shell on its raised tail fin.

The motif of these inkwells seems to have been popular for a considerable time, as is suggested by extant variants which seem to be later in style. In the Beit collection formerly in London there was a *Dolphin* alone balancing a disproportionately large shell on its raised tail fin (Bode 1906–12, II, Pl. CLXV). The Kunsthistorisches Museum in Vienna also possesses a small *Dolphin* on which is seated a figure of Cupid holding arrows in his hands; the dolphin is rearing, and carries a shell on its raised tail fin (Bode 1906–12, II, Pl. CLXV; Planiscig 1924, no. 218, and Leithe-Jasper 1976, no. 125). Finally in the Victoria and Albert Museum there is a gilt inkwell in which the dolphin once again balances a shell on its outstretched tail, with a fairly large Cupid riding on its head and drawing an arrow from his quiver (Planiscig 1930, Pl. CLXX, fig. 293, with incorrect measurements). A replica of this *Cupid* alone is in the Palazzo Schifanoia in Ferrara (Varese 1974, no. 98). These related or similar *amoretti* differ considerably from the *putti* in the first group of ink-wells described above. The hairstyle, with longer curls over the forehead and temples, as well as the different proportions and *mouvementé* drapery, show them to be work of the later seventeenth century, whereas the *putti* of the first group in Vienna, Vaduz and London belong to an earlier stylistic phase.

In accordance with the widespread tendency to assign to Venice all bronze statuettes with a subject related to the sea, the present work and its variants were originally taken to be the product of a Venetian foundry between 1550

Close to Adriaen de Vries(?)
*c.*1545–1626
(See Biography, p. 283)

Bronze group intended as an ink-well. Hollow cast, the shell probably cast from nature. Black lacquer; dark brown patina.
Height 11.4 cm, length 17.4 cm.
Inv. no. Pl. 9117.

PROVENANCE
Gustav von Benda collection, Vienna. In 1932 bequeathed to the Kunsthistorisches Museum by Gustav von Benda.

BIBLIOGRAPHY
Leithe-Jasper, M. 1973, No. 101.
Leithe-Jasper, M. 1976, pp. 101, 102, No. 124.
Leithe-Jasper, M. 1978/79, pp. 310, 311, Nos. 251 and 253.
Radcliffe, A.F. 1978/79, p. 311, No. 252.

ADDITIONAL BIBLIOGRAPHY
Bode, W. 1906–1912, II, p. 24, Plates CLXV and CLXX, also III., p. 23, Plate CCLXI.
Planiscig, L. 1927, p. 566.
Planiscig, L. 1930, p. 38, Plate CLXX, Fig. 293.
Bode, W., and Draper, J.D. 1980, p. 103, Plate CLXX.

and 1575 (Bode 1906–12, Planiscig 1930). Planiscig had earlier (1927) attri-buted the Liechtenstein version to Leone Leoni. Neither of these views can be sustained, however, in view of the *putto*'s unmistakable resemblance to a Florentine type based on an invention of Giambologna's: he resembles one of the two bronze *putti* which, as Dhanens (1956, pp. 241–53), followed by Lar-sson (1967, p. 13), correctly supposed, were executed by Adriaen de Vries after a model of Giambologna's for the Cappella Grimaldi in Genoa.

Accordingly Leithe-Jasper (1973 and 1976) for the first time connected this group of inkwells with Adriaen de Vries. The Vienna *putto* and his counter-parts in Vaduz and London all have features typical of de Vries: the high forehead, firmly retracted stomach and fine curly hair. Similar *putti* are found in de Vries's early work, especially the Hercules fountain in Augsburg, which also has nearly identical dolphins. It therefore seems very probable that this inkwell and the closely related variants in Vaduz and London are early works by Adriaen de Vries, executed when he was still under the in-fluence of Giambologna; whether in Italy or when he was already in South Germany, cannot now be stated with certainty. In the latter case, de Vries would deserve credit for having reintroduced north of the Alps this type of vessel with its roots in the early Italian Renaissance.

60. Chronos – Saturn

Attributed to Pietro Francavilla

1548–1615

(See Biography, p. 280)

Bronze statuette; thick-walled cast. Dark brownish-red smoke varnish; yellowish-brown patina.

Height 24.1 cm.

Inv. no. Pl. 5888.

PROVENANCE

In the possession of Emperor Matthias and documented in 1619 in his collection at the Vienna Hofburg in the fragment of an inventory preserved at the Wolfenbüttel library: "Allerlei schone stuckh von messing . . . Nr. 21. 1 mansbildl, den linkhen fues auf eine kugel haltent." (Köhler 1906–07, p. xv, Regest. 19449, 1). The next reference does not appear until the inventory of the Imperial Treasury in Vienna of 1750, p. 574, no. 37 "Ein stehender Saturnus von pronso." (Zimmermann 1889, p. cccx). Transferred from the Treasury to the Ambras collection in Vienna in 1871 and transferred with the entire collection to the Kunsthistorisches Museum in 1891.

BIBLIOGRAPHY

Ilg, A. 1891, p. 225, Room XXIV, Case 4, No. 36.
von Schlosser, J. 1910, p. 17, Plate XLIV, No. 1.
Planiscig, L. 1921, pp. 471–473, Fig. 492.
Planiscig, L. 1924, pp. 106, 107, No. 184.
Planiscig, L. 1930, p. 36, Plate CLXI, Fig. 278.
van Marle, R. 1931, p. 172.
Planiscig, L. and Kris, E. 1935, p. 91, Room XIII, Case 38, No. 4.
Pope-Hennessy, J. 1963[1], II, p. 62.
Weihrauch, H.R. 1967, p. 238.
Leithe-Jasper, M. 1973, No. 98.
Leithe-Jasper, M. 1978/79, p. 122, No. 39b.

The gaunt old man stands with his right foot on a small square base; on it is a globe, on which he rests his left foot. His torso is inclined slightly forward and turned sharply to the left; his left arm is bent behind him, the hand resting on the top of a rudder. His right arm hangs diagonally in front of him, across his left thigh, so that his forefinger points to the globe at his feet. His head is bent forward; his short curly hair is bound by a fillet; a long wavy beard extends to his left armpit. His gaze is fixed on the globe to which his right hand points; on it the four continents are schematically represented, with the names EVROPA, ASIA, AFRICA and AMERICA. The aged man's left thigh is covered by a bull's hide.

Outstanding features are the torsion of the body and the diagonal crossings of the compositional axes; also the extremely long limbs, small head and thin, bony fingers. The modeling of the statuette is highly differentiated, and the afterworking especially careful. The bull's hide is roughened with the burin on the outside and hammered on the inside; the blade of the rudder is also hammered.

Schlosser (1910) identified the statuette as a river-god. Planiscig (1921 and 1924) and Van Marle (1931), surely rightly, entitled it *Chronos-Saturn*, as was already done in the Treasury inventory of 1750. Planiscig (1930) changed the designation to *Allegory of Earth*, but reverted to *Chronos* in 1935.

Late nineteenth-century inventories describe the statuette as German, seventeenth century. Planiscig (1921 and 1924) assigned it to Venice. Along with several other bronze statuettes including cat. 41, 73 and 74, he believed it to be part of the *œuvre* of the "Master of the Haggard Old Men", an artist of his own invention, supposedly belonging to the circle of Alessandro Vittoria. The only common feature of the statuettes of this group is indeed the gauntness of the old men whom they depict. Later (1935) Planiscig recognized that the group could not be of Venetian origin; instead, he assigned it to Rome and to Guglielmo della Porta, but he gave no arguments and the attribution is equally unsatisfactory. He was followed by Weihrauch (1967), while Pope-Hennessy (1963), who also treated the group more or less as a single unit, ascribed it to Camillo Mariani, a native of Vicenza who was active in Rome. Leithe-Jasper (1973, 1976 and 1978/79), discussing the present statuette and others of the supposed "group" in the Kunsthistorisches Museum, tried to show that in all probability none was of Venetian origin and, moreover, no two of them were by the same hand. The statuette of *Saturn* must be Florentine, as it corresponds in reverse to an early invention of Giambologna's, the small statuette of *Apollo* in the Bargello in Florence (*Giambologna* 1978/79, cat. 37). The elongated proportions and overdramatized gestures are certainly foreign to Giambologna himself, but they appear in the *œuvre* of his pupil and assistant Pietro Francavilla. Dhanens (1956) says that Francavilla did not produce any statuettes in bronze, but there is no documentary evidence for this. The light-colored alloy and the type of varnish also seem characteristic of Giambologna's followers.

The statuette is generally thought to be a pendant to a *River-god* in the Kunsthistorisches Museum, but this seems not correct (*cf* cat. 73).

No replicas are known.

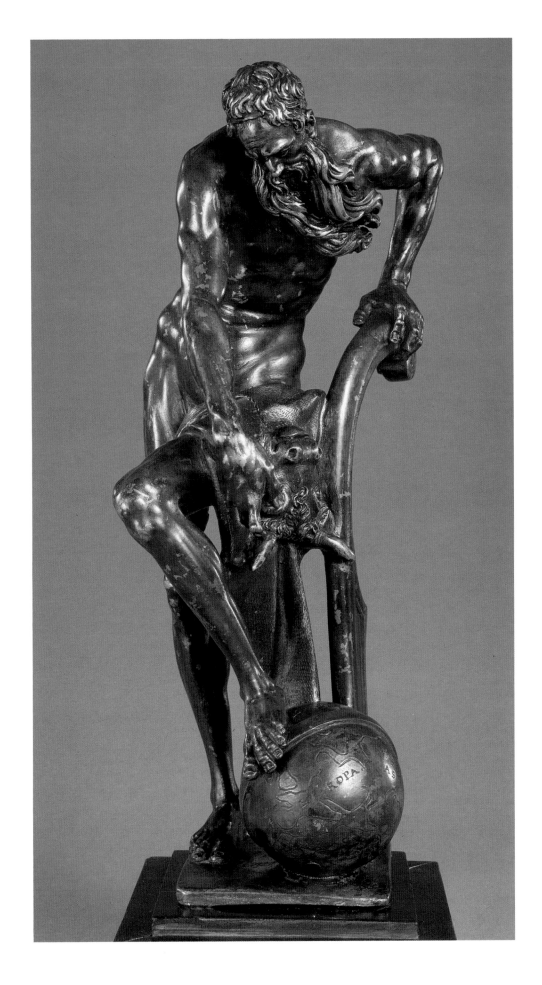

61. Greyhound

French(?), second half of the sixteenth century

Bronze statuette; thick-walled cast. Several unusually large core-support pins visible on the dog's neck and body and on the integrally cast base. On its left foreleg, a small filling of different metal; a small crack in its right forepaw. An old square opening in the center of the upper surface of the base. Remains of old leaf-gilding on the base; traces of reddish-brown lacquer; dark brown lacquer; brown patina; some verdigris on the dog's lower belly, which is not afterworked.
Height, including base, 18 cm.
Inv. no. Pl. 9992.

PROVENANCE
Robert Mayer collection, Vienna. Acquired by the Kunsthistorisches Museum in 1955.

BIBLIOGRAPHY
Planiscig, L. 1930[1], p. 19, Plate LXXXIX, Fig. 150.
Planisicig, L. and Kris, E, 1936, No. 45.

ADDITIONAL BIBLIOGRAPHY
Bode, W. 1907, II, Plate CXIII.
Alte Goldschmiedearbeiten aus Frankfurter Privatbesitz und Kirchenschätzen 1914, No. 85, Fig. 21.
Bode, W. and Draper, J.D. 1980, p. 98, Plate CXIII.

The dog sits in a stiffly upright posture on an integrally cast molded pedestal in the form of a truncated pyramid, its curled-up tail hanging over the edge. Its forefeet are between its hind legs; its head is stretched forward, and its tongue protrudes from its panting muzzle. The plain, smooth collar has a ring for the attachment of a leash.

Despite the evident abstraction of form, the work clearly suggests the nature of the intensely nervous animal, which seems to be impatiently waiting for a sign that will allow it to jump up and run.

There are numerous file marks on the surface, some quite deep, indicating that the statuette came from the casting mold in a fairly crude state and required thoroughgoing afterwork.

The shape of the base and the square hole in its top suggest that the statuette was intended to stand on a piece of furniture. The formal, abstract severity and the almost ornamental stylization seem to indicate an origin in France in the second half of the sixteenth century rather than in northern Italy about 1500 as suggested by Bode (1907) and Planiscig (1930). A replica, but with a different base, was formerly in the collection of M. Leroy in Paris (Bode 1907, II, Pl. CXIII). Draper (Bode and Draper 1980) thought this might be South German, sixteenth century. A similar sitting *Greyhound* seems to have been used by a sixteenth-century Augsburg goldsmith as a model for a drinking vessel that was in the collection of Baron Max von Goldschmidt-Rothschild in Frankfurt in 1914 (*Alte Goldschmiedearbeiten aus Frankfurter Privatbesitz und Kirchenschätzen* 1914, No. 85, Fig. 21).

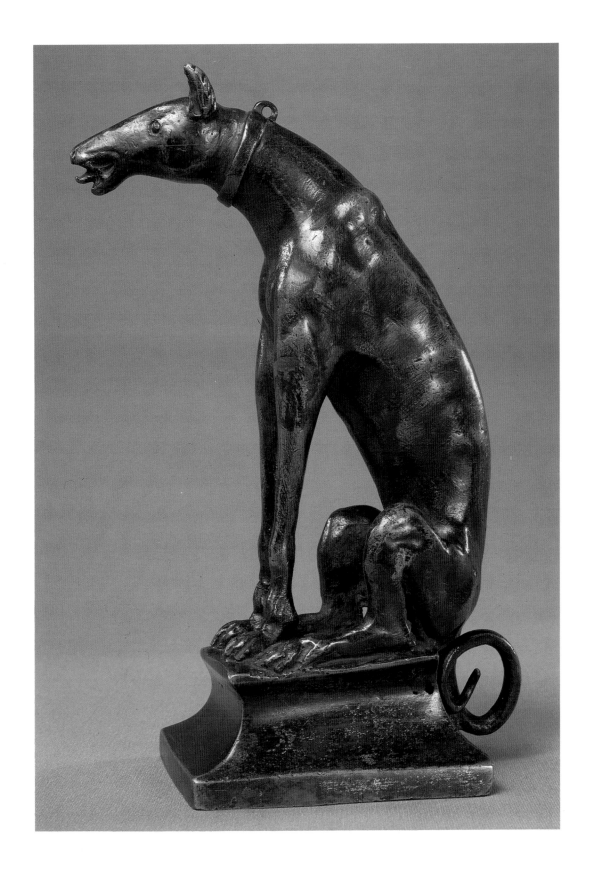

62. Elephant

Italian, second half of the sixteenth century

Bronze statuette; thin-walled cast. Black lacquer and light brown patina. The figure 825 in white on the back of the right hind leg is that of the pre-1823 inventory of the Imperial and Royal Cabinet of Coins and Antiquities.
Height 12.6 cm.
Inv. no. Pl. 5721.

PROVENANCE
Documented before 1823 in the Imperial and Royal Cabinet of Coins and Antiquities. Transferred in 1880 to the Ambras collection and with this collection to the Kunsthistorisches Museum in 1891.

BIBLIOGRAPHY
Bode, 1907, II, p. 12, Plate CXVII.
Planiscig, L. 1924, p. 47, No. 82.
Planiscig, L. and Kris, E. 1935, p. 135, Room XVI, Case 1, No. 5.
Belloni, G.G. 1966, p. 67, No. 113.
Leithe-Jasper, M. 1973, No. 110.
Leithe-Jasper, M. 1976, pp. 107, 108, No. 147.
Bode, W., and Draper, J.D. 1980, p. 98, Plate CXVII.

The elephant stands with arched back and legs spread apart; its head is somewhat lowered and turned to the right, and its trunk is raised in an S-shape.

The animal is modeled in a bold, expressive fashion, without regard for detailed realism; the effect is that of a cursory sketch transformed into sculpture. It is strange therefore that Bode (1907) assigned the bronze to the Italian Quattrocento. Planiscig (1924) dated it, no doubt rightly, to the second half of the sixteenth century; less convincing, however, is his reference to the animal bronzes of Giambologna's circle. Florence seems to be ruled out on stylistic grounds, for instance the almost grotesque deformation of the body, and also the surface treatment, lacquer and patina. The animal seems rather to belong to the tradition of *Horses* by followers of Leonardo in collections in Budapest, London, Dublin and New York, so that an origin in Milan ought to be considered. From this point of view the Vienna example is basically different from other such bronzes of *Elephants*. Draper (Bode and Draper 1980) seems irresolute between Florence and the Netherlands in the early seventeenth century.

The only known replica is in the Castello Sforzesco in Milan. It differs from the Vienna example in that the elephant is caparisoned and a naked female figure (perhaps a later addition) is perched on its back, pulling a thorn out of her left foot. This Milan version was classified by Belloni (1966) as "Italian, sixteenth(?) century". An *Elephant* of this type seems also to have been used by Christoph Jamnitzer as a model for his table centerpiece in the Kunstgewerbemuseum in Berlin.

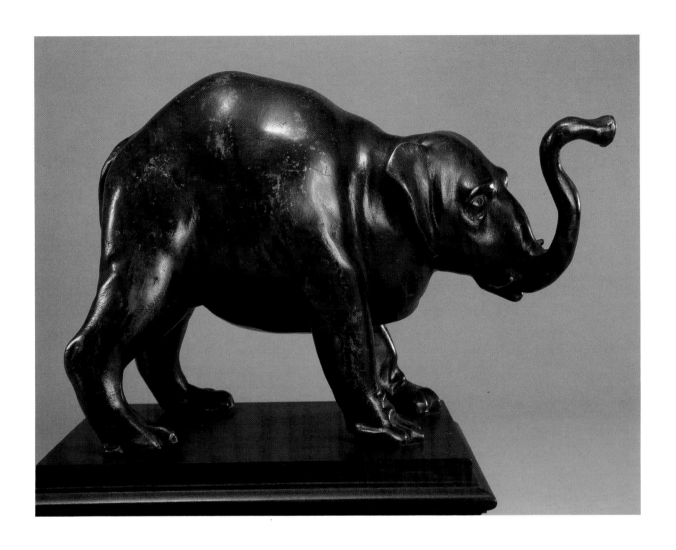

63. Standing putto

North Italian, sixteenth century

Statuette; bronze, hollow-cast. Small
casting flaws on the left calf; two
small holes by the forelock. Artificial
green patina; brown natural patina
in places that have been rubbed.
Height 21.2 cm.
Inv. no. Pl. 5882.

PROVENANCE
First documented in 1863 as no. 62 among the
"Modern Cinquecento bronzes and more rec-
ent Indian and Oriental sculptures of the
Imperial and Royal Cabinet of Coins and
Antiquities". Surrendered in 1880 to the
Ambras collection and transferred with the
entire collection to the Kunsthistorisches
Museum in 1891.

BIBLIOGRAPHY
Planiscig, L. 1924, No. 111.
Planiscig, L. 1929, pp. 88–89, Ill. 91.
Planiscig, L., and Kris, E. 1935, p. 61, Room
 x, Case 58, No. 4.
Byam Shaw, J. 1937, pp. 57–60.
Pope-Hennessy, J. 1964, no page numbers.
Montagu, J. 1966, p. 46.
Hackenbroch, Y. 1971, p. 121.
Leithe-Jasper, M. 1973, No. 86.
Leithe-Jasper, M. 1976, No. 71.
Sheard, W.S. 1978, No. 6.

ADDITIONAL BIBLIOGRAPHY
von Falke, O. 1912, pp. 60, 61, No. 17,
 Plate XLVI.

The *putto* stands on an integrally cast oval base in a firmly balanced attitude,
his weight resting on his left leg only; his head is turned to the right. In his
raised left hand he holds an unidentified object, perhaps the handle of some
implement broken off at the model stage, before casting. In his lowered right
hand is a spoon; this may be reason to identify him with the child who, in
the legend of St Augustine, was endeavoring to scoop the sea dry.

The artificial green patina *all'antica* partly conceals the surface, to all ap-
pearances carefully modeled and afterworked. The boy's locks are strikingly
differentiated and to a large extent also chased with the burin.

Planiscig (1924) dated the statuette to the beginning of the sixteenth
century in Florence: he saw points of resemblance to Quattrocento works,
especially those of Desiderio da Settignano and Luca della Robbia, but
considered that the execution ruled out such an early dating. In 1929 another
example (now in the Museum of Fine Arts, Houston) came to light in the
sale of the collection of the Marquis de Pompignan in Paris; Planiscig, regar-
ding this as an original work by Verrocchio, decided (1929) that the Vienna
bronze was a later variant of it, reduced in size. However, Planiscig was here
misled by a misprint in his own catalogue of Vienna bronzes of the height of
the *putto* in Vienna, which in fact stands taller than the Houston example by
7 mm, *ie* by the thickness of the integrally cast base. In his 1935 catalogue
Planiscig repeated the designation "after Verrocchio". Pope-Hennessy (1964)
and Leithe-Jasper (1973 and 1976) likewise subscribed to a prototype of
Tuscan origin. Byam Shaw (1937) connected the *putto* in Houston (at that
time in the Straus collection in New York) and its replica in Vienna with a
drawing in the Fondazione Horne in Florence which he attributed to Zoan
Andrea and which shows the same *putto* from two viewpoints; he supposed
the drawing to have been made from a similar bronze. It could not have
been the Vienna bronze, however, as the *putto* in the drawing is not holding
a spoon. A similar small figure must have been known to Francesco Cossa
between 1470 and 1480, as is shown by the *bambini* in the first row of the
group of children in the fresco of the *Month of May* in the Palazzo Schifanoia
in Ferrara (oral communication from Jennifer Montagu). Byam Shaw sup-
posed that Mantegna possessed this or a similar statuette and used it as a
model. The small *putto* at the left edge of his 1475 engraving, the *Bacchanal
with a wine-vat*, is a variation of the same motif – not in reverse, however,
for the head is turned in the direction of the weight-bearing leg, not of the
relaxed leg as in the bronzes. But there are also strikingly similar represen-
tations of small boys in Mantegna's later *Madonna* compositions. Even in de-
tails such as facial expression, the shape of the eyes and the arrangement of
the hair, the boy in the Houston statuette is so much more like Mantegna
than Verrocchio that there is much to be said for the view put forward by
Jennifer Montagu (1966), Yvonne Hackenbroch (1971) and Wendy Sheard
(1978) that the statuette should be assigned to Mantua and to Mantegna's
immediate circle. Planiscig's suggestion to Byam Shaw that both the draw-
ing and the bronze are based on a single, possibly antique prototype is not
very convincing.

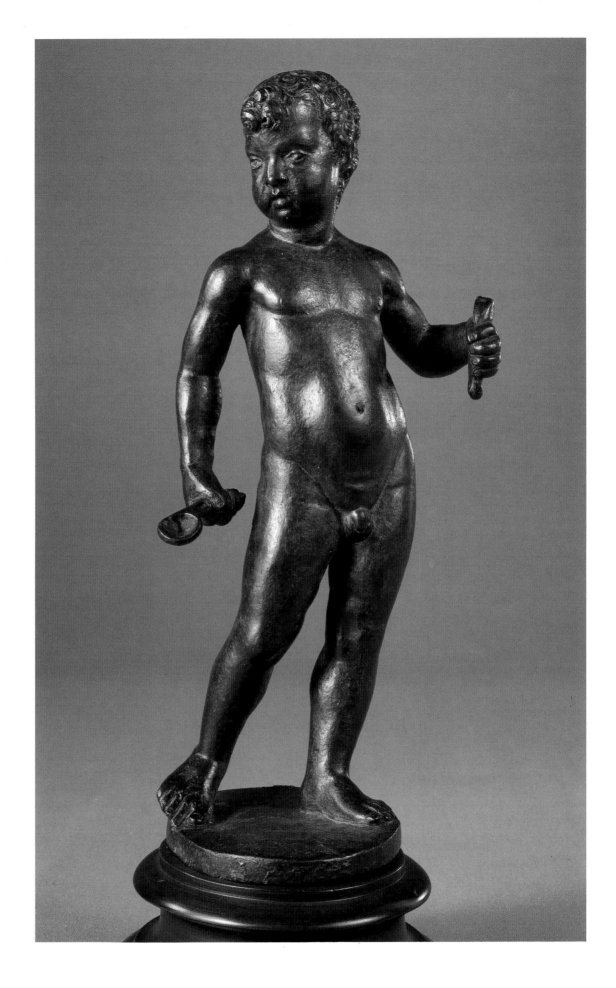

239

The Vienna replica lacks the spontaneity and force of the Houston version. The pseudo-antique "refinement" by means of chasing and patination shows it to be a sixteenth-century "*Kunstkammer* piece", so that in this respect Planiscig's later dating is acceptable.

Another replica, closer to the Houston than to the Vienna example, is in the Metropolitan Museum of Art in New York. A weaker replica with the left hand broken off was in the Eugen Gutmann collection in Berlin in 1912, and a further rather weak example is in the Victoria and Albert Museum in London.

64. Pacing horse

The right foreleg of the pacing horse is fully raised, the left hindleg slightly so. Its head, with open mouth and snorting nostrils, is thrown a little backward and inclined to the right. The short wavy mane is bunched over its forehead; the bushy, undulating tail is somewhat raised. The shoes are nailed, with calkins. The cast is of great technical perfection and the afterworking extremely precise. Despite the most careful smoothing with fine files and perhaps pumice, the sensitivity of modeling is clearly felt in the swelling of the powerful muscles, in the veins of the head, body and extremities, in the hairs of the mane and especially the tail. The strands of the tail with its lively movement are hammered, as are the pupils of the eyes. The richly differentiated surface of the head, extremities and hair, contrasts with the smoothness of the powerful body, creating a vivid impression of high-bred sensitivity.

The *Horse* is certainly based on antique prototypes. However, the position of the legs, and the animal's posture pushing forward over the weight-bearing foreleg, is reminiscent not so much of the horses of St Mark's, which are amblers, as of the horse in the statue of *Marcus Aurelius* in Rome and particularly the *Regisole* in Pavia, destroyed in the eighteenth century. Leonardo da Vinci frequently reverted to this prototype when working in nearby Milan on the model for an equestrian statue of Francesco Sforza and later of Giangiacomo Trivulzio. The immediate prototype of the present statuette is most likely to have been one of Leonardo's many sketches of horses or one of the *bozzetti* by him which, the sources tell us, existed in Milan and Florence in the late sixteenth century.

Schlosser (1910 and 1913/14) therefore supposed the Vienna statuette and a gilt replica in the Musée Jacquemart-André in Paris (Müntz 1891, II, p. 792) to be the work of Leonardo's pupil Francesco Rustici. Planiscig (1924) dated the statuette somewhat later, classifying it as Florentine, second half of the sixteenth century.

There is, however, a tradition – less than entirely certain, because the description in the inventories is insufficiently detailed – that the horse is from the collection of the Archduke Leopold Wilhelm, where the 1659 inventory lists it as "von dem de Fries Original". On the strength of this Weihrauch (1967) and, with some hesitation, Larsson (1969 and 1970) ascribed the work to Adriaen de Vries. For previously (1967) Larsson, in agreement with Schlosser (1913/14) and Planiscig (1924), had attributed to de Vries two other statuettes of horses which are, however, certainly from Giambologna's workshop.

The taut, precise modeling and extremely careful finish of the Vienna statuette scarcely match the *Horses* ascribed with certainty to de Vries in Prague and from Drottningholm (now in the National Museum, Stockholm), which are much softer and less tense in modeling and also more conventional in form. These lack the intensity and heroic posture of the Vienna *Horse*, which seems rooted in Quattrocento tradition. Nor does any *Horse* by de Vries possess such a luxuriant tail, the like of which we do not find even in Giambologna's figures of *Nessus*. Indeed, the *Horses* of Giambologna and his school have nothing in common with the present statuette.

Italian (Milan?), second half of the sixteenth century

Bronze statuette; hollow cast. The head (from the base of the neck), the right foreleg, probably also the right hind leg, and the tail (from the first curve) are separately cast, sleeved and riveted; some seams and rivets are clearly visible under the lacquer, Gray-black lacquer; brown patina. Height 31.9 cm.
Inv. no. Pl. 5772.

PROVENANCE

Possibly in the possession of Archduke
Leopold Wilhelm. Inventory of the art collec-
tion of Archduke Leopold Wilhelm of 1659
in Vienna, p. 447, no. 125 "Ein schwarczes,
von Metal gegossenes Rosz auf einem
schwarczten Postament von Ebenholcz. Von
dem de Fries Original. 1 Spann 2 Finger hoch
unndt lang." (Berger 1883, p. CLXIX). The
further disposition of the statuette within the
imperial collections in Vienna cannot yet be
reconstructed with certainty. Probably one of
the four *Horse* statuettes illustrated in the 1735
Prodromus on plate 30 (Zimmermann 1888).
Unlike other pieces from the collection of
Leopold Wilhelm, the statuette does not
seem to have been taken over by the Imperial
Treasury, but to have entered the Gallery in
the Upper Belvedere. In any case, the *Horse*
statuette was transferred to the Cabinet of
Coins and Antiquities in 1802, then transfer-
red to the Ambras collection in the Lower
Belvedere, and finally with the entire Ambras
collection to the Kunsthistorisches Museum in
1891.

BIBLIOGRAPHY

Müntz, E. 1891, II, p. 792.
von Schlosser, J. 1901, p. 12, Plate XV/2.
von Schlosser, J. 1910, p. 4, Plate X/2.
von Schlosser, J. 1913/14, pp. 120, 121,
 Fig. 48.
Übersicht 1916/17, pp. 188, 189, Room XXIV,
 Case 1, No. 13.
Planiscig, L. 1924, p. 138, No. 237.
Bertaux, E. 1929, p. 64, No. 454.
Weihrauch, H.R. 1967, p. 358.
Larsson, L.O. 1969, p. 11, Fig. j.
Larsson, L.O. 1970, p. 174.
Leithe-Jasper, M. 1973, No. 71.
Leithe-Jasper, M. 1976, pp. 110, 111, No. 157.

Leithe-Jasper (1973 and 1976) therefore supposed the work to have
originated in Milan, not Florence. A rearing *Horse*, sold in Paris in 1984 and
signed by Adriaen de Vries, is perhaps more similar to the Vienna *Horse*
than any others by that artist, so far as is known. However, it has not been
possible to compare them directly, or to compare the details of the casting
technique. The comparison might settle for certain whether de Vries can be
regarded as a possible author of the Vienna statuette, too. Much too little is
known of de Vries's activity in northern Italy, where he worked for a time
after leaving Giambologna's workshop; and it is only in that early period
that his authorship seems conceivable, as his later works increasingly show a
dissolution of form by "painterly" modeling, which is quite out of keeping
with the Vienna statuette.

The Archduke Leopold Wilhelm possessed two other statuettes of *Horses*
by de Vries, both with light-colored patina, and also a fine *pietradura* table
with a bronze foot by de Vries representing Ganymede with Jupiter's eagle;
formerly in the collection of Rudolf II, this was destroyed in the Brussels
palace fire in the eighteenth century. However, as other inventory entries
show, the Archduke was not always certain whether his bronze statuettes
were de Vries's work or not.

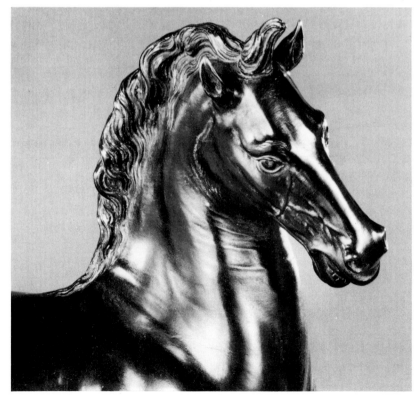

Pacing horse, detail of head

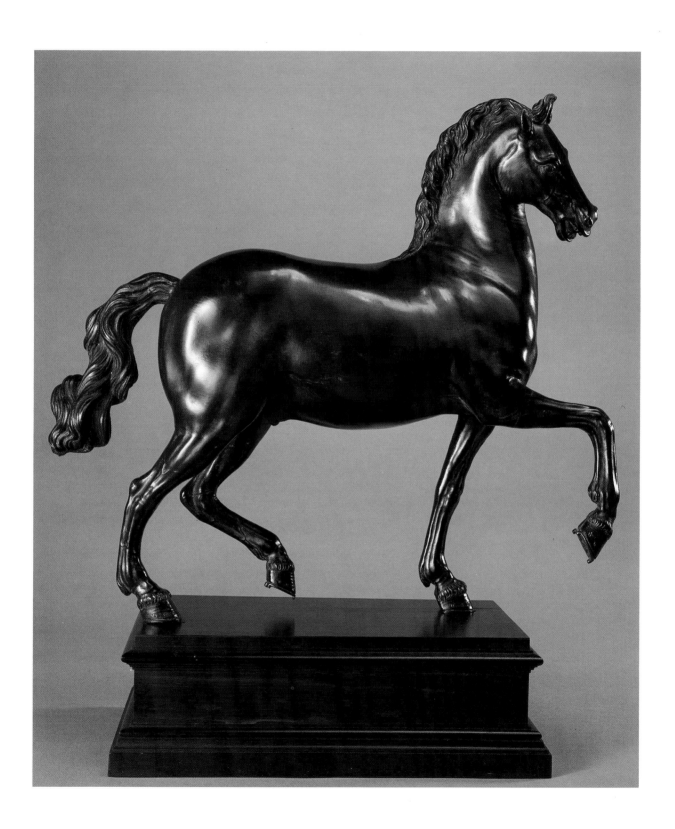

65. Archduke Leopold Wilhelm on horseback

Florentine(?), mid-seventeenth century

Bronze group; thin-walled cast. The horse and rider are cast separately and riveted together at the saddle-cloth. Also separately cast are the lower end of the sash and the Archduke's head and short linen collar trimmed with lace. The accessories, such as the marshal's baton, harness, reins, check-strap and stirrup, are cast separately and mounted. A crack on the right elbow. Remains of original orange-brown lacquer; greenish-brown patina.
Height 38.7 cm.
Inv. no. Pl. 6002.

PROVENANCE
Collection of Archduke Leopold Wilhelm. First documented in the painting by David Teniers, dated 1652, showing the Archduke's gallery in Brussels: the statuette can be seen on the table next to the window. Listed in the inventory of the collection of Archduke Leopold Wilhelm in Vienna, 1659, "Vernaichnusz der steinenen, metallenen Statuen, anderer Antiquitäten vndt Figuren: fol. 440', Nr. 50. Ein klein Stückhl Ihrer ertz-herzoglichen Durchleucht Leopoldi Wilhelmi Contrafait gantzer Postur zu Pferdt in Metall gegossen mit dem Generalstab in der rechten Handt. Auf einem viereckhendten Postament von Ebenholcz, 1 Spann 9 Finger hoch." (Berger 1883, Reg. 495, p. CLXVII). From the Stallburg it was transferred to the Belvedere, then from the Belvedere to the Cabinet of Coins and Antiquities, and then, at an uncertain date, to the Imperial Treasury in Vienna where it is documented with certainty from 1826 in an inventory (p. 105, "Sechster Kasten auf der Höhe, Erzherzog Wilhelm."). In 1871 transferred to the Ambras collection in Vienna and transferred with the entire collection to the Kunsthistorisches Museum in 1891. (The ebony base clearly showing the inventory-number 50 of the collection of Archduke Leopold Wilhelm, which was mentioned by H.J. Hermann in 1927, has been replaced and seems no longer to exist.)

This is an equestrian statue of the Archduke Leopold Wilhelm (1614–62), younger brother of the Emperor Ferdinand III and Governor General of the Habsburg Netherlands from 1646 to 1656, also Bishop of Passau, Strasburg, Olmütz (Olomouc), Breslau (Wroclaw) and Halberstadt, an outstanding commander and one of the most notable art collectors of the house of Habsburg. He is in full armor, wearing the sash of the military commander and with a baton in his right hand. The armor is basically typical of the middle decades of the seventeenth century, but has some elements of the artist's invention such as the lions' heads on the pauldrons and the mask on the breastplate. Under the sash, the Archduke wears on his breast the cross of the Grand Master of the Teutonic Order of Knights, a dignity to which he was appointed in 1641. The horse is pacing quietly, with its left foreleg and right hindleg raised and its head slightly bent to the left. With small variation and some simplification, this is the type of horse used by Giambologna's workshop for the statuette of Philip III of Spain at the Löwenburg in Kassel or that of Henri IV of France in the Musée des Beaux-Arts, Dijon (cf Giambologna 1978/79, nos. 160 and 161).

This equestrian statue of Leopold Wilhelm appears in a painting by David Teniers the Younger of the Archduke's gallery in Brussels, dated 1652; there it shows the golden lacquer of which only traces now remain. Schlosser (1910 and 1913/14) attributed the statuette to Gianfrancesco Susini and connected it with the passage in Baldinucci's *Life* of Antonio Susini (editions of 1770 and 1772, vol. XII, p. 204) which says of Gianfrancesco: "Fece più modelli di piccoli cavalli, e talora servissi di quei del Zio [Antonio Susini], e di Giovan Bologna, facendovi sopra le figure co' ritratti di coloro che gli domandavano, e di sì fatte sue opere mandò gran quantità in Lombardia, in Germania, e in Francia a gran prezzi " Subsequent writers have accepted this attribution. It is true that the type of the horse and the separate casting of the horse and rider, and in this case also of the head and body, are in accordance with the procedure of Giambologna's successors; but there seem to be equally strong arguments against Susini's authorship.

Despite the careful execution, and although, as pointed out above, the horse can be related to products of Giambologna's workshop, the horse does not have the impressive physical quality or conciseness of detail that are characteristic of Florentine *Horses*. It is also questionable whether the pectoral cross of the Teutonic Order could have been so accurately reproduced in Florence, at least without a special commission by the Archduke. The lions' heads on the pauldrons of the armor do not seem to be traceable in Florence – we have not yet been able to follow up Schlosser's reference to a similar equestrian statuette of Don Federigo Colonna in the Palazzo Colonna in Rome – but they are very similar to those of the equestrian statuette of *Charles I of England* by Hubert Le Sueur at Ickworth (Avery 1979); however, none of Le Sueur's equestrian statuettes are equal in quality to the present work. Furthermore, the relatively strong idealization of the Archduke's features in the Vienna statuette makes it doubtful that it could be the work of a sculptor belonging to his immediate entourage, such as Jérôme Duques-

BIBLIOGRAPHY
von Schlosser, J. 1910, p. 14, Plate XXXVIII,
 No. 1.
von Schlosser, J. 1913/14, pp. 126.
Übersicht 1916/17, p. 192, Room XXIV, Case
 IV, No. 1.
Planiscig, L. 1924, p. 171, No. 281.
Hermann, H. J. 1927, pp. 257, 258.

Planiscig, L. and Kris, E. 1935, p. 144, Room
 XVII, No. 31.
Montagu, J. 1963, p. 83, Fig. 77.
Leithe-Jasper, M. 1976, pp. 113, 114, No. 165.

ADDITIONAL BIBLIOGRAPHY
Avery, C. 1979, pp. 128–147.

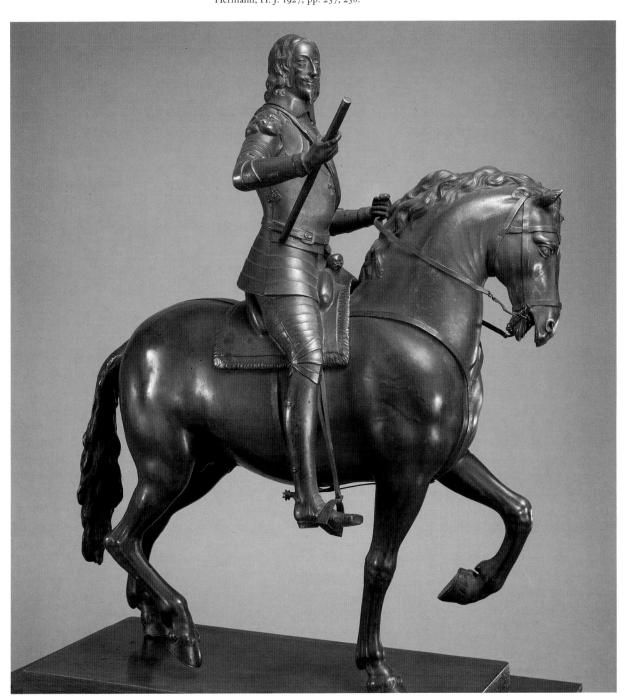

noy. Nonetheless, Duquesnoy's medal of 1647 and his portrait bust of 1650
resemble the equestrian statuette more closely than any other portraits of the
Archduke do. To judge from his apparent age in the statuette, it must have
been made about the the time of his arrival in the Netherlands in 1647. As
noted above, it is first recorded in Teniers's 1652 picture of the Archduke's
gallery.

66a. Emperor Ferdinand III on horseback

Attributed to Caspar Gras

c.1585–1674

(See Biography, p. 280)

Bronze group, hollow cast. The horse and rider riveted or screwed together at the saddlecloth. Each is cast in several parts welded or screwed together. The body of the horse is cast in one piece, including the hindlegs and the forelegs to below the carpus. The rest of the forelegs, the head and base of the neck, the tail and, in some examples, the mask on the horse's breastplate were all cast separately. The rider's body, saddle and saddlecloth form one piece; the head, arms below the shoulder, and large bow of the sash are all cast separately; the head is merely inserted in the neck aperture, and is thus changeable. In addition, all free-hanging or loose accessories – *ie* parts of the harness, the stirrups, the marshal's baton, the sword and sword-belt and the laurel wreath – were separately made and attached. Some are hooked into special eyelets; the stirrups are suspended from under the saddlecloth and down the inner side of the legs. Reddish-brown lacquer, translucent where it is thinner, crazed where thicker and hence opaque; yellowish-brown natural patina.

Height 36.2 cm.

Inv. no. Pl. 6020.

The horse is in a curveting posture with its forelegs in the air, its head turned slightly to the right, its mane and tail waving. The rider stands upright in the stirrups; the padded and quilted saddle rests on a rectangular saddlecloth with a punched ground and a double border. The rider wears armor with scalloped cuisses, knee-pieces and large couters at the joints. His feet and lower legs are covered by riding-boots, the tops of which are concealed by the armor. He wears a polished breastplate with a broad sash across it; this is tied at the back in a great bow, the ends of which are embroidered with lace. His neck is covered by a turn-down linen collar with broad lace trimming, cast in one piece with the torso. The arms are protected by stout pauldrons, scalloped upper sleeves, large elbow-couters, a smooth covering for the forearm, and articulated gauntlets. He holds the reins in his left hand; in his raised right hand is a very long marshal's baton, held against his thigh. The detachable head is crowned by a laurel wreath; the long and slightly wavy hair falls to the neck. The face, softly modeled in large planes, is distinguished by round uplifted eyebrows, a slightly curved nose, an upturned mustache and a Van Dyke beard. The work is very carefully finished.

The physical features show the statuette to be a portrait of the Emperor Ferdinand III at an early age (born 1608; King of Hungary 1625, of Bohemia 1627, of the Romans 1636; Holy Roman Emperor 1637–57).

The group belongs to a series of equestrian statuettes which presumably all represented Habsburgs. Five are now in the Kunsthistorisches Museum, representing: Ferdinand III in youth (the present group, inv. no. 6020); Ferdinand III at a later age (inv. no. 5989); Leopold I in youth (inv. no. 6000); a figure who cannot be identified with certainty – the Archduke Leopold V is probably excluded, and Ferdinand II is not very probable (inv. no. 6025); and Archduke Ferdinand Carl (1628–62) or Siegmund Franz (1630–65), the only example with a black patina (inv. no. 5995). Another statuette, most probably of the Archduke Ferdinand Carl, now in the Victoria and Albert Museum (inv. no. A 16–1960), belonged to the Kunsthistorisches Museum until 1933 (inv. no. 6012). An equestrian statuette in the Statens Museum for Kunst, Copenhagen, is traceable back to 1737 in the inventories of the Royal Danish *Kunstkammer*; the rider's head (detachable, as with all the examples in this group) bears the features of the Archduke Leopold Wilhelm, younger brother of Ferdinand III. This statuette is the only gilt one in the group. H. Olsen (1980) mentions a further equestrian group, sold in Paris on 25 February 1955 (Hôtel Drouot, lot 90) as a likeness of the Duc de Vendôme. At the beginning of this century the Galleria Sangiorgi in Rome offered for sale two very similar riders on identical horses.

In 1984 the National Gallery in Washington was offered a related equestrian group representing either the Archduke Ferdinand Carl or the Emperor Leopold I. However, the horse in this group appears in full gallop, and its pose and the form of the tail resemble less the Vienna group's than Nessus's in a group of *Nessus and Deianira* in the possession of Mr John Lewis in London (*Giambologna* 1978/79, no. 67b). The rider in Washington differs from the Vienna series by wearing over his armor the collar of the Order of

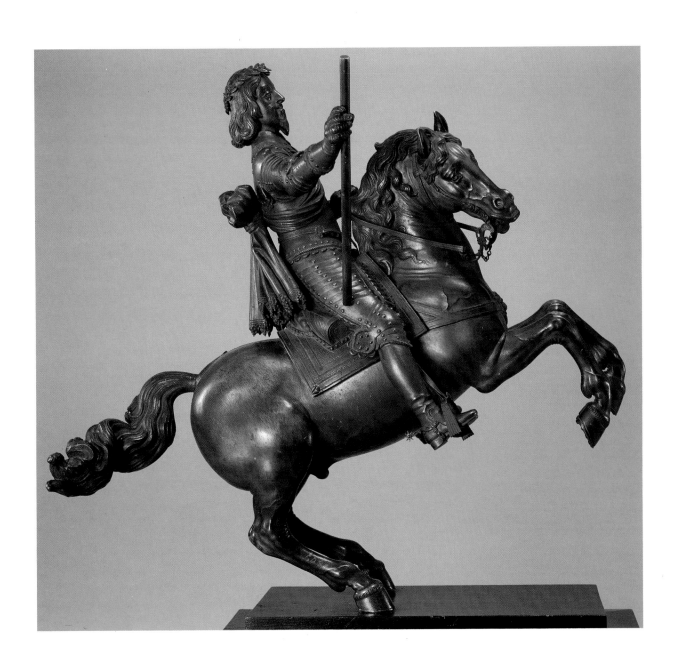

the Golden Fleece, unlike any of the riders in Copenhagen, London, Vienna or Rome. Only one rider in Vienna wears the emblem of the Fleece itself, attached not to the collar but to the riband.

On the other hand, the Fleece collar connects the Washington rider with a young horseman in the Düsseldorf Kunstmuseum (inv. no. 174 P/B 14) and with two others, probably representing Philip IV of Spain and the Emperor Ferdinand III, offered for sale by the Galleria Sangiorgi in Rome in about 1900. However, in these three examples the horse is not curveting but pacing; its tail hangs straight down, and its long mane falls in fine strands to the right.

Of the equestrian portraits with a curveting horse in Vienna, London, Copenhagen and Rome, the horse in each case seems to be cast from the same model: differences are only noticeable in very small details such as the masks or the cartouche on the breast-strap, and in the finishing. On the other hand, no two riders are exactly the same. Type 1 is represented by the present statuette of Ferdinand III (inv. no. 6020) and that of the unidentified Habsburg (inv. no. 6025) and by the riders of the Galleria Sangiorgi. In this type the rider sits in the saddle facing forward; his left arm is bent, his right outstretched and raised shoulder-high. He wears iron gauntlets and jack-boots, also a sash that passes over his left shoulder and under his right arm and is tied in a large bow at the back.

Type 2, a slight variation on Type 1, is represented by the Copenhagen statuette of the Archduke Leopold Wilhelm. The rider faces forward, his left arm bent, the right outstretched at shoulder height. The collar is not attached to the body but to the separately cast head. He wears iron gauntlets but no sash; his boots reach only to the calf and have broad turn-downs.

Type 3 is represented by the statuette of Ferdinand III in later life (inv. no. 5989). The rider is turned to the right, his left arm raised to his chest, the right arm stretched downward. He wears no sash; the narrow turn-down collar is attached to the head, not to the body.

Type 4 is represented by the statuette of Leopold I (inv. no. 6000). The rider generally resembles the preceding type, but his gloves are of leather, not iron (cf Type 6). He wears high riding-boots. The collar is cast with the head, not the body.

Type 5 is represented by the statuette of Archduke Ferdinand Carl in Vienna (inv. no. 5995). The rider is turned to the right; his left arm is raised to his chest, his right somewhat lowered. His sash, with a bow at the back, passes over his right shoulder; he is the only rider to display the Golden Fleece (on its riband). His gauntlets are of iron, his boots knee-length.

Type 6 is represented by the rider in London, formerly Vienna (inv. no. 6012). It corresponds basically to Type 5. However, the rider wears no Golden Fleece. His gloves are of leather, as in Type 4; his turn-down boots reach only to the calf, as in Type 2 (Copenhagen).

Again, while the armor is very similar in all cases, no two are quite alike. The chief variation is in the ornamentation and the form of the *merli* on the steel bands of the armor. The earliest type of armor is seen in inv. no. 6025,

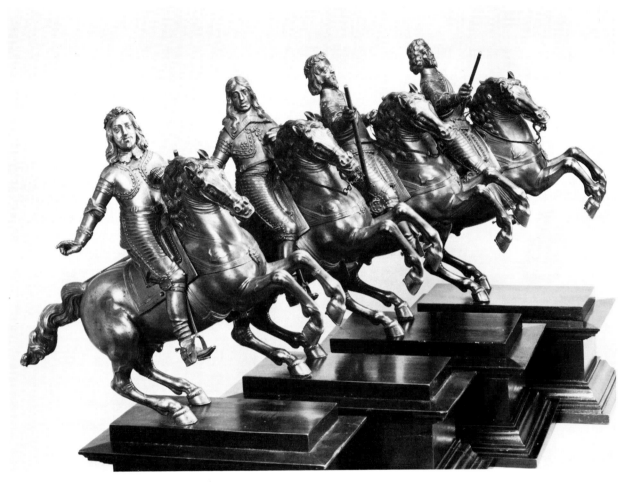

Caspar Gras: group of four riders. From left
to right:
Emperor Ferdinand III, Emperor Leopold I,
Emperor Ferdinand III, unidentified member
of the Habsburg family.
Kunsthistorisches Museum (Inv. Nos. 5989,
6000, 6020, 6025).

PROVENANCE

This equestrian statue of Emperor Ferdinand III is the only one of which the provenance is absolutely certain. It can be traced back to the Imperial Treasury in Vienna in 1750. The Treasury inventory of 1750 compiled by the Treasurer Josef Angelo de France reads: p. 479, "Zwölfter Kasten, auf der Höhe in der Mitte, Ferdinandus III. als König zu Pferd, von pronso." (Zimmermann 1889, Reg. 6253, p. CCCI). The statuette can be traced through all the Treasury inventories up to 1844. In 1871 it was handed over by the Treasury to the Ambras collection in Vienna and was transferred with the entire collection to the Kunsthistorisches Museum in 1891. Inv. no. 6000, *Emperor Leopold I as a Youth*, was in the Treasury, too. However, the compilers of the inventory were not always certain of the identity of the horseman. It is at first incorrectly referred to as Rudolf II, and in 1784 as Archduke Wilhelm (Leopold Wilhelm), then, in 1844, correctly as Leopold I and finally, in the Ambras collection, to which it was transferred, like Ferdinand III, in 1871, it is once again incorrectly described as Archduke Siegmund Franz. Since 1891 in the Kunsthistorisches Museum.

The collection of the Imperial Treasurer Josef Angelo de France contained two equestrian statues (Martini 1781, pp. 78–80, Descriptio Signorum, Super Scrinio VII et VIII, no. 674, "(S. Scrin. VII. nr. 59. Cat. A.n. 318) FERDINANDVS CAROLVS, Archidux Austriae, stemmatis Tyrolensis penultimus, brevi mystace, capillis longis, depexis et intra sese crispantibus, absque laurea, toto corpore armatus, equitans maximo cursu, dextra baculum, sin. gladium tenens. Omnia mores nostros produnt. Aes, 13 3/4 alt. 14 5/8 long. In b. lign. (Est, qui *Gasparum Grasium* operis artificem suspicetur." and no. 683, "(S. Scrin. VIII. no. 73. Cat. A.n. 66c) LEOPOLDVS, vel, quod alii malunt, FERDINANDVS III, mystace ac brevi barba in mento, capillis longis, et infra crispatis, laureatus, ac toto corpore pro superioris seculi more armatus, maximo cursu equitans, d. gladium tenens, s. equum regens. Op. ut videtur ejusdem artificis, qui supra n. 674 confecit. Aes, 13 1/2 alt, 14 7/12 long. In b. lign. aere inducta." The former statuette is probably the version now in the Victoria and Albert Museum (formerly in the collection of Sculpture and Decorative Arts in the Kunsthistorisches Museum, inv. no. 6012); the latter is the statuette of Ferdinand III as an older man (inv. no. 5989). These two statuettes were acquired in 1808 with the de France collection for the Imperial and Royal Cabinet of

the latest in inv. no. 6000 (information kindly furnished by Dr Christian Beaufort-Spontin). However, it is difficult to establish a chronological order from the armor alone, as single elements were freely interchanged.

From what is said above it can be seen that these figures of horsemen were produced in quantity and kept in store; in all probability the heads were executed last, when it was known who was to be portrayed. It is noteworthy, however, how economically the work was organized. For the rider, as we have seen, there were two basic models, one sitting straight and the other turned to the right, with minor variations in the accessories; the horse, on the other hand, is always cast from the same model. Its piece-molds were in each case so correctly prepared for the casting mold that the individual horses scarcely differ from one another even in their interior measurements and details. This economy seems to be pushed to extremes when the bent forelegs of the model are simply replaced by the unaltered outstretched ones on which the animal stands, so that instead of rearing it kicks out. A horse in this modified form formerly in the Lederer collection in Geneva is now in the Getty Museum in Malibu; another was formerly in the Kaiser Friedrich Museum in Berlin (Bode 1930, cat. 173); a third in the Galleria Sangiorgi in Rome, where the horse was combined with a lion attacking it (noted by Weihrauch 1967, pp. 338, 339). A fine example of such a group was sold at Sotheby's in 1967.

The equestrian statuettes are now attributed to the sculptor Caspar Gras in Innsbruck, on the basis of a long tradition which, however, is not absolutely certain. Anton Roschmann (1742) first mentioned Gras's name in this connection, when stating that Count Brandis in Innsbruck possessed an equestrian statuette with interchangeable heads of the Archdukes Ferdinand Carl and Siegmund Franz. The Kunsthistorisches Museum possesses two such heads, probably representing Leopold I and the Archduke Siegmund Franz (see below and cat. 66b). A further interchangeable head is in the collection of Herr von Inama-Sternegg at Schloss Lichtwehr in the Tyrol (Egg 1960, p. 53, and Caramelle 1975, p. 12); this, however, probably represents Leopold I rather than Ferdinand Carl, and is very similar to that of the statuette in the Kunsthistorisches Museum (inv. no. 6000).

Two of the equestrian groups now in the Kunsthistorisches Museum are also connected with Caspar Gras in the 1781 catalogue of the collection of the Imperial Treasurer Josef Angelo de France (Martini 1781, pp. 78–80, nos. 674 and 633, see below), which states: "Est, qui Gasparum Grasium operis artificem suspicetur."

E. von Sacken (1855) wrote *à propos* of one of the equestrian groups that had meanwhile become part of the Ambras collection in Vienna, "said to be by Caspar Gras"; and A. Ilg (1891) connected the whole series with Gras. This view was also followed in the main inventory (1896) of the Industrial Art Collection, now the collection of sculpture and decorative art of the Kunsthistorisches Museum.

Schlosser, however (1910 and 1913/14), attributed the statuettes to Giovanni Francesco Susini, having in mind Baldinucci's statement in his *Life*

of the artist: "Fece più modelli di piccoli cavalli, e talora servissi di quei del Zio [Antonio Susini], e di Giovan Bologna, facendovi sopra le figure co' ritratti di coloro che gli domandavano, e di sì fatte sue opere mandò in quantità in Lombardia, in Germania, e in Francia a gran prezzi."

Planiscig (1924 and later) followed Schlosser's view, which was also accepted by Radcliffe (1966). Egg (1960) first reverted to the old ascription to Caspar Gras, connecting it with Gras's monumental equestrian figure of the Archduke Leopold V (1630). He was followed by Weihrauch (1967), Caramelle (1972), Koch (1975/76), Leithe-Jasper (1976 and 1978/79), and Olsen (1980).

The statuettes certainly belong to a type that originated among Giambologna's followers in Florence but ultimately goes back to Leonardo's designs for a monument to Giangiacomo Trivulzio. Radcliffe (1966) rightly observed that, within Giambologna's œuvre, the inspiration for the Vienna groups was to be found not so much in any particular model of a horse, but rather in his Nessus in the groups of *Nessus and Deianira*, while the motif could have been suggested by Pietro Tacca's designs for the equestrian statues of Philip IV of Spain and Carl Emmanuel of Savoy. Also, as far as can be ascertained, Tacca's workshop was the first to introduce the practice of making models for equestrian statues with interchangeable horses, riders and heads; this, Baldinucci tells us, was also the practice of Francesco Susini.

However, the statuettes cannot easily be related stylistically to those works that are today ascribed with confidence to Susini; nor can they be definitely excluded from his œuvre on stylistic grounds. One reason for assigning them to Susini's workshop might be the fact that scarcely any of the riders wear the Golden Fleece. Caspar Gras would certainly have been acquainted with the Habsburg family Order, whereas Susini worked for an international clientèle, not all of whom were members of it.

On the other hand Caspar Gras would certainly have been capable of making such statuettes, as is sufficiently proved by his monumental equestrian statue of the Archduke Leopold V in Innsbruck (1622–31). This could not have been created without some knowledge of contemporary Florentine work; but it is the first example, and before Tacca, of a monumental sculpture of a rider on a curveting horse. (There is no basis for E. Tietze-Conrat's assertion (1918) that the horse could not be Gras's work.) The court of Innsbruck had close family relations with that of Florence: the Archduke Leopold married Claudia, daughter of Ferdinando I de' Medici, and Leopold's son Ferdinand Carl married Anna, daughter of Cosimo II de' Medici. Artistic relations between the two courts are proven for painting, and may be examined for sculpture. Inventories of the Innsbruck collection mention works by Giambologna's school, though admittedly none of the equestrian statuettes.

Even though the type of horse in the present equestrian group differs slightly from that in the Leopold fountain, it is similar enough to be quite possibly the work of Caspar Gras. Leopold V wears trunk-hose and a cart-wheel ruff in the fashion of 1625–30. But taking into account the dates of

Coins and Antiquities and transferred in 1824 to the Ambras collection. They entered the Kunsthistorisches Museum in 1891 together with the two statuettes from the Treasury and the entire Ambras collection. Another two statuettes as well as two unattached heads in the *Kunstkammer* of the Prince-Archbishops of Salzburg are described in *Inventarium über verschiedene Seltenheiten aus Steinarten, Erde, Bronze, Bein und dergleichen, dann anderer Gegenstände, welche bisher in der sogenannten großen Gallerie im Residenzgebäude in Verwahrung waren, vom 15. Juny 1805*, under the entry no. 230 as follows: "2 Metalle, vermuthlich Herzoge zu Pferd, mit dem Kommandostabe. 1 Schuh hoch, mit besonderen zweyen Köpfen zum Aufstecken gerichtet". After the secularization of the archbishopric they were transferred in 1806 to the Imperial and Royal Cabinet of Coins and Antiquities in Vienna and from there in 1824 to the Ambras collection. All six equestrian groups reached the Kunsthistorisches Museum together with the Ambras collection in 1891. It may be noted that, so far, none of the above mentioned or similar statuettes can be traced in the inventories of the art collections at Schloss Ambras near Innsbruck or at the Hofburg itself. The uncertainty surrounding the history of provenance may be due not only to the insufficient description in the inventories but also to the fact that the statuettes have interchangeable heads and that these were apparently changed around during the frequent relocations of the statuettes, the last occasion being noted by Planiscig (1924).

BIBLIOGRAPHY

Roschmann, A 1742, pp. 45–47.

Baldinucci, F. 1688 (1770), x, p. 204.

von Sacken, E. 1855, p. 82.

Ilg, A. 1891, p. 230, Room xxiva, Nos. 12, 18, 24, 25, 42 and 47.

von Schlosser, J. 1910, p. 14, Room xxxviii/2.

von Schlosser, J. 1913/14, pp. 119–128.

Übersicht 1916/17, p. 192, Room xxiv, Case iiv, No. 62.

Tietze-Conrat, E. 1918, pp. 69–71.

Peltzer, R.A. 1921, pp. 523–524.

Planiscig, L. 1924, pp. 170–174, No. 280 (with incorrect inventory number and a different head) and Nos. 278, 279, 282 and 283.

Planiscig, L. and Kris, E. 1935, p. 124, Room xx, Nos. 24 and 25 (Inv. No. 5989 and 6025).

Weihrauch, H.R. 1943/44, pp. 105–111.

Egg, E. 1960/61, pp. 53, 54.

Egg, E. 1964, p. 745.

Radcliffe, A.F. 1966, p. 93.

Weihrauch, H.R. 1967, pp. 338, 339.

Caramelle, F. 1972, pp. 220–222.

Caramelle, F. 1974/75, p. 22.

Koch, E. 1975/76, pp. 32–80.

Leithe-Jasper, M. 1976, pp. 44–115, Nos. 166 and 167–168.

Leithe-Jasper, M. 1978/79, pp. 245–247, Nos. 163a and 163b–163e.

Olsen, H. 1980, pp. 56–58, Fig. 148.

Seling, H. 1980, Cat. Nos. 586–593.

ADDITIONAL BIBLIOGRAPHY FOR HABSBURG ICONOGRAPHY

Zimmermann, H. 1905, pp. 172–218.

Ebenstein, E. 1906–1907, pp. 183–254.

Heinze, G. 1963, pp. 99–224.

birth of the riders depicted, the statuettes can hardly be dated before 1650; that of Leopold I cannot be earlier than 1655, and the Siegmund Franz cannot be earlier than 1665, the year in which he relinquished holy orders. At that date Francesco Susini was already dead, while Caspar Gras lived till 1674.

The facture, especially the curling strands of the hair, has points of resemblance to Caspar Gras's figures of deities on the fountain crowned by the equestrian statue of Leopold V. While it is not easy to compare the style of a horse with that of a man, or a man in armor with a nude, nevertheless this comparison reveals some common features. Although the riders' identity is not wholly clear, they all appear to be Habsburgs, and the prominence given to members of the Tyrol line, Ferdinand Carl and Siegmund Franz, suggests an Innsbruck origin for the statuettes. So does the small silver statuette of Leopold V (Leithe-Jasper 1978/79, no. 163e), which may be a link between them and the monumental statue. No bronze sculptor in Vienna at that time, as far as is known, would have been sufficiently skilled to make these statuettes.

A comparison of the alloys of all the statuettes might throw light on their provenance. This information is available for two of the Vienna examples (inv. no. 5989: Cu 78.83, Sn 0.83, Pb 4.31, Zn 14.42, Fe 0.83, Ni 0.32, Ag 0.07, Sb 0.19, As 0.20; inv. no. 6025: Cu 83.6, Sn 1.97, Pb 3.44, Zn 9.76, Fe 0.62, Ni 0.43, Ag 0.10, Sb 0.15, As 0.47). The high zinc content indicates that these are cast in brass rather than bronze.

Finally, it has not yet been possible to investigate Schlosser's statement (1910 and 1913/14) that a Medici series of the same type is to be found in the Parma museums, and that similar equestrian groups under the name of Susini are in the Palazzo Corsini in Florence and the Museo Nazionale in that city. It would also be worth following up Tietze-Conrat's reference (1918, p. 72, n. 41) to Augsburg silver cups in equestrian form (*cf* H. Seling 1980, cat. 586–93) for a possible connection with the bronzes.

After Caspar Gras's equestrian statue of Leopold V, crowning the central column of a many-figured monumental fountain in Innsbruck, the next monumental equestrian statue of a Habsburg was one executed for the Emperor Franz I (1745–65) by Balthasar Moll and exhibited in the Burggarten in Vienna. It is evident that Gras did not found any tradition of such statues. So it is all the more interesting that the equestrian statuettes of Habsburgs stand at the beginning of a series of *Saalmonumente* or "indoor monuments", chief of which are Matthias Steinl's three ivory figures of *Leopold I, Joseph I* and *Carl VI* in the Kunsthistorisches Museum.

66b. Unattached head, probably of the Archduke Ferdinand Carl or Siegmund Franz

The head belongs to a full-faced young man with wavy hair reaching to his shoulders. He has a slightly aquiline nose, a somewhat protruding lower lip and a small mustache. His neck is covered by a rectangular turn-down collar in two parts, with a lace border, in the fashion of 1660.

This is an interchangeable head for an equestrian statuette of the type of cat. 66a. As the collar is cast in one piece with the head, it must fit one of the types where the body is not conjoined with a collar, such as Kunsthistorisches Museum, Vienna, inv. no. 5989 or 6000. The identity of the subject is not quite certain, but the features are most like those of the Archduke Ferdinand Carl (1628–62) or his younger brother the Archduke Siegmund Franz (1630–65): sons of Archduke Leopold V and Claudia de' Medici, they were the last male scions of the Tyrol Habsburgs. Another possibility is Ferdinand IV (1633–54), King of the Romans, eldest son of Emperor Ferdinand III and brother of Emperor Leopold I.

A counterpart (inv. no. 6754) probably represents Leopold I. Both heads in all probability come from the *Kunstkammer* of the Prince-Archbishop of Salzburg, though the inventories of that collection do not specifically identify them.

Attributed to Caspar Gras
*c.*1585–1674
(See Biography, p. 280)

Bronze, thick-walled hollow cast. Reddish-brown lacquer and golden-brown patina.
Height 6.9 cm.
Inv. no. Pl. 6753.

PROVENANCE
Kunstkammer of the Prince-Archbishops of Salzburg. *Inventarium über verschiedene Seltenheiten aus Steinarten, Erde, Bronze, Bein und dergleichen, dann anderer Gegenstände, welche bisher in der sogenannten großen Gallerie im Residenzgebäude in Verwahrung waren, vom 15. Juny 1805, no. 230: "2 Metalle, vermuthlich Herzoge zu Pferd, mit dem Kommandostabe. 1 Schuh hoch, mit besonderen zweyen Köpfen zum Aufstecken gerichtet".* In 1806, after the secularization of the Archbishopric, transferred to the Imperial and Royal Cabinet of Coins and Antiquities in Vienna and in 1824 to the Ambras collection in Vienna; transferred with the entire collection to the Kunsthistorisches Museum in 1891.

BIBLIOGRAPHY
Unpublished.

ADDITIONAL BIBLIOGRAPHY
Leithe-Jasper, M. 1976, p. 115, No. 169 (The head mentioned here is still described as that of Ferdinand Carl and not Leopold I). See also bibliography for Cat. No. 66a.

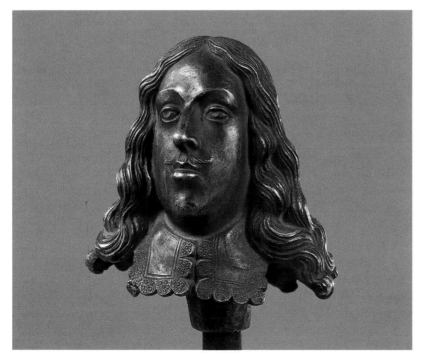

67. Mercury and Psyche

Caspar Gras(?)

*c.*1585–1674

(See Biography, p. 280)

"Bronze" group; hollow cast in brass. The two figures are cast separately and welded together at Mercury's right hand and Psyche's drapery. Mercury's head, and the globe he is standing on, are also cast separately and attached. Cracks on Mercury's left foot and at his right wrist. The wing on his left foot restored and riveted. Psyche's right hand is bent backward. Reddish-brown lacquer; light brown patina. The figure 994 in white on the further side of the globe is the pre-1823 inventory number of the Imperial and Royal Cabinet of Coins and Antiquities.

Height 38.6 cm.

Inv. no. Pl. 5859.

PROVENANCE

Collection of the Imperial Treasurer Josef Angelo de France in Vienna (Martini 1781, p. 27, Descriptio Signorum, Scrinium II. Nr. 222.) "(Ser. I. Cat. A.n. 475) MERCVRIVS, Nympham raptam abducens. Laevo pede in globo stat, dextr. alte sustulit, nymphamque utraque manu amplexus portat. Is praeter petasum alatum, singulasque in pede alas, totus nudus est, haec leuiter vestita. Aes, 14 1/2 als. In b. lign." Acquired in 1808 with the de France collection for the Imperial and Royal Cabinet of Coins and Antiquities, and transferred to the Ambras collection in 1880 and with the Ambras collection to the Kunsthistorisches Museum in 1891.

Mercury, naked except for the *petasus* on his head, seems to be taking off in flight from the globe which forms the base of the group. He is carrying off to Olympus the lightly-veiled Psyche, who by Jupiter's decree is finally to be united in immortality with her lover Cupid.

From ancient times the Psyche of Greek myth was identified with the human soul, while Mercury stood for the mind or wisdom. Thus the group is an allegory of the soul led by wisdom to immortality. In the Renaissance the *Marriage of Cupid and Psyche* had been painted in frescoes in the Villa Farnesina in Rome by Raphael, and the theme became very popular with artists surrounding the court of the Emperor Rudolf II.

Formally the group is an interesting combination of two inventions by Giambologna, the *Flying Mercury* and the *Abduction* group (see cat. 51–52). The composition of Psyche derives from the Deianiras of Giambologna's *Nessus and Deianira* groups and from elements of his two- or three-figure groups representing the *Rape of a Sabine* woman. In the present work, however, the artist is not seeking to narrate a dramatic event but to express harmony and unison: thus the parallel movements of Mercury and Psyche are reminiscent of a pair of figure skaters in modern times.

The additive, somewhat eclectic composition shows the artist to have been well acquainted with Giambologna's work but not to be a direct pupil of his.

Schlosser (1910) classified the group as by an "Italo-Netherlandish artist, close to Giambologna", connecting it with the bronze groups of *Hercules, Nessus and Deianira* and *Mars, Venus and Cupid* which he attributed to Pietro Francavilla but which are now acknowledged to be the work of Hubert Gerhard. Vollmer (1916) agreed with Schlosser's view. Tietze-Conrat (1917) classified the *Mercury and Psyche* group as Florentine, close to Giambologna's circle. Brinckmann was the first critic to propose Adriaen de Vries as the author: he did so with reserve in 1919 and firmly in 1923. Bange (1923) agreed to the extent that he regarded the group as a studio product. Planiscig (1924 and 1935) reverted to Schlosser's attribution to Pietro Francavilla, while Vollmer, who had previously followed this view, in 1940 adopted that of Bange. Larsson (1967) rejected the authorship of Adriaen de Vries. Weihrauch (1967) endorsed the view of Schlosser and Planiscig, while de Francqueville (1968) reserved judgement. Leithe-Jasper (1973 and 1976) followed Planiscig, though with some reserve, while Balogh (1975) favored de Vries. Finally Leithe-Jasper (1978) for the first time tentatively proposed Caspar Gras.

There are both stylistic and technical arguments in favor of Caspar Gras. He was active at the court of Innsbruck, which was closely related to that of Florence by family and artistic ties. There is a particular resemblance between the present group and a *Nessus and Deianira* in the John Lewis collection in London (*Giambologna* 1978–79, pp. 159, 160, no. 67b), which in turn may be compared with Gras's equestrian statuettes (cat. 66) and also with his figures on the Leopold fountain in Innsbruck. From the technical point of view the fact that the *Mercury and Psyche* group consists of parts cast separately and joined together is significant: this seems to have been a characteristic

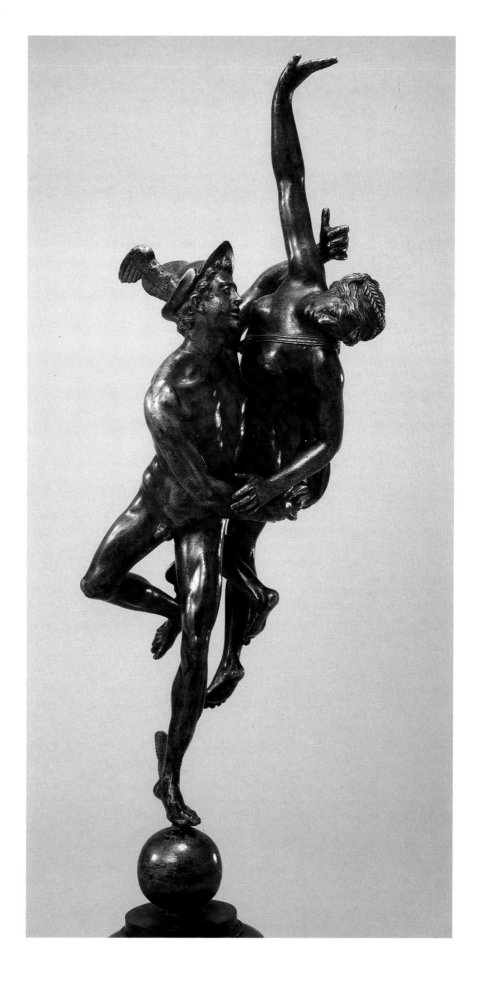

BIBLIOGRAPHY

von Frimmel, T. 1883, p. 59, No. 960.
von Schlosser, J. 1910, pp. 12, 13, Plate
 XXIV/3.
Vollmer, H. 1916, p. 385.
Tietze-Conrat, E. 1917, pp. 27, 28.
Brinckmann, A.E. 1917, I, p. 169.
Brinckmann, A.E. 1923, p. 35, No. 74.
Bange, E.F. 1923, pp. 36, 37, No. 7980.
Planiscig, L. 1924, pp. 206, 207, No. 332.
Planiscig, L. and Kris, E. 1935, p. 136, Room
 XVI, No. 20.
Vollmer, H. 1940, p. 573.
Strohmer, E.V. 1947–1948 (1950), p. 137,
 No. 114.
Larsson, L.O. 1967, pp. 15, 16.
Weihrauch, H.R. 1967, p. 231.
de Francqueville, R. 1968, pp. 112, 113.
Leithe-Jasper, M. 1973, No. 97.
Balogh, J. 1975, p. 206, No. 291.
Leithe-Jasper, M. 1976, p. 88, No. 87.
Leithe-Jasper, M. 1978, pp. 145, 146, No. 59b.

practice of Gras's, and can also be seen in his equestrian statuettes.

The Museum of Fine Arts in Budapest possesses a replica in which Psyche's right hand is not bent back, so that the height of the bronze is slightly greater (Balogh 1975). A *Mercury and Psyche* group nearly twice as large, of which there are variants in the Bode Museum in East Berlin, in the Louvre in Paris and in the Hermitage in Leningrad (*cf* Bange 1923, no. 75), resembles the Vienna and Budapest group but is not by the same hand. It is certainly not, as Bange thought, by Adriaen de Vries, but rather belongs to the circle of Hubert Gerhard; this again goes to explain the stylistic affinity with Caspar Gras, who was a pupil of Gerhard's.

68. Warbler

The bird is about to take flight. Its wings are opened and its tail feathers raised; its head is turned upward to the left and its beak is open. The figure belongs to a group of seven, small birds of different species, first mentioned in the posthumous inventory (1596) of Archduke Ferdinand II, where they are referred to as a group of five plus two individual pieces. At least from the time of the 1788 inventory of the *Kunstkammer* at Schloss Ambras near Innsbruck, the birds were attached to a composite tree-trunk of bronze, cast from nature and resembling a mountain. This work, without the birds, is already mentioned in the Ambras inventory of 1596 and is still in the Kunsthistorisches Museum (Planiscig 1924, no. 369). Whether the birds themselves were cast from life is uncertain, but they are very accurately observed. They bear some resemblance to the birds fluttering among vine-leaves round the twisted columns of the monument to Archduke Maximilian III in Innsbruck Cathedral, completed in 1619. The architectural parts of the monument are certainly the work of Caspar Gras. The resemblance was probably noticed by Alois Primisser, custodian of the Ambras collection in Innsbruck and Vienna, who in his inventory of 1821 attributed the tree with the birds to Caspar Gras, a view followed by all subsequent writers.

However, it has hitherto been overlooked that both the birds and the tree-trunk already belonged to the Archduke Ferdinand II at Ambras, at a time when Caspar Gras was not yet living at Innsbruck; he was in fact still a lad, and not yet working as a sculptor. Egg (1961) expressed the view that the birds were by Caspar Gras but were studies for those on the monument to Maximilian III. This view, if appropriately modified, gains in significance, as Caspar Gras probably saw these small bronzes at Ambras and modeled his own work on them.

Florentine, end of the sixteenth century

Bronze statuette; hollow cast, but the core not removed; a core support pin visible on the left and right of the bird's belly. The feet separately cast and attached. Greenish-brown patina.
Height 5.9 cm.
Inv. no. Pl. 5756.

PROVENANCE
From the *Kunstkammer* of Archduke Ferdinand II at Schloss Ambras near Innsbruck. First mentioned in the inventory of 1596, fol. 422. "Dreizehend casten, darinnen allerlai metallene pilder, Auf der vierten Stell: Ain von metall gossens vögele, steht auf dem lingen fuesz und helt den rechten uber sich. Mer ain metales vögele ohne fuesz.", fol. 423′ "funf steende gegossne vögelen.", fol. 427′ "Auf der sechsten Stell: Mer ain metal, gegossen wie ain perg." (Boeheim 1888, Reg. 5556, p. CCXCVIII–CCC). Ambras inventory of 1666, fol. 31′ "Vierter Caßten, Nr. 4., Darinnen allerlay metalene pilder, Auf der vierten Stöll: Siben gegoßne vögl, darunte ainer ohne fueß", fol. 38′ "Auf der sechsten Stöll: Mehr ain metal gegosßen wie ain perg."
Inventory of the *Kunstkammer* at Schloss Ambras of 1788, p. 127, case VIII, no. 170, "Ein Berg, worauf allerhand Bäume und gestümmelten Ästen stehen. Darauf sind 8 Stück Vögel, welche eigentlich nicht zu dem Berg gehören, sondern mit Draht an die Äste der Bäume festgebunden sind; darunter hat einer keine Füße, der oberste, der auf dem Gipfel sitzt, breitet die Flügel etwas aus, und hält has Maul offen, und ein gar kleiner, von plumperer Arbeit ist unten hohl. Alles von Erz, zusammen 16 Zoll hoch."
Again, the inventory of 1811 lists only seven birds on the mountain.
Transferred in 1821 from Schloss Ambras to the Ambras collection in Vienna. 1821 inventory of the Ambras collection in Vienna, p. 359, no. 259, "Ein Baumstrunk, worauf 7 Vögel stehen. Von Metall gegossen. Eine Arbeit von Kasper Gras".
Transferred with the Ambras collection to the Kunsthistorisches Museum in 1891.

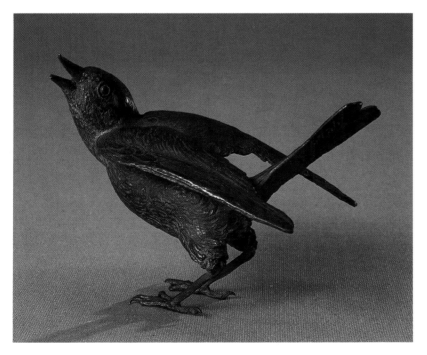

BIBLIOGRAPHY

von Sacken, E. 1855, p. 96.

Ilg, A. and Boeheim, W. 1882, p. 86, Room
v, Wall cabinet 5, No. 43.

Ilg, A. 1891, p. 221, Room XXIV, Case 2,
Nos. 18, 31, 33, 87, 89 and 91.

Peltzer, R.A. 1921, p. 524.

Planiscig, L. 1924, p. 229,
Nos. 369–374, particularly No. 373.

Planiscig, L. and Kris, E. 1935, p. 127, Room
XV, No. 35.

Weihrauch, H.R. 1956, pp. 160, 161,
Nos. 196, 197.

Egg, E. 1961, p. 37.

Montagu, J. 1963, p. 91, Fig. 99.

Pope-Hennessy, J. 1965, p. 149, No. 549.

Weihrauch, H.R. 1967, p. 338.

Caramelle, F. 1972, pp. 208–211, and Cat.
No. 51.

Leithe-Jasper, M. 1976, p. 108, No. 151.

But it is not at all certain that the bronzes originated in Innsbruck. The alloy seems untypical of Innsbruck, as it contains no zinc. The bronzes bear no resemblance to the products of the earlier Innsbruck foundry, and are most probably of Florentine origin. It is perhaps a further argument for their Florentine origin that such birds are also to be found in Italian collections. We know, in any case, that Antonio Susini, and later his nephew Francesco Susini, also made animal bronzes of the smallest size.

Weihrauch (1967) and Caramelle (1972) regard these small bronze figures of birds as merely *Kunstkammer* pieces. They might, however, have stood originally on the marble parapets of fountain pavilions in the gardens of the Hofburg at Innsbruck or at Schloss Ambras. It is not clear whether the tree-trunk and the birds originally belonged together, as the birds were only fastened to the trunk with wire. Since they are still mentioned separately in the 1666 inventory, the idea of combining them into a single composition would seem to be a very late example of *style rustique* and of the nostalgic taste exhibited in Ferdinand II's collection of works of art and curiosities at Ambras.

In addition to the set of seven birds in the Kunsthistorisches Museum there is a single example which was acquired in 1880, not from Ambras but from the Imperial and Royal Cabinet of Coins and Antiquities. There are also two in the Bayerisches Nationalmuseum, two in the Museo Nazionale del Bargello in Florence, one in the Museo Nazionale di Capodimonte in Naples, and one in the Kress collection in the National Gallery in Washington.

69. Nereid

The nereid is depicted as a seated young woman; her legs, terminating in fishtails, are crossed over each other. The end of the right-hand tail is brought up over her left shoulder, while the left-hand one is drawn up beside her right hip. Her arms are in the shape of wings resembling fins. Her head leans slightly back, and she is gazing wistfully upward. Long wavy hair falls on to her neck and shoulders.

The small, dainty statuette is finished with great care. Delicate file-marks follow every curve of the body, and the grooves of the tail fins are, in addition, hammered with a fine punch. It is not clear whether the work served a practical or merely an ornamental purpose. A slightly varied replica of gilt bronze, and a pendant representing a *Triton* (with E. Lubin, New York, in 1985), have round holes on the wings, probably for screws, suggesting that this pair at least was intended to decorate the corners of a piece of furniture.

The statuette was mentioned in the literature from a relatively early date and gave rise to the most varied and contradictory opinions of its authorship and place of origin. Schlosser (1901 and 1910) classified it as Venetian, end of the fifteenth century. Bode (1907) agreed that it was Venetian but dated it around 1570. Unaccountably, both critics associated it with bronzes that clearly belong to the early Italian Renaissance: Schlosser with the *Venus* (cat. 33), and Bode with the *putto mictans* (cat. 6).

Planiscig (1924) also assigned the statuette to Venice but dated it to the end of the sixteenth century. Pechstein (1968) agreed with the view then held by

Attributed to Caspar Gras
*c.*1585–1674
(See Biography, p. 280)

Bronze statuette; hollow cast. A large irregular opening on the underside; some flaws and cracks, especially on the fishes' tails. Traces of reddish-brown iron-oxide (?) lacquer under dark-brown lacquer; brown patina. The figure 795 in white on the back of the right wing is a pre-1823 inventory number of the Imperial and Royal Cabinet of Coins and Antiquities.
Height 10.2 cm.
Inv. no. Pl. 5669.

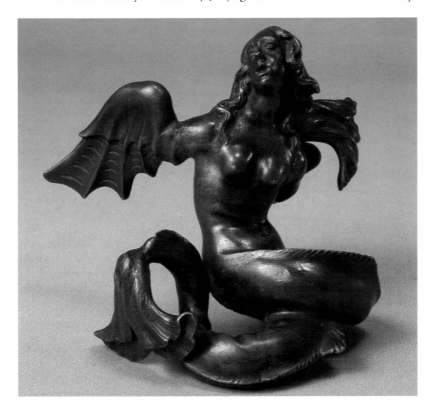

PROVENANCE

Collection of the Imperial Treasurer Josef
Angelo de France in Vienna. (Martini 1781,
p. 62 Descriptio Signorum, Scrinium VII, no.
549, "(Ser. 3. Cat. A.n. 988) NEREIS, vultu
dolorem significante; duos in pisces desinens,
et alas pro brachiis habens. Pisces sese decuss-
ant, et eorum alterius cauda circa alam unam
voluitur. Op. prob. Aes, 3 7/8 alt. 4 1/2 long.
et 3lat." Acquired in 1808 with the de France
Collection for the Imperial and Royal Cabinet
of Coins and Antiquities, and transferred in
1880 to the Ambras collection and with this
collection to the Kunsthistorisches Museum in
1891.

BIBLIOGRAPHY

Ilg, A. 1891, p. 220, Room XXIV, Case 2,
 No. 4.
von Schlosser, J. 1901, p. 13, Plate XX, No. 3.
Bode, W. 1907, II, p. 24, Plate CLXVII.
von Schlosser, J. 1910, p. 2, Plate IV, No. 3.
Planiscig, L. 1924, p. 127, No. 321.
Planiscig, L. and Kris, E. 1935, p. 136, Room
 XVI, Case 18, No. 8.
Pechstein, K. 1968, Nos. 119, 120.
Caramelle, F. 1972, pp. 226–227.
Caramelle, F. 1974, p. 14.
Leithe-Jasper, M. 1976, p. 90, No. 92.
Bode, W. and Draper, J.D. 1980, p. 103,
 Plate CLXVII.
Lubin, E.R. 1985, No. 38.

Leithe-Jasper that the statuette was not from Venice but was more probably by the Innsbruck artist Casper Gras. Caramelle (1972) endorsed this attribution, which Leithe-Jasper repeated in 1976.

The statuette indeed shows some points of resemblance to the bronze figures of female deities on Caspar Gras's Leopold fountain at Innsbruck and to other works attributed to him. However, Pechstein's comparison of the statuette with two *Sirens* in the Berlin Kunstgewerbemuseum is not very convincing.

The male counterpart of this replica, which appeared recently on the New York art market, bears much less resemblance to works by Caspar Gras, and it therefore seems necessary to reconsider the attribution of the *Nereid*. Compared to bronzes that are known to be by Gras, the modeling both of the *Nereid* and of the companion figure is much smoother and the details less graphically rendered. These statuettes are more reminiscent of the *œuvre* of Ferdinando Tacca, which has only recently been reconstructed thanks to the researches of Montagu and Radcliffe; at all events some investigation in this direction is desirable. The *Nereid* with her oval face and flowing hair, her open mouth and wide-open eyes with their longing, almost suffering expression, and likewise the *Triton* with his elegant beard, can be compared with figures on Tacca's great antependium in Santo Stefano in Florence and with several of his bronze groups. Moreover some technical details, such as the delicate punching on the tail fins, are characteristic of Tacca and cannot be attested in Gras's work in this form.

However, it must also be borne in mind that at the time when Caspar Gras worked for the court at Innsbruck there were close family ties with the court of Florence. If only for this reason Gras must have been acquainted with the work of Florentine artists, and he may have seen sculpture by his contemporary Ferdinando Tacca in the Innsbruck collections.

70. Triton with a fish

The triton, a kind of merman with legs in the form of fishes' tails, kneels on his curled-up extremities, holding in both hands the fish of huge proportions that he is carrying on his back. The fish's mouth is wide open. Its mighty form and smooth modeling contrast with the more detailed, differentiated modeling of the triton.

Following Niccolò Tribolo's work for the Medici villa at Castello near Florence, such *Tritons* often featured as fountain ornaments. The motif was used by Montorsoli, Stoldo Lorenzi, Giorgio Vasari and others. Hence this small decorative bronze is probably Florentine of the latter half of the sixteenth century, rather than Venetian *c.*1575 as Bode thought (1906–12), or, as Planiscig (1936) thought, by Leone Leoni. Draper (Bode and Draper 1980) believed it to be Netherlandish, early seventeenth century. The fish's mouth is wide open for use as an inkwell.

Florentine(?), second half of the sixteenth century

Bronze group; hollow cast. The triton and fish are cast separately, so are the fish's fins. Large apertures in the *Triton's* rump and back; a casting flaw on his right upper arm. Black lacquer, dark brown patina.
Height 14.6 cm.
Inv. no. Pl. 9122.

PROVENANCE
Collection of Gustav von Benda, Vienna. In 1932 bequeathed to the Kunsthistorisches Museum by Gustav von Benda.

BIBLIOGRAPHY
Bode, W. 1906–1912, II, p. 24, Plate CLXVI.
Planisicig, L. and Kris, E. 1936, p. 14, No. 62.
Bode, W. and Draper, J.D. 1980, p. 103, Plate CLXVI.

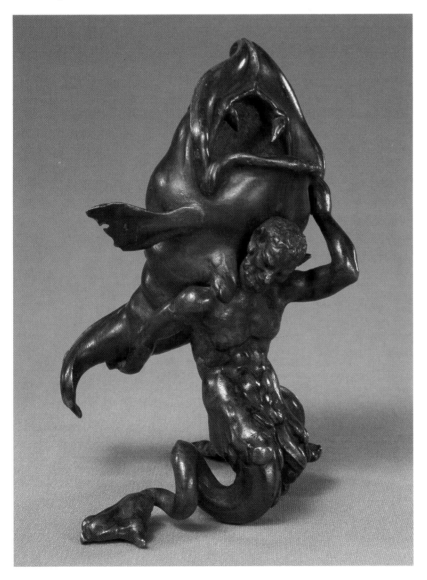

71. Two horses gamboling

Attributed to Hubert Gerhard

*c.*1550–1622/23

(See Biography, p. 280)

Bronze group; hollow cast in yellow metal. The horses were apparently cast separately and welded together at the belly, while the hind legs of the rearing horse are attached to the ground below the horse lying on its back. The divisions of the piece-molds can be seen on the horses' bodies. The right foreleg of the rearing horse is broken below the carpus. Broken-off sections have been repaired with solder on the ground between the tail of the recumbent horse and the right foreleg of the rearing horse, also between the former's mane and the latter's right foreleg. Reddish-brown lacquer, much abraded on the high points, revealing a light brown patina. The ground is covered naturalistically with a coating of grayish-green oil paint, under which golden-yellow bronze can be seen. The figure 745 in white, on the ground next to the mane of the recumbent horse, is a pre-1823 inventory number of the Imperial and Royal Cabinet of Coins and Antiquities.

Height 38.2 cm.

Inv. no. Pl. 6005.

A stallion lies on its back on an undulating patch of ground; its mouth is open and its legs stretched upward. Another stallion, in a rearing attitude, is jumping over it. The dramatic effect is enhanced by the waving manes and tails of both horses and their excited expressions, with open mouths, bared teeth, protruding lips and flaring nostrils. They are not fighting, however, but appear to be playing boisterously. The composition is remarkably naturalistic, as are the details including the nailed horseshoes.

The casting and afterworking show great care. Delicate file marks cover the bodies of both horses, closely following every curve of the surface. The grooves of the mane and tail are chased with care though by no means schematically; the joints are hammered. Altogether the work is a *Kunstkammer* piece of the highest standard.

Ilg (1891) and Schlosser (1910) supposed the group to be from Giambologna's workshop. Brinckmann (1921 and 1923) attributed it to Hubert Gerhard. Planiscig (1924) classified it as "South German, first half of the seventeenth century" and "probably related to the frequently encountered bronze imitations and variants of the ancient marble group on the Capitol in Rome, which are cited in Baldinucci's list of Giambologna's works"; later (1935) he too named Gerhard as the author. Weihrauch (1967) also followed Brinckmann in ascribing the work to Gerhard, but unfortunately could not carry out his intention of publishing a monograph of this artist. Leithe-Jasper (1976) at first agreed with this attribution but later questioned it (1978/79). The observation that the group must have been inspired by products of Giambologna's workshop is certainly correct. But it seems far too dramatic for Giambologna, and unusually so for Hubert Gerhard.

PROVENANCE

Kunstkammer of the Prince-Archbishops of Salzburg. *Inventarium über verschiedene Seltenheiten aus Steinarten, Erde, Bronze, Bein und dergleichen, dann andere Gegenstände, welche bisher in der sogenannten großen Gallerie im Residenzgebäude in Verwahrung waren, vom 15. Juny 1805*, no. 231: "1 Gruppe zweyer spielender Pferde, 1 Schuh hoch." In 1806, after the secularization of the Archbishopric, transferred to the Imperial and Royal Cabinet of Coins and Antiquities in Vienna and thence to the Ambras collection in Vienna in 1880 and with the entire collection to the Kunsthistorisches Museum in 1891.

BIBLIOGRAPHY

von Sacken, E. and Kenner, F. 1866, p. 480, No. 14.
Ilg, A. 1891, p. 231, Room XXIVa, No. 29.
von Schlosser, J. 1910, p. 13, Fig. 10.
Übersicht 1916/17, p. 188, Room XXIV, No. 83.
Brinckmann, A.E. 1921, p. 150.
Brinckmann, A.E. 1923, p. 28, No. 35.
Planiscig, L. 1924, p. 204, No. 331.
Planiscig, L. and Kris, E. 1935, p. 112, Room XIV, No. 31.
Weihrauch, H.R. 1967, p. 351.
Leithe-Jasper, M. 1976, pp. 112, 113, No. 163.
Leithe-Jasper, M. 1978/79, p. 259, No. 174a.

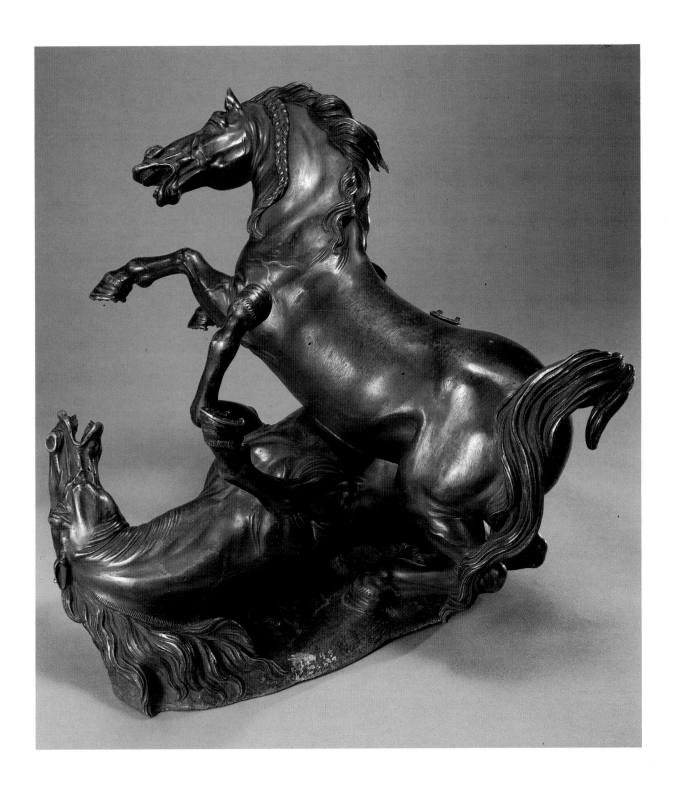

72. Mars, Venus and Cupid

Hubert Gerhard

*c.*1550–1622/23
(See Biography, p. 280)

Bronze group; hollow cast; high zinc
content. Cupid, and Mars's right
foot, are cast separately. Dark,
many-layered reddish brown smoke
varnish, under which the surface has
been burnt to a golden tone, prob-
ably by etching; light brown patina.
Height 41.4 cm.
Inv. no. Pl. 5848.

PROVENANCE
Possibly in the possession of Emperor Rudolf
II in Prague; however, not documented in the
inventory of 1607–11. Certainly in the pos-
session of Emperor Matthias and documented
in 1619 in the collection at the Vienna
Hofburg in the fragment of an inventory pre-
served at the Wolfenbüttel library: "Allerlei
schone stuckh von messing . . . 13. 1 stukh, ist
Marss, Venus und Cupito, sizend." (Köhler
1906–07, p. xv Regest 19449, 1). The next
reference is in the inventory of the Imperial
Treasury in Vienna in 1750, p. 593 "Auf die-
sen (Ein Schrank mit inkrustationen von flor-
entiner Pietradura-arbeit) befindet sich in der
mitte: Eine figur zu Pferd, so den kaiser
Commodum vorstellt. Auf deszen beeden
seithen zwei Gladiatores, unter sich aber
Apolo [sic], Venus et Cupido. Erstangemerkte
vier stuck seind von pronso verfertigt." (Zim-
mermann 1889, p. CCCXII). Transferred from
the Treasury to the Ambras collection in
Vienna in 1871 and transferred with this en-
tire collection to the Kunsthistorisches
Museum in 1891. Documentation of the ac-
tivity of Hubert Gerhard for Rudolf II
(through the intervention of Archduke
Maximilian III) can be found in the *Jahrbuch
der Kunsthistorischen Sammlungen des Allerhöch-
sten Kaiserhauses,* vol. XIX/2, 1898, (Regesten
16481, 16491, 16574, 16582 and 16589), and
herausgegeben von H. von Voltelini, and in J.
Hirn, *Erzherzog Maximilian der Deutschmeister
und Regent von Tirol,* vol. I, Innsbruck 1915,
p. 352, note 2.

Mars and Venus are seated together on a pedestal resembling a bench; a
drapery is spread on it, which also covers Venus's pudenda. Two steps lead
up to the pedestal. Mars has laid his left leg over Venus's right thigh as if to
make her uncross her legs. He faces Venus with the upper part of his body
turned to the left so as to embrace her shoulders and prevent her turning
away from him. Venus offers no resistance; with her left hand she attempts
to push Mars's left hand away from her shoulder, but this is done playfully
and rather as a gesture of tenderness, as is suggested by her yearning look at
Mars. In her raised right hand she holds a burning heart representing love;
she holds this at a safe distance from the impetuous Mars. On the steps of the
pedestal at the deities' feet, sheltered by Mars's left leg, is their son, the small
winged Cupid.

The highly animated composition of these three bodies, each one sinuous
in itself, is determined by the ever varied way in which they interlock. With
great consistency, the lines forming the composition converge as the eye
moves upward, till it culminates in the mutual gaze of the two main figures.
The composition is effective not only from the front but also from an ob-
lique angle, from the side and from behind. The prototype is certainly to be
found in Italian sculptures such as Vincenzo de Rossi's group of *Theseus and
Helen* in Florence (1561) or Moschino's *Atalanta and Meleager* in the Nelson
Gallery of Art in Kansas City. But the Vienna group surpasses its models in
the complexity with which its interlocking elements are smoothly combined,
in a manner that recalls paintings by Bartholomäus Spranger. The motif of
Venus's crossed legs is certainly traceable to Giambologna's *Architecture*,
which was so evidently also used by Hans Reichle in his bronze statuette of
Spring (*Giambologna* 1978/79, no. 18). The movement uniting Mars and
Venus seems to be epitomized in Cupid nestling on the steps below.

Like the composition as a whole, the modeling of the figures is full of
tension and movement. The details, for example, of the faces, their eyes
shadowed by heavy, clear-cut lids, and of the hands and hair, are differen-
tiated with great liveliness. The cast seems flawless, and the afterworking
highly skilful yet not pedantic.

Ilg (1883), whom the group rightly reminded of Bartholomäus Spranger's
pictures, classified it as by Adriaen de Vries. Later, however (1891), on
becoming aware of Hubert Gerhard's huge bronze group of the same subject
in the Bayerisches Nationalmuseum in Munich, he changed his mind and as-
cribed the Vienna group also to Gerhard. Buchwald (1899), who apparently
overlooked Ilg's ascription, is wrongly credited as the first critic to attribute
the Vienna group to Hubert Gerhard. Schlosser (1910) rightly perceived that
the similarities between the Munich and the Vienna group were of motif
rather than style. However, he wrongly concluded that they must be by dif-
ferent artists, and ascribed the Vienna group, quite unconvincingly, to Pietro
Francavilla. Later (*Übersicht* 1916/17) he reverted to Gerhard. Peltzer (1918)
first connected the group with documents indicating that in 1602 and 1605
Hubert Gerhard sent bronze statuettes to the Emperor Rudolf II through
Archduke Maximilian III, by whom he was employed from 1602 to 1613.

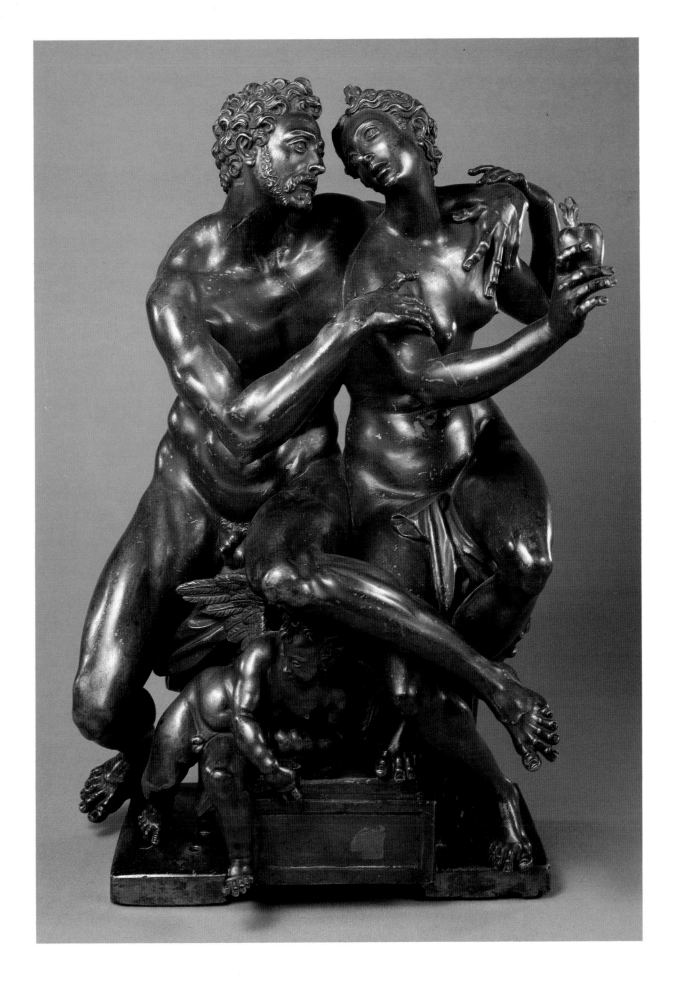

BIBLIOGRAPHY

Ilg, A. 1883, pp. 140, 141, No. 3.

Ilg, A. 1891, p. 124, Room XXIV, Case III, No. 74.

Buchwald, C. 1899, p. 114.

von Schlosser, J. 1910, p. 13, Plate XXXV, 2.

Übersicht 1916/1917, p. 191, Room XXIV, Case III, No. 18.

Peltzer, R.A. 1918, pp. 135–143, Fig. 27.

Brinckmann, A.E. 1921, pp. 149, 150, Fig. 5.

Brinckmann, A.E. 1923, pp. 6, 7 and p. 23, No. 12 and p. 28, No. 32.

Planiscig, L. 1924, pp. 201, 202, No. 326.

Feulner, A. 1926, pp. 17–20.

Planiscig, L. and Kris, E. 1935, p. 112, Room XIV, No. 29.

Weihrauch, H.R. 1956, pp. 137–140, No. 171.

Montagu, J. 1963, p. 85.

Weihrauch, H.R. 1964, p. 280.

Radcliffe, A.F. 1966, p. 101, Fig. 66.

Weihrauch, H.R. 1967, p. 351.

Wixom, W.D. 1975, No. 213.

Welt im Umbruch 1980, pp. 170, 171, No. 532.

Distelberger, R. 1982, p. 107.

Brinckmann (1921) first observed and analysed with unsurpassable accuracy the features of the present group that are characteristic of Hubert Gerhard. "Details that should be noted are the domed forehead, the large eyes with sharply carved lids, with holes for the pupils and circles for the irises; the slight naivety of the woman's profile, her coiffure with the clasp so beloved by Gerhard, the rather prominent knuckles of the fingers and toes, the slantwise veins on the feet above the toes, those on the back of the man's hand, and the man's jugular artery; above all the strongly accented articulation in contrast to the soft, painterly modeling of an Adriaen de Vries or the undulating smoothness of the school of Giovanni da Bologna."

Since Schlosser (1910) all critics have pointed out the stylistic difference between the Vienna group and Gerhard's early monumental work, which was created in 1585–90 on the commission of Hans Fugger for a fountain in the courtyard of Schloss Kirchheim an der Mindel and has been in the Bayerisches Nationalmuseum in Munich since 1871. In that work the figures are much more powerful and massively proportioned, and the composition is much more direct in its almost primitive, down-to-earth eroticism. In the Vienna group the eroticism is less emphatic and more subtly treated, for instance in the contrast between the man's "open" body and the woman's "closed" one; the man's grasp is tentative rather than rough, and the woman looks at him with melting devotion. The slim proportions of the figures, the rhythmic lines and elegance of movement could not contrast more sharply with the Munich group. One is therefore inclined to suppose that Gerhard had acquired some knowledge, perhaps through pictures and engravings, of the refined art of Rudolf II's court, and to connect the Vienna group with a work of which the Archduke Maximilian III told the imperial chamberlain Philipp Lang that he had never seen its like among the Emperor's possessions, but that Gerhard must have arrived at the artistic solution by himself. It would be logical that the work by Gerhard that Maximilian sent to his brother Rudolf II in Prague in 1605 was, in style in at least, of a kind acceptable to the Prague court.

The bronze group cannot, however, be traced in the 1607–11 inventory of Rudolf II's collection. If he ever owned it, it must have reached Prague at a later date, and is therefore probably not identical with the bronze of 1605. The group is first traceable with certainty in 1619, in the posthumous inventory of the art collection of the Emperor Matthias in the Burg in Vienna, where it appears, indeed, among numerous bronzes that had previously belonged to his brother Rudolf.

No replicas of the Vienna group of *Mars, Venus and Cupid* are known. There is a variant of it in a group of *Tarquin and Lucretia*, preserved in numerous replicas; the attribution of this group to Gerhard requires further investigation.

73. River-god

A gaunt old man rests his left knee on a vase from which water is flowing; the right leg, on which he is standing, is also slightly bent. His torso is inclined forward and to the right. His hands are clasped in prayer, his eyes upraised; his long fine-stranded beard hangs to the left. A drapery with many folds is wound around his hips and his right arm and falls to the ground beside the vase.

The statuette is distinguished by concise modeling and careful afterworking. The delicate file-marks on the carefully smoothed surface of the body follow the structure of its swelling planes. The drapery is animated with delicate matt-punching, like the surface of the vase, which in addition has an engraved decoration.

It is uncertain whether the title *River-god* is correct. Old inventories sometimes list the work as *St Jerome*, no doubt because of the praying gesture, despite the absence of the saint's attributes (crucifix, skull and lion). Planiscig (1930) once classified it as an *Allegory of the Sea*, a counterpart to the *Allegory of the Earth* (cat. 60).

Late nineteenth-century inventories date the work to the seventeenth century but do not give any artist's name. Planiscig (1921 and 1924) assigned it to Venice and, together with cat. 41, 60 and 74, to the "Master of the Haggard Old Men", an imaginary artist whom he believed to have been a member of the circle of Alessandro Vittoria. However, while the statuettes thus grouped all depict gaunt, bearded old men, they have no similarity of style. There is moreover no stylistic link with Alessandro Vittoria, and little link in motif; indeed it would appear that none of the statuettes in question originated in Venice. Probably realizing this, Planiscig later (1935) assigned the whole group to Guglielmo della Porta in Rome; however, he gave no detailed reasons for this theory, which is equally unconvincing. Weihrauch (1967) accepted Planiscig's later view. Pope-Hennessy (1963) ascribed the whole group, no less improbably, to Camillo Mariani, a native of Vicenza who worked in Rome.

Leithe-Jasper (1973, 1976 and 1978/79) showed that no two members of the "group" could be by the same artist, although the *River-god* bears a close similarity to *Saturn* (cat. 60); the two are for this reason always regarded as forming a pair, though the subjects are really unrelated. Planiscig attempted in 1930 to interpret the *River-god* and *Saturn* as allegories of the ocean and earth respectively, but in 1935 he abandoned this view.

The two statuettes are first mentioned in 1619, in the posthumous inventory of the Emperor Matthias. From then on, although sometimes given different titles, they are always listed one after the other, which makes it easier to trace them back through the various inventories. There are, however, differences between them as regards lacquering and, it would seem, in style also. The proportions of the *River-god* are not so extremely elongated as

South German(?), beginning of the seventeenth century

Bronze statuette; extremely thick-walled cast. The right big toe broken off. Light golden-brown lacquer; light brown patina.
Height 24 cm.
Inv. no. Pl. 5890.

PROVENANCE
In the possession of Emperor Matthias and documented in 1619 in his estate at the Vienna Hofburg in the fragment of an inventory preserved at the Wolfenbüttel library: "Allerlei schöne stuckh von messing . . . 22. 1 Mansbildnis, Noe, mit dem linkhen fües knieglend." (Köhler 1907-07, p. xv, Regest 19449, 1). The next reference is in the inventory of the Imperial Treasury in Vienna of 1750, p. 574, no. 38, "Ein alt bettende mannsfigur, so mit einen fuesz auf einer vasa kniet, von pronso." (Zimmermann 1889, p. cccx). Transferred from the Treasury to the Ambras collection in Vienna in 1871 and transferred with the entire collection to the Kunsthistorisches Museum in 1891.

BIBLIOGRAPHY
Ilg, A. 1891, p. 225, Room xxiv, Case iv, No. 38.
von Schlosser, J. 1910, p. 17, Plate xliv, No. 3.
Planiscig, L. 1921, pp. 471–473, Fig. 491.
Planiscig, L. 1924, p. 106, No. 183.
Planiscig, L. 1930, p. 36, Plate clxi, Fig. 279.
Planiscig, L. and Kris, E. 1935, p. 91, Room xiii, Case 38, No. 2.
Pope-Hennessy, J. 1961/62, No. 156.
Pope-Hennessy, J. 1963, ii, p. 62, Fig. 28.
Weihrauch, H.R. 1967, p. 238.

Saturn's are; the former's beard is not so lifelike and fully modeled; all the details of the *River-god* appear more graphic than those of *Saturn*. The ornament on the body of the vase is very similar to that on a vase in the silver copy of Giambologna's relief with the *Allegory of Francesco de' Medici* (cat. 53; *cf Giambologna* 1978/79, nos. 119 and 120). The silver relief is considered to be South German work of the late sixteenth century. The *River-god* might likewise be the work of a South German master of the early seventeenth century who had come into some contact with followers of Giambologna. No replicas are known.

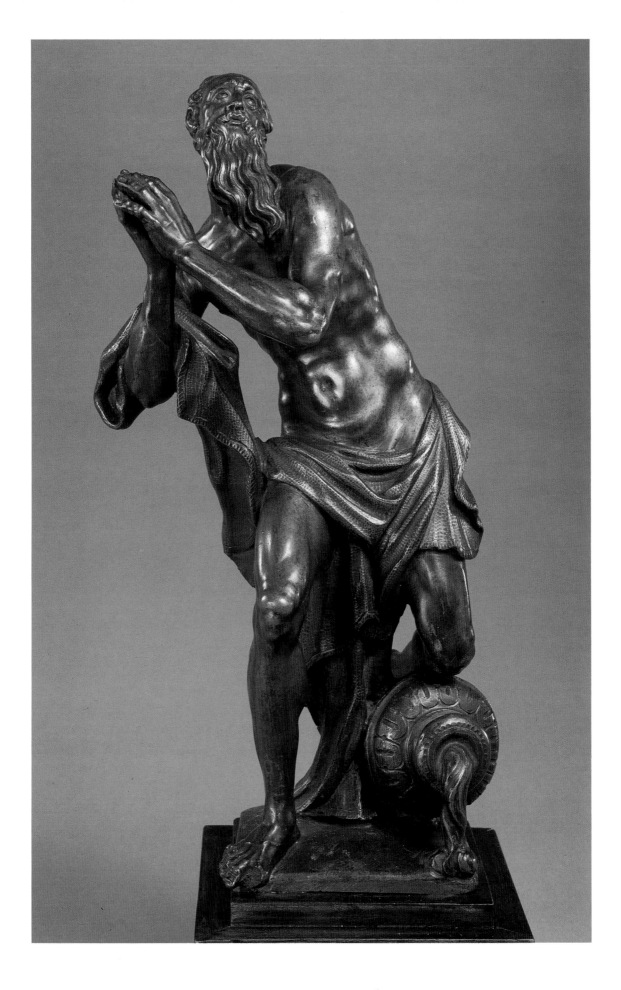

74. St Jerome

South German or Venetian after a South German prototype (perhaps by Georg Petel), end of the seventeenth century

Bronze statuette; hollow cast. A casting flaw on the left ankle and on the front of the base. Black lacquer; light reddish-brown patina. Height 25.9 cm to the top of the cross; 24.6 cm to the saint's head. Inv. no. Pl. E.7561.

PROVENANCE
Collection of the Marchese Tommaso degli Obizzi at the castle of Il Cataio near Padua. Inventory compiled by F.A. Visconti in 1806, no. 2150 "Statuetta di S. Girolamo, in altezza poco più di un palmo, di buon lavoro moderno 1." (Documenti inediti per servire alla storia dei Musei d'Italia, Vol. III. Firenze 1880, pp. 29–80, Museo Obiziano). Bequeathed in his will of 1803 by Tommaso degli Obizzi with his collection to the Este Dukes of Modena or, in the case of the extinction of their male heirs, to the House of Austria-Este, a younger branch of the Habsburgs. Transferred toward the end of the 19th century from Cataio to Vienna and taken over in 1923 by the Kunsthistorisches Museum.

St Jerome, a Doctor of the Western Church, is shown as a penitent, wearing only a loincloth. He kneels with his right knee on a forked tree stump; his torso is inclined forward. He holds a crucifix in his raised left hand, and in his lowered outstretched right hand a stone with which he is about to beat his breast. At his feet is couched the legendary lion from whose paw he pulled a thorn. The casting is comparatively rough, the afterwork coarse and negligent; however, some refinements are probably concealed by the thick coating of black lacquer.

The motif of the statuette is one of the most popular in small sculpture of the sixteenth, seventeenth and eighteenth centuries: the work exists in countless variants and replicas. For a long time this bronze was believed to be the original version of the theme and the prototype of all later ones. This has recently been questioned by Leithe-Jasper (1973 and 1976). The hitherto accepted classification of the statuette is also by no means certain. Its provenance is Venetian, and the rather careless execution, as well as the use of black lacquer, is not unusual in Venetian workshops of the late sixteenth and seventeenth centuries, but in the literature too much stress has been laid on Venetian stylistic features.

Hermann (1906), who first critically investigated the holdings of the Este art collection in Vienna, connected the statuette with Alessandro Vittoria and compared it with his statues of *St Jerome* in Santi Giovanni e Paolo and the Frari in Venice. Planiscig (1918) also perceived similarities of style and motif with the school of Jacopo Sansovino in Venice, and (1921 and 1924) assigned the work, together with other bronze statuettes, to an anonymous master whom he believed to have been associated with Alessandro Vittoria and whom he called the "Master of the Haggard Old Men". However, the bronzes that Planiscig included in the *œuvre* of this imaginary master have in fact nothing in common except the haggardness of their (always bearded) subjects. No two of them can be ascribed to a single artist: this is clear enough from the present exhibition, which includes a selection from the supposed *œuvre* (cat. 41, 60, 73), and is confirmed by an examination of the other bronze statuettes that Planiscig assigned to the group. Moreover, except for the present *St Jerome* none of the statuettes is of Venetian provenance, nor do they show any appreciable sign of the influence of Sansovino or Alessandro Vittoria, other than in motif (Leithe-Jasper 1973 and 1976). Pope-Hennessy (1963) attributed the whole group, except for the present work, and another statuette of *St Jerome* in the Victoria and Albert Museum in London, to Camillo Mariani, a native of Vicenza active in Rome, who is regarded as a link between Venice of the late Renaissance and Roman Baroque. He made no suggestion for the Vienna statuette.

Even though the *St Jerome* may have been cast in Venice, the invention is certainly not Venetian. To judge from the slenderness of the figure it probably dates from the late seventeenth century if not later, so that it cannot have been the prototype of so many imitations and variants, as has hitherto been believed; it must, along with all other replicas, itself be based on a prototype that was no doubt extremely popular in its time. The author of

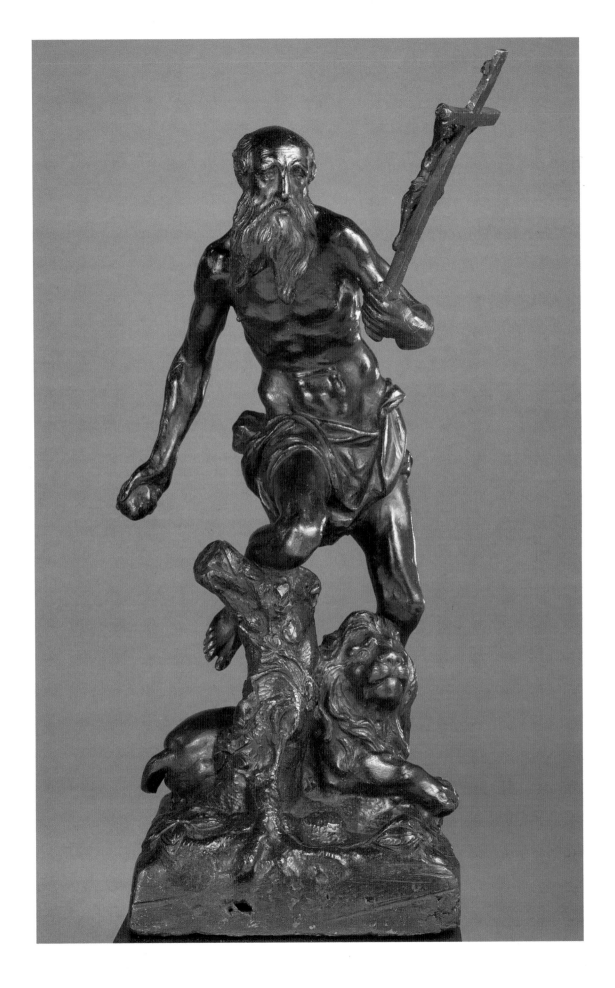

BIBLIOGRAPHY

Hermann, H.J. 1906, p. 98.

Planiscig, L. 1918, p. 5.

Planiscig, L. 1919, pp. 131, 132, No. 200.

Planiscig, L. 1921, pp. 471–475, Fig. 490.

Volbach, W.F. 1923, pp. 67, 68, No. K. 8719.

Planiscig, L. and Kris, E. 1935, p. 91, Room
 XII, Case 38, No. 5.

Bachmann, E. 1953, pp. 136–144.

Pope-Hennessy, J. 1963, p. 62.

Theuerkauff, C. 1964, p. 33.

Asche, S. 1966, p. 305.

Weihrauch, H.R. 1967, p. 238.

Arndt, K. 1967, p. 177.

Feuchtmayr, K. and Schädler, A. 1973,
 p. 134, No. 44.

Leithe-Jasper, M. 1973, No. 53.

Leithe-Jasper, M. 1976, pp. 96, 97, No. 108.

Theuerkauff, C. and Möller, L.L. 1977,
 pp. 219–221, No. 130.

Hunter-Stiebel, P. 1978, pp. 42–53.

Este 1979, pp. 32, 33.

Trenschel, H.P. 1980, pp. 37–39, No. 19.

Bayerische Rokokoplastik 1985, pp 49, 50,
 No. 28.

this apparently no longer existing prototype was probably Georg Petel. In the Herzog Anton Ulrich Museum in Brunswick there is a drawing by Petel of the torso of a St Jerome corresponding to the composition of the Vienna statuette. It certainly does not, as Arndt (1967) and Feuchtmayr and Schädler (1973) supposed, represent the Vienna statuette itself, but rather the work which was to become the prototype of so many statuettes of St Jerome in the most diverse materials. Like Petel's lost St Jerome, his statuette of St Sebastian in the Bayerisches Nationalmuseum in Munich was copied many times (Feuchtmayr and Schädler 1973). The two works actually both appear among the studio models of the Würzburg sculptor Johann Peter Wagner (1730–1809). Petel's St Sebastian was in Mannheim from 1731, and Wagner may have seen it there, as he was active for a time in the workshop of Paul or Augustin Egell. Possibly the St Jerome was then in Mannheim also.

The only replica which was undoubtedly made in the Veneto is an earthenware figure manufactured by Gerolamo I Franchini (1728–1808) in Este, which might have been based on the Vienna statuette if this was then already in Obizzi possession at the Cataio castle near Este. It is certainly not simply a cast, however: the differences, especially around the base, are too great. The numerous other replicas – in all kinds of materials, such as wax, ivory, wood, plaster, stucco and porcelain – are certainly of northern origin. Their dates extend from the late seventeenth to the late eighteenth century, and their uses range from display in a Kunstkammer to study in a sculptor's workshop.

Replicas and variants:

(A) in wax:

(1) Herzog Anton Ulrich Museum, Brunswick, inv. no. H 29, no. 617; red wax, height 23.5 cm; German, c.1700; (2) Museum für Kunst und Gewerbe, Hamburg, inv. no. 1927, 94; red wax, height 23.3 cm; German, first half of the eighteenth century.

(B) in ivory:

(1) Neue Residenz, Bamberg; height 20 cm; South German, beginning of the eighteenth century, according to Asche (1966), but not by Permoser as Bachmann thought (1953); (2) Kunstgewerbemuseum, Berlin, inv. no. K. 8719; height 15 cm; signed "T.W. Freese, Bremen 1726" (Volbach (1923) mentioned a replica, also by Freese, recorded in Brunswick in 1791, now lost); (3) Ader, Picard and Tajan sale, Hôtel Drouot, Paris, 14 June 1974, lot 138; height 24 cm; signed "Walterus Pompe fecit Anvers" (1703–77); (4) formerly Berlin, Salomon collection, sold by Lepke, Berlin, 15 May 1917, lot 96, pl. 29; height 26 cm; combined with wood in the manner of Simon Troger; (5) sold by Lepke, Cologne, 5 August 1953; height 23.5 cm; the base and the tree of wood; German, eighteenth century.

(C) in wood:

(1) formerly H. Oelze collection, Amsterdam, sold by Paul Brandt, Amsterdam, 23 April 1968, lot 44; height 24 cm; chestnut; (2) formerly Friedinger-Prandter collection, Vienna; height 38 cm; walnut.

(D) in stucco:

(1) Mainfränkisches Museum, Würzburg, inv. no. 14401; height 24.4 cm; by
Johann Peter Wagner; (2) Minneapolis Institute of Art, Minneapolis, inv.
no., 66, 27; height 25.4 cm; (3) Städtische Kunstsammlungen, Augsburg, inv.
no. 6324: height 25.5 cm; polychromed.

(E) in porcelain:

(1) Amsterdam art market, 1975 (Theuerkauff and Möller 1977, p. 221, n.
8); height c.25 cm; Weesp porcelain factory, after 1757; (2) examples from
the Ansbach porcelain factory: white examples in the Residenz, Ansbach;
Museum of Art and Archeology, University of Michigan, inv. no.
1974/1.90, height 22.5 cm; Museum of History and Technology of the
Smithsonian Institution, Washington DC; painted examples in the Residenz,
Ansbach; (3) Museo Civico, Este; white earthenware, factory of Gerolamo I
Franchini, Este, c.1785.

75. Venus or Amphitrite

Netherlandish, *c.*1640
Perhaps Jérôme Duquesnoy the
Younger 1602–1654
(See Biography, p. 279)

Brass statuette; hollow cast. The
outer part of the square base sep-
arately cast in order to extend the
original round surface. A round fill-
ing on the left knee; a small hole at
the back of the head. Remains of
orange brown and dark reddish
brown lacquer; light brown, some-
what greenish patina. The figure
1004 in white at the back of the base
is a pre-1823 inventory number of
the Imperial and Royal Cabinet of
Coins and Antiquities.
Height 49.2 cm.
Inv. no. Pl. 5850.

PROVENANCE
Collection of Archduke Leopold Wilhelm.
First documented in the painting by David
Teniers, dated 1652, representing the
Archduke's Gallery in Brussels, in which the
statuette can be seen on the cabinet next to the
window, on the left-hand side of the painting.
Inventory of the collection of Archduke
Leopold Wilhelm in Vienna from the year
1659, p. 439, no. 33 "Ein klein metal-
gegossenes Pildt einer nackhendten Frawen,
hält in der rechten Handt ein Schneckhen
vndt auff einem dürren Baum die linckhe.
Auf einem viereckhendten Postament von
spänischen Holcz mit schwartz ebenen Leis-
ten, 2 Spann 3 Finger hoch; antic" (Berger
1883, Regest 495, p. CLXVI). Illustrated in 1735
in the *Prodromus*, plate 30 (Zimmermann
1888). How the statuette reached the Cabinet
of Coins and Antiquities, where it is docu-
mented before 1823, is uncertain – probably
via the Imperial Treasury. Transferred in 1880
from the Imperial and Royal Cabinet of
Coins and Antiquities to the Ambras collection in
Vienna and transferred with the entire
collection to the Kunsthistorisches Museum in
1891.

A bare tree stump grows from a square base representing a patch of ground.
Amphitrite stands naked beside it, with her left foot on a root of the tree and
her left hand on a projecting branch. Her torso and head are inclined slightly
forward and turned to her left. She holds out a shell in her raised right hand.
Her luxuriant hair is parted in the center, taken up at the sides and in the
nape of the neck, and held by a fillet which is tied in a bow over her fore-
head. A strand hangs down over her neck and right shoulder.

The work is executed with great care, so that the modeling, soft in itself,
shows to full advantage. The tree stump on which the goddess leans is
roughened with hammer and burin. The base of the original model seems to
have been round, as shown by the seams on the surface, and was enlarged
only in the final version. The gesture of the right hand with the open shell
suggests that the model was originally designed to decorate a fountain. At all
events the tree stump and the treatment of its surface justify the assumption
that the artist was thinking less of bronze than of sculpture in stone.

The statuette is known in several examples, but all the others are inferior
in quality, less well balanced and smaller than the Vienna version; they also
vary among themselves in size. The Vienna statuette, from the collection of
the Archduke Leopold Wilhelm, has the oldest provenance and was the first
to be noticed in the literature, though there is still some uncertainty as to its
classification.

Ilg (1891) designated it as Italian, seventeenth century. Schlosser (1910) ex-
pressed no opinion, while Brinckmann (1917) described it as North Italian,
*c.*1580. Both Brinckmann and Planiscig after him (1924) emphasized the re-
semblance to Venetian bronze statuettes of the late Renaissance, among
which one might single out the type of *Venus Marina* developed by
Girolamo Campagna. No less important, however, is the classical quality of
the work, which in all probability points to direct acquaintance with antique
models. At the same time, Planiscig was right to discern northern elements
in the figure's somewhat heavy form. For this reason he initially suggested a
connection with Johann Gregor van der Schardt, and later (1935) ascribed
the work definitely to that artist. Weihrauch (1967 and 1970) and Leeuwen-
berg and Halsema-Kubes (1973) followed Planiscig. This view, however, ig-
nores the fact that Venus's opulent, indeed Baroque form is not typical of the
late sixteenth century; nor is it typical of Johann Gregor van der Schardt, as
can be seen by comparing it with his *Minerva* in the Smith collection or the
Four Seasons in Vienna, modeled for Wenzel Jamnitzer. The Venetian com-
position seems, moreover, to have been modified in a way reminiscent of
François Duquesnoy's statuettes of *Apollo* and *Mercury*. Taking account of
this, as well as provenance and casting technique, Leithe-Jasper designated
the statuette "circle of François Duquesnoy", while Avery (1977) independ-
ently ascribed it to Jérôme Duquesnoy. Jérôme Duquesnoy was court sculp-
tor to the Archduke Leopold Wilhelm during his governorship in Brussels,
and owned the works left by his brother François, who died in his arms in
Leghorn in 1643. The statuette can be seen in the 1652 painting of the
Archduke's gallery in Brussels by David Teniers the Younger, where it ap-

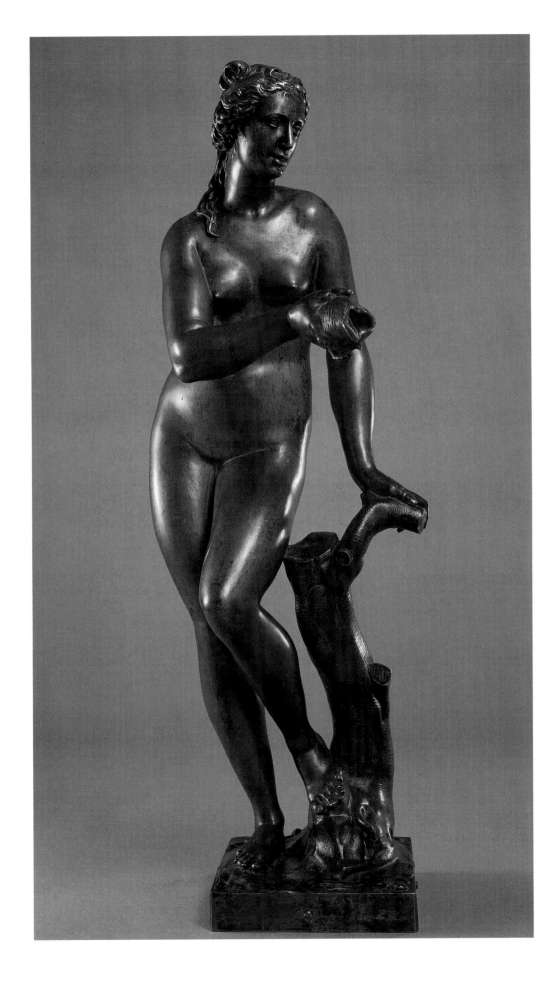

BIBLIOGRAPHY

Ilg, A. 1891, p. 224, Room XXIV, Case III,
 No. 76.
von Schlosser, J. 1910, p. 8, Plate XXI, No. 2.
Brinckmann, A.E. 1917, II, p. 321.
Planiscig, L. 1924, pp. 199, 200, No. 324.
Planiscig, L. and Kris, E. 1935, p. 113, Room
 XIV, No. 38.
Brinckman, A.E. n.d., p. 284, Fig. 327.
*Le Triomphe du Maniérisme – de Michelange
 au Greco* 1955, p. 182, No. 368.
Vienne à Versailles 1964, pp. 152, 153,
 No. 220.
Weihrauch, H.R. 1967, p. 325 and 348.
von der Osten, G. and Vey, H. 1969, p. 286.
Weihrauch, H.R. 1970, pp. 71, 72.
Leeuwenberg, J. and Halsema-Kubes, W.
 1973, p. 166, No. 198.
Avery, C. 1977, p. 43.
Olsen, H. 1980, p. 42.
Radcliffe, A.F. 1985, p. 98.

pears in a prominent position on the cabinet beside the window. It is at first sight rather strange that the compiler of the 1659 inventory of the collection should not have learnt from the Archduke that his former court sculptor Jérôme Duquesnoy was the author of the statuette, which is otherwise described in full detail; but the artist had been executed in 1654 for committing sodomy in a church, and perhaps the name was deliberately omitted in view of the scandalous circumstances. It is noteworthy that Jérôme Duquesnoy is also not mentioned in the inventory as the author of a portrait bust of the Archduke, signed in full and dated 1650, whereas in the case of the bust by Dusart the author is named.

It would be worth investigating a possible connection between the Vienna statuette and the almost life-size bronze *Amphitrite* in the Mellon collection in the National Gallery of Art in Washington, which is certainly somewhat earlier and was until recently attributed to Jacopo Sansovino.

The following replicas of the Vienna statuette are known: Rijksmuseum, Amsterdam, inv. no. Br. 460, height 47 cm (from the collection of F. Koenig in Hemstede, previously sold at Christie's, London, September 26, 1936); Statens Museum for Kunst, Copenhagen, inv. no. 6114, II, 153, height 46 cm (acquired in 1956 from Frank Partridge & Sons, London); Toledo Museum of Art, Toledo, Ohio, inv. no. 75,2, gift of Edward Drummond Libbey, height 46.3 cm; Arthur Sackler collection, on loan to the National Gallery of Art, Washington DC, inv. no. 80.4.10, height 48.3 cm; the examples formerly with Bernhard Black Gallery, New York, and with Michael Inchbald, London (*Die Kunst und das schöne Heim*, 1972, p. 688, fig. 4), probably identical with the statuettes in American possession. Variants representing *Venus with Cupid*, cast in Nuremberg in the seventeenth century, are in Naples and Vienna (Weihrauch 1967, figs. 394, 396).

Biographies

of artists whose works appear in the exhibition (in alphabetical order of artists)

Adriano Fiorentino (Adriano di Giovanni de' Maestri)
(c.1450/60 Florence – Florence 1499)
Adriano Fiorentino was an assistant to Bertoldo di Giovanni and was the caster of his *Bellerophon* group. From 1486 he was in the service of the *condottiere* Virginio Orsini in Naples, probably as a cannon founder; later he was employed by the court there. In Naples and afterwards Urbino he was also noted as a medalist. He was summoned to Germany, perhaps by the Emperor Maximilian I and probably in connection with the plans for the Emperor's funeral monument. There he executed a portrait bust, signed and dated 1498, of the Elector Frederick the Wise of Saxony, who was at that time in the Emperor's suite; the bust is now in the Sculpture collection in Dresden.

Antico (Jacopo Alari-Bonacolsi)
(c.1460 Mantua – Gazzuolo 1528)
Nothing specific is known of Antico's training as an artist, but we may safely suppose that it included sculpture and goldsmithing. His earliest known works are medals, but he was also active from an early date as a restorer of antique marble sculpture in Rome and probably Mantua. However, his fame rests chiefly on his bronzes, busts, statuettes and reliefs, most of which were executed for Gianfrancesco Gonzaga, lord of Bozzolo, and his wife Antonia del Balzo; Bishop Ludovico Gonzaga; and Isabella d'Este, wife of Francesco I Gonzaga, Marquis of Mantua. Antico's works are distinguished by classicism, an extraordinary delicacy of finish, and a casting technique that was highly advanced for its time. The largest collection of his works is in the Kunsthistorisches Museum in Vienna.

Tiziano Aspetti
(c.1559 Padua – Pisa 1606)
Tiziano Aspetti was the nephew of Tiziano Aspetti the Elder, called Minio, and grandson of the bronze-caster Guido Lizzaro. He seems to have received his first training in the family workshop. Later he was apparently an assistant to Girolamo Campagna, though his work also shows the influence of Alessandro Vittoria. He was perhaps less successful in marble; his best work was in bronze, especially the figures completed in 1592 for the Grimani family in San Francesco della Vigna in Venice, followed by bronze reliefs for the shrine of St Daniel in the crypt of Padua Cathedral and bronze figures for the altar of St Anthony in the Santo at Padua. He was in Tuscany from 1599 to 1602 and subsequently, but must have been attracted by Giambologna's art at an earlier date.

Antonio Averlino, see **Filarete**

Bertoldo di Giovanni
(c.1440 Florence – Poggio a Caiano 1492)
Bertoldo described himself as a pupil of Donatello's, but as yet there is little convincing evidence of his collaboration with the great Florentine master. On the strength of his close relations with Lorenzo il Magnifico de' Medici and of a certain un-

conventional, inventive dilettantism that is sometimes seen in his work, Ulrich Middeldorf surmised that Bertoldo was an illegitimate son of Giovanni de' Medici. As the mentor of an academy of young artists who studied antique sculpture in the Casino of the Medici in the garden by San Marco in Florence, he influenced the next generation and particularly the young Michelangelo. His chief works in bronze are a relief of a cavalry *Battle*, modeled on an antique sarcophagus relief, and a relief of the *Crucifixion*, both in the Museo Nazionale del Bargello in Florence; the statuette of *Hercules on Horseback* in the Museo Estense in Modena; and the *Bellerophon* group in Vienna.

Simone Bianco
(active in Venice between 1512 and 1553)
Simone Bianco is described by Vasari as a "scultore fiorentino", but all records of him, dating between 1512 and 1553, relate to his activity in Venice. He did, however, also carry out commissions on the mainland and for Christoph Fugger in Augsburg. He usually signed himself in Greek letters: ΣΙΜΩΝ ΛΕΥΚΟΣ ΟΥΕΝΕΤΟΣ. Works known to be his are exclusively marble sculptures, especially portrait busts of antique inspiration; on the strength of these, however, some bronze busts are also attributed to him.

Giovanni Bologna, see **Giambologna**

Andrea Briosco, see **Riccio**

Jérôme Duquesnoy the Younger
(1602 Brussels – Ghent 1654)
Jérôme Duquesnoy the Younger, like his more famous elder brother François, probably received his first training from his father Jérôme the Elder. There followed years of apprenticeship and travel in Italy and Spain. In 1643 he was on the way home from Rome with his brother when François died at Livorno; Jérôme thereupon took possession of his artistic property. Later he became court sculptor to the Archduke Leopold Wilhelm in Brussels. Jérôme worked in marble, clay, wood and ivory, and perhaps in bronze; his works are influenced by early Roman baroque and by his brother's art.

When supervising the erection of the monument to Bishop Antoine Triest at St Bavo's in Ghent, he committed a moral offense in the church, for which he was condemned to death and executed on September 28, 1654.

Filarete (Antonio Averlino)
(c.1400 Florence – Rome 1469)
Perhaps trained in Lorenzo Ghiberti's workshop; in about 1433 Pope Eugenius IV summoned him to Rome, where he created his masterpiece, the bronze central doors of St Peter's. He remained in Rome till forced to leave in 1447. In 1451, after a short stay in Venice, he entered the service of Francesco Sforza in Milan, where the Ospedale Maggiore was erected to his design and where he composed his *Trattato dell'Architettura*.

After a dispute with Francesco Sforza he returned via Mantua to Florence and finally to Rome. Besides the doors of St Peter's, his principal bronze sculptures include the equestrian statuette of *Marcus Aurelius* in the Albertinum in Dresden and the equestrian statuette of *Hector* in the Museo Arqueológico Nacional in Madrid.

Adriano Fiorentino, see **Adriano**

Pietro Francavilla
(1548 Cambrai – Paris 1615)
Pietro Francavilla – originally de Francqueville – probably received his first training in Paris. In 1566–77 he is known to have been in Innsbruck, at the court of the Archduke Ferdinand II of Austria; there he probably worked in Alexander Colin's studio, though he is only recorded as having climbed a mountain in the Tyrol. In 1572 he went to Florence with a recommendation from the Archduke and was admitted to Giambologna's studio. He became one of the artist's chief assistants and was probably responsible for the execution of marble sculptures, though he also worked in bronze; his skill can also be seen in numerous independent works. Between 1602 and 1607 he moved to Paris to supervise the erection of the equestrian statue of King Henri IV on the Pont Neuf.

Francavilla's work in small sculpture is still in need of systematic study.

Hubert Gerhard
(*c.*1550, probably Amsterdam – Munich 1622/23)
Nothing is known from documents about Gerhard's training or years of travel. It can, however, be inferred from his works that he spent some time in Florence and probably also Venice. He was already a mature artist in 1581, when he entered the service of the Fuggers in Augsburg. He worked chiefly in clay and bronze. His principal works are: the sculptural decoration of the Fuggers' castle of Kirchheim on the Mindel; the Augustus Fountain, commissioned by the city of Augsburg in 1587 and completed in 1594; the sculptural decoration, in clay and bronze, of the Michaelskirche in Munich, commissioned by Duke Wilhelm V of Bavaria, on which work continued till the Duke's fall in 1597; and several fountains in Munich. From 1602 he worked at Innsbruck for the Archduke Maximilian III of Austria, returning to Munich in 1613.

Together with Adriaen de Vries, Hubert Gerhard is the most important of the South German sculptors who were strongly influenced by the Italian late Renaissance. His roots lie rather in Florentine sculpture before Giambologna, whereas Adriaen de Vries was a pupil of Giambologna.

Giambologna (Giovanni Bologna)
(1529 Douai – Florence 1608)
Giovanni Bologna – or Jean Boulogne to give him his correct name as a native of French-speaking Flanders – was a pupil of Jacques Dubroeucq at Mons. Around 1550 he made the journey to Rome to acquaint himself with the works of classical sculpture and of Michelangelo. In Florence on the way home he met the wealthy patron and collector Bernardo Vecchietti, who encouraged him to stay there and introduced him to Francesco de' Medici, the future Grand Duke of Tuscany. This led in 1561 to Giambologna's appointment as court sculptor. He became famous, however, for his monumental Fountain of Neptune at Bologna, which he created between 1563 and 1565. From then on he was entrusted with numerous commissions by the Medici and became the dominant artistic figure in Florence. His ever-growing workshop employed many eminent sculptors as assistants, including Pietro Francavilla, Antonio Susini, Pietro Tacca, Adriaen de Vries and Hans Reichle; the foreigners among them, when they returned to their own countries, spread his fame and the knowledge of his style far and wide outside Italy. Another cause of his popularity abroad was the Florentine court's custom of sending works by him, usually bronze statuettes, as diplomatic presents to friendly rulers. The princes of Europe vied to obtain his works, and in 1588 the Emperor Rudolf II, a passionate collector of his bronzes, actually conferred on him a title of hereditary nobility. Like Michelangelo before him, Giambologna became a classic, whose works, like those of classical antiquity, served as a model to generations of sculptors.

Giambologna's influence on European sculpture is discernible right up to the Rococo period.

Caspar Gras
(*c.*1585, probably Mergentheim – Schwaz 1674)
In 1602 Caspar Gras became a pupil of Hubert Gerhard at Innsbruck, probably through the agency of the Archduke Maximilian III. After Gerhard's departure in 1613 he was promoted to court embosser (*Hofbossierer*). Maximilian III died in 1618, and in 1619 the Archduke Leopold V appointed Gras *Kammerbossierer*. Gras continued to work for the Innsbruck court. His chief works are the completion of Maximilian III's tomb in Innsbruck Cathedral, begun by Hubert Gerhard, and the figures on the Leopold Fountain in that city, cast in 1622–32, including the equestrian statue of Leopold V, the first monumental representation of a rider on a curveting horse. Numerous bronze statuettes are also attributed to him.

As a pupil of Gerhard's, employed at a court which had close family ties with Florence, Gras became an important representative of the late Renaissance style of sculpture north of the Alps, modeled on Giambologna and his school.

Antonio Lombardo
(*c.*1458 Padua or Venice – Ferrara 1516)
Son of the sculptor and architect Pietro Lombardo, and probably junior to his brother Tullio, Antonio Lombardo was trained in his father's workshop and remained active there for a considerable time. He is known to have worked as an assistant on numerous funeral monuments in Venice and Treviso, and on

the building of Santa Maria dei Miracoli in Venice. His first wholly independent work seems to have been the monumental marble relief in the Santo in Padua, completed in 1501 and representing the *Miracle of the Speaking Infant*. His chief work in bronze is the *Madonna della Scarpa* on the altar of the Chapel of Cardinal Zen in St Mark's in Venice. In 1503 he and Alessandro Leopardi were jointly commissioned to build the Zen Chapel, but in 1506 he left Venice for Ferrara, where he entered the service of Duke Alfonso I d'Este. He created a series of extremely subtly executed marble reliefs of mythological subjects for the decoration of the Camerino degli Albastri and the Studio di Marmo in the palace at Ferrara; these are now for the most part in the Hermitage in Leningrad and other museums.

Francesco di Giorgio Martini
(1439 Siena – Siena 1501)
Francesco di Giorgio Martini was a pupil of Vecchietta's and, till 1475, an assistant to Neroccio dei Landi in Siena. A universal artist, he was celebrated as a sculptor, painter, illuminator, engineer, architect and writer on architectural theory.

In addition to Siena, he worked in Urbino for Duke Federigo da Montefeltro, and for a short time with Leonardo in Milan. Among his principal bronze sculptures are two figures of *Angels* in Siena cathedral; the *Aesculapius* or *Laocoön* in the Albertinum in Dresden; the reliefs of the *Scourging of Christ* in the Galleria Nazionale dell'Umbria in Perugia and of the *Deposition* in Santa Maria del Carmine in Venice; and some reliefs in the National Gallery in Washington DC.

Tiziano Minio
(c.1511/12 Padua – Padua 1552)
Tiziano Minio, son of the bronze-caster Guido Lizzaro degli Aspetti, was a pupil and assistant to Jacopo Sansovino, whose influence is strongly felt in Minio's works in stucco, bronze and marble in Padua and Venice. In general Minio's work has been little investigated.

Moderno (probably Galeazzo Mondella)
(active from c.1490 to c.1540)
Following W. Bode, Moderno is nowadays generally identified with the Veronese goldsmith Mondella on the strength of the inscription HOC.OPVS.MONDEL.ADER.AVRIFEX.MCCCCXC on the reverse side of a pax (Molinier 1880, no. 161) which also occurs with the signature HOC OPVS MO/DERNI/. C.C. (Kress collection in the National Gallery, Washington DC). The latest mention of Moderno is in a letter from the painter Francisco de Hollanda dating from before 1549, which speaks of him as living in Rome. His pseudonym was probably chosen to contrast with Antico's; his work shows Antico's influence as well as that of Leonardo's school in Milan, and also that of Antiquity, especially during and after his stay in Rome. The chief basis for a study of his numerous works consists of a few signed reliefs, two of key importance being the pair of silver plaquettes in the Kunsthistorisches Museum in Vienna.

Giovanni Maria Mosca
(active between 1507 and 1573)
Probably born near Padua, son of the boatman Matteo Mosca, Giovanni Maria was trained by the Padua stonemasons Giovanni Minelli and Bartolomeo Mantello. He also worked from an early age with the bronze-caster Guido Aspetti, called Lizzaro, the father of Tiziano Minio. Mosca's chief work in Padua is in the Santo: a large marble relief, completed in 1528, of the *Miracle of the Unbroken Glass*. In 1530 he went to Poland on the invitation of King Sigismund I, and is said to have been still active there in 1573. It is not certain whether he executed any larger bronzes, except for a relief of the *Beheading of St John* in the Baptistery of Padua Cathedral.

Niccolò de' Pericoli, see Tribolo

Riccio (Andrea Briosco)
(1470, probably Trent – Padua 1532)
Andrea Briosco, known as Riccio ("hedgehog") on account of his curly hair, was one of six sons of the goldsmith Ambrogio di Cristoforo Briosco, a native of Milan. He was trained as a goldsmith in his father's workshop in Padua, and afterward as a sculptor by Donatello's pupil Bartolomeo Bellano, his chosen media being clay and bronze. He moved in the cultivated circles of Padua University, and his work shows numerous traces of Neoplatonism, Aristotelian metaphysics, and natural philosophy. From this point of view his most celebrated achievement, and the key to his whole work, is the Easter candelabrum (1507–16) in the Santo (basilica of St Anthony) in Padua. The bronze statuettes attributed to him are legion; for some years a critical review has been in progress.

Nicolò Roccatagliata
(active between 1593 and 1636)
Nicolò Roccatagliata was a native of Genoa, where he is said to have been taught by the goldsmith Cesare Groppi. He went to Venice at an early age and is said to have been trained there as a sculptor in stone; however, all his known works are not in stone but in bronze. He is believed to have made small models, chiefly studies of movement, for Jacopo Tintoretto. He is first mentioned in a document of 1593, when he received the commission for the bronze statuettes of *St George* and *St Stephen* and for several wall brackets and candelabra for San Giorgio Maggiore in Venice. He seems to have returned to Genoa in 1598, but came back to Venice 30 years later. The bronze antependium in San Moisè, dated 1633, bears his signature and that of his son Sebastiano, also those of the casters, of French origin, Johannes Chenet and Marinus Feroni. While Roccatagliata's early work is entirely in the tradition of the school of Jacopo Sansovino, his later works present Counter-Reformation and early Baroque features, with touches of Quattrocento expressionism.

Sansovino (Jacopo Tatti)
(1486 Florence – Venice 1570)
Jacopo Tatti was a pupil of Andrea Sansovino, whose name he adopted. In about 1506 he came to Rome and entered the workshop of Giuliano da Sangallo. He became famous by winning a competition for the best copy of the *Laocoön* group, discovered in 1506.

He returned to Florence in 1511, but went back to Rome many times thereafter. He was noted both as a sculptor and as an architect. After the sack of Rome in 1527 he fled to Venice, where apart from short journeys he spent the rest of his life. Thanks to the influence of Venetian friends who had strong links with Rome, such as Doge Andrea Gritti and the Grimani family, he soon became *protomaestro* of St Mark's, or official architect of Venice, and this exercised enormous influence on the city's artistic development. Through his influence Venetian sculpture came closer into line with that of Florence and Rome. He became the head of a school of sculpture whose pupils of the first and second generation – Tiziano Minio, Danese Cattaneo, Alessandro Vittoria, Girolamo Campagna, Tiziano Aspetti and Nicolò Roccatagliata – were influential until well into the seventeenth century.

Johann Gregor van der Schardt
(c.1530 Nijmegen – Nuremberg (?) c.1581)
Like many Netherlandish artists of his time, Johann Gregor van der Schardt traveled to Italy for his studies. He stayed in Rome, Florence, Bologna and Venice, and must have had some reputation, as Vasari in 1568 refers to him as "Giovanni di Sart di Nimega eccellente scultore". In 1569 he entered the service of the Emperor Maximilian II, first in Vienna and from 1570 in Nuremberg. Another patron of his was the Nuremberg patrician and collector Paulus von Praun, while later he received commissions from King Frederick II of Denmark. His principal known works are bronze statuettes and terracotta portraits. They show the influence of Florentine sculptors such as Cellini and Bandinelli and of the Tuscan Danese Cattaneo, who worked in Venice, and are also reminiscent of the clay sculpture of Emilia.

Antonio Susini
(active from c.1580 – died Florence 1624)
One of Giambologna's closest collaborators, and the specialist in bronze statuettes in Giambologna's workshop, Susini founded his own workshop in 1600 but continued also to make casts from Giambologna's models. Thanks to Susini's technical skill, Giambologna's workshop was famous for the production of high-quality replicas of the master's works.

Giovanni Francesco Susini
(active from c.1596 – died Florence 1653)
A nephew of Antonio Susini's. After Antonio's death in 1624 he took over his workshop in the Via dei Pilastri in Florence, where he continued the tradition of making aftercasts from

models by Giambologna. Among the best known of his own bronzes are the statuettes of *Venus burning Cupid's arrows* and *Venus chastising Cupid*, which have survived in casts dated 1638 and 1639 respectively, in the collections of the Reigning Princes of Liechtenstein in Vaduz and in the Louvre.

Jacopo Tatti, see Sansovino

Il Tribolo (Niccolò de' Pericoli)
(1500 Florence – Florence 1550)
Niccolò Tribolo was a pupil of Jacopo Sansovino's in 1511–18, when Sansovino was working on his statue of *St James* for the Cathedral in Florence. Later Tribolo was active in Rome, Bologna, Pisa, Loel Sarto, he was influenced above all by Michelangelo, with whom he worked in the New Sacristy of San Lorenzo in Florence. Among his most successful creations are decorative sculptures such as the fountains of the Medici Villa at Castello near Florence. Tribolo worked chiefly in marble. The only bronze sculpture known with certainty to be his is a small *Faun*, sitting on a vase and playing the flute, in the Museo Nazionale del Bargello in Florence. The marked torsion of this figure is an anticipation of works by Giambologna designed to be seen in the round.

Alessandro Vittoria
(1525 Trent – Venice 1608)
Alessandro Vittoria was probably first trained in his home town of Trent by the Paduan sculptors Vincenzo and Giangirolamo Grandi, who were then active there. In 1543 he entered Sansovino's workshop in Venice. No less important to his development, however, was a stay in Vicenza from 1551 to 1553, where he worked in stucco and became acquainted with the art of Palladio, Giulio Romano and Parmigianino. Supported by Pietro Aretino among others, he became Sansovino's successor and, by the end of the sixteenth century, the dominant artistic personality in Venice.

Vittoria was also an architect and dabbled in painting; he worked in stucco, bronze and marble, and in his youth also as a medalist. His numerous stucco decorations, such as the Scala d'Oro in the Doge's palace and the staircase in the Biblioteca Marciana, and his numerous altars and tombs in churches, are important landmarks of Venetian sculpture. His portrait busts are among the finest in the genre and will stand comparison with the masterpieces of Venetian painting. The same is true of his bronzes, which include, in chronological order, a statuette of *Diana* in Berlin, one of *Mercury* – probably originally a companion piece – in the Getty Museum at Malibu, the figure of *Winter* or a *Philosopher* in Vienna, a statuette of *Jupiter* in the Musée de la Renaissance at Écouen, and the so-called Pala Fugger in the Chicago Art Institute.

Vittoria's immediate pupils were not sculptors of importance. His style was much imitated, however; it influenced Camillo Mariani and, through him, the young Bernini, and can be felt in Venetian and also Austrian sculpture of the eighteenth century.

Adriaen de Vries

(c.1545 The Hague – Prague 1626)

Nothing is known of the earliest artistic training of Adriaen de
Vries (or Fries, as he himself spelt it). However, he is traceable
in Florence in 1581, as an assistant in Giambologna's workshop,
and in 1588 was appointed court sculptor to Duke Carl
Emmanuel I of Savoy at Turin. By 1593 at latest he was in the
service of the Emperor Rudolf II in Prague. In 1595 he was for a
time in Rome and in 1596 in Augsburg, where he carried out
work on the bronze figures of the Mercury and Hercules Foun-
tains, completed in 1602. He was appointed court sculptor to
the Emperor in 1601 and moved to Prague probably in 1602;
there he worked chiefly for the Emperor until the latter's death
in 1612. Subsequently he carried out commissions for Count
Ernst von Schaumburg-Lippe, King Christian IV of Denmark,
and Prince Albrecht von Waldstein. His works – nearly all in
bronze as far as is known – consist of religious sculptures, por-
trait busts and reliefs, statuettes, tombs, fountains and garden
figures. Many are now in the gardens of Drottningholm,
having reached Sweden as booty from the Thirty Years' War
(1618–1648) or the Swedish–Danish war (1659).

Together with Hubert Gerhard, Adriaen de Vries is regarded
as the principal bronze sculptor of the late Renaissance north of
the Alps.

List of inventories

relevant to the history of provenances of the bronzes in the Vienna Collection

A. Ambraser Sammlung (The Ambras Collection)

Inventar des Nachlasses Erzherzog Ferdinands II. in Ruhelust, Innsbruck und Ambras, dated 30 May 1596: Sammlung für Plastik und Kunstgewerbe in the Kunsthistorisches Museum, Vienna, inv. no. 6652. Another copy is in the manuscript collection of the Nationalbibliothek, Vienna, inv. Cod. Mscrpt. 8228. This was published by W. Boeheim in *Jahrbuch der Kunsthistorischen Sammlungen des Allerhöchsten Kaiserhauses*, VII/2, 1888, pp. CCXXVI–CCCXII, and X, 1889, pp. I–X.

Inventar "über das Fürstlich Schloß Ambras", 1603: Landesregierungsarchiv für Tirol, Innsbruck, inv. no. A 40/10.

Inventar des Schlosses Ambras, 1613: Sammlung für Plastik und Kunstgewerbe in the Kunsthistorisches Museum, Vienna, inv. no. 6653.

Inventar des Schlosses Ambras, 1621: Sammlung für Plastik und Kunstgewerbe in the Kunsthistorisches Museum, Vienna, inv. no. 6654. A copy is in the Landesregierungsarchiv für Tirol, Innsbruck, inv. no. A 40/13.

"Haubt Inventarij über die Kunstkammer des Erzfürstlichen Schlosses zu Ambras", 1663: Landesregierungsarchiv für Tirol, Innsbruck, inv. no. A 40/21.

Inventar des Schlosses Ambras, 1666: presumably in the manuscript collection of the Österreichische Nationalbibliothek, Vienna. A typewritten transcript is in the Archiv der Sammlung für Plastik und Kunstgewerbe in the Kunsthistorisches Museum, Vienna.

Inventar der Kunstkammer des Schlosses Ambras, 1680; Landesregierungsarchiv für Tirol, Innsbruck, inv. no. A 40/23.

Inventar der Kunstkammer des Schlosses Ambras, 1696; Landesregierungsarchiv für Tirol, Innsbruck, inv. no. 40/24.

Inventar des Schlosses Ambras, 1704: Landesregierungsarchiv für Tirol, Innsbruck, inv. no. 40/26 und 40/27.

Inventar des Schlosses Ambras, 1730, by Anton Roschmann; Sammlung für Plastik und Kunstgewerbe in the Kunsthistorisches Museum, Vienna, inv. no. 6656.

Inventar des Schlosses Ambras, 1788, by Johann Primisser; Sammlung für Plastik und Kunstgewerbe in the Kunsthistorisches Museum, Vienna, inv. nos. 6657–6659 and 6660–6662.

Inventar des Schlosses Ambras, 1811, Restbestände nach 1806 Sammlung für Plastik und Kunstgewerbe in the Kunsthistorisches Museum, Vienna, inv. no. 6665.

Supplementinventar der K.K. Ambraser Sammlung, 1806–1824; Archiv der Sammlung für Plastik und Kunstgewerbe in the Kunsthistorisches Museum, Vienna, (unnumbered).

Inventar der K.K. Ambraser Sammlung in Wien, 1821; Sammlung für Plastik und Kunstgewerbe in the Kunsthistorisches Museum, Vienna, inv. no. 6675.

Acquisitionsjournal der K.K. Ambraser Sammlung 1871–1877, Nachträge seit 1876(–1880): Archiv der Sammlung für Plastik und Kunstgewerbe in the Kunsthistorisches Museum, Vienna.

"Theil-Inventar über die zum beweglichen Fideicommiss-Vermögen des a.d. Erzhauses gehörige von dem K.K. Oberst-kämmererstabe verwahrte K.K. Ambraser Sammlung, 1877";

Sammlung für Plastik und Kunstgewerbe in the Kunsthistorisches Museum, Vienna.

Inventar, (Nachträge seit 1876) bis 1899. Sammlung für Plastik und Kunstgewerbe in the Kunsthistorisches Museum, Vienna.

"Inventarium der im K.K. Schlosse Ambras befindlichen Sammlungsgegenstände und Gemaelde", 1870; Sammlung für Plastik und Kunstgewerbe in the Kunsthistorisches Museum, Vienna.

Inventar der auf Schloss Ambras verbliebenen Kunstgegenstände, not including those on loan from the Sammlung für Plastik und Kunstgewerbe in the Kunsthistorisches Museum, Vienna, 1982.

B. The Kunstkammer of Emperor Rudolf II and Nachfolgesammlungen

Das Kunstkammerinventar Kaiser Rudolfs II., 1607–1611, "Von Anno 1607, Verzaichnus was in der Röm:Kay: May: Kunst-cammer gefunden worden": manuscript in the Library of the Reigning Prince of Liechtenstein; published, edited by R. Bauer and H. Haupt, in *Jahrbuch der Kunsthistorischen Sammlungen in Wien*. LXXII, 1976.

Fragment eines Inventars der Kunstgegenstände aus dem Nachlass des Kaisers Matthias in der Burg zu Wien, verfasst nach Juni 1619. "Allerlei türgsche porzelen, terra sigelata und ander messingen und dergleichen sachen – allerlei schone stuckh von messing." Manuscript in Wolfenbüttel Library, inv. no. Novi 371. Published by W. Köhler in *Jahrbuch der Kunsthistor-ischen Sammlungen des Allerhöchsten Kaiserhauses*, XXVI, 1906–07, Regest 19449, pp. XIII–XVI.

Inventar der Prager Schatz- und Kunstkammer dated 6 December 1621: Manuscript collection of the Österreichische Nationalbibliothek, Vienna, inv. no. 8196. Published with supplementary material from the records of the Imperial and Royal Chancellery in Vienna, by H. Zimmermann in *Jahrbuch der Kunsthistorischen Sammlungen des Allerhöchsten Kaiserhauses*, XXV, 1905, pp. XIII–LXXV.

C. The Kunstkammer of Archduke Leopold Wilhelm

Inventar der Kunstsammlung des Erzherzogs Leopold Wilhelm von Österreich aus dem Jahre 1659: manuscript in the Fürstlich Schwarzenberg'schen Zentral-Archiv in Vienna. Published by A. Berger in *Jahrbuch der Kunsthistorischen Sammlungen des Aller-höchsten Kaiserhauses*, I/II, 1883, pp. LXXIX–CLXXVII.

Ferdinand Storffer (properly Astorffer), "Gemaltes Inven-tarium der Aufstellung der Gemäldegalerie in der Stallburg", 3 volumes, 1720–33, particularly vol. II, 1730. Archiv der Gemäldegalerie in the Kunsthistorisches Museum, Vienna.

Francisco de Stampart and Antonio de Prenner, *Prodromus* or "Vor-Licht des eröffneten Schau- und Wunder-Prachtes aller deren an dem Kaiserl.Hof . . . Carl des Sechsten . . . sich befind-lichen Kunst-Schätzen und Kostbarkeiten", Vienna 1735. (30 etched plates.) Published by H. Zimmermann in *Jahrbuch der Kunsthistorischen Sammlungen des Allerhöchsten Kaiserhauses*, VII, 1888, pp. VII–XIV. Reg. 4584.

D. The Imperial Treasury

"Inventarium der Kayserlichen Kleinen Geheimen Schatz-Camer. De Anno MDCCXXXI", 1731: Archiv der Schatzkammer in the Kunsthistorisches Museum, Vienna, no. Ia/b. Published by H. Zimmermann in *Jahrbuch der Kunsthistorischen Sammlungen des Allerhöchsten Kaiserhauses*, X, 1889, pp. CCII–CCXLIII, Regest 6241.

"Inventarium Thesauri Imperialis Viennensis", 1750: Archiv der Schatzkammer in the Kunsthistorisches Museum, Vienna, no. II a/b. Published by H. Zimmermann in *Jahrbuch der Kunsthistorischen Sammlungen des Allerhöchsten Kaiserhauses*, X, 1889, pp. CCLI–CCCXXIV, Reg. 6253.

Inventar der Kaiserlichen Schatzkammer, 1773; Archiv der Schatzkammer in the Kunsthistorisches Museum, Vienna, no. IV.

Inventar der Kaiserlichen und Königlichen Schatzkammer, 1785; Archiv der Schatzkammer in the Kunsthistorisches Museum, Vienna, no. V.

Inventar der K.K. Schatzkammer, 1797; Archiv der Schatzkammer in the Kunsthistorisches Museum, Vienna, no. VI.

Inventar der K.K. Schatzkammer, 1815; Archiv der Schatzkammer in the Kunsthistorisches Museum, Vienna, no. VII a/b.

Inventar der K.K. Schatzkammer, 1826; Archiv der Schatzkammer in the Kunsthistorisches Museum, Vienna, no. VIIIb.

Inventar der K.K. Schatzkammer, 1841; Archiv der Schatzkammer in the Kunsthistorisches Museum, Vienna, no. VIIIa.

Inventar der K.K. Schatzkammer, 1842; Archiv der Schatzkammer in the Kunsthistorisches Museum, Vienna, no. IX.

Inventarium des Habsburg-Lothringischen Hausschatzes, 1874; Archiv der Schatzkammer in the Kunsthistorisches Museum, Vienna, no. XII.

E. The collection of Josef Angelo de France

G.H. Martini, "Musei Franciani Descriptio: Pars Posterior, comprehendens Signa, Capita et Imagines, quas Protomas vulgo appellant, Anaglypha, seu Caelata Opera, Vasa, Pocula, Pateras, aliam Supellectilem et Instrumenta, Res Varias et Miscellas", Leipzig 1781.

F. The Imperial and Royal Cabinet of Coins and Antiquities

"Beschreibung des K.K. Münz- und Antiken-Cabinets. Band I., Marmore, Bronzen, Terracotten, Glas", manuscript completed 1819, presented 1821: Archiv der Antikensammlung in the Kunsthistorisches Museum, Vienna, (unnumbered).

"Inventarium des K.K. Münz- und Antiken-Cabinets, die antiken und modernen Münzen, geschnittene Steine, Gemmen, Gold- und Silbergefäße, Marmor, Bronzen und Vasen ec., begreifend, welche den unwandelbaren Hauptstamm dieser K.K. Sammlung bilden. . . . Wien 1821": Archiv der Antikensammlung in the Kunsthistorisches Museum, Vienna, no. 106.

Beschreibung der Antiken Bronzen des K.K. Münz- und Antiken-Cabinets von Eduard Freiherr von Sacken, Wien 1852: Archiv der Antikensammlung in the Kunsthistorisches Museum, Vienna, (unnumbered).

"Cinquecento und moderne Bronzen, indische und orientalische Sculpturen des K.K. Münz- und Antiken Kabinetes", 1863: Archiv der Sammlung für Plastik und Kunstgewerbe in the Kunsthistorisches Museum, Vienna, (unnumbered).

"Theil-Inventar über das zum beweglichen Fideicommiss-Vermögen des a.d. Erzhauses gehörige, von dem K.K. Oberstkämmererstabe verwaltete K.K. Münz- und Antiken-Cabinet, I. und II. Theil, Wien 1875": Archiv der Antikensammlung in the Kunsthistorisches Museums, Vienna, (unnumbered).

G. The Este Collection

Inventar des Nachlasses des Marchese Tomaso degli Obizzi, dated 20 July 1803: Biblioteca del Museo Civico di Padova, Ms.B.P. 1386/VI. Published by P. and P.L. Fantelli, in *Bollettino del Museo Civico di Padova*, LXXI, 1982, pp. 101–238.

F.A. Visconti, "Oggetti di antichità e d'arte esistenti al Catajo, 24. Settembre 1806", published in *Documenti inediti per servire alla storia dei Musei d'Italia*, III, Florence 1880, pp. 28–80.

Inventar des Bronzen-Cabinets der Estensischen Kunstsammlung in Wien (undated, probably end of the 19th century): Archiv der Sammlung für Plastik und Kunstgewerbe in the Kunsthistorisches Museum, Vienna, (unnumbered).

Also further undated and unsystematic inventories.

H. The Current Inventory

"Inventar der Sammlung Kunstindustrieller Gegenstände des Allerhöchsten Kaiserhauses, nach dem Stande vom 31. December 1896, mit Fortsetzung bis zu Gegenwart": Archiv der Sammlung für Plastik und Kunstgewerbe in the Kunsthistorisches Museum, Vienna.

Bibliography

Agghazy, M.G. *Olasz renaissance és barokk kisbronzok*, Szépművészeti Museum, Budapest 1968.

Agghazy, M.G. *'Nuovi aspetti di una Discussione Leonardesca'*, Akademiai Kiadó, Budapest 1969, pp. 743–746.

Agghazy, M.G. 'Leonardo da Vinci, Francesco I el il bronzetto equestre del Museo di Budapest', *Arte Lombarda*, XXXVI, 1972, pp. 91–99.

Alte Goldschmiedearbeiten aus Frankfurtes Privatbesitz und Kirchenschätzen, exhibition catalogue, Kunstgewerbemuseum, Frankfurt am Main, June–September 1914.

Androssow, S.O. *Italienische Bronzen der Renaissance (aus der Sammlung der Staatlichen Ermitage in Leningrad)*, East Berlin 1978.

Androssow, S.O. and Faenson, L.I. *Italienische Bronzen der Renaissance (aus der Sammlung der Staatlichen Ermitage in Leningrad)*, exhibition catalogue, Berlin, n.d. (c. 1978).

Androssow, S.O. 'Bemerkungen zu Kleinplastiken zweier Ausstellungen (Leningrad, 1977–Budapest, 1978)', *Acta Historiae Artium Academiae Scientiarum Hungaricae*, XXVI, 1–2, 1980, pp. 143–157.

Androssow, S.O. *Kudozhestvennaya Bronza Ital'ianskogo Voepozhdeneia*, Leningrad, 1977.

Arnaiz, P.M. 'La Exposicion Giambolnia y sus conexiones con el Patrimonio Nacional y otros Museos de España', in *Reales Sitios*, XVI/60, 1979, pp. 57–62.

Arndt, K. 'Studien zu Georg Petel', *Jahrbuch der Berliner Museen*, 1967, pp. 165–231.

Art the Ape of Nature: Studies in Honor of H.W. Janson, edd. M. Barash and L.F. Sandler, New York 1981.

Asche, S. *Balthasar Permoser unde die Barockskulptur des Dresdner Zwingers*, Frankfurt am Main, 1966.

Aufgang der Neuzeit. Deutsche Kunst und Kultur von Dürers Tod bis zum Dreissigjahrigen Krieg, 1530–1650, exhibition catalogue, Germanisches Nationalmuseum (Nuremberg), Bielefeld 1952.

Avery, C. *Florentine Renaissance Sculpture*, London 1970.

Avery, C. 'Hendrick de Keyser as a sculptor of small bronzes', *Bulletin van het Rijksmuseum*, XXI, 1973, no. 1, pp. 3–24.

Avery, C. and Keeble, K.C. *Florentine Baroque Bronzes and other Objects of Art*, Royal Ontario Museum, Toronto 1975.

Avery, C. 'Soldani's Small Bronze Statuettes after "Old Masters" Sculptures in Florence', in *Kunst des Barock in der Toscana – Studien zur Kunst unter den letzten Medici*, Munich 1976, pp. 165–172.

Avery, C. 'Sculpture in the Rijksmuseum (review of J. Leeuwenberg and W. Halsema-Kubes 1973)', *The Burlington Magazine*, CXIX, 1977, no. 886, pp. 42–44.

Avery, C. in *Giambologna 1529–1608, Ein Wendepunkt der Europäischen Plastik*, exhibition catalogue, Vienna 1978/79.

Avery, C. 'Hubert le Sueurs portraits of King Charles I in bronze at Stourhead, Ickworth and elsewhere', *National Trust Studies*, 1979, pp. 128–147.

Avery, C. *Studies in European Sculpture*, London 1981.

Avery, C. and Radcliffe, A.F. 'Severo Calzetta da Ravenna: New Discoveries', in *Studien zum Europäischen Kunsthandwerk: Festschrift Yvonne Hackenbroch*, Munich 1983, pp. 107–122.

Avery, C. in *Important Renaissance Bronzes, Sculpture and Works of Art*, sale catalogue, Christie's, London, 15 May 1984.

Bachmann, E. 'Einige unveröffentlichte Elfenbeine aus dem Anfang des 18. Jahrhunderts', *Wiener Jahrbuch für Kunstgeschichte*, XV, 1953, pp. 136–144.

Baldass, L. 'Neuerwerbungen des Budapester Museums der Bildenden Künste', *Kunst und Kunsthandwerk*, XX, 1917, pp. 396, 397.

Balogh, J. *Die Sammlungen Alter Skulpturen (Führer durch die Sammlungen des Museums der Bildenden Künste)*, Budapest 1965.

Balogh, J. *Katalog der Ausländischen Bildwerke des Museums der Bildenden Künste in Budapest, IV.–XVIII. Jahrhundert*, 2 vols, Budapest 1975.

Baldinucci, F. *Delle notizie de' Professori del disegno da Cimabue in qua* (1688), ed. D.M. Manni, Florence 1770–72.

Bange, E.F. *Die Bildwerke in Bronze (Die Bildwerke des Deutschen Museums, Band II)*, Berlin-Leipzig 1923.

Bange, E.F. in *Die Sammlung Dr. Eduard Simon*, sale catalogue, Galerie Hugo Helbing, vol. 1, Berlin 1929.

Bange, E.F. *Die Deutschen Bronzestatuetten des 16. Jahrhunderts*, Berlin 1949.

Bauer, R. and Haupt, H. 'Das Kunstkammerinventar Kaiser Rudolfs II., 1607–1611', *Jahrbuch der Kunsthistorischen Sammlungen in Wien*, LXXII, 1976.

Bayerisches Nationalmuseum. Bildführer I, Munich 1974.

Bayerische Rokokoplastik – Vom Entwurf zur Ausführung, exhibition catalogue, Bayerisches Nationalmuseum, Munich 1985.

Beck, H. in *Dürers Verwandlungen in der Skulptur zwischen Renaissance und Barock*, exhibition catalogue, Liebieghaus, Frankfurt am Main 1982.

Beck, H. 'Von der Kunstkammer zum bürgerlichen Wohnzimmer', in *Natur und Antike in der Renaissance*, exhibition catalogue, Frankfurt am Main 1985/86, pp. 282–304.

Belloni, G.G. *Il Castello Sforzesco di Milano*, Milan 1966.

Bennett, B.A. and Wilkins, D.G. *Donatello*, Oxford 1984.

Berger, A. 'Inventar der Kunstsammlung des Erzherzogs Leopold Wilhelm von Österreich. Nach der Originalhandschrift im fürstlich Schwarzenberg'schen Centralarchive . . .', *Jahrbuch der Kunsthistorischen Sammlungen des Allerhöchsten Kaiserhauses*, I/2, 1883, pp. LXXIX–CLXXVII.

Bergmann, J. *Pflege der Numismatik in Österreich im XVIII. Jahrhundert. Mit besonderem Hinblick auf das k.k. Münz- und Antiken-Cabinet in Wien*, Vienna 1856.

Bernhart, M. *Die Plakettensammlung Alfred Walcher Ritter von Molthein*, sale catalogue, Galerie Hugo Helbing, Munich 1926.

Bertaux, E. 'Trois Chefs-D'Oeuvres Italiens de la Collection Aynard', *La Revue de l'Art ancien et moderne*, XIX, 1906, pp. 81–96.

Bertaux, E. *Donatello*, Paris 1910.

Bertaux, E. *Musée Jacquemart-André, Catalogue itinéraire*, sixième édition, Paris 1929.

Blanc, C. *Collection d'objets d'art de M. Thiers léguée au musée du Louvre*, Paris 1884.

Blume, D. 'Antike und Christentum', in *Natur und Antike in der Renaissance*, Frankfurt am Main 1985/86, pp. 84–129.

Blume, D. 'Mythos und Widerspruch – Herkules oder die Ambivalenz des Helden', ibid., pp. 131–138.

Blume, D. 'Beseelte Natur und ländliche Idylle', ibid., pp. 173–197.

Bober, P. 'The Census of Antique Works of Art Known to Renaissance Artists', in *The Renaissance and Mannerism – Studies in Western Art. Acts of the Twentieth International Congress of the History of Art*, vol. II, Princeton, New Jersey 1963, pp. 82–89.

Bode, W. *Denkmäler der Renaissanceskulptur Toscanas*, Munich 1892–1905.

Bode, W. 'Bertoldo di Giovanni und seine Bronzebildwerke', *Jahrbuch der Königlich Preuszischen Kunstsammlungen*, XVI, 1895, pp. 143–159.

Bode, W. 'Moderno', *Kunstchronik*, XV, 1903–1904, p. 269.

Bode, W. *Die Italienische Bronzen (Königliche Museen zu Berlin, Beschreibung der Bildwerke der christlichen Epochen, zweite Auflage, Band II)*, Berlin 1904.

Bode, W. *Die Italienischen Bronzestatuetten der Renaissance*, 3 vols, Berlin 1907.

Bode, W. *The Italian Bronze Statuettes of the Renaissance*, 3 vols, Berlin 1907–1912.

Bode, W. *Florentiner Bildhauer der Renaissance*, zweite Auflage, Berlin 1910.

Bode, W. *Collection of J. Pierpont Morgan – Bronzes of the Renaissance and Subsequent Periods*, 2 vols, Paris 1910.

Bode, W. 'Gian Bologna und seine Tätigkeit als Bildner von Kleinbronzen', *Kunst und Künstler*, IX, 1911.

Bode, W. *Catalogue of the Collection of Pictures and Bronzes in the Possession of Mr. Otto Beit*, London 1913.

Bode, W. *Florentiner Bildhauer der Renaissance*, vierte Auflage, Berlin 1921.

Bode, W. *Die Italienischen Bronzestatuetten der Renaissance – Kleine neu bearbeitete Ausgabe*, Berlin 1922.

Bode, W. *Bertoldo und Lorenzo dei Medici*, Freiburg im Breisgau 1925.

Bode, W. *Staatliche Museen zu Berlin, Die Italienischen Bildwerke der Renaissance und des Barock*, Band II: *Bronzestatuetten, Büsten und Gebrauchsgegenstände*, vierte Auflage, Berlin/Leipzig 1930.

Bode, W. and Draper, J.D. *The Italian Bronze Statuettes of the Renaissance*, by W. Bode, new edition edited and revised by J.D. Draper, New York 1980.

Boeheim, W. 'Urkunden und Regesten aus der k.k. Hofbibliothek', *Jahrbuch der Kunsthistorischen Sammlungen des Allerhöchsten Kaiserhauses*, VII/2, Wien 1888, pp. XCI–CCCXV.

Bombe, W. 'Danti, Vincenzo', in *Allgemeines Lexikon der Bildenden Künstler von der Antike bis zur Gegenwart*, edd. U.

Thieme and F. Becker, vol. 8, Leipzig 1913, pp. 384–387.

Borghini, R. *Il Riposo, in cui della pittura e della scultura si favella, de' più illustri pittori e scultori, ed delle più famose opere loro si fa mentione; e le cose principali appartenenti a dette arti s'insegnano*, Florence 1584.

Bowron, E.P. *Renaissance Bronzes in the Walters Art Gallery*, Baltimore 1978.

Braun, E.W. *Die Bronzen der Sammlung Guido von Rhò in Wien*, (Österreichische Privatsammlungen, Band I), Vienna 1908.

Braun, E.W. 'Circe', in *Reallexikon zur Deutschen Kunstgeschichte*, Band III, Stuttgart 1954, pp. 777–788.

Bräutigam, G. 'Erwerbungen', *Anzeiger des Germanischen Nationalmuseums, 1982*, pp. 111, 112, fig. 5.

Bredekamp, H. 'Mythos und Widerspruch – Der "Traum vom Liebeskampf" als Tor zur Antike', in *Natur und Antike in der Renaissance*, exhibition catalogue, Frankfurt am Main 1985/86, pp. 131–138.

Bredekamp, H. 'Mythos und Widerspruch – Schönheit und Schrecken', ibid., 1985/86, pp. 153–172.

Brinckmann, A.E. *Barockskulptur*, Handbuch der Kunstwissenschaft, Band I, Berlin–Neubabelsberg 1917 (dritte Auflage, Potsdam, n.d.).

Brinckmann, A.E. 'Deutsche Kleinbronzen um 1600', in *Jahrbuch der preuszischen Kunstsammlungen*, XLII, 1921, pp. 147–160.

Brinckmann, A.E. *Süddeutsche Bronzebildhauer des Frühbarocks*, Munich 1923.

Brommer, F. *Herakles, Die zwölf Taten des Helden in Antiker Kunst und Literatur*, Münster–Cologne 1953.

Brown, C.M. '"Lo insaciabile desiderio Nostro de cose antique": New Documents on Isabella d'Este's Collection of Antiquities', in *Cultural Aspects of the Italian Renaissance*, ed. C.H. Clough, Manchester–New York 1976, pp. 324–353.

Brown, C.M. and Lorenzoni, A.M. 'The Grotta of Isabella d'Este', *Gazette des Beaux-Arts*, LXXXIX, 1977, pp. 155–171.

Bruegels Tid – Nederländsk konst 1540–1620, exhibition catalogue, Nationalmuseum, Stockholm 1984/85.

Buchwald, C. 'Adriaen de Vries', *Beiträge zur Kunstgeschichte*, N.F. XV, 1899.

Byam Shaw, J. 'A Group of Mantegnesque Drawings, and Their Relation to the Engravings of Mantegna's School', *Old Master Drawings*, XI, March 1937, pp. 57–60.

Cannata, P. *Rilievi e Placchette dal XV al XVIII secolo*, exhibition catalogue, Museo di Palazzo Venezia, Rome 1982.

Cannata, P. 'Le Placchette del Filarete', contribution to the symposium on plaquettes organized by the Center for Advanced Study in the Visual Arts, National Gallery, Washington DC March 1985, forthcoming in *Studies in the History of Art*, 1987.

Caramelle, F. *Caspar Gras (1585–1674) – Leben und Werke*, Phil. Diss., Innsbruck 1972 (typescript).

Caramelle, F. 'Caspar Gras (1585–1674), zum 300. Todestag des grossen Bronzekünstlers', in *Tirol – immer einen Urlaub wert!*, V, 1974/75.

Castelfranco, G. *Il Quattrocento Toscano*, Milan 1968.

Cessi, F. *Alessandro Vittoria, Bronzista (1525–1608)*, Collana Artisti Trentini, Trent 1960.

Cessi, F. *Andrea Briosco, detto il Riccio, Scultore (1470–1532)*, Collana Artisti Trentini, Trent 1965.

Cessi, F. *Vincenzo e Gian Gerolamo Grandi, Scultori (sec XVI]*, Collana Artisti Trentini, Trent 1967.

Ciardi Dupré, M.G., *I bronzetti del Rinascimento*, Milan 1966.

Ciardi Dupré dal Poggetto, M.G. 'Proposte per Vittore Ghiberti', in *Lorenzo Ghiberti nel suo tempo, Atti del Convegno Internazionale di Studi (Firenze 18–21 ottobre 1978)*, Florence 1980.

Cicognara, L. *Storia della scultura dal suo Risorgimento in Italia sino al secolo di Napoleone; per servire di continuazione alle opere di Winckelmann e di d'Agincourt*, 3 vols, Venice 1813–18.

Cope, M.E. *The Venetian Chapel of the Sacrament in the Sixteenth Century*, Garland Outstanding Dissertations in the Fine Arts, New York–London 1979 (1965).

Cordonnier, E. 'A propos d'une plaquette de Moderno', *Arethuse*, IV, no. 4, 1927, pp. 182–188.

Cott, P.B. *National Gallery of Art, Washington: Renaissance Bronzes, Statuettes, Reliefs and Plaquettes, Medals and Coins from the Kress Collection*, Washington 1951.

Courajod, L. 'Communication au sujet de quelques sculptures de la collection du cardinal de Richelieu', *Bulletin de la Société des Antiquaires de France*, 1882, pp. 218–220.

Courajod, L. 'Communication', *Bulletin de la Société Nationale des Antiquaires de France*, 1883, pp. 148–149 and 268–269.

Courajod, L. 'L'imitation et la contrefaçon des objets d'art antiques au XVᵉ et au XVIᵉ siècle', II, *Gazette des Beaux-Arts*, 1886, pp. 312–330.

Courajod, L. 'Quelques sculptures en bronze de Filarète', *Gazette Archéologique*, 1887, pp. 286–288.

Davis, C. 'The Genius of Venice, 1500–1600. Ausstellung in der Royal Academy of Arts, 25.11.1983–11.3.1984', (review), *Kunstchronik*, XXXVII, March 1984, pp. 81–88.

Decorative Art of the Italian Renaissance 1400–1600, exhibition catalogue, Detroit Institute of Arts, Detroit 1958–59.

Delacre, M. *Le Dessin de Michel-Ange*, Brussels 1938.

Delogu, G. *Antologia della Scultura Italiana – Dall' XI al XIX Secolo*, Milan 1956.

Desjardins, A. *La vie et l'oeuvre de Jean Boulogne, d'après les manuscrits inédits recueillis par Foucques de Vagnonville*, Paris 1883.

Dhanens, E. *Jean Boulogne – Giovanni Bologna Fiammingo (Douai 1529–Florence 1608)*, Brussels 1956.

Dhanens, E. *Bronzen uit de Renaissance – van Donatello tot Frans Duquesnoy behorend tot Belgische privé verzamelingen*, exhibition catalogue, Laarne 1967.

Distelberger, R. and Leithe-Jasper, M. *Kunsthistorisches Museum Wien – Schatzkammer und Sammlung für Plastik und Kunstgewerbe*, London 1982.

Doering, O. *Des Augsburger Patriciers Philipp Hainhofer Beziehung zum Herzog Philipp II. von Pommern-Stettin –*

Correspondenzen aus den Jahren 1610–1619, Quellenschriften für Kunstgeschichte und Kunsttechnik des Mittelalters und der Neuzeit, Vienna 1894.

Draper, J.D. 'Sculpture: Renaissance and Later', in *Highlights of the Untermyer Collection of English and Continental Decorative Arts*, New York 1977, pp. 161, 162, no. 302.

Draper, J.D. 'Andrea Riccio and his Colleagues in the Untermyer Collection – Speculations on the chronology of his statuettes and on attributions to Francesco da Sant'Agata and Moderno', *Apollo*, CVII, no. 193, March 1978, pp. 170–180.

Draper, J.D. 'Giovanni Bologna in Edinburgh, London and Vienna', *Antologia di belle Arti*, II, no. 6, May 1979, pp. 155–156.

Ebenstein, E. 'Der Hofmaler Franz Luycx', *Jahrbuch der Kunsthistorischen Sammlungen des Allerhöchsten Kaiserhauses*, XXVI, 1906–1907, pp. 183–254.

Egg, E. 'Caspar Gras und der Tiroler Bronzeguss des 17. Jahrhunderts', *Veröffentlichungen des Museums Ferdinandeum in Innsbruck*, XL, 1960 (Innsbruck 1961).

Egg, E. 'Gras, Kaspar', in *Neue Deutsche Biographie*, Band VI, Berlin 1964, p. 754.

Eisler, R. 'Die Hochzeitstruhen der letzten Gräfin von Görz', *Jahrbuch der k.k. Zentral-Kommission für Erforschung und Erhaltung der Kunst- und Historischen Denkmale*, III, 1905, pp. 64–175.

Enking, R. 'Andrea Riccio und seine Quellen', *Jahrbuch der Preuszischen Kunstsammlungen*, LXII, 1941, pp. 77–107.

Ernst, R. 'Die Sammlung von Metallarbeiten', in *Das k.k. Österreichische Museum für Kunst und Industrie 1864–1914*, Vienna 1914.

Este Ceramiche Porcellane – L'Arte della Ceramica dal 1700, exhibition catalogue, Chiesa di San Rocco, Este 1979.

Ettlinger, L.D. 'Hercules Florentinus', *Mitteilungen des Kunsthistorischen Institutes in Florenz*, XVI, 1972, pp. 119–142.

Ettlinger, L.D. *Antonio and Piero Pollaiuolo*, Oxford 1978.

L'Europe humaniste, exhibition catalogue, Brussels 1954–55.

Fabriczy, C. von 'Une oeuvre inconnue d'Adriano Fiorentino', *Courrier de l'Art*, 1885, pp. 412–413.

Fabriczy, C. von 'Adriano Fiorentino', *Jahrbuch der Königlich Preuszischen Kunstsammlungen*, XXIV, 1903, pp. 71–98.

Fabriczy, C. von 'Rezension von Julius von Schlosser, Album ausgewählter Gegenstände der kunstindustriellen Sammlung des Allerhöchsten Kaiserhauses', *Repertorium für Kunstwissenschaft*, XXV, Heft 3, 1903, pp. 222–227.

Falke, O. von *Die Kunstsammlung Eugen Gutmann*, Berlin 1912.

Falke, O. von *Die Kunstsammlung von Pannwitz, II, Skulpturen und Kunstgewerbe*, Munich 1925.

Feuchtmayr, K. and Schädler, A. *Georg Petel 1601/2–1634*, Berlin 1973.

Feulner, A. *Die Deutsche Plastik des siebzehnten Jahrhunderts*, Florence–Munich 1926.

Fleischhauer, W. *Die Geschichte der Kunstkammer der Herzöge von*

Württemberg in Stuttgart, Stuttgart 1976.

Fletcher, J.M. 'Isabella d'Este, Patron and Collector', in *Splendours of the Gonzaga*, exhibition catalogue, Victoria and Albert Museum, London 1981, pp. 51–63.

Fock, C.W. 'Der Goldschmied Jacques Bylivelt aus Delft und sein Wirken in der Mediceischen Werkstatt in Florenz', *Jahrbuch der Kunsthistorischen Sammlungen in Wien*, LXX, 1974, pp. 89–178.

Francqueville, R. de *Pierre de Francqueville – Sculpteur des Médicis et du roi Henri IV, 1548–1615*, Paris 1968.

Frankenburger, M. 'Jamnitzer, Wenzel I', in *Allgemeines Lexikon der Bildenden Künstler*, edd. U. Thieme und F. Becker, vol. 18, Leipzig 1925, pp. 369–374.

Frimmel, T. *Katalog der Historischen Bronze-Ausstellung im k.k. Österreichische, Museum für Kunst und Industrie*, Vienna 1883.

Frimmel, T. 'Die Bellerophongruppe des Bertoldo', *Jahrbuch der Kunsthistorischen Sammlungen des Allerhöchsten Kaiserhauses*, V, 1887, pp. 90–96.

Frimmel, T. *Der Anonimo Morelliano (Marcanton Michiels Notizie d'Opere del Disegno)*, Quellenschriften für Kunstgeschichte und Kunsttechnik, Vienna 1888.

Frommel, C.L. *Baldassare Peruzzi als Maler und Zeichner*, Vienna–Munich 1967–68.

Frosien-Leinz, H. 'Antikisches Gebrauchsgerät – Weisheit und Magie in den Öllampen Riccios', in *Natur und Antike in der Renaissance*, exhibition catalogue, Frankfurt am Main 1985–86, pp. 226–257.

Frosien-Leinz, H. 'Das Studiolo und seine Ausstattung', ibid., pp. 258–281.

Führer durch das Österreichische Museum für Kunst und Industrie, Vienna 1929.

Führer durch die Sammlung Gustav Benda, Vienna 1932.

Fürtwaengler, A. *Die antiken Gemmen*, Leipzig 1900.

Gábor, I. *Medaillen und Plaketten der Renaissance und Barocke – Sammlungen des Ingen. Ignaz Gábor*, Budapest 1923 (Manuscript catalogue in the library of the Cleveland Museum of Art).

Galassi, G. *La Scultura Fiorentina del Quattrocento*, Milan 1949.

Gamber, O. and Beaufort-Spontin, C. *Curiositäten und Inventionen aus Kunst- und Rüstkammer*, exhibition catalogue, Vienna 1978.

Gauricus, P. *De Sculptura, Florenz 1504. Mit Einleitung und Übersetzung neu herausgegeben von Heinrich Brockhaus*, Leipzig 1886.

Gauricus, P. *De Sculptura*, edd. A. Chastel and R. Klein, Geneva–Paris 1969.

Geese, U. 'Antike als Programm – Der Statuenhof des Belvedere im Vatikan', in *Natur und Antike in der Renaissance*, exhibition catalogue, Frankfurt am Main 1985–86, pp. 24–50.

Gericke, T. 'Die Bändigung des Pegasos', *Mitteilungen des Deutschen Archäologischen Instituts–Athener Abteilung*, LXXI, 1956, pp. 193–201, Beilagen 108–112.

Lorenzo Ghiberti nel suo tempo, Atti del Convegno Internazionale di Studi, Firenze 1978, 2 vols, Florence 1980.

Giambologna, 1529–1608: Sculptor to the Medici, exhibition catalogue, Victoria and Albert Museum, edd. C. Avery and A.F. Radcliffe, London 1978.

Giambologna, 1529–1608: ein Wendepunkt der Europäischen Plastik, exhibition catalogue, Kunsthistorisches Museum Vienna, edd. C. Avery, A.F. Radcliffe and M. Leithe-Jasper, Vienna 1978–1979.

Gibbon, A. and Banks, G. *Bronzes de la Renaissance*, Paris 1982.

Goldschmidt, F. *Die Italienischen Bronzen der Renaissance und des Barock (Königliche Museen zu Berlin, Beschreibung der Bildwerke der christlichen Epochen, Band II)*, dritte Auflage, Berlin 1914.

Goldschmidt, F. in *Die Sammlung Richard von Kaufmann, Berlin*, Band III, *Die Bildwerke*, Berlin 1917.

Goldschmidt, F. 'Die Heiligenfiguren des Alessandro Vittoria', *Amtliche Berichte aus den Preuszischen Kunstsammlungen*, XL, no. 10, July 1919, pp. 231–240.

Goloubew, V. *Die Skizzenbucher des Jacopo Bellini*, II. Teil, *Das Pariser Skizzenbuch*, Brussels 1908.

Gramaccini, N. 'Das genaue Abbild der Natur – Riccios Tiere und die Theorie des Naturabgusses seit Cennino Cennini', in *Natur und Antike in der Renaissance*, exhibition catalogue, Frankfurt am Main 1985–86, pp. 198–225.

Gramberg, W. *Giovanni Bologna – Eine Untersuchung über die Werke seiner Wanderjahre (bis 1567)*, Phil. Diss., Berlin 1936.

Gramberg, W. 'Notizen zu den Kruzifixen des Guglielmo della Porta und zur Entstehungsgeschichte des Hochaltarkreuzes in S. Pietro in Vaticano – In memoriam Hans Robert Weihrauch', *Münchner Jahrbuch der bildenden Kunst*, Dritte Folge XXXII, 1981, pp. 95–114.

Grünwald, A. *Florentiner Studien*, Prague 1914.

Hackenbroch, Y. *Bronzes, Other Metalwork and Sculpture in the Irvin Untermyer Collection*, New York 1962.

Hackenbroch, Y. 'Italian Renaissance bronzes in the Museum of Fine Arts at Houston', *The Connoisseur*, June 1971, pp. 121–129.

Hall, M. 'Reconsiderations of Sculpture by Leonardo da Vinci – A Bronze Statuette in the J.B. Speed Art Museum', *J.B. Speed Art Museum Bulletin*, XXIX, November 1973, pp. 16–19.

Haskell, F. and Penny, N. *Taste and Antiquity – The Lure of Classical Sculpture 1500–1900*, New Haven–London 1981.

The Hatvany Collection – Highly important Bronzes and Other Works of Art, sale catalogue, Christie's, London 25 June 1980.

Heikamp, D. *L'Antico*, Maestri della Scultura, Milan 1966.

Heinz, G. 'Studien zur Portraitmalerei an den Höfen der Österreichischen Erblande', *Jahrbuch der Kunsthistorischen Sammlungen in Wien*, LIX, 1963, pp. 99–224.

Helbig, W. *Führer durch die öffentlichen Sammlungen klassischer Altertümer in Rom*, vierte Auflage, Tübingen 1963–72.

Herklotz, J. 'Die Darstellung des fliegenden Merkur bei Giovanni Bologna', *Zeitschrift für Kunstgeschichte*, XL, 1977, pp. 270–274.

Hermann, H.J. and Egger, O. 'Aus den Kunstsammlungen des Hauses Este in Wien', *Zeitschrift für Bildende Kunst*, N.F. XVII, 1906, pp. 84–105.

Hermann, H.J. 'Pier Jacopo Alari-Bonacolsi, genannt Antico', *Jahrbuch der Kunsthistorischen Sammlungen des Allerhöchsten Kaiserhauses*, XXVIII, 1909–10, pp. 202–288.

Hermann, H.J. 'Zwei unbekannte Büsten des Erzherzogs Leopold Wilhelm von Hieronymus Duquesnoy d.J. und François Dusart', in *Festschrift für Julius Schlosser zum 60. Geburtstage*, Vienna 1927, pp. 254–266.

Herzner, V. 'Die Kanzeln Donatellos in S. Lorenzo', *Münchner Jahrbuch der bildenden Kunst*, XXIII, 1972, pp. 101–164.

Hibbard, H. *Masterpieces of Western Sculpture from Medieval to Modern*, London 1977.

Hill, G.F. 'Classical Influence on the Italian Medal', *The Burlington Magazine*, XVIII, 1910, pp. 259–268.

Hill, G.F. *A Corpus of Italian Medals of the Renaissance before Cellini*, London 1930.

Hill, G.F. *Medals of the Renaissance*, revised and enlarged by Graham Pollard, London 1978.

Hiller, S. *Bellerophon, ein griechischer Mythos in der römischen Kunst* (Münchner archäologische studien, Band I), Munich 1970.

Hind, A. *Early Italian Engraving*, 8 vols, London 1948.

The Robert von Hirsch Collection, vol. II: *Works of Art*, sale catalogue, Sotheby Parke Bernet & Co, London, 22 June 1978.

Holderbaum, J. *The Sculptor Giovanni Bologna*, Garland Outstanding Dissertations in the Fine Arts, New York–London 1983 (1959).

Holzhausen, W. 'Die Bronzen der Kurfürstlich Sächsischen Kunstkammer zu Dresden', *Jahrbuch der Preußischen Kunstsammlungen*, LIV, 1933, Beiheft, pp. 45–88.

Hunter-Stiebel, P. 'A Statuette of Saint Jerome', *Bulletin, Museums of Art and Archaeology, The University of Michigan*, I, 1978, pp. 42–53.

Hunter-Stiebel, P. *A Bronze Bestiary*, exhibition catalogue, New York 1985.

Ilg, A. and Boeheim, W. *Führer durch die k.k. Ambraser Sammlung (Im unteren Belvedere)*, zweite umgearbeitete Auflage, Vienna 1882.

Ilg, A. 'Adriaen de Fries', *Jahrbuch der Kunsthistorischen Sammlungen des Allerhöchsten Kaiserhauses*, I, 1883, pp. 118–148.

Ilg, A. 'Giovanni da Bologna und seine Beziehungen zum Keiserlichen Hofe', *Jahrbuch der Kunsthistorischen Sammlungen des Allerhöchsten Kaiserhauses*, IV, 1886, pp. 38–51.

Ilg, A. 'Werke des "Moderni" in den Kaiserlichen Sammlungen', *Jahrbuch der Kunsthistorischen Sammlungen des Allerhöchsten Kaiserhauses*, XI, 1890, pp. 100–110.

Ilg, A. *Kunsthistorische Sammlungen des Allerhöchsten Kaiserhauses – Führer durch die Sammlung der Kunstindustriellen Gegenstände*, Vienna 1891.

Imbert, E. and Morazzoni, G. *Le Placchette Italiane, secolo XV–XIX – Contributo ala Conoscenza della Placchetta Italiana*, Milan, no date.

Italian Renaissance Sculpture in the Time of Donatello, exhibition catalogue, Detroit Institute of Arts/Kimbell Art Museum (Fort Worth), Detroit 1985–86.

Italienische Bronzen der Renaissance und des Barock: Statuetten, Reliefs, Medaillen, Plaketten und Gebrauchsgegenstände aus den Museen Berlin, exhibition catalogue (Dresden, Budapest and Prague), Berlin 1967.

Jacob, S. *Italienische Bronzen (Bildhefte des Herzog Anton Ulrich-Museums, Nr. 3)*, Brunswick 1972.

Jacob, S. *Europäische Kleinplastik aus dem Herzog Anton Ulrich-Museum in Braunschweig*, catalogue of the exhibition traveling to Lübeck, Osnabrück and Bielefeld, Brunswick 1976.

Jacobsen, E. 'Plaketten im Museo Correr zu Venedig', *Repertorium für Kunstwissenschaft*, XVI, 1893, pp. 54–75.

Jantzen, J. 'Kleinplastische Bronzeportraits des 15. bis 16. Jahrhunderts und ihre Formen – Werner Gramberg zum 65. Geburtstag', *Zeitschrift des Deutschen Vereins für Kunstwissenschaft*, XVII, 1963, pp. 105–116.

Jestaz, B. 'Travaux récents sur les Bronzes I. Renaissance Italienne; II. Renaissance Septentrionale et Baroque', *La Revue de l'Art*, VI, 1969, pp. 79–81; IX, 1969, pp. 78–81.

Jestaz, B. 'Un bronze inédit de Riccio', *La revue du Louvre et des Musées de France*, XXV, 1975, no. 3, pp. 156–162.

Jestaz, B. 'La statuette de la Fortune de Jean Bologne', *La revue du Louvre et des Musées de France*, XXVIII, 1978, no. 1, pp. 48–52.

Jestaz, B. 'A propos de Jean Bologne', *Revue de l'Art*, XLVI, 1979, pp. 75–82.

Jestaz, B. 'Un groupe de bronze érotique de Riccio', *Monuments et Mémoires*, LXV, 1983, pp. 25–54.

Jestaz, B. *Die Kunst der Renaissance*, Freiburg im Breisgau 1985.

Joannides, P. 'Michelangelo's lost Hercules', *The Burlington Magazine*, CXIX, no. 893, 1977, pp. 550–554.

Joannides, P. 'A supplement to Michelangelo's lost Hercules', *The Burlington Magazine*, CXXIII, no. 943, 1981, pp. 20–23.

Jones, M. *The Art of the Medal*, London 1979.

Keeble, K.C. *European Bronzes in The Royal Ontario Museum*, Toronto 1982.

Keutner, H. 'The Palazzo Pitti "Venus" and Other Works by Vincenzo Danti', *The Burlington Magazine*, C, 1958, pp. 426–431.

Keutner, H. 'Italienische Kleinbronzen', review of the exhibitions in London (July–October 1961), Amsterdam (October 1961–January 1962) and Florence (February–March 1962), *Kunstchronik*, XV, July 1962, pp. 169–177.

Keutner, H. 'Die künstlerische Entwicklung Giambolognas bis zur Aufrichtung der Gruppe des Sabinerinnenraubes', in *Giambologna – Ein Wendepunkt der Europäischen Plastik*, exhibition catalogue, Vienna 1978–79, pp. 19–30.

Keutner, H. *Giambologna – Il Mercurio volante e altre opere giovanili*, Lo specchio del Bargello, no. 17, Florence 1984.

Knapp, F. *Italienische Plastik vom fünfzehnten bis achtzehnten Jahrhundert*, Munich 1923.

Koch, E. 'Das barocke Reitermonument in Österreich', in

Mitteilungen der Österreichischen Galerie 19/20, 1975–1976, nos. 63–64, pp. 32–80.

Koepplin, D. and Falk, T. *Lukas Cranach – Gemälde, Zeichnungen, Druckgraphik*, exhibition catalogue, Kunstmuseum (Basel), Stuttgart 1974.

Köhler, W. 'Aktenstücke zur Geschichte der Wiener Kunstkammer in der Herzoglichen Bibliothek zu Wolfenbüttel', *Jahrbuch der Kunsthistorischen Sammlungen des Allerhöchsten Kaiserhauses*, XXVI, 1906–07, pp. I–XX.

Kriegbaum, F. 'Der Bildhauer Giovanni Bologna', *Münchner Jahrbuch der bildenden Künste*, N.F. III, 1952–53, pp. 37–67.

Kris, E. 'Der Stil "rustique" – Die Verwendung des Naturabgusses bei Wenzel Jamnitzer und Bernard Palissy', *Jahrbuch der Kunsthistorischen Sammlungen in Wien*, N.F. I, 1926, pp. 137–208.

Kunsthistorisches Museum, Schloss Ambras – Die Kunstkammer, Innsbruck 1977.

Ladendorf, H. *Antikenstudium und Antikenkopie – Vorarbeiten zu einer Darstellung ihrer Bedeutung in der mittelalterlichen und neueren Zeit*, Berlin 1953.

Lanckheit, K. *Florentinische Barockplastik – Die Kunst am Hofe der letzten Medici, 1670–1743*, Munich 1962.

Landais, H. *Les Bronzes italiens de la Renaissance*, Paris 1958.

Larsson, L.O. *Adrian de Vries – Adrianus Fries Hagiensis Batavus 1545–1626*, Vienna–Munich 1967.

Larsson, L.O. 'An Equestrian Statuette in the University of Kansas Museum and other Equestrian Portraits of Emperor Rudolf II', *The Register of the Museum of Art, The University of Kansas*, IV, no. I, 1969, pp. 4–16.

Larsson, L.O. 'Bemerkungen zur Bildhauerkunst am Rudolfinischen Hofe', *Uměni*, XVIII, 1970, pp. 172–184.

Larsson, L.O. *Von allen Seiten gleich schön. Studien zum Begriff der Vielansichtigkeit in der europäischen Plastik von der Renaissance bis zum Klassizismus*, Uppsala 1974.

Larsson, L.O. *Nationalmuseum Stockholm – Katalog der Bronzen*, Stockholm 1984 (manuscript).

Larsson, L.O. 'Zwei Frühwerke von Adriaen de Fries', in *Netherlandish Mannerism – Papers given at a symposium in the Nationalmuseum, Stockholm, September 21–22, 1984*, Stockholm 1985.

Lauts, J. *Isabella d'Este, Fürstin der Renaissance, 1474–1539*, Hamburg 1952.

Lazzaroni, M. and Muñoz, A. *Filarete – Scultore e Architetto del secolo XV*, Rome 1908.

Leeuwenberg, J. and Halsema-Kubes, W. *Beeldhouwkunst in het Rijksmuseum*, Amsterdam 1973.

Leithe-Jasper, M. 'Alessandro Vittoria – Beiträge zu einer Analyse seiner figürlichen Plastiken unter Berücksichtigung der Beziehungen zur gleichzeitigen Malerei in Venedig', Phil. Diss, Vienna 1963 (manuscript); resumé in *Mitteilungen der Gesellschaft für vergleichende Kunstforschung in Wien*, XVI/XVII, 1963–65, pp. 26–33.

Leithe-Jasper, M. *Italienische Kleinbronzen und Handzeichnungen*

der Renaissance und des Manierismus aus Österreichischem Staatbesitz, exhibition catalogue, Tokyo 1973.

Leithe-Jasper, M. 'Wenzel Jamnitzer – Der Frühling, der Herbst', in *Renaissance in Österreich*, exhibition catalogue, Schloss Schallaburg 1974.

Leithe-Jasper, M. in *Italienische Kleinplastiken, Zeichnungen und Musik der Renaissance. Waffen des 16. und 17. Jahrhunderts*, exhibition catalogue, Schloss Schallaburg 1976.

Leithe-Jasper, M. in *Das Kunsthistorisches Museum in Wien*, Salzburg and Vienna 1978.

Leithe-Jasper, M. in *Giambologna 1529–1608 – Ein Wendepunkt der Europäischen Plastik*, exhibition catalogue, Vienna 1978–79.

Leithe-Jasper, M. 'Inkunabeln der Bronzeplastik der Renaissance', *Die Weltkunst*, XXI, 1981, pp. 3188–3190.

Leithe-Jasper, M. and Distelberger, R. *The Kunsthistorisches Museum, Vienna. The Treasury and Collection of Sculpture*, London 1982.

Leithe-Jasper, M. in *The Genius of Venice, 1500–1600*, exhibition catalogue, Royal Academy of Arts, edd. J. Martineau and C. Hope, London 1983.

The Lempertz sale catalogue, Cologne 22 November 1971.

Lewis, D. 'A "Modern" Medalist in the Circle of "Antico"', *Studies in the History of Art*, forthcoming 1986.

Lhotsky, A. *Festschrift des Kunsthistorischen Museums zur Feier des fünfzigjährigen Bestandes: II. Teil, Die Geschichte der Sammlungen*, Vienna 1941–45.

Property from the Jack and Belle Linsky Collection, sale catalogue, Sotheby Parke Bernet Co., New York, 21 May 1985.

Lisner, M. 'Das Quattrocento und Michelangelo', in *Stil und Überlieferung in der Kunst des Abendlandes*, Akten des 21. Internationalen Kongresses für Kunstgeschichte in Bonn, Band II: *Michelangelo*, Berlin 1967.

Lisner, M. 'Form und Sinngehalt von Michelangelos Kentaurenschlacht mit Notizen zu Bertoldo di Giovanni', *Mitteilungen des Kunsthistorischen Institutes in Florenz*, XXIV, 1980, pp. 283–344.

Lorenzetti, G: see Vasari, G. (1913).

Lubin, E.R. *European Works of Art – A Selection from the Gallery*, New York 1985.

Macchioni, S. 'Cattaneo, Danese', in *Dizionario Biografico degli Italiani*, vol. 22, Rome 1979, pp. 449–452.

Maclagan, E. *Italian Sculpture of the Renaissance*, Cambridge, Massachusetts 1935.

Maclagan, E. *The Frick Collection Catalogue*, New York 1953.

Mahl, E. in *Katalog der Sammlung für Plastik und Kunstgewerbe, II. Teil, Renaissance*, Kunsthistorisches Museum, Vienna 1966, nos. 181–248.

Mann, J.G. *Wallace Collection Catalogues: Sculpture*, London 1931; reprinted with supplement, London 1981.

Mannheim, C. in *Catalogue des Objets d'Art de la Renaissance composant la Collection de feu M. Eugène Piot*, Paris 1890.

Andrea Mantegna, exhibition catalogue, Mantua 1961.

Mariacher, G. *Venetian Bronzes from the Collections of the Correr*

Museum, Venice, exhibition catalogue, Smithsonian Institution, Washington DC 1968.

Mariacher, G. *Bronzetti Veneti del Rinascimento*, Vicenza 1971.

Marquand, A. *Andrea della Robbia and his Atelier*, 2 vols, Princeton 1922.

Martini, G.H. *Musei Franciani descriptio*, pars posterior, Leipzig 1781.

Marle, R. van *Iconographie de l'art profane*, The Hague 1932.

Matz, F. *Die Dionysischen Sarkophage*, 4 vols, Berlin 1968.

Meller, P. 'Marmi e Bronzi di Simone Bianco', *Mitteilungen des Kunsthistorischen Institutes in Florenz*, XXI, 1977, Heft 2, pp. 199–210.

Meller, S. *Ferenczy István bronzgyüjteményének kiállítása*, Orsz. Magy. Szépművészeti Múzeum, Budapest 1917.

Meller, S. *Die Deutschen Bronzestatuetten der Renaissance*, Florence–Munich 1926.

Menzhausen, J. *Dresdner Kunstkammer und Grünes Gewölbe*, Leipzig 1977.

Mezzetti, A. 'Un "Ercole e Anteo" del Mantegna', *Bollettino d'Arte*, IV, XLIII, 1958, pp. 232–244.

Middeldorf, U. and Goetz, O. *Medals and Plaquettes from the Sigmund Morgenroth Collection*, Chicago 1944.

Middeldorf, U. 'Eine seltene Bronze der Spätrenaissance', *Giessener Beiträge zur Kunstgeschichte*, I, (Festschrift Günther Fiensch zum 60. Geburtstag), 1970, pp. 78–83.

Middeldorf, U. 'Filarete? Für Giulia Brunetti, in alter Freundschaft', *Mitteilungen des Kunsthistorischen Institutes in Florenz*, XVII, 1973, pp. 75–86; reprinted in *Raccolta di Scritti, that is Collected Writings II, 1939–1973*, Florence 1980, pp. 369–376.

Middeldorf, U. 'On the Dilettante Sculptor', *Apollo*, CVII, 1978, pp. 310–322; reprinted in *Raccolta di Scritti, that is Collected Writings, III, 1974–1979*, Florence 1981, pp. 173–202.

Middeldorf, U. *Raccolta di Scritti, that is Collected Writings 1924–1979*, 3 vols, Florence 1979–81 (vol. 1, 1979; vol. 2, 1980; vol. 3, 1981).

Migeon, G. *Catalogue des Bronzes & Cuivres du Moyen Age de la Renaissance et des Temps modernes*, Musée National du Louvre, Paris 1904.

Milkovich, M. in *The Age of Vasari*, exhibition catalogue, Art Gallery, University of Notre Dame, Notre Dame, Indiana, February–March 1970, and University Art Gallery, State University of New York at Binghampton, April–May 1970, pp. 166–186.

Möbius, H. 'Vier Hellenistische Skulpturen', *Antike Plastik*, X, 1970, pp. 39–47.

Molinier, E. *Les Plaquettes – Catalogue raisonné*, 2 vols, Paris 1886.

Molinier, E. in *Catalogue des Objets d'Art et de haute Curiosité composant l'importante Collection Spitzer*, vente à Paris, 2 vols, 1893.

Möller, L.L. 'Über die Florentinische Einwirkung auf die Kunst des Johann Gregor van der Schardt', in *Studien zur Toskanischen Kunst – Festschrift für Ludwig Heinrich Heydenreich zum 23. März 1963*, Munich 1964, pp. 191–204.

Montagu, J. *Bronzes*, London 1963.

Montagu, J. *Review of the Exhibition Renaissance Bronzes in American Collections*, Northampton, Massachusetts, 1964, *The Burlington Magazine*, CVIII, January 1966, p. 46.

Montagu, J. in *The Collecting Muse, a Selection from the Nathalie and Hugo Weisgall Collection*, exhibition catalogue, E.B. Crocker Art Gallery, Sacramento, California 1975.

Montagu, J. 'The Bronze Groups made for the Electress Palatine', in *Kunst des Barock in der Toskana – Studien zur Kunst unter den letzten Medici*, Munich 1976, pp. 126–136.

Moschetti, A. 'Andrea Briosco detto il Riccio – a proposito di una recente pubblicazione', *Bollettino del Museo Civico di Padova*, n.s. III, 1927, pp. 118–158.

Müller-Hofsteede, J. 'Jacques de Backe. Ein Vertreter des florentinisch–römischen Manierismus in Antwerpen', *Wallraf-Richartz-Jahrbuch*, XXXV, 1973, pp. 227–260.

Munhall, E. *Severo Calzetta, called Severo da Ravenna*, exhibition catalogue, The Frick Collection, New York 1978.

Müntz, E. *Donatello*, Paris, n.d. (1885).

Müntz, E. *La Renaissance en Italie*, Paris 1891.

Müntz, E. *Histoire de l'art pendant la Renaissance*, III, *Italie: La fin de la Renaissance*, Paris 1895.

Natur und Antike in der Renaissance, exhibition catalogue, Frankfurt am Main 1985–1986.

Negri-Arnoldi, F. *La Scultura del Rinascimento nell'Italia centrale* (*Storia della Scultura*, III), Milan 1966.

Nesselrath, A. 'Antico and Monte Cavallo', *The Burlington Magazine*, CXXIV, 1982, pp. 353–357.

"Noel" sale catalogue, Christie's, London 9 December 1980.

Oberhuber, K. *Die Kunst der Graphik III: Renaissance in Italien, 16. Jahrhundert* (*Werke aus dem Besitz der Albertina*), Vienna 1966.

Olbricht, K.H. 'Die Kleinplastiken Giambolognas', *Die Kunst und das schöne Heim*, XCI, 1979, Heft II, pp. 743–746.

Olsen, H. *Statens Museums for Kunst – Aeldre udenlandske Skulptur*, 2 vols, Copenhagen 1980.

Osten, G. von der and Vey, H. *Painting and Sculpture in Germany and the Netherlands, 1500–1600*, the Pelican History of Art, Harmondsworth 1969.

Paccagnini, G. *Pisanello alla Corte dei Gonzaga*, Milan 1972.

Parker, K. *Catalogue of the Collection of Drawings in the Ashmolean Museum*, vol. 2: *Italian School*, Oxford 1956.

Paulsen, V. *Les Portraits Romains*, vol. 2, Copenhagen 1974.

Pechstein, K. *Bronzen und Plaketten vom ausgehenden 15. Jahrhundert bis zur Mitte des 17. Jahrhunderts* (*Kataloge des Kunstgewerbemuseums Berlin*, Band III), Berlin 1968.

Peltzer, R.A. 'Johann Gregor von der Schardt (Jan de Zar) aus Nymwegen, ein Bildhauer der Spätrenaissance', *Münchner Jahrbuch der Bildenden Kunst*, X, 1916–1918, pp. 198–216.

Peltzer, R.A. 'Der Bildhauer Hubert Gerhard in München und Innsbruck', *Kunst und Kunsthandwerk*, XXI, 1918, pp. 109–152.

Peltzer, R.A., 'Gras, Caspar' in *Allgemeines Lexikon der Bildenden Künstler*, edd. U. Thieme and F. Becker, vol. 14, Leipzig 1921, pp. 523–524.

Perkins, C. 'Donatello', *Gazette des Beaux Arts*, XXV, no. 2, 1868, pp. 299–320.

Pittoni, L. *Jacopo Sansovino Scultore*, Venice 1909.

Planiscig, L. 'Randglossen zu Venedigs Bronzeplastik der Hochrenaissance', *Jahrbuch der Kunsthistorischen Sammlungen des Allerhöchsten Kaiserhauses*, XXXIV, 1918, pp. 1–24.

Planiscig, L. *Die Estensische Kunstsammlung*, Band I, *Skulpturen und Plastiken des Mittelalters und der Renaissance*, Vienna 1919.

Planiscig, L. *Venezianische Bildhauer der Renaissance*, Vienna 1921.

Planiscig, L. *Die Bronzeplastiken, Statuetten, Reliefs, Geräte und Plaketten (Publikationen aus den Sammlungen für Plastik und Kunstgewerbe, Band IV)*, Vienna 1924.

Planiscig, L. *Die Italienische Bronzestatuette der Renaissance*, Vienna 1925.

Planiscig, L. 'Bronzi minori di Leone Leoni', *Dedalo*, VII, 1926–1927, pp. 544–567.

Planiscig, L. *Andrea Riccio*, Vienna 1927.

Planiscig, L. 'Toskanische Plastiken des Quattrocento', *Jahrbuch der Kunsthistorischen Sammlungen in Wien*, N.F. III, 1929.

Planiscig, L. *Piccoli Bronzi Italiani del Rinascimento*, Milan 1930.

Planiscig, L. 'Moderno', in *Allgemeines Lexikon der Bildenden Künstler*, edd. U. Thieme and F. Becker, vol. 24, Leipzig 1930, pp. 604–606.

Planiscig, L. *La Collezione Auriti*, Natale 1931 (typescript catalogue, with supplement until 1962, in the archive of the direction of the Museo di Palazzo Venezia, Rome).

Planiscig, L. 'Per il quarto centenario della morte di Tullio Lombardo e di Andrea Riccio', *Dedalo*, XII, 1932, pp. 917–920.

Planiscig, L. 'Roccatagliata', Nicolò (Nicolino)', in *Allgemeines Lexikon der bildenden Künstler von der Antike bis zur Gegenwart*, edd. U. Thieme and F. Becker, vol. 38, Leipzig 1934, pp. 443, 444.

Planiscig, L. 'Bronzes of the Italian Renaissance, I, An Unknown Work by Antico', *The Burlington Magazine*, LXVI, 1935, pp. 127, 128.

Planiscig, L. and Kris, E. *Katalog der Sammlungen für Plastik und Kunstgewerbe*, Vienna 1935.

Planiscig, L. and Kris, E. *Kunsthistorisches Museum, Sammlungen für Plastik und Kunstgewerbe, III. Ausstellung – Kleinkunst der Italienischen Frührenaissance*, Vienna 1936.

Planiscig, L. 'Pietro, Tullio und Antonio Lombardo (Neue Beiträge zu ihrem Werk)', *Jahrbuch der Kunsthistorischen Sammlungen in Wien*, N.F. XI, 1937, pp. 87–115.

Planiscig, L. *Katalog der Kunstsammlungen im Stifte Klosterneuburg*, III: *Die Bronzen*, Vienna 1942.

Pollard, G. *Museo Nazionale del Bargello: Medaglie Italiane del Rinascimento (Italian Renaissance Medals)*, Florence 1983.

Pope-Hennessy, J. *Italian Renaissance Sculpture*, London 1958.

Pope-Hennessy, J. *Meesters van het brons der Italiaanse Renaissance*, exhibition catalogue, Amsterdam 1961–62.

Pope-Hennessy, J. (1963[1]), 'Italian Bronze Statuettes I and II', *The Burlington Magazine*, CV, Jan. 1963, pp. 14–23, and Feb. 1963, pp. 58–71; reprinted as 'An Exhibition of Italian Bronze Statuettes', in *Essays on Italian Sculpture*, London–New York 1968, pp. 172–198.

Pope-Hennessy, J. (1963[2]), *Italian High Renaissance and Baroque Sculpture*, London 1963.

Pope-Hennessy, J. 'The Italian Plaquette', *Proceedings of the British Academy*, I, 1964; reprinted in *The Study and Criticism of Italian Sculpture*, New York 1980, pp. 192–222.

Pope-Hennessy, J. introduction in *Renaissance Bronzes in American Collections*, exhibition catalogue, Smith College Museum of Art, Northampton, Massachusetts 1964.

Pope-Hennessy, J. *Renaissance Bronzes from the Samuel H. Kress Collection. Reliefs, Plaquettes, Statuettes, Utensils and Mortars*, London 1965.

Pope-Hennessy, J. *Essays on Italian Sculpture*, London–New York 1968.

Pope-Hennessy, J. assisted by Radcliffe, A.F. *The Frick Collection*, Volume III: *Sculpture, Italian*, New York 1970.

Pope-Hennessy, J. *The Study and Criticism of Italian Sculpture*, New York 1980.

Popham, A.E. *Catalogue of Drawings by Parmigianino*, 3 vols, New York–New Haven 1971.

Primisser, A. *Die kaiserliche-königliche Ambraser-Sammlung*, Vienna 1819.

Prohaska, W. *Kunsthistorisches Museum Wien: II, Gemäldegalerie*, London–Munich–Florence 1984.

Rackham, B. 'Some Maiolica Paintings by Nicola Pellipario', *The Burlington Magazine*, LXVI, 1935, pp. 104–109.

Radcliffe, A.F. *European Bronze Statuettes*, London 1966.

Radcliffe, A.F. 'Ferdinando Tacca, the Missing Link in Florence Baroque Bronzes', in *Kunst des Barock in der Toskana – Studien zur Kunst unter den letzten Medici*, Munich 1976.

Radcliffe, A.F. in *Giambologna – Ein Wendepunkt der europäischen Plastik*, exhibition catalogue, Vienna 1978–79.

Radcliffe, A.F. in *Sculptures from the David Daniels Collection*, exhibition catalogue, The Minneapolis Institute of Arts, October 1979–January 1980, Minneapolis 1979–80, pp. 12–15 and pp. 24–27.

Radcliffe, A.F. 'Antico and the Mantuan Bronze', in *Splendours of the Gonzaga*, exhibition catalogue, Victoria and Albert Museum, London 1981, pp. 44–49.

Radcliffe, A.F. 'Schardt, Tertrode, and some possible sculptural sources for Goltzius', in *Netherlandish Mannerism – Papers given at a symposium in the Nationalmuseum, Stockholm, September 21–22, 1984*, ed. G. Cavalli-Björkman, Stockholm 1985, pp. 97–108.

Ragghianti, C.L. 'La Mostra di scultura italiana antica a Detroit (U.S.A.)', *La Critica d'arte*, III, 1938, pp. 170–183.

Reinach, S. *Pierres gravées*, Paris 1885.

Reinach, S. *Répertoire de la Statuaire grecque et romaine*, vol. II, 1–2, Paris 1897–98.

Reymond, M. *La Sculpture Florentine*, vol. 3, Florence 1899.

Ricci, S. de *The Gustav Dreyfus Collection: Reliefs and Plaquettes*, Oxford 1931.

Riederer, J. 'Metallanalysen von Statuetten der Wurzelbauer-Werkstatt in Nürnberg', *Berliner Beiträge zur Archäometrie*, V, 1980, pp. 43–58.

Riederer, J. 'Die Zusammensetzung deutscher Renaissance-statuetten aus Kupferlegierungen', *Zeitschrift des deutschen Vereins für Kunstwissenschaft*, XXXVI, Heft 1/4, 1982, pp. 42–48.

Riederer, J. 'Metallanalysen an Erzeugnissen der Vischer-Werkstatt', *Berliner Beiträge zur Archäometrie*, VIII, 1983, pp. 89–99.

Rizzini, P. *Illustrazione dei Musei Civici di Brescia. Placchette e Bassorilievi*, Brescia 1889.

Romano, G. 'Verso la maniera moderna: da Mantegna a Raffaello', in *Storia dell'Arte Italiana*, II/2/1: *Cinquecento e Seicento*, Turin 1981, pp. 3–85.

Roschmann, A. *Tyrolis pictoria et statuaria*, Innsbruck 1742 (Tiroler Landesmuseum Ferdinandeum, Dip. 1031).

Rossi, F. *Musei Civici di Brescia, Cataloghi*: no. 1, *Placchette Sec. XV–XIX*, Vicenza 1974.

Rossi, U. *I Medaglisti del Rinascimento alla Corte di Mantova*, Rivista italiana di numismatica, I, 1888, fasc. II, pp. 161–194; fasc. IV, pp. 433–438.

Ruhmer, E. 'Antonio Lombardo – Versuch einer Charakteristik', *Arte Veneta*, XXVII, 1974, pp. 39–73.

Russoli, F. *Scultura Italiana*, vol. 3: *Il Rinascimento*, Milan 1967.

Sacken, E. von *Die k.k. Ambraser Sammlung*, II. Teil: *Die Kunst- und Wunderkammern und die Bibliothek*, Vienna 1855.

Sacken, E. von *Kunstwerke und Geräthe des Mittelalters und der Renaissance in der kais.kön. Ambraser Sammlung in Original-photographien*, n.d. (1865).

Sacken, E. von and Kenner, F. *Die Sammlungen des k.k. Münz- und Antikencabinets*, Vienna 1866.

Sacken, E. von *Die antiken Bronzen des k.k. Münz- und Antiken-cabinets in Wien*, I. Theil, *Die figuralischen Bildwerke Classischer Kunst mit LIV Tafeln*, Vienna 1871.

Santangelo, A. *Museo di Palazzo Venezia. La Collezione Auriti – piccoli bronzi, placchette, incisioni e oggetti d'uso*, Rome 1964.

Sartori, A. *Documenti per la Storia dell'Arte a Padova*, Vicenza 1976.

Sauerlandt, M. *Das Museum für Kunst und Gewerbe in Hamburg 1877–1927, Neuerwerbungen aus den Jahren 1919–1927*, Hamburg 1929.

Savage, G. *A Concise History of Bronzes*, London 1968.

Scamozzi, V. *L'Idea della Architettura universale*, Venice 1615.

Scheicher, E. *Die Kunst- und Wunderkammern der Habsburger*, Vienna–Munich–Zurich 1978.

Schlegel, U. 'Riccios "Nackter Mann mit Vase" – Zur Deutung einer Gruppe italienischer Kleinbronzen', in *Festschrift Ulrich Middeldorf*, Berlin 1968, pp. 350–357.

Schlegel, U. 'Mars, Venus und Amor. Ein Relief von Antonio Lombardi', in *Mitteilungen des Kunsthistorischen Institutes in Florenz*, XXVIII/1, 1984, pp. 65–76.

Schlosser, J. von *Album ausgewählter Gegenstände der Kunstindustriellen Sammlung des Allerhöchsten Kaiserhauses*, Vienna 1901.

Schlosser, J. von *Werke der Kleinplastik in der Skulpturensammlung des Allerhöchsten Kaiserhauses*, Vienna 1910.

Schlosser, J. von 'Aus der Bildwerkstatt der Renaissance', *Jahrbuch der Kunsthistorischen Sammlungen des Allerhöchsten Kaiserhauses*, XXXI, 1913–14, pp. 67–135.

Schlosser, J. von, *Fünf Italienische Bronzen*, Vienna 1922.

Schmidt, A. *Wiens Umgebungen auf zwanzig Stunden im Umkreis*, vol. 2/2, Vienna 1837.

Schneider, R. von 'Neuere Erwerbungen der Antikensammlung des Österreichischen Kaiserhauses in Wien. 1880–1891', *Jahrbuch des kaiserl. deutschen Archäologischen Instituts*, VII, 1892, Beiblatt, p. 53.

Schottky, J.M. *Das k.k. Lustschloss Laxenburg, mit allergnädigster Bewilligung des Kaisers beschrieben*, Vienna 1821 (Manuscript in the Österreichischen Nationalbibliothek, no. 13820).

Schottmüller, F. *Donatello*, Munich 1904.

Schottmüller, F. 'Bertoldo di Giovanni', in *Allgemeines Lexikon der Bildenden Künstler*, edd. U. Thieme and F. Becker, vol. 3, Leipzig 1907, pp. 505–507.

Schottmüller, F. *Königliche Museen zu Berlin, Beschreibung der Bildwerke der christlichen Epochen*, zweite Auflage, V. Band: *Die italienischen und spanischen Bildwerke der Renaissance und des Barocks in Marmor, Ton, Holz und Stuck*, Berlin 1913.

Schottmüller, F. *Bronzestatuetten und Geräte*, Berlin 1918.

Schottmüller, F. *Staatliche Museen zu Berlin, Bildwerke des Kaiser-Friedrich-Museums – Die Italienischen und Spanischen Bildwerke der Renaissance und des Barock*, Erster Band, *Die Bildwerke in Stein, Holz, Ton und Wachs*, zweite Auflage, Berlin 1933.

Schubring, P. *Donatello – Des Meisters Werke in 277 Abbildungen*, Klassiker der Kunst, vol. II, Stuttgart–Leipzig 1907.

Schubring, P. *Die Italienische Plastik des Quattrocento – Handbuch der Kunstwissenschaft*, Munich 1915.

Seling, H. *Die Kunst der Augsburger Goldschmiede 1529–1868*, 3 vols, Munich 1980.

Semenzato, C. in *Dopo il Mantegna*, exhibition catalogue, Padua 1976, p. 130, no. 90.

Semper, H. *Donatellos Leben und Werke*, Innsbruck 1887.

Semrau, M. *Donatellos Kanzeln in San Lorenzo. Ein Beitrag zur Geschichte der italienischen Plastik im XV. Jahrhundert*, Breslau 1891.

Severo Calzetta, called Severo da Ravenna, exhibition catalogue, The Frick Collection, New York 1978.

Seymour Jr, C. 'An Attribution to Riccio and other recent Acquisitions of Italian Renaissance Bronzes', *Yale Art Gallery Bulletin*, April 1962, pp. 5–21.

Seymour Jr, C. *Sculpture in Italy – 1400 to 1500*, Pelican History of Art, Harmondsworth 1966.

Seymour Jr, C. 'Bertoldo di Giovanni', in *Dizionario biografico*

degli Italiani, vol. 9, 1967, pp. 589–591.

Sheard, W.S. *Antiquity in the Renaissance*, exhibition catalogue, Smith College Museum of Art, Northampton, Massachusetts 1978.

Sieveking, J. 'Bronzestatuette einer Pantherin', *Münchner Jahrbuch der bildenden Kunst*, VII, 1912, pp. 1–3.

Soprani, R. *Le vite de' Pittori, Scultori ed Architetti genovesi*, Genoa 1874.

Sorbelli, A. *Le Marche bibliografiche bolognesi nel secolo XVI*, Milan, n.d.

Spencer, J.R. 'Filarete, the Medallist of the Roman Emperors', *The Art Bulletin*, LXI, 1979, pp. 550–561.

Splendours of the Gonzaga, exhibition catalogue, Victoria and Albert Museum, edd. D. Chambers and J. Martineau, London 1981.

Sponsel, J.L. *Führer durch das königliche Grüne Gewölbe zu Dresden*, Dresden 1915.

Stix, A. and Spitzmüller, A. *Beschreibender Katalog der Handzeichnungen in der Graphischen Sammlung Albertina – Die Schulen von Ferrara, Bologna, Parma und Modena, der Lombardei, Genua, Neapels und Siziliens*, VI, Vienna 1941.

Stone, R.E. 'Antico and the Development of Bronze Casting in Italy at the End of the Quattrocento', *Metropolitan Museum Journal*, XVI, 1982, pp. 87–116.

Strohmer, E.V. 'Bemerkungen zu den Werken des Adriaen de Vries', *Nationalmusei Årsbok*, 1947–48, (1950), pp. 93–138.

Suermann, M.-T. 'Zur Baugeschichte und Ikonographie des Stadthagener Mausoleums', *Niederdeutsche Beiträge zur Kunstgeschichte*, XXII, 1983, pp. 67–90.

Summers, J.D. *The Sculpture of Vincenzo Danti: A Study in the Influence of Michelangelo and the Ideals of the Maniera*, Garland Outstanding Dissertations in the Fine Arts, New York–London 1979.

Supino, J.B. *Catalogo del R. Museo Nazionale di Firenze (Palazzo del Podestà)*, Rome 1898.

Theuerkauff, C. 'Scultura Tedesca del XVIII secolo ad Amburgo', *Antichità Viva*, III, 1964, pp. 30–46.

Theuerkauff, C. and Möller, L.L. *Die Bildwerke des 18. Jahrhunderts*, (Kataloge des Museums für Kunst und Gewerbe Hamburg, Band IV), Hamburg 1977.

Ticozzi, S. *Dizionario degli architetti, scultori, pittori, intagliatori in rame ed in pietra, coniatori di medaglie, mosaicisti, niellatori, intarsiatori d'ogni età e d'ogni nazione*, 4 vols, Milan 1830–1833.

Tietze, H. and Tietze-Conrat, E. *The Drawings of the Venetian Painters in the 15th and 16th Centuries*, New York 1944.

Tietze-Conrat, E. 'Bologna, Giovanni', in *Allgemeines Lexikon der Bildenden Künstler*, edd. U. Thieme and F. Becker, vol. 4, Leipzig 1910, pp. 247–252.

Tietze-Conrat, E. *Die Bronzen der Fürstlich Liechtensteinschen Kunstkammer*, Vienna 1917/1918.

Tietze-Conrat, E. 'Beiträge zur Geschichte der italienischen Spätrenaissance- und Barockskulptur', *Jahrbuch des Kunsthistorischen Institutes des deutschösterreichischen Staatsdenkmalamtes*

in Wien, XII, 1918, pp. 44–75.

Tietze-Conrat, E. 'Zur Höfischen Allegorie der Renaissance', *Jahrbuch der Kunsthistorischen Sammlungen des Allerhöchsten Kaiserhauses*, XXXIV, 1918, pp. 25–32.

Timofiewitsch, W. *Girolamo Campagna – Studien zur venezianischen Plastik um das Jahr 1600*, Munich 1972.

Trenschel, H.P. 'Der Würzburger Hofbildhauer Johann Peter Wagner (1730–1809) – Zur Sonderausstellung des Mainfränkischen Museums Würzburg (26. Februar–18. Mai 1980) aus Anlaß des 250. Geburtstages Johann Peter Wagners', *Mainfränkische Hefte*, LXXI, 1980.

Le Triomphe du Maniérisme Européen – de Michel-Ange au Gréco, exhibition catalogue, Amsterdam 1955.

Tuttle, R. *New Light on Giambologna's Works in Bologna*, unpublished paper given in Edinburgh in August 1978.

Übersicht der Kunsthistorischen Sammlungen des Allerhöchsten Kaiserhauses, Vienna 1916, 1917.

Utz, H. 'Skulpturen und andere Arbeiten des Battista Lorenzi', *Metropolitan Museum Journal*, VII, 1973, pp. 37–70.

Valentiner, W., 'A Neglected Sculptor in the Mannerist Exhibition of Amsterdam', in *The Art Quarterly*, XIX (1956), pp. 41–49.

Varese, R. *Placchette e bronzi nelle Civiche Collezioni (Ferrara)*, Florence 1974.

Vasari, G. *Le Vite de' più eccellenti pittori, scultori ed architetti* (1568), ed. G. Milanesi, 9 vols, Florence 1878–85.

Vasari, G. *Vita di Jacopo Tatti detto il Sansovino*, ed. G. Lorenzetti, Florence 1913.

Venturi, A. 'Zur Geschichte der Kunstsammlungen Kaiser Rudolfs II', *Repertorium für Kunstwissenschaft*, VIII, 1885, pp. 1–23.

Venturi, A. *Storia dell'Arte Italiana*, VI: *La scultura del Quattrocento*, Milan 1908.

Venturi, A. 'Esposizione d'oggetti d'arte e di storia restituiti dall'Austria Ungheria', in *L'Arte*, 1922, pp. 142–148.

Venturi, A. *Storia dell'Arte Italiana*, X/1, Milan 1935.

Venturi, A. *Storia dell'Arte Italiana*, X/2, Milan 1936.

Venturi, A. *Storia dell'Arte Italiana*, X/3, Milan 1937.

Vermeule, C. 'An imperial medallion of Leone Leoni and Giovanni Bologna's statue of the flying Mercury', *Spink's Numismatic Circular*, November 1952, pp. 506–510.

Vermeule, C. *European Art and the Classical Past*, Cambridge, Massachusetts 1965.

Vienne à Versailles – Les grandes Collections Autrichiennes au Château de Versailles, May–October 1964, Versailles 1964.

Volbach, W.F. *Die Elfenbeinbildwerke – Staatliche Museen zu Berlin, Die Bildwerke des Deutschen Museums*, Band I, Berlin–Leipzig 1923.

Volk, P. in *Bayerisches National Museum, Bildführer* I: *Bronzeplastik – Erwerbungen 1956–1973*, Munich 1974, pp. 52, 53, no. 34.

Vollmer, H. 'Franqueville, Pierre', in *Allgemeines Lexikon der Bildenden Künstler*, edd. U. Thieme and F. Becker, vol. 12, Leipzig 1916, pp. 384–386.

Vollmer, H. 'de Vries, Adriaen', ibid. vol. 34, Leipzig 1940, pp. 572–574.

Vollmer, H. 'Vittoria, Alessandro', ibid. vol. 34, Leipzig 1940, pp. 438–440.

Wark, R.R. *Sculpture in the Huntington Collection*, San Marino 1959.

Watson, K.J. and Avery, C. 'Medici and Stuart: a Grand Ducal Gift of Giovanni Bologna Bronzes for Henry Prince of Wales (1612)', *The Burlington Magazine*, CXV, August 1973, pp. 493–507.

Watson, K.J. 'A Bronze "Mercury" after Giambologna', *Allen Memorial Art Museum Bulletin*, XXXIII, no. 2, 1975–76, pp. 59–71.

Weber, I. *Deutsche, Niederländische und Französische Renaissance Plaketten 1500–1650*, Munich 1975.

Weihrauch, H.R. *Studien zum Bildnerischen Werke des Jacopo Sansovino*, Zur Kunstgeschichte des Auslandes, Strasbourg 1935.

Weihrauch, H.R. 'Tatti, Jacopo d'Antonio, genannt Jacopo Sansovino', in *Allgemeines Lexikon der Bildenden Künstler von der Antike bis zur Gegenwart*, edd. U. Thieme and F. Becker, vol. 32, Leipzig 1938, pp. 465–470.

Weihrauch, H.R. 'Beiträge zu Andrea Riccio', *Pantheon*, XXV, 1940, pp. 64–66.

Weihrauch, H.R. 'Der Innsbrucker Brunnen des Kaspar Gras', *Pantheon*, XXXI–XXXII, 1943–44, pp. 105–111.

Weihrauch, H.R. *Bayerisches Nationalmuseum München, Kataloge Band XIII/5: Die Bildwerke in Bronze und in anderen Metallen. Mit einem Anhang: Die Bronzebildwerke des Residenzmuseums*, Munich 1956.

Weihrauch, H.R. 'Gerhard(t) (Gherardi, Girardi), Hubert (Hubrecht, Ruprecht, Robert)', in *Neue Deutsche Biographie*, vol. 6, Berlin 1964, pp. 278–281.

Weihrauch, H.R. *Europäische Bronzestatuetten*, Brunswick 1967.

Weihrauch, H.R. 'Beiträge zu Benedikt Wurzelbauer und Adriaen de Vries', *Umèni*, I, 1970, pp. 69–73.

Weller, A.S. *Francesco di Giorgio, 1439–1501*, Chicago 1943.

Welt in Umbruch – Augsburg zwischen Renaissance und Barock, exhibition catalogue, 2 vols, Augsburg 1980.

Wickhoff, F. 'Die italienische Handzeichnungen der Albertina, II. Teil: Die Römische Schule', *Jahrbuch der Kunsthistorischen Sammlungen des Allerhöchsten Kaiserhauses*, XIII/2, 1892 pp. CLXXV–CCLXXXIII.

Wiles, B.H. *The Fountains of Florentine Sculptors and their Followers from Donatello to Bernini*, Cambridge, Massachusetts 1933; reprinted New York 1975.

Wilson, C.C. *Renaissance Small Bronze Sculpture and Associated Decorative Arts at the National Gallery of Art*, Washington DC 1983.

Wilson, E. in *Medieval, Renaissance & Baroque Works of Art* and *a Collection of Italian Renaissance Plaquettes*, sale catalogue, Sothebys Parke Bernet & Co., London 24 June 1982.

Wixom, W.D. *Renaissance Bronzes from Ohio Collections*, The Cleveland Museum of Art, Cleveland 1975.

Zeiss, A. *Beschreibung meiner Kunstsammlung*, Berlin 1900.

Zimmermann, H. 'Franz v. Stamparts und Anton v. Prenners Prodromus zum Theatrum Artis Pictoriae von den Originalplatten in der K.K.Hofbibliothek zu Wien. Abgedruckt und mit einer erläuternden Vorbemerkung neu herausgegeben', *Jahrbuch der Kunsthistorischen Sammlungen des Allerhöchsten Kaiserhauses*, VII, II. Teil, 1888, pp. VII–XIV, and plates 1–30.

Zimmermann, H. 'Inventare, Acten und Regesten aus der Schatzkammer des Allerhöchsten Kaiserhauses', *Jahrbuch der Kunsthistorischen Sammlungen des Allerhöchsten Kaiserhauses*, X/2, 1889, pp. CCI–CCCXXVI.

Zimmermann, H. 'Das Inventar der Prager Schatz-und Kunstkammer vom 6. Dezember 1621, nach Acten des K. und K. Reichsfinanzarchivs in Wien', *Jahrbuch der Kunsthistorischen Sammlungen des Allerhöchsten Kaiserhauses*, XXV/2, 1905, pp. XIII–LXXV.

Zimmermann, H. 'Zur Ikonographie des Hauses Habsburg', *Jahrbuch der Kunsthistorischen Sammlungen des Allerhöchsten Kaiserhauses*, XXV, 1905, pp. 171–218.

Index